THE HIDDEN
LEONARDO

Rand McNally & Company

Chicago · New York · San Francisco

THE HIDDEN
LEONARDO

MARCO ROSCI

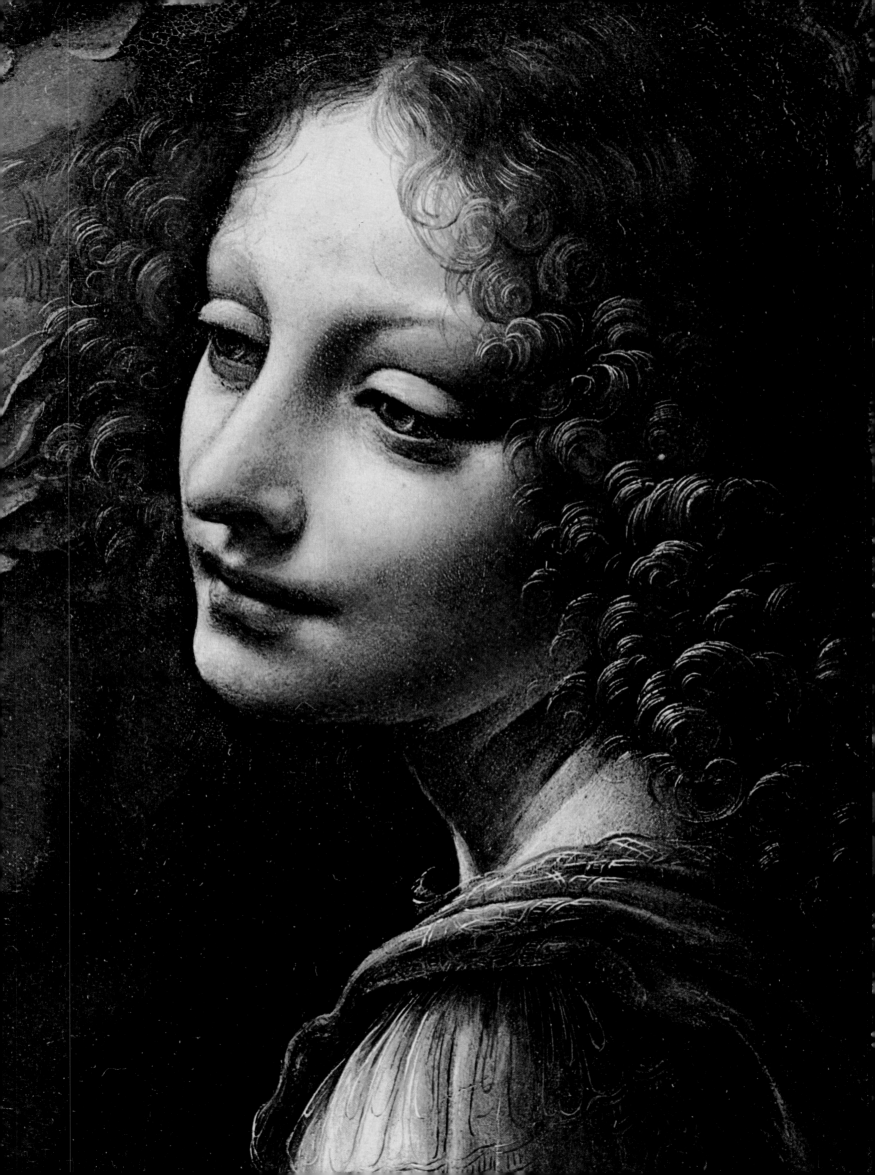

Frontispiece illustration:
VIRGIN OF THE ROCKS
Detail
Oil on wood panel: 75 × 47¼ in
(190 × 120 cm)
London, National Gallery
See page 55

THE
HIDDEN
LEONARDO

BY MARCO ROSCI

EDITORS: MARIELLA DE BATTISTI, MARISA MELIS
EDITORIAL COLLABORATION: PAOLA LOVATO,
ADRIANA NANNICINI
GRAPHIC DESIGN: ENRICO SEGRÈ
TRANSLATED FROM THE ITALIAN BY JOHN GILBERT

Published in U.S.A., 1977 by Rand McNally & Co., Chicago, Ill.
Library of Congress Catalog Card No. 77-70250
ISBN: 528-81042-1

Printed in Italy by Officine Grafiche di
Arnoldo Mondadori Editore, Verona

Filmset by Keyspools Ltd, Golborne, Lancashire

Contents

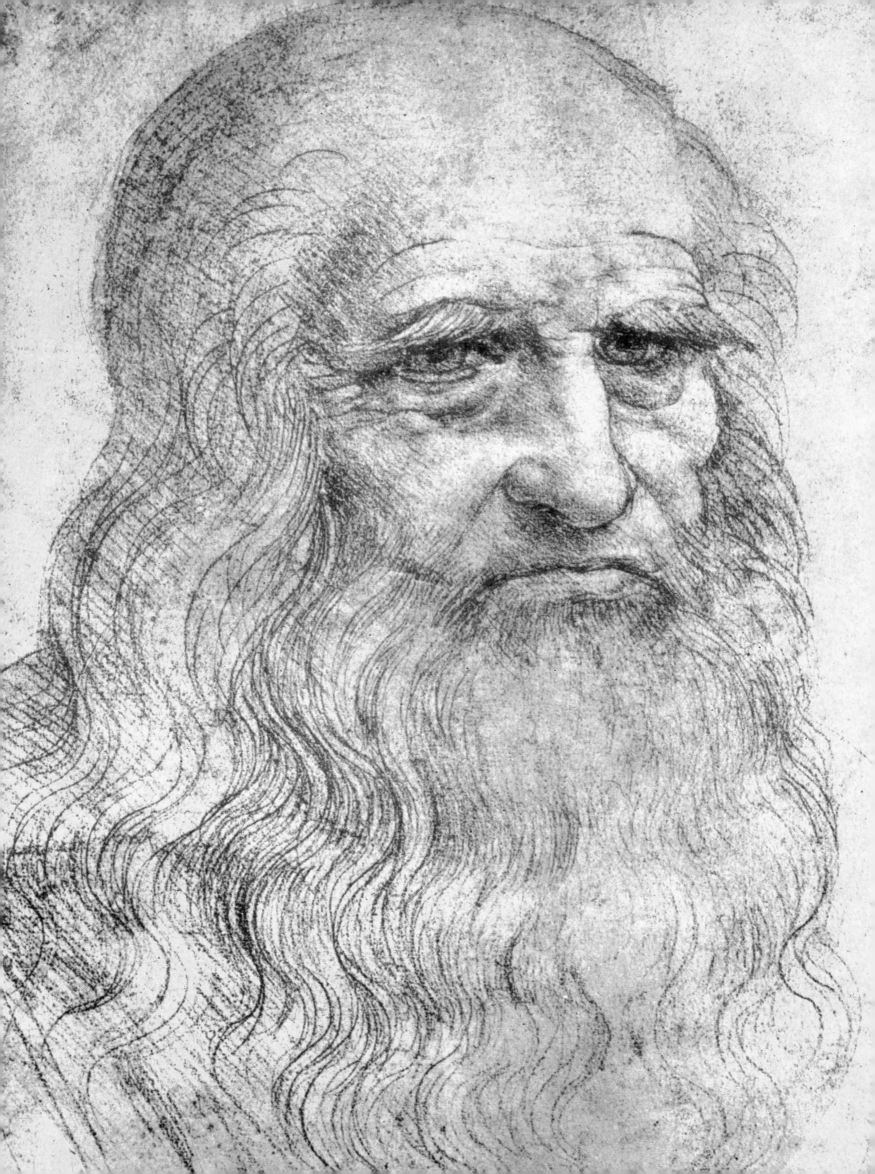

The first recognized biography of Leonardo da Vinci (preceded only by Paolo
Giovio's *De viris illustribus*, dating from around 1524) was written by the Arezzo-
born painter and writer Giorgio Vasari. Leonardo was the subject of one of the
chapters in Vasari's monumental study of contemporary artists entitled *The Lives of
the Most Eminent Italian Architects, Painters, and Sculptors* (1550–68), which was to
remain a standard reference work for some two centuries. Unfortunately, Vasari did
his hero a disservice in portraying him not so much as an outstandingly gifted man
as a magical figure from the realms of mythology – a romantic interpretation that
many later art critics, literary critics and historians were to carry to even more
ridiculous extremes.

"The heavens," wrote Vasari, "often rain down the richest gifts, naturally, on
human beings but, sometimes, with lavish abundance, bestow upon a single
individual beauty, grace, and ability, so that, whatever he does, every action is so
divine that he outdistances all other men, clearly demonstrating that his genius is
the gift of God and not an acquisition of human art. Men saw this in Leonardo da
Vinci, whose personal beauty could not be exaggerated, whose every movement was
inherently graceful, and whose abilities were so extraordinary that he could readily
solve every difficulty. He possessed great personal strength, combined with
dexterity; and his spirit and courage were invariably regal and magnanimous. The
fame of his name spread far and wide, so that not only was he highly esteemed in his
own day, but his renown has even more greatly increased since his death. Leonardo,
son of Ser Piero da Vinci, was truly marvelous and divine."

In the eyes of his contemporaries, as Vasari made quite clear, Leonardo was
already spoken of with wonder; and confronted by this superhuman example of
"divine genius," it is hardly surprising that those not too kindly disposed toward
him should resent his unconventional and unorthodox opinions.

Vasari had distinguished three Golden Ages of the Italian Renaissance, the first
dominated by Giotto and the Pisano family and the second by Brunelleschi,
Donatello, and Masaccio. The third age, representing the "peak of perfection," was
personified by Leonardo, Raphael, and Michelangelo. Yet there is a striking
contrast between Vasari's introduction to the life of Leonardo and that of the other
two men. In all three cases, Vasari adopted the rhetorical style reminiscent of
classical Roman history and oratory, but his enthusiasm for Leonardo was on a very
different plane. True, Raphael and Michelangelo were also acknowledged to be
"divinely" inspired; but neither in the case of Michelangelo's achievements in the
plastic arts and poetry nor of Raphael's artistic endeavors and exemplary life
was there a hint of anything mysterious or superhuman. Their talents were of
human dimensions, specific rather than "universal." They were complete profes-
sionals, their feet firmly planted on the ground, although Vasari did not for a
moment underestimate their remarkable technical ability and supreme natural-
istic skill.

Leonardo was a man who surely exemplified all the best qualities of fifteenth-
century humanism, especially in his attitudes toward traditional learning and
culture. It seems strange, therefore, that contemporaries should have seen anything
mysterious or unorthodox about him. For here was someone who adopted an

empirical approach to every thought, opinion, and action and who accepted no truth unless verified or verifiable, whether related to natural phenomena, human behavior, or social activities. His inquiring mind would fasten as eagerly on the practical problems of everyday life as on the mysteries of the universe. Time and time again he condemned the empty abstractions of hallowed authority, refusing to see any contradiction or to recognize any distinction between theoretical, experimental and applied science and regarding continual experimentation as the cardinal inspiration of all his work, whether in the arts, in practical mechanics, or in an incredibly broad range of observations on diverse aspects of human activity. Yet, in Vasari's biographical essay, terms such as *whims, caprices, follies*, and *odd habits* crop up repeatedly, explained in the first edition (1550) as being due to the fact that "his cast of mind was so heretical that he did not adhere to any religion, thinking perhaps that it was better to be a philosopher than a Christian." This note was prudently suppressed in the second edition of 1568, five years after the proclamation of the decrees of the Council of Trent.

Leonardo has indeed been ill served both by the romantics, who have persisted in seeing him as a shadowy "Faust" figure dabbling with alchemy in a frenzied quest for knowledge, and by the patriots, obsessed with "racial genius," who have credited him with having thought up every technical innovation associated with the Industrial Revolution some three centuries later. Vasari, on the other hand, was largely responsible for encouraging the myth-making strain of biography and criticism.

In the context of art history, Leonardo's bold, unconventional, innovative ideas and statements are certainly extraordinary and his empirical methods remarkable for their time, but there is nothing mysterious about his admirably logical "vision of the world"; and in the field of visual art, Leonardo's works proved to be a lasting influence. A direct line can be traced from such works of Leonardo (dating from the last twenty years of the fifteenth century) as *The Adoration of the Magi*, the cartoon of the *Virgin and Child with St. Anne*, the *Virgin of the Rocks*, and *The Last Supper* to the prototypes of the new European art forms of the sixteenth century, from Michelangelo to Raphael and from Giorgione to Dürer and Holbein. This strain of artistic works was part of the broader process of historical development – the political crises and changes affecting western civilization and extending beyond these confines (for Leonardo was born a year after Mahomet II entered Constantinople) in the fifteenth and sixteenth centuries – that lead to the emergence of modern science, the appearance of national states and absolute monarchy, the birth of the Protestant religion, and the first concerted manifestations of mercantile middle-class power.

The most sensible way of avoiding the risks of exaggeration and romanticization is to try to analyze the complex character of Leonardo in the context of the times in which he lived. Against the background of contemporary events, his true contribution can be seen to be not that of a seer or crystal gazer but that of an explorer and pathfinder, clearing away the debris of outmoded conventions and pointing the way forward to new visions of the world and reality. This constituted a fresh conception of the artist's role in society. Leonardo expressed his ideas, to some extent, in visual form; but it was in the language of visual impressions that he found a vehicle of analysis and communication far more fundamental and effective than purely representational art.

LANDSCAPE OF VALLEY OF THE ARNO
Pen drawing on white paper; strokes mostly from left to right; $7\frac{3}{8} \times 11\frac{1}{4}$ in (19.4 × 28.6 cm)
Florence, Uffizi Gallery, Drawings and Prints Collection
At upper left a note in "mirror" writing by Leonardo himself: "This day of Sta Maria della Neve, the fifth of August 1473." Below, the name "Leonardo."

His Birth – the Historical Setting

Leonardo, the illegitimate son of the local notary Ser Piero and a peasant girl named Caterina, was born at three o'clock in the morning on April 15, 1452, in the village of Vinci. In Florence, Cosimo the Elder, the so-called father of his country, was the effective, if unofficial, ruler. His grandson, Lorenzo de' Medici, later to be known as "the Magnificent," was then three years old. The Medici palace was in the process of being built by Michelozzo; and, in 1459, Benozzo Gozzoli would paint his frescoes on the subject of *The Procession of the Magi* for the palace chapel. In 1478, the conspiracy of the Pazzi family would take place; and, in the following year, Leonardo was to draw a picture of the hanged corpse of Giuliano de' Medici's murderer, Bernardo di Bandino Baroncelli.

In Milan, Francesco Sforza became duke in the year of Leonardo's birth; and, in the previous year, another Sforza, Ludovico Maria, subsequently known as "Il Moro," or "the Moor," had been born. Pope Nicholas V was to die in Rome in 1455; so, too, would Fra Angelico, the man who painted frescoes of scenes from the lives of Saints Lawrence and Stephen in the Vatican chapel. In 1449, the rump Council of Basle had been brought to an end, terminating the last schism of the Catholic church in western Europe; the Renaissance Popes Eugenius IV, Nicholas V, Pius II, and the great humanist Enea Silvio de' Piccolomini were the initiators of Rome's spiritual and cultural revival.

Leonardo was thirty-one years older than Luther, thirty-two years older than Zwingli, and thirty-nine years older than Ignatius of Loyola. They were still children when, between 1495 and 1497, he painted *The Last Supper*.

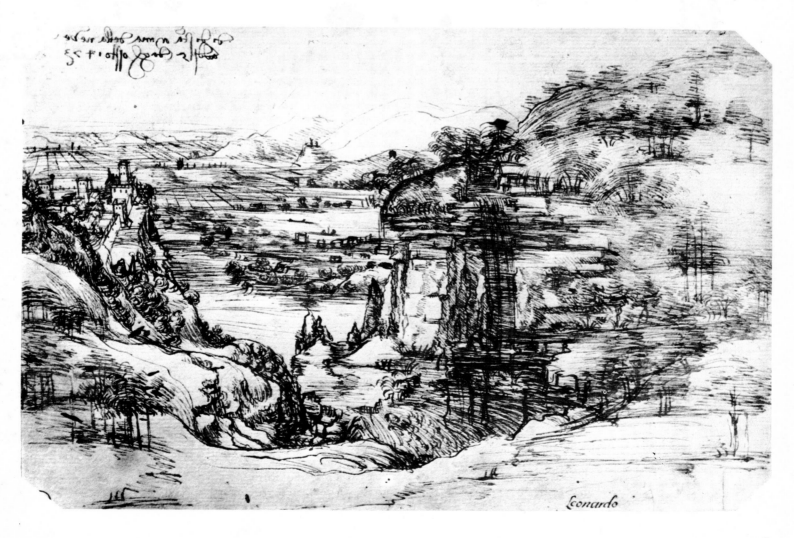

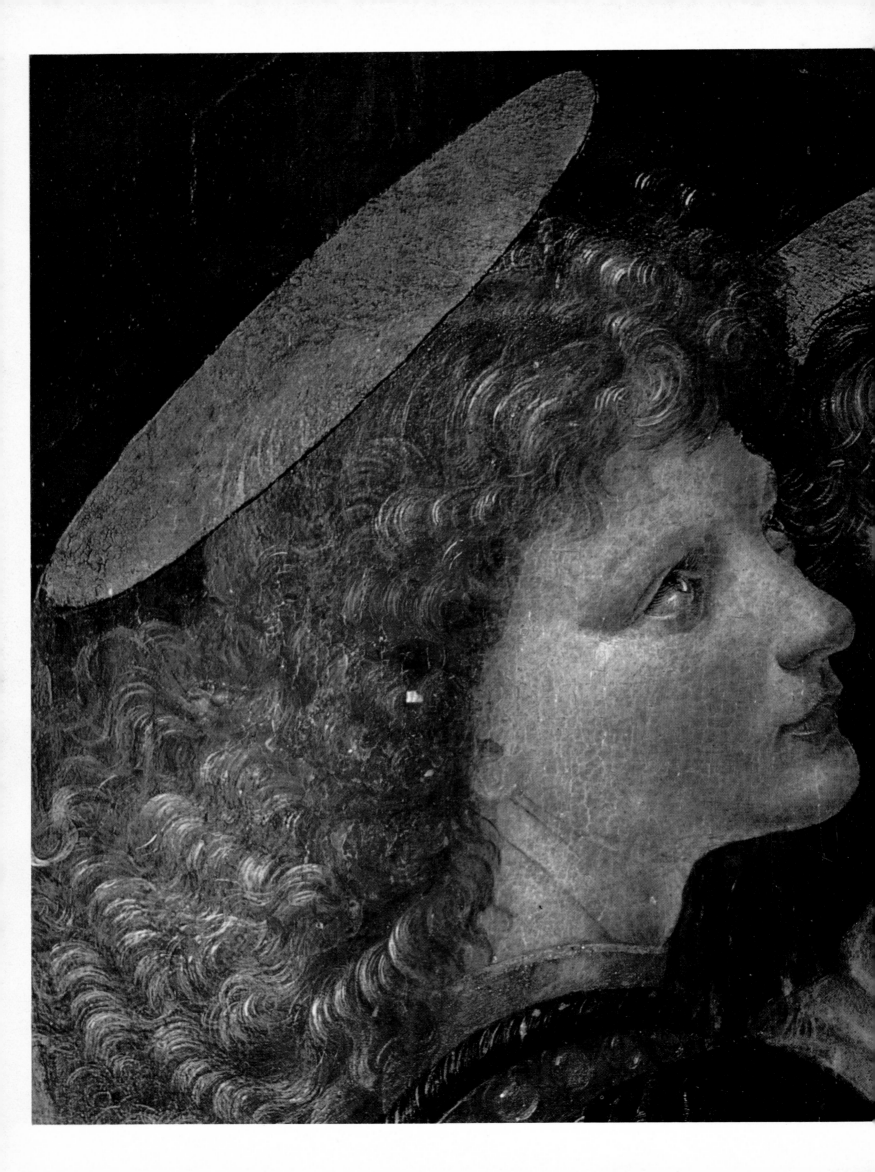

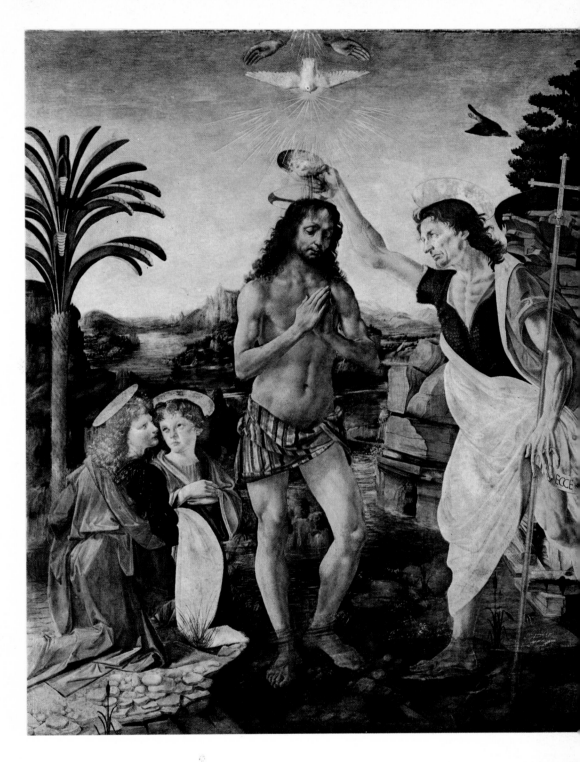

*Leonardo, Verrocchio and
workshop (?)*
BAPTISM OF CHRIST
Tempera and oil on wood panel;
69¾ × 59½ in (177 × 151 cm)
Florence, Uffizi Gallery
Painted for the Church of San Salvi,
later in possession of Vallombrosian
Sisters of Santa Verdiana, then, from
1810 in the Academy of Fine Arts,
Florence, and after 1914 in the Uffizi.
Facing page: detail of angel at far left.
Stated to be by Leonardo in Albertini's
Memoriale (1510) and accepted as such
as Vasari.

For ten years prior to Leonardo's birth, Alfonso V of Aragon had been king of
Naples; and, in 1453, Francesco de Laurana began constructing Alfonso's
triumphal arch at the entrance to the Castel Nuovo. Leonardo was seventeen when
Ferdinand, heir of Aragon, married Isabella of Castile, and twenty-seven when, in
1479, they became joint monarchs of Spain. Christopher Columbus was one year
older than Leonardo. In France, Charles VII, crowned by Joan of Arc in Rheims in
1429, was still on the throne; when his last patron, Francis I, was born, Leonardo
was forty years old. Frederick III, founder of the Hapsburg dynasty, was Holy
Roman Emperor. Three years later, the Wars of the Roses erupted in England. Six
years after Leonardo was born, Matthias Corvinus (Matthias I) was elected king of
Hungary; and it was probably Leonardo, the "finest painter," who was commis-
sioned by Il Moro, in 1485, to do a painting of the *Madonna* as a gift to the
Hungarian monarch. When Ivan III ("the Great") was proclaimed the first Russian
czar, Leonardo was ten years of age.

Thus, Leonardo was born at a time when European history was about to be
transformed by a variety of political and religious upheavals – a swelling wave of
events destined to reach their climax during the lifetimes of other great figures of the

Renaissance, who were, on the average, a generation or so younger than Leonardo. In the cultural sphere, too, Leonardo stood on the threshold of a new era. In 1440, twelve years before Leonardo's birth, Nicholas of Cusa, philosopher and churchman, had written *De docta ignorantia (Of Learned Ignorance)*. Nicholas exerted strong influence on Copernicus, who was born in 1473. Marsilio Ficino, one of the leaders of Florentine Neoplatonism, was nineteen years older than Leonardo. When Gutenberg printed his Bible, Leonardo was about four years old. He was fifteen years older than Erasmus of Rotterdam, seventeen years older than Niccolo Machiavelli, and twenty-six years older than Thomas More.

In fixing these terms of reference, it is important to remind ourselves that Leonardo's conceptions of learning, science, and philosophy were, if not beyond the bounds of contemporary thinking, at least somewhat removed from the mainstream of humanist opinion on such matters. This is evident from his reiterated attacks on "false mental sciences" that had not been tested or experienced. In Manuscript I, dating from the end of his first period in Milan, he condemned "the authors who, by using only their imagination, have tried to set themselves up as interpreters between nature and man." In a couple of pages of one of the Anatomy Manuscripts at Windsor, there are further thoughts on science in general, including the statement that "mental things that have not passed through the understanding are vain and give birth to no truth apart from what is harmful." Elsewhere in this same Manuscript, Leonardo proclaimed his faith in mathematics: "He who blames the supreme certainty of mathematics feeds on confusion and will never impose silence

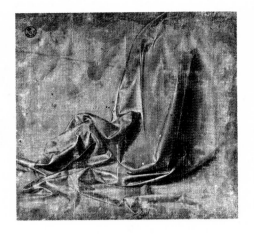

Leonardo (?)
DRAPERY STUDY
Watercolor, heightened with white, on canvas; $6\frac{3}{4} \times 6\frac{1}{2}$ in (17×16.5 cm)
Florence, Uffizi Gallery, Drawings and Prints Collection.

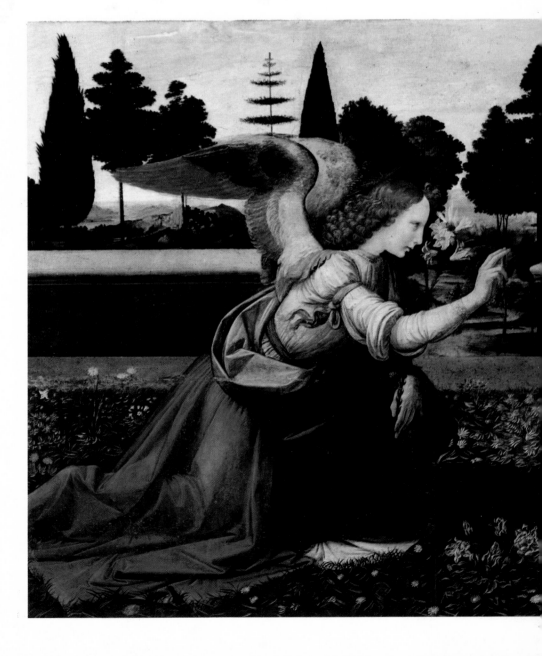

THE ANNUNCIATION
Oil on wood panel; $41 \times 85\frac{1}{2}$ in (104×217 cm)
Florence, Uffizi Gallery
Originally in the Convent of San Bartolomeo, Monteoliveto, where it was attributed to Domenico Ghirlandaio. Not mentioned by Vasari. In the Uffizi since 1867. Liphart was the first to attribute it to Leonardo and after long controversy this is now accepted by most authorities.
Pages 14–15: Detail of angel of the Annunciation.

upon the contradictions of the sophistical sciences, which give rise to perpetual clamor." In Manuscript G, Leonardo states: "There is no certainty where one can neither apply any of the mathematical sciences nor any of those that are based on the mathematical sciences."

Florence, during Leonardo's formative years, was the great center of humanist culture, an incomparable proving ground for new ideas and art forms. Although he was to abandon the city at the age of thirty (perhaps sensing the impending crisis heralded by the appointment, in 1482, of Girolamo Savonarola as lecturer in sacred literature at the convent of St Mark's), Leonardo's remarkable versatility stemmed largely from the theoretical and practical training he received in one of the finest *botteghe*, or art workshops, in Florence. For that reason, above all, and bearing in mind that the art versus science dispute only began during and after Leonardo's lifetime, it is fair to assume that the principal influence in these early years came from other artists, and that Leonardo, in turn, exercised a similar influence on younger painters and sculptors.

Leonardo was eight years younger than Bramante, nineteen years older than Dürer, twenty years older than Cranach the Elder, twenty-three years older than Michelangelo, twenty-three to twenty-eight years older (the exact birth date being uncertain) than Jean Clouet, twenty-five years older than Giorgione, thirty-one years older than Raphael, almost forty years older than Titian, and forty-five years older than Hans Holbein the Younger. Brunelleschi had died in 1446 at the age of sixty-nine. His last church design was that of Santo Spirito, begun in 1436 and still

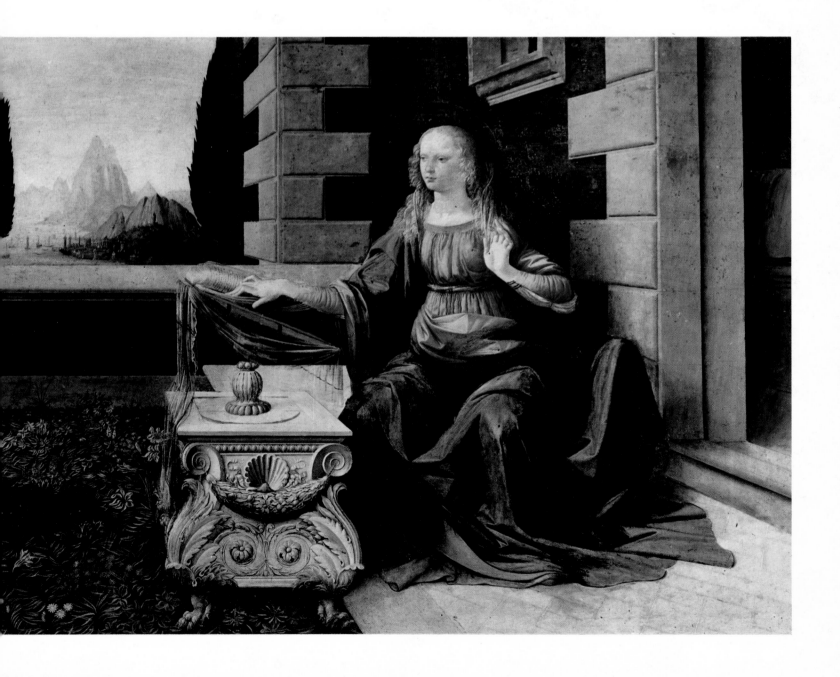

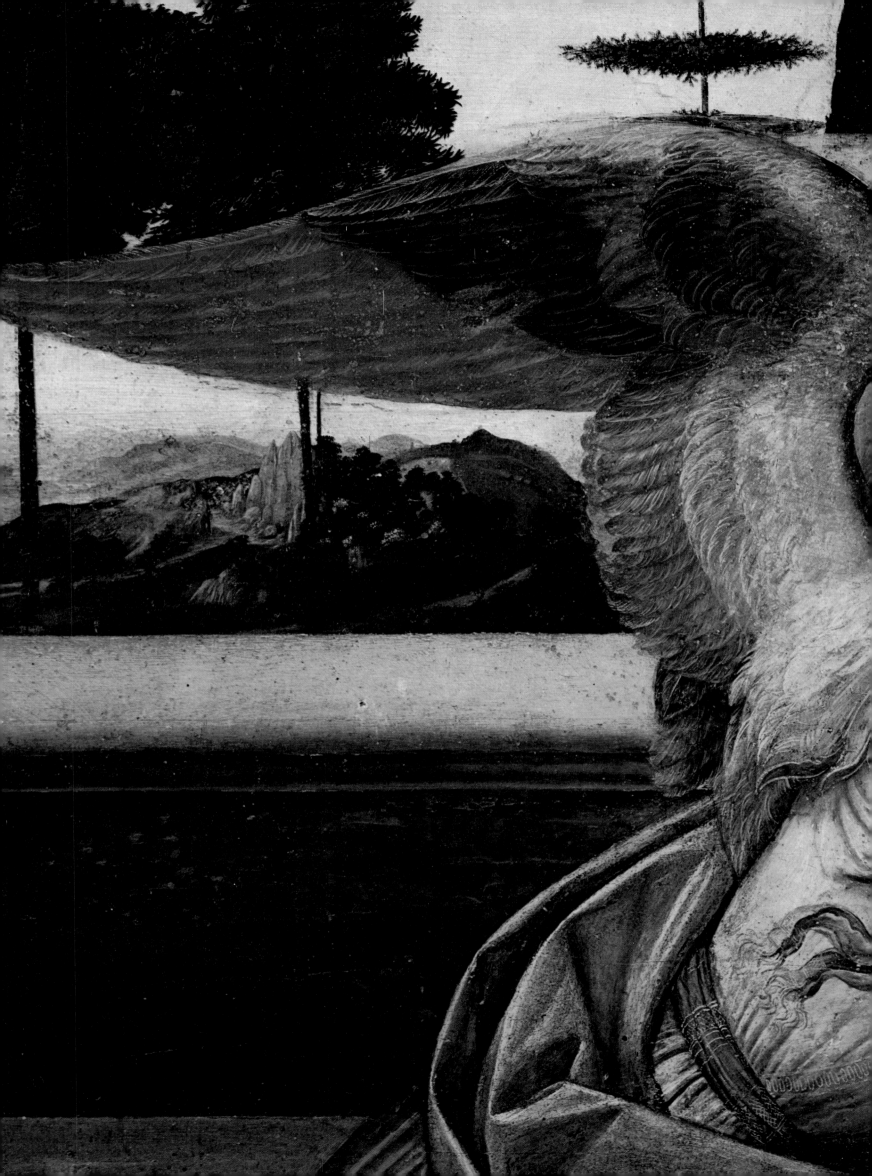

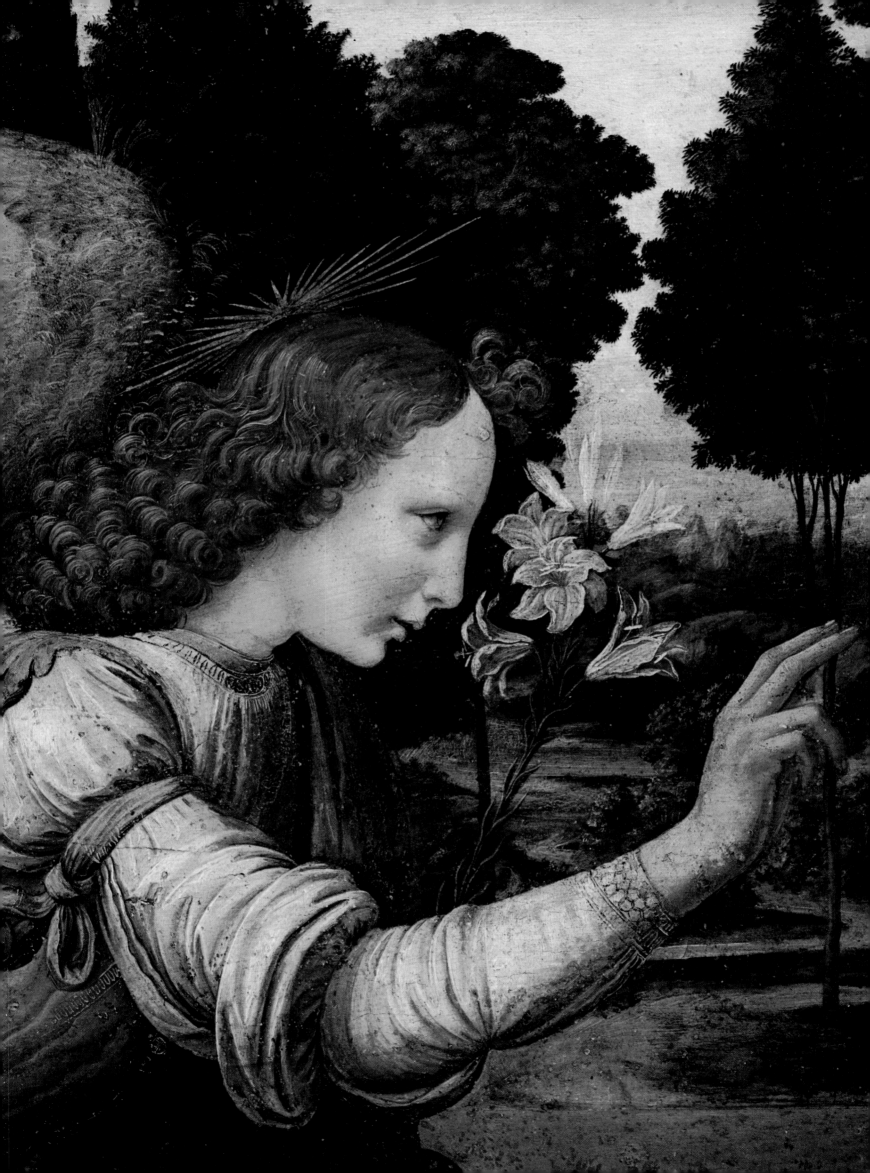

the course of construction at his death. Lorenzo Ghiberti was to die in 1455; Donatello would continue working for another decade. At the time of Leonardo's birth, Donatello was working in Padua. Two years previously, he had completed the equestrian statue of the Venetian condottiere, Erasmo da Narni, known as "Gattamelata." This monument was to serve as a prototype both for Verrocchio's statue of another condottiere, Bartolomeo Colleoni, and for two statues, of Francesco Sforza and Marshal Trivulzio, that were planned but never finished by Leonardo.

A few years after Leonardo was born, Paolo Uccello painted his triptych on *The Rout of San Romano*. Andrea del Castagno had recently completed frescoes for the refectory of Sant'Apollonia; and Filippo Lippi was working on his frescoes in the great choir of the cathedral at Prato. Domenico Veneziano had painted his finest surviving work, the altarpiece for Santa Lucia dei Magnoli in Florence, around 1448; but the cycle of frescoes he had previously painted for San Egidio in the same city has been lost. As a youth, he had been assistant to Piero della Francesca, who, in 1452, was starting work on his own frescoes *(The Legend of the Cross)* at Arezzo. In 1450, Leon Battista Alberti had been commissioned to rebuild the facade of San Francesco in Rimini, which the Malatestas were to transform into a veritable "temple"; and work on Alberti's designs for the Palazzo Rucellai in Florence had been concluded in the following year.

Also in the year of Leonardo's birth, Andrea Mantegna was at work on his first frescoes for the Church of the Eremitani in Padua; four years later, he was to start on the altarpiece for San Zeno, Verona. It was in 1456, too, that the first dated work, *The Three Crosses*, of Vincenzo Foppa appeared; today this is in the Accademia Carrara at Bergamo. In 1432, twenty years prior to Leonardo's birth, the Van Eyck brothers had finished the altarpiece *The Adoration of the Lamb* for Saint Bavon in Ghent. In 1450, Roger van der Weyden had passed through Florence during his journey to Italy.

Of artists particularly close to Leonardo, Verrocchio, his teacher, was eighteen years his senior; Antonio Pollaiuolo, twenty-one years older; and Piero Pollaiuoulo, about ten years older. Other famous contemporaries included Botticelli, born in 1445; Luca Signorelli and Giuliano da Sangallo, both born around this same year; Perugino, born at some date between 1445 and 1450; and Ghirlandaio, born in 1449. The elder Antonio da Sangallo was about three years younger than Leonardo; Lorenzo di Credi, seven years younger; and Piero di Cosimo, eleven years his junior.

The first dated work by Leonardo was a landscape drawing, revolutionary both in concept and execution, bearing the date August 5, 1473. It was at about this time that he may also have painted *The Annunciation* and collaborated with Verrocchio on the *Baptism of Christ*. (All three works are now in the Uffizi, Florence.) Dürer, whose watercolor landscapes dating from the last decade of the century were painted in a similar style, was then two years old. Michelangelo, Giorgione, and Raphael were not yet born; and by then, Donatello, Andrea del Castagno, Filippo Lippi, and van der Weyden were all dead. Alberti, too, had died in the previous year and had just finished the facade of San Andrea in Mantua. Paolo Uccello was to die in 1475 at the age of seventy-eight. Piero della Francesca was at work on his *Madonna and Saints, with Federigo da Montefeltro* (now in the Brera Gallery, Milan); and Mantegna was painting frescoes for the Camera degli Sposi in the ducal palace at Mantua.

In 1470, Cossa and De Roberti, probably under the direction of Tura, had completed their frescoes in the Palazzo Schifanoia at Ferrara. Antonello da Messina was about to depart for Venice, where he would eventually paint his finest works, including *The Crucifixion* (Antwerp) and *St. Sebastian* (Dresden). Giovanni Bellini was working on his altarpiece, *The Coronation of the Virgin*, in Pesaro; and Vincenzo Foppa had recently completed the frescoes of the Portinari Chapel in Milan's San Eustorgio. In 1475, the Belgian painter Hugo van der Goes was to begin the *Portinari Triptych (The Adoration of the Shepherds)*, which aroused keen interest when sent to Florence. Work was in full swing on the ducal palace of Urbino, based originally on the plans of Luciano Laurana and subsequently replaced by those of Francesco di Giorgio Martini. In 1480, Bramante would leave for Milan, preceding

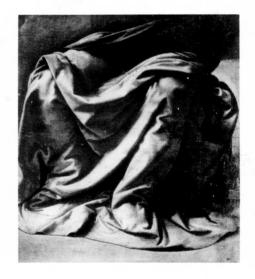

DRAPERY STUDY FOR "THE ANNUNCIATION," RELATING TO LAP OF THE VIRGIN
Bistre, heightened with white, on linen canvas; $10\frac{3}{8} \times 9\frac{1}{16}$ in (26.3×22.9 cm)
Paris, Louvre, Drawings Room.

THE ANNUNCIATION
Detail of the Virgin
Florence, Uffizi Gallery
Pages 18–19: Background landscape.

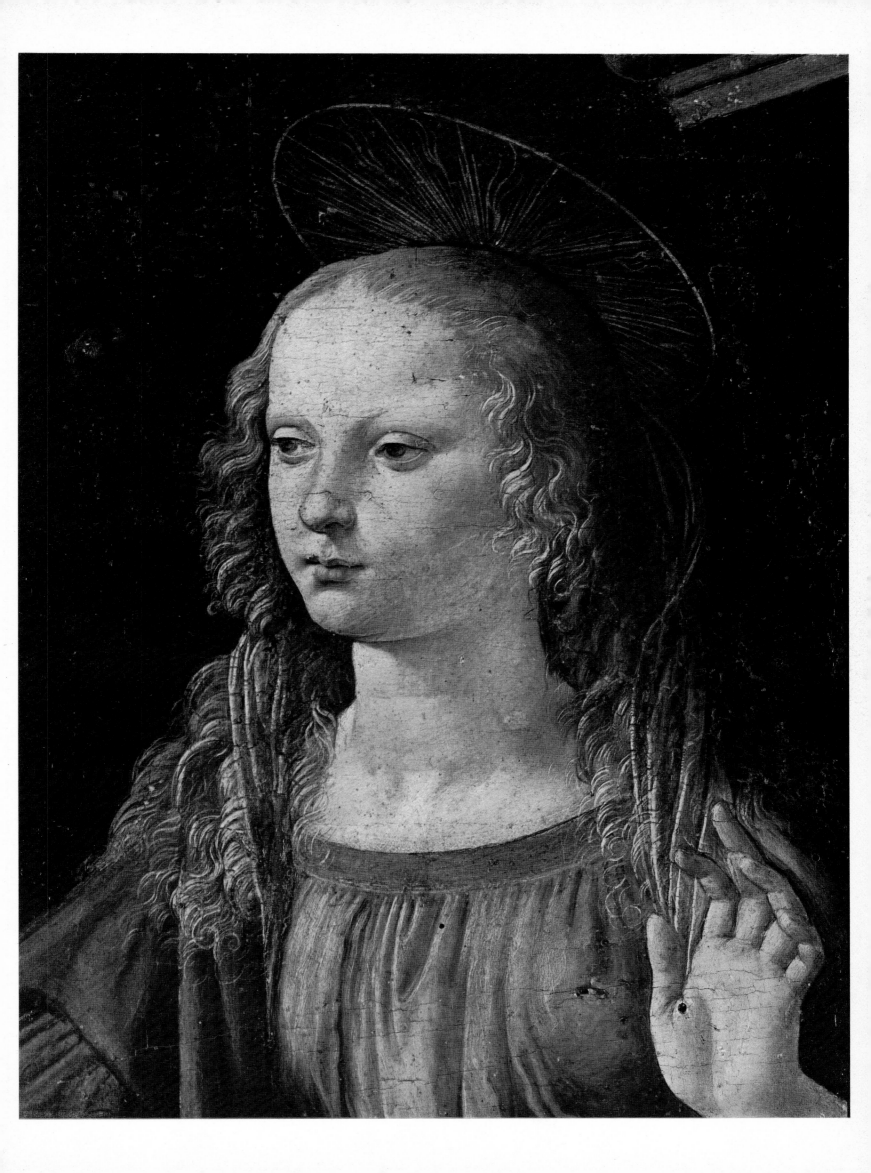

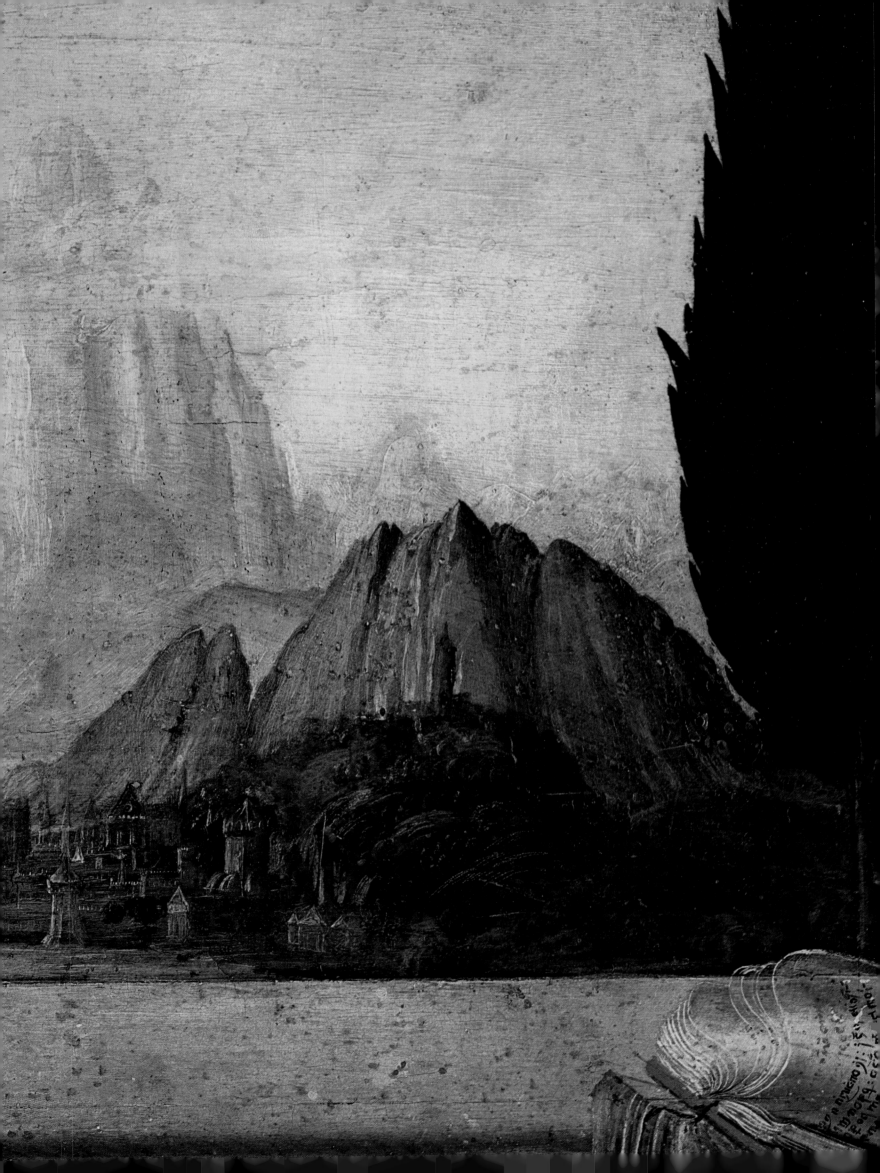

Leonardo's departure for the city by three years. Botticelli's youthful *Fortitude* (now in the Uffizi), was painted for the merchants' tribunal in Florence and dates from 1470. Perugino and Lorenzo di Credi were colleagues of Leonardo in the workshop of Verrocchio, and the master himself had just finished his funerary monument to Giovanni and Piero de' Medici in San Lorenzo.

Early Years

Leonardo had entered Verrocchio's *bottega* as an apprentice around 1469 and, in 1472, had been admitted to the Corporation of San Luca – the Florentine Guild of Painters. It is known, through verified documents, that, in 1457, when he was five, Leonardo was living in the house of his paternal grandfather, Ser Antonio, in the village of Vinci, together with his father, the thirty-year-old Ser Piero, and the latter's first wife, Albiera, aged twenty-one. Leonardo's mother, Caterina, was by now married to Accattabriga di Piero del Vacca and lived on a farm owned by Ser Antonio in Anchiano. Caterina was to be invited by her son to Milan in 1493 and

eventually died there, probably two years later. The expenses covering her funeral were recorded in minute detail by Leonardo and appear on a page of the Forster Bequest Manuscript in the Victoria and Albert Museum in London. In 1468, when Leonardo was sixteen, his grandfather died and he continued living with his father and his father's second wife, twenty-year-old Francesca di Ser Giuliano Lanfredini. At that time, he was the only son of Ser Piero, although for legal reasons and especially because a notary's family was concerned, he was officially referred to as "illegitimate." Ser Piero's first legitimate son was born in 1476, of his third marriage, and in due course (and after four marriages), ten more children were born.

In 1910, Sigmund Freud published his famous essay entitled *Leonardo da Vinci and a Memory of His Childhood*. Like all biographers and critics concerned with the life of Leonardo, Freud only had a few verified facts and scraps of information on which to build his theories. Freud made a psychoanalytical study consisting of more

THE ANNUNCIATION
Tempera on wood panel; $5\frac{1}{2} \times 23\frac{1}{4}$ in (14×59 cm)
Paris, Louvre
Thought by some experts to be part of the predella of an altarpiece depicting *Madonna and Saints (Pistoia Madonna)* in Pistoia Cathedral. The commission was given to Verrocchio and the painting done by members of the workshop under the direction of Lorenzo di Credi. Assumed to be by Ghirlandaio, it came to the Louvre with the Campana collection in 1861. In 1893 Morelli attributed it to Leonardo and this view is almost unanimously accepted today.

than seventy pages in the translated standard edition. He based his analysis on the sparse evidence provided by Leonardo himself and various sources relating to incidents in his childhood and early life, on known facts concerning the family situation (being parted from his mother at the age of five and then living successively with two stepmothers, both young), and on references made by Leonardo to Caterina's visit to Milan and to the death of his father in Florence. Freud found it significant that in describing both events, Leonardo used a form of repetition indicating an attempt to secure perseveration: "On the 16th day of July. Caterina came on the 16th day of July, 1493" and "On the 9th day of July, 1504, on Wednesday at 7 o'clock, died, at the Palace of the Podestà, Ser Piero da Vinci, notary, my father, at 7 o'clock." Freud also laid great stress on Leonardo's childhood memory (recorded on a page of the Codice Atlantico in the Ambrosian Library, Milan) of an incident when "it seemed to me when I was in the cradle that a kite came and opened my mouth with its tail and struck me many times with its tail against my lips."

In his essay, Freud suggested that there was sufficient direct and indirect evidence to support the theory that Leonardo had homosexual inclinations, although not necessarily extending to homosexual activity. Certainly there were hints of this possibility from earlier biographers. Vasari referred to one of Leonardo's pupils, Gian Giacomo Caprotti, nicknamed the "Milanese Salai" (Sucino), or "little devil." Sucino came to work and live with Leonardo in 1490; Vasari described him as "a graceful and delightful youth with fine curly hair, which gave Leonardo much pleasure." He was then ten years old and remained with Leonardo for twenty-six years and was remembered in his will. The relationship may well have been platonic, but it was widely commented on at the time; and we have Leonardo's own written admission of singular indulgence and affection for a boy whom he described as "thievish, untruthful, selfish, and greedy."

Previous to this relationship, in 1476, Leonardo was one of several young men anonymously accused of consorting with a boy prostitute named Jacopo Saltarelli. The case, however, remained unproved and Leonardo was discharged. Freud, in any event, dismissed the episode as unimportant to his thesis. What interested him was not Leonardo's alleged behavior but his emotional attitude, influenced to some extent by his early sexual experiences. Freud held the opinion that certain psychological and emotional impulses from his childhood and adolescence affected Leonardo's work and influenced his attitudes and general behavior throughout his life.

In Freud's opinion, the fact that Leonardo spent his early formative years with his "poor, forsaken, real mother," who felt the absence of his father, was decisive in molding his character and mental attitudes. Living in this environment lead to later sexual repression and caused him to sublimate his libido into the "urge to know," the impulse to investigate. Building his case on the "kite" episode and the known and inferred facts concerning the boy's relationship with his parents, Freud surmised (although he admitted that he could not vouch for the certainty of his conclusions) that infantile sexual repression stunted his adult sexual life and adversely affected his creative activities.

In his youth, Leonardo apparently worked without inhibition, finding a father substitute in Duke Ludovico (Il Moro); but sexual repression was to lead to a diminution of artistic activity and an inability to make quick decisions. The sexual researches of his childhood were sublimated and gave way to a process, analogous to neurotic regression, whereby he became an investigator', "at first still in the service of his art, but later independently of it and away from it." With the loss of his father substitute, the regressive shift assumed larger proportions, and even the research that had replaced artistic creation showed increasing rigidity and lack of ability to adapt to real circumstances. But at the peak of his life, during his early fifties, a transformation took place that enabled him to recover his youthful stimulus, leading to an artistic revival. "This final development," asserted Freud, "is obscured from our eyes in the shadows of approaching age. Before this, his intellect had soared upward to the highest realizations of a conception of the world that left his epoch far behind it."

The charge against Freud of profaning Leonardo's reputation by subjecting him

to psychoanalytical study is, needless to say, ridiculous. He admitted freely that he had embarked on the exercise because he had succumbed to the "attraction of this great and mysterious man." The fact remains, however, that Freud's view of Leonardo is essentially romantic; and the weakest points of the argument are his acceptance of what so many earlier commentators had vaguely defined as "creative genius" and the assumption that artistic creation and intellectual inquiry must be separate and incompatible. It is difficult to accept the validity of Freud's neat subdivisions of Leonardo's life to explain his apparent vacillation between art and science, and even allowing for the fact that the term *regression* is part of the vocabulary of modern psychoanalysis, there still remains Freud's explicit claim that "the investigator in him never in the course of his development left the artist entirely free but often made severe encroachments on him and perhaps in the end suppressed him." It has to be admitted, nevertheless, that Freud was not content merely to echo the traditional, unedifying references of earlier critics to Leonardo's "genius" as a phenomenon to be venerated but not explained. His essay is a genuine, original attempt to understand the nature of Leonardo's character and work; it is the first endeavor that takes into account the complex psychological and emotional sources of creative and cognitive activity.

There are at least three arguments one can legitimately use to refute the conventional view of Leonardo as a man torn between the demands of art and scientific research (interpreting the latter in its broadest sense to embrace inquiry into man and nature, mathematics, physics, mechanics, and a host of other subjects). First, there was the sheer wealth and variety of Leonardo's national heritage – a treasury of painting, sculpture, prose, and poetry – on which he could draw for inspiration. This environment instilled in Leonardo a sense of cultural and historical awareness that could only encourage a comprehensive, rather than a narrow, provincial, outlook on life. Second, and stemming from this, there was the fact that all such artistic endeavors were interdependent. The seeds of innumerable ideas were ever present in the mind, now dormant, now germinating, with the result that projects in widely varying fields might be initiated, temporarily abandoned, and reexplored in depth at the dictates of inner promptings. Finally, one has to recognize that in the *bottega,* or art workshop, where Leonardo served his apprenticeship, there was no clear-cut distinction between theory and practice or between artistic activity and empirical enquiry. In such an environment, there was ample scope for the utilization of varied talents. It was no place for abstract speculation, but it would have given free rein to both practical accomplishments and intellectual pursuits.

The first signed and dated work by Leonardo, and therefore, the first of his works that can be attributed to him with certainty, is the drawing of a Tuscan landscape that bears the inscription: "This day of Sta Maria delle Neve, the fifth of August, 1473." In the context of the history of Italian art, this countryside view is in the mid-fifteenth century "avant-garde" tradition of Piero della Francesca, Alessio Baldovinetti, Piero Pollaiuolo, Antonello da Messina, and Giovanni Bellini, in some of whose works there are anticipatory links with the great Flemish school of the Van Eycks and van der Weyden. In the pictures of these artists, stylization and formal figuration had given way to individual effects of lighting and an objective sense of topography, with special emphasis on background detail.

In Leonardo's drawing, the landscape features are carefully observed. There is a keen appreciation of spatial depth and an almost "scientific" approach to the representation of natural objects. Even in this early work, there is ample evidence of the artist and the scientist in embryo. He displays an instinctive feeling for atmosphere, heightened by light and shadow, a desire for topographical precision (note the castle perched on top of the hill at the left), and a fascination for geological detail, as shown in the depiction of the rocks.

The twenty-one-year-old Leonardo had been working in Andrea del Verrocchio's *bottega* for about four years, and this drawing provides evidence both of his formal artistic training and of the range of his scientific interests – doubtless still unfocused and largely intuitive but soon to branch out in many directions and increase in profundity. It also shows that Leonardo was revolutionary with respect to the aforementioned "avant-garde" artists and his master Verrocchio. What was

MADONNA WITH THE CARNATION
(MADONNA WITH THE VASE)
Oil on poplar panel; $24\frac{3}{8} \times 18\frac{3}{4}$ in
(62×47.5 cm)
Munich, Alte Pinakothek
The painting was acquired in **1886** from the collection of A. Haug in Günzburg. Experts now almost all agree that it is Leonardo's work.
Pages 24–25: Detail of the Virgin.

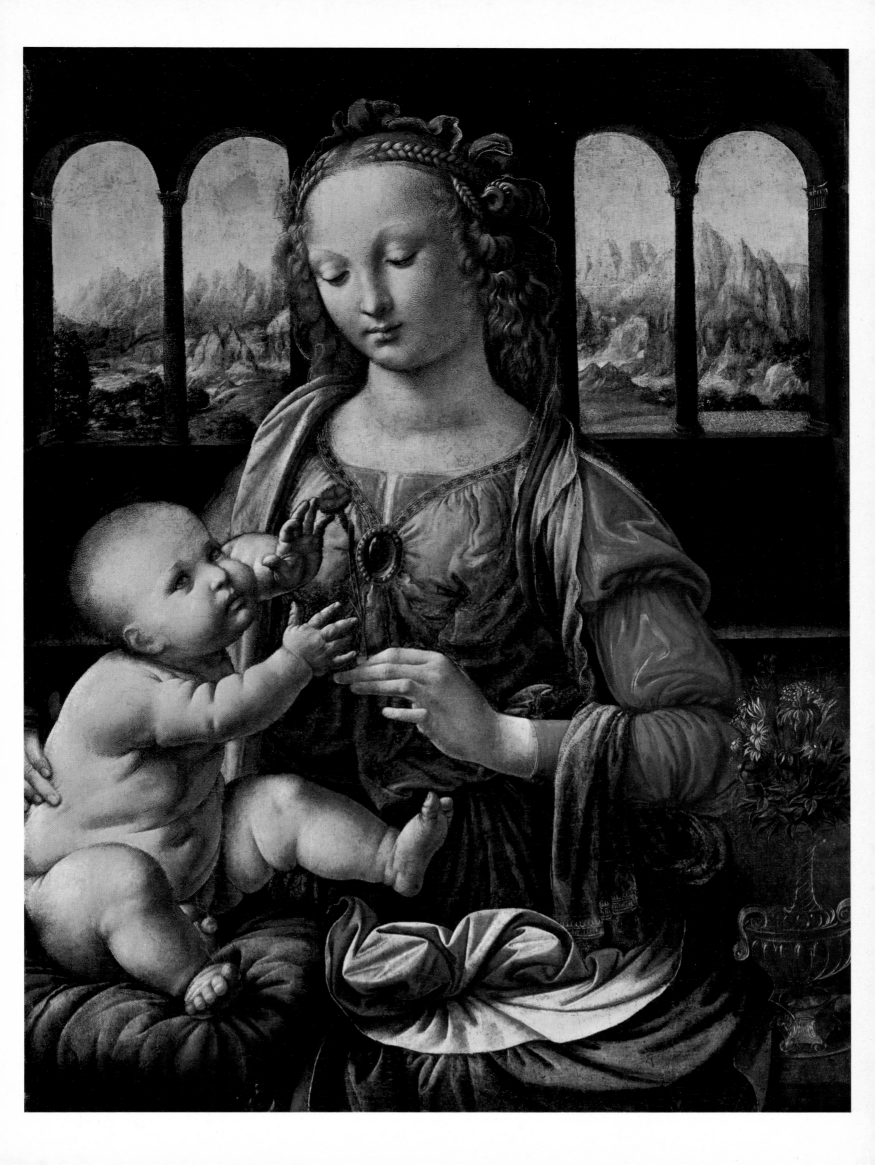

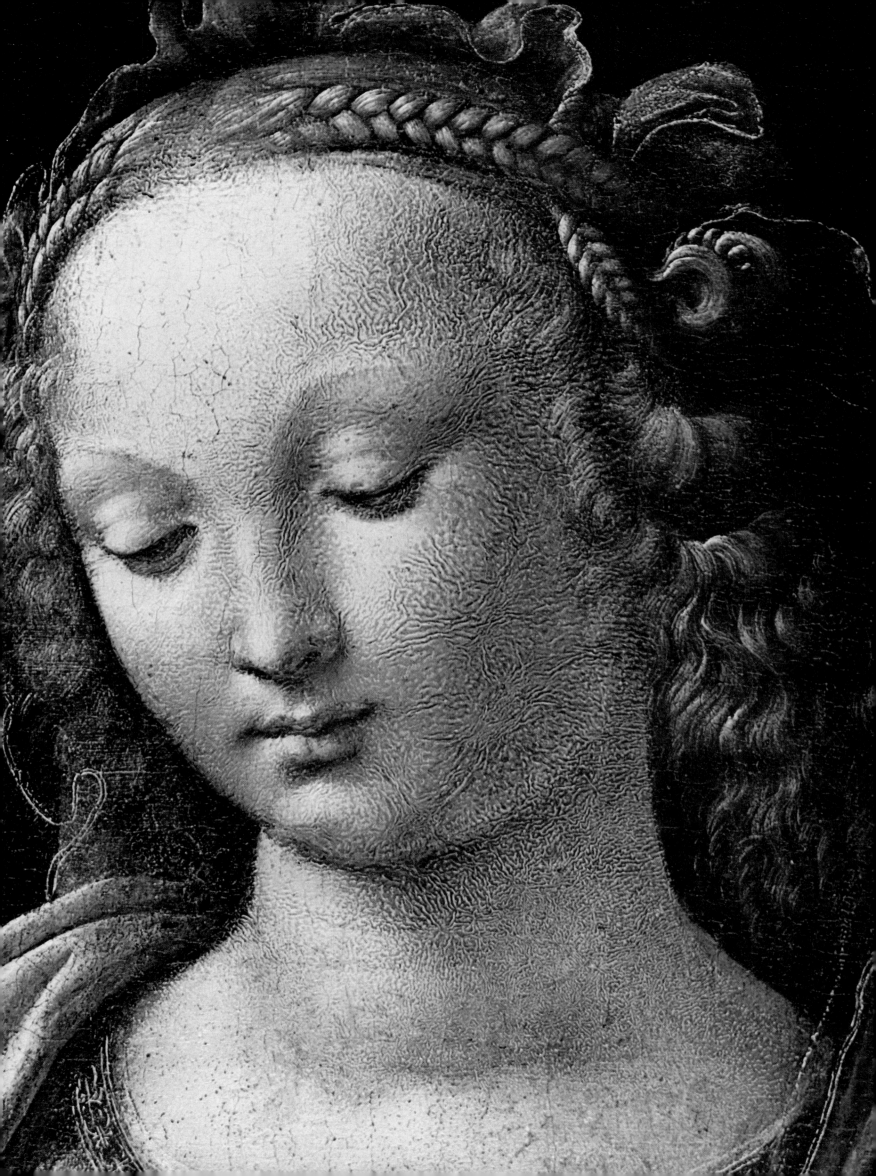

revolutionary about Leonardo – already evident in the 1473 drawing – lies in the life and vibrancy of the graphic form. The generation of Florentine painters following Masaccio, who died in 1428, explored to their utmost the expressive possibilities of light and shade, but Leonardo was to develop it most effectively in the 1480s with his use of sfumato, derived from theories and experiments in optics, in which he explored extremes of light and darkness and blended them to produce an illusion of smoke.

In Verrocchio's Workshop

This new style of painting that incorporated subtle contrasts of color and light, heightening the three-dimensional effect and producing a greater range of pictorial rhythms, revolutionized the compositional methods of most of the Florentine workshops, including Verrocchio's. Such qualities are very noticeable in certain parts of Verrocchio's *Baptism of Christ,* a painting hung originally in the Church of San Salvi in Florence, later in Santa Verdiana, from 1810 onward (following the Napoleonic confiscations of church property) in the Florence Accademia, and, finally, in 1914, transferred to the Uffizi. The sections that stand out from the rest are the figure of the kneeling angel at the extreme left of the picture and the landscape of hills and water in the background (very like the Leonardo drawing of 1473). Early sixteenth-century critics, echoed subsequently by Vasari, explicitly mentioned Verrocchio as being the artist responsible for the work as a whole but suggested that Leonardo had painted the angel shown in profile. Modern art critics (with the exception of a few early twentieth-centuty authorities who have invented a pupil of Verrocchio for the role) tend to agree with the earlier sources and go further in also attributing part of the landscape to Leonardo. Their view is supported by the discovery by Bode, in 1882, that the angel, the hair of Christ, and the background scenery are all painted in oils on a tempera ground and by the later revelation (as a result of postwar radiographic tests) that the landscape on the left is superimposed on an earlier, different version. In 1954, another opinion came from Carlo Ludovico Ragghianti, who, while agreeing that the work must date from the period of Leonardo's apprenticeship in Verrocchio's studio, has suggested a collaboration between Leonardo (who, in Ragghianti's view, is responsible for the painting of the entire background) and Botticelli.

Critical discussion aside, it is obvious to any unbiased observer that there is a striking contrast in quality between angel, in the foreground and the landscape, on the one hand, and the rest of the picture. It is not merely a question of form and technique (as in the texture and shading of the angel's draped clothing) but also of attitude and insight. For example, the radiantly alive expression on the face of the angel on the left can be contrasted with the total lack of spiritual expression on the face of the other angel immediately alongside.

It is interesting not only to study the contrasting parts of the *Baptism of Christ* but also to compare the sections commonly attributed to Leonardo with other works for which he is said to have been responsible while under the tutelage of Verrocchio. Leonardo's efforts in the *bottega* preceded a painting that documents and other references point to being his own, namely *The Adoration of the Magi.* This was commissioned for the monastery of San Donato a Scopeto in March 1481 but was unfinished because of Leonardo's departure from Florence.

Some critics question whether the *Baptism of Christ* is Leonardo's first recorded painting simply because it is not wholly his work. But they ignore the complex realities of production methods and relationships, both among individuals and between artists and corporate institutions, that prevailed in the major art studios of

STUDY FOR "MADONNA WITH THE CAT"
Pen and black chalk drawing on white paper; $8\frac{1}{8} \times 5\frac{5}{8}$ in (20.6×14.3 cm)
London, British Museum.

STUDY FOR "MADONNA WITH THE CAT"
Pen drawing on white paper; $5\frac{3}{16} \times 3\frac{3}{4}$ in (13.2×9.5 cm)
London, British Museum (no. 1856-6-21-1).

STUDY FOR "MADONNA WITH THE CAT"
Pen and watercolor drawing; $5\frac{3}{16} \times 3\frac{3}{4}$ in (13.2×9.5 cm)
London, British Museum (no. 1856-6-21).

26

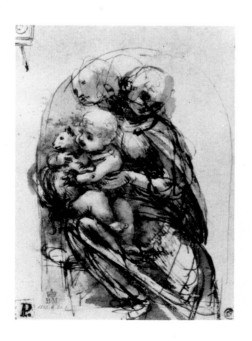

the High Renaissance. Collaboration between two or more artists was accepted procedure. That Leonardo was already recognized as an artist in his own right is shown by the fact that he had been admitted to the Corporation of San Luca (the Florentine painters' guild) in 1472. Furthermore, there is Vasari's story of Verrocchio, who, when he saw Leonardo's angel in its completed form on his own panel, was so impressed and discouraged with his own work that he "never again wanted to touch paints." This tale, readily accepted by later critics but surely a product of Vasari's imagination, if taken at face value, would suggest that the episode marked an end, rather than a beginning, of a collaboration between Leonardo and Verrocchio. The truth is that the young Leonardo was one of a highly gifted team of artists that, during the 1470s, included Botticelli, Botticini, Perugino, and the ever-loyal Lorenzo di Credi. Although any of them might be called on to carry out a commission, or at least to lend a helping hand, Verrocchio was indisputably the head of the studio. He was the old "master," who was responsible for supervising the work of his pupils, whether the commission was for painting, sculpture, or jewelry, for dealing with all the legal and financial problems relating to clients, and for making the necessary arrangements for spectacles held on feast days and ceremonial occasions.

In this relaxed atmosphere of private and collective artistic activity, the youthful Leonardo was free to develop his individual style, in collaboration with colleagues parallel to and developing in conjunction with his work. Leonardo's own works executed under the tutelage of Verrocchio were *The Annunciation* (now in the Uffizi) and the so-called *Madonna with the Carnation* (in the Alte Pinakothek, Munich). Those enterprises undertaken by Leonardo in conjunction with his colleagues included the *Baptism of Christ*, polyptyches (as perhaps *The Annunciation* in the Louvre), and preparatory work for ambitious projects in various media, such as the watercolor cartoon entitled *Paradise*, which was intended to adorn a door-cover tapestry for the king of Portugal. The tapestry was never woven but Vasari mentioned seeing the cartoon in the home of Ottaviano de' Medici. It is possible that Leonardo did some sculpture as well, particularly if one joins Valentiner and Middoldorf, among others, in accepting him as the author of the terra-cotta *Madonna and Child* (in Victoria and Albert Museum, London.

The significance of the informal working conditions in the *bottega* is that Leonardo clearly enjoyed sufficient independence to embark on a wide range of artistic and intellectual pursuits. Verrocchio himself was essentially a sculptor, and the works produced by his studio – painting, sculpture, and objects in the minor arts – could be ranked alongside those of other leading establishments, such as those of Pollaiuolo and Ghirlandaio. Far from being upset by evidence that "a youth should have been better than he," as Vasari claims, it is more likely that Verrocchio should have been gratified to have under his wing a pupil who showed such precocious promise. In Vasari's words: "The grace of God so possessed his mind, his memory and intellect formed such a mighty union, and he could so clearly express his ideas in conversation that he was able to confound the boldest opponents." In a sense, the young Leonardo personified and led the spirit of eager inquiry and inventiveness that gave Verrocchio's workshop its high reputation in Florence.

Leonardo's profound artistic sensibility and technical skill must have been a perpetual source of inspiration to his companions; and Verrocchio himself seems to have felt the influence of his talented pupil, who was already proving his originality in both the conception and execution of the works with which he was involved. Although he did not give any practical assistance, Leonardo may well have been a guiding force for Verrocchio in the latter's famous bronze group *Christ and the Doubting Thomas*, in Orsanmichele. Certainly the spatial and psychological relationship of the figures in this piece of sculpture is quite revolutionary. The rich, flowing, naturalistic drapery of the figures specifically harks back to the young Leonardo's extraordinary drawings in bistre and white lead as well as in silverpoint of similar subjects done. Since the work dates back from a time just prior to Leonardo's departure for Milan, it is reasonable to assume that by then the former pupil had achieved a dominant position in the *bottega*.

A comparable freshness of attitude and treatment characterizes a number of the works that emerged from the *bottega* at that period. It is manifest, for example, in

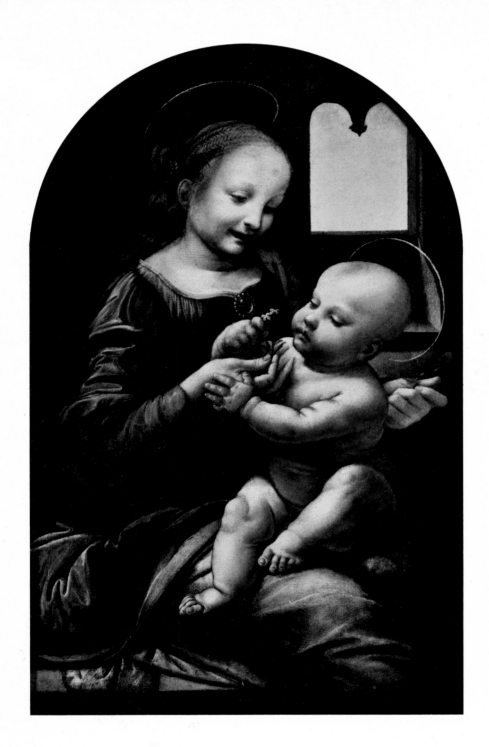

MADONNA WITH THE
FLOWER
(BENOIS MADONNA)
Oil on wood panel transferred to
canvas; 19½ × 12¾ in (49.5 × 31.5 cm)
1478 (?)
Leningrad, Hermitage
Obtained by Tsar Nicholas II for the
Hermitage in 1914 from the widow of
the painter Léon Benois. In 1909
Liphart attributed it with certainty to
Leonardo and this view has now gen-
erally been accepted by critics who
tend to regard it as one of the two
"Virgin Marys" painted by Leonardo
in 1478.

Verrocchio's classically conceived *Lady with the Primroses* (now in the Bargello,
Florence). The pose (upper part of body, including hands) is similar to that adopted
later by Leonardo for the Mona Lisa and, in some ways, resembles his portrait of a
lady presumed to be Ginevra de' Benci. In conception, the work is also closely
related to a number of paintings of the Madonna and the Christ Child. These works
were characteristic products of Verrocchio's workshop and are attributed, either
certainly or doubtfully, to Verrocchio, the young Perugino, Lorenzo di Credi, and
even Leonardo himself. This last claim is supported by Leonardo's note (now in the
Uffizi [446 E. r.]) that states: "——mber 1478 I began the two Virgin Marys."
Leonardo's deep, recurring interest for the sacred theme was evident from this
mention of the two Madonnas and from two authenticated masterpieces separated
by many years, the *Virgin of the Rocks* and the *Virgin and Child with St. Anne*. (It
may be treading on dangerous ground, however, to relate this interest to Leonardo's
childhood and the complex relationships with his real mother and the young first
wife of his father.)

Compared with the traditional representations of the Madonna made by Filippo
Lippi and his followers and subsequently adopted and developed by Botticelli, the

treatments of the subject by Verrocchio's *bottega* were refreshingly novel and advanced for their time. It can safely be claimed that it was Leonardo who was primarily responsible for initiating this new approach to the theme of the Holy Family within Verrocchio's *bottega*. His qualities of innovation had already been made apparent in his treatment of the angel in the *Baptism of Christ*. In this and later religious paintings, the essential novelty was the perfect "classical" balance between a geometrically planned composition (already tending toward the pyramidal form), which was to be adopted by the young Michelangelo and Raphael, and the separate parts, subtly linked to produce an impression of depth and luminosity and with decreasing emphasis on surface lines. At the same time, greater stress was placed on the emotional and psychological bond between the Virgin and the Child as reflected in the features, which were far more alive than those in the stylized versions of Lippi and Botticelli. The paintings as a whole suggested a much deeper understanding of the human relationships involved.

This instinctive sense of equilibrium emerges clearly in the series of Madonnas presumed to have been painted by Leonardo while working with Verrocchio. It is splendidly exemplified in the *Madonna with the Carnation* (now in the Alte Pinakothek, Munich). The two figures spring radiantly from the shadowy room with its two symmetrical mullion windows, through which appears a brightly lit rocky landscape. Despite the fact that parts of the original surface of the picture had been

Verrocchio's workshop
MADONNA WITH THE POMEGRANATE
(DREYFUS MADONNA)
Oil on canvas; 6½ × 5 in
(16.5 × 12.7 cm)
Washington, National Gallery of Art, Kress Collection
Generally regarded as a product of Verrocchio's workshop, possibly by Lorenzo di Credi, and attributed to Leonardo only by Suida and Degenhart.

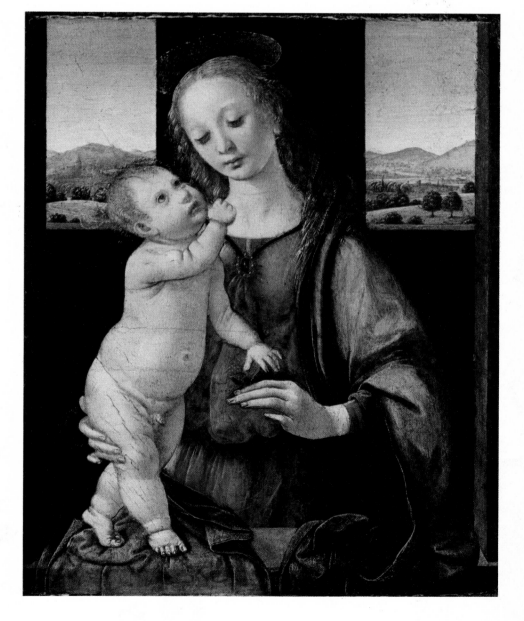

altered as a result of repainting in oils, the work was immediately recognized as Leonardo's when it was transferred from the Haug collection in Günzburg to the Munich Museum in 1886. Only a few critics of the nineteenth and twentieth centuries tried to attribute it either to Verrocchio or Lorenzo di Credi. Support for Leonardo's authorship has come from the delicate drawing of the Madonna's head in charcoal with touches of the pen, in the Louvre.

This masterpiece of Leonardo's youth is remarkable for its experimental gradations of light and for its characteristic lovingly detailed treatment of female hair (echoed later in studies of eddies and whirlpools), arranged in a manner similar to that of Filippo and Filippino Lippi. It is perhaps this painting of the Madonna (sometimes known as *Madonna with the Vase*) to which Vasari referred in his description of a picture that belonged to Pope Clement VII. This painting, Vasari states, "contained a vase of flowers, the dew on the leaves being imitated so faithfully that they seemed more real than nature itself."

Roberto Longhi attributes the copy of this painting of the Madonna (now in the Louvre) to Adam Elsheimer, a German painter active in Rome at the beginning of the seventeenth century, when Caravaggio was at work. Longhi pointed out that the vase of flowers "is in the style of Breughel (meaning Jan "Velvet" Breughel, son of the great Pieter) rather than Verrocchio." Actually, the naturalistic treatment of the flowers in Leonardo's original version shows the influence of fifteenth-century Flemish painting on the Florentine school. This indicates that as a youth Leonardo was already familiar with the mainstreams of European art. Hugo van der Goes's triptych, *The Adoration of the Shepherds*, commissioned by Tommaso Portinari, had arrived in Florence around 1475.

The naturalism of the vase of flowers, to be found later in the *Virgin of the Rocks*, is also strikingly evident in *The Annunciation* (the Uffizi version); but the impression of light and space is heightened in *The Annunciation* by the interplay, so unFlemish, of morning sunshine and long shadows. This panel in oils, originally painted for San Bartolomeo di Monteoliveto, near Florence, was exhibited by the Uffizi in 1867 and was for some time a talking point for the critics. Even today, its attribution to Leonardo is not accepted by Heydenreich. Other critics have put forward the claims of Domenico Ghirlandaio (who was originally thought to be the author), of his son Ridolfo (an absurd theory but one that recognizes the novelty of the painting by advancing the date of its creation to at least the opening decade of the sixteenth century), and of Verrocchio. The majority of critics, however, including Bode, Adolfo Venturi, Berenson, Suida, Clark, and Brizio, have pronounced in favor of Leonardo. A few others have suggested a collaboration between Leonardo and Lorenzo di Credi.

In the case of *The Annunciation*, as of the *Madonna with the Carnation*, support for Leonardo comes from a series of marvelous drawings, notably studies of draperies, already mentioned. The work of many contemporary or slightly earlier Florentine painters shows emphasis placed on the "functional line." But these drawings possess a rounded, sculptural quality, with subtle effects of chiaroscuro, obtained by the use of new graphic techniques such as bistre, white lead, and silverpoint. In Christ Church, Oxford, there is one study for the right arm of the angel of the Annunciation, in which Leonardo uses one of his favorite techniques (as, especially, in his anatomical drawings) – strong strokes of red chalk being given greater fluidity and depth by occasional touches of chiaroscuro, applied with lighter diagonal strokes in parallel.

The drawings themselves are not proof positive of Leonardo's authorship, and, in pronouncing judgment, the critics have naturally considered the painting in its entirety, examining its compositional and pictorial qualities in relation to other works produced in the 1470s. Those reluctant to attribute it to Leonardo have tended to use as their criterion the hazily romantic notion of "genius," claiming that this magic element, which helped to make even his earliest works so profoundly expressive, is missing from this painting. They point to a certain academic coldness in the overall conception, in which typical stylistic elements of Verrocchio's studio are combined with those associated with Ghirlandaio (though this would date the work from at least the 1480s!). The iconography, they claim, resembles that of the altarpiece of the Pistoia Cathedral. This latter work, the so-called *Madonna di*

VIRTUTEM FORMA DECORAT
Inscription painted on the back of the panel of *Ginevra de' Benci*. The writing appears on a scroll between branches of laurel and palm, the tips of which cross above a sprig of juniper.

PORTRAIT OF A WOMAN (GINEVRA DE' BENCI ?)
Oil on wood panel; 16½ × 14½ in (42 × 37 cm)
Washington, National Gallery of Art
Formerly in the collection of the princes of Liechstenstein, it was identified positively as a work of Leonardo by Bode in 1882 and as the portrait of Ginevra, daughter of Amerigo Benci, as mentioned from various sources.

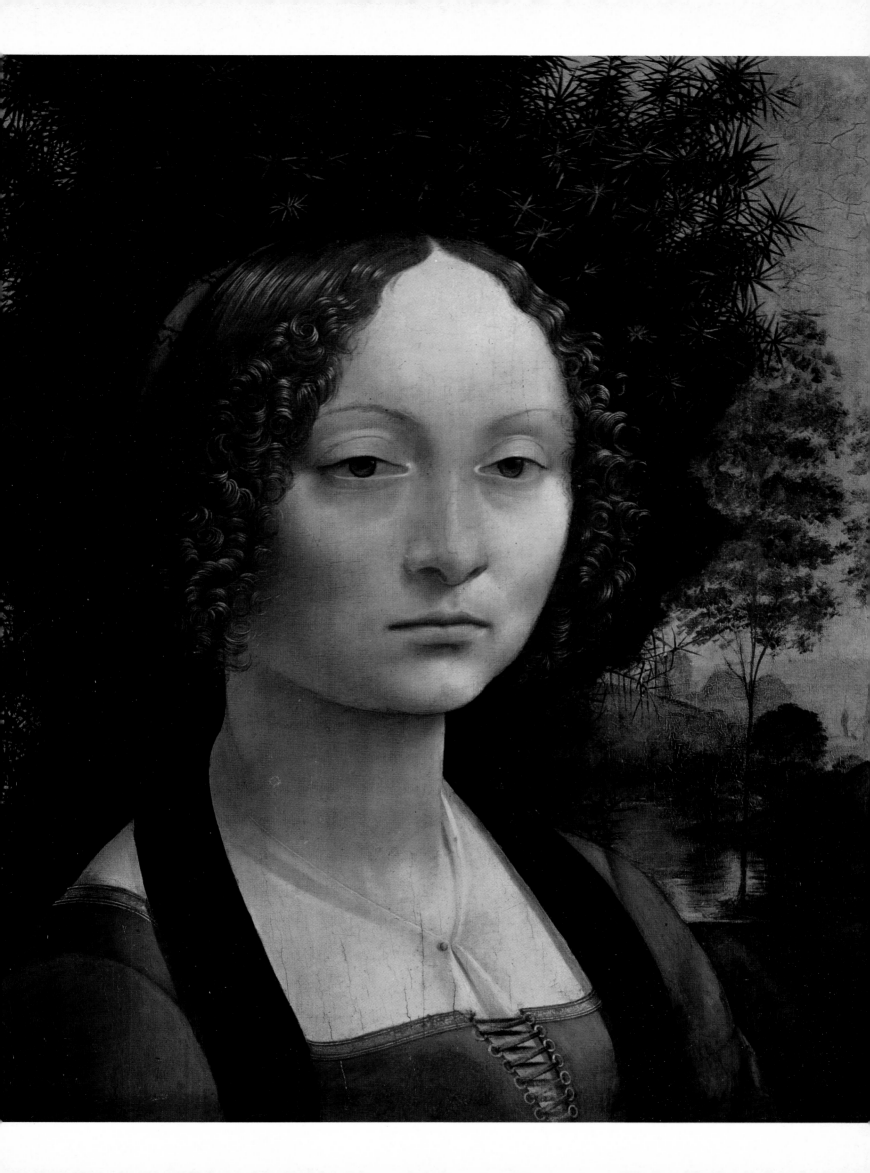

ST. JEROME IN PENITENCE
Wood panel; 40⅝ × 29½ in
(103 × 75 cm)
Rome, Vatican Gallery
The panel, once in the Vatican col-
lection and later belonging to the
painter Angelica Kaufmann (divided
into two sections), was acquired by
Cardinal Fesch, Napoleon's uncle.
Pope Pius IX obtained the work from
the cardinal's heirs in 1845.
Facing page: Detail.

Piazza, was a studio commission, perhaps planned by Verrocchio and painted,
according to modern critical opinion, by Lorenzo di Credi between 1478 and 1485.
The iconographic pattern of this altarpiece is basically in the tradition of Angelico,
Filippo Lippi, and Domenico Veneziano; but there are also points of formal and
pictorial detail that reflect the advanced ideas circulating in Verrocchio's work-
shop. The expressive and structural problems are not wholly resolved, but the
altarpiece does show signs of innovation, perhaps attributable to the presence
of Leonardo himself. However, the difference in quality between this altarpiece
and *The Annunciation* is very striking. The latter work, certainly dating from
the 1470s, has a rare beauty and freshness, surely the hallmarks of the young
Leonardo.

No artist other than Leonardo could have achieved such a delicately perfect
balance between humanism and naturalism, the former exemplified in the classical
clothing and the contemporary architecture (in the style of Michelozzo) and the
latter vividly conveyed in the background landscape, painted with meticulous,
optically precise care for detail. The eagerness of the young Leonardo to challenge
existing assumptions and to treat traditional themes in a new manner shows
evidence of intellectual rather than emotional fervor; and in this painting, compared
with his handling of the angel and landscape of the *Baptism of Christ*, there are still
signs of irresolution and abstraction.

This scrupulous attention to detail, doubtless the fruit of long and patient
planning, was characteristic of the mental attitude of all who worked in the *bottega*
and had been worthily exemplified in Verrocchio's own splendid tomb to the
memory of Giovanni and Piero de' Medici in San Lorenzo, Florence, that was
completed in 1472. In lesser artists, the overall effect tended to be fussy and
overelaborate; but in the work of Leonardo, even at this early stage, the delicacy of
pictorial detail was sharpened by a crystalline purity of light and a subtle handling
of chiaroscuro, not seen in Florence since the time of Domenico Veneziano.
Leonardo's highly individual style was already developing here. This is shown by
his bold experimentation with contrasted, juxtaposed surfaces and forms, light and
dark. It is particularly evident in the right-hand part of the panel, with its
beautifully composed and painted figure of the Virgin. The hem of her deep red dress
peeps from below the voluminous robe of rich ultramarine flecked with white. The
robe covers the lap and is then draped over the seat. The garments are highlighted
by the golden marble terrace separating the house from the flowery meadow. The
upper part of the body, too, stands out vividly against the brown, angled wall of the
building, with its corner bosses in pale gray marble. This alternation of light and
dark planes continues across to the other side of the picture, with the foreground
area of grass, the surrounding path, the dark brown dividing wall and the gray
parapet, and the line of dark cypresses etched against the grayish gold dawn sky. It
is a procedure handled to even better effect in the artist's portrait of Ginevra de'
Benci that dates from the final years of the 1470s.

In discussing *The Annunciation*, in the Uffizi, mention must also be made of *The
Annunciation* in the Louvre. The latter is a wood panel in tempera – which was
certainly part of a predella – and is smaller than the Uffizi version. It came into the
possession of the Louvre, when the museum acquired the famous Campana
collection in 1861. The panel was originally attributed to Domenico Ghirlandaio.
Giovanni Morelli was the first expert to suggest, in 1893, that it may have been
painted by Leonardo, and his view was echoed by other critics. However, in 1952,
Goldscheider pronounced in favor of Lorenzo di Credi, with Leonardo's
collaboration. Not until some thirty years ago was it suggested that there was a
link between this painting and the aforementioned *Madonna di Piazza* in Pistoia,
one of the major communal undertakings of the Verrocchio workshop. It is now
generally accepted that the predella formed part of the Pistoia altarpiece (now in
the Louvre).

The critical debate that has raged over the two versions of *The Annunciation*
typifies the determination of art historians, notably during the first two decades of
the twentieth century, to establish authenticity of previously disputed authorship
on the basis of both conceptual and formalistic evidence. The reason that the critics
have come out almost unanimously in favor of Leonardo as the painter of *The*

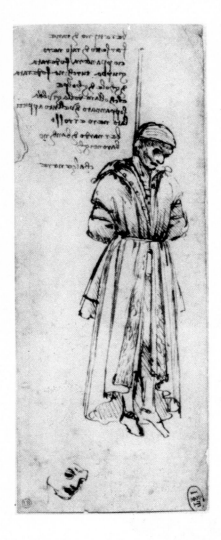

PICTURE OF A HANGED MAN
– BERNARDO DI BANDINO
BARONCELLI
Pen drawing on white paper;
signature from left to right;
$7\frac{1}{2} \times 2\frac{13}{16}$ in (19.1 × 7.2 cm)
1479
Bayonne, Léon Bonnat Museum
Formerly in the collections of Evans
Lombe, De Chennevières and A. W.
Thibaudeau.
At the left is a note by Leonardo
about Baroncelli's clothing: "Small
tawny cap/black satin doublet/black-
lined gown/lined dark blue jacket/
with fox ruff/and the jacket collar/
lined with black and red velvet/
bernardo di bandino/baroncigli/black
shoes."

Annunciation in the Louvre and expressed doubts about his execution *The Annunciation* in the Uffizi (a view that underestimates the clear iconographic links between the two versions) stems from a general opinion that the smaller panel in Paris shows a greater sense of structural unity, a surer pictorial touch, in short, an altogether higher level of creative inspiration. It is as if the small-scale work (only a fragment of a much more ambitious undertaking, as it undoubtedly was, and prior to any associations with the *Madonna di Pistoia*) afforded the artist better opportunities for careful evaluation and allowed him more scope for imagination than the larger commission, technically more complex but necessarily more formal and stereotyped. Because it is more elaborate and lacks the harmonious unity of the smaller panel, *The Annunciation* in the Uffizi has perhaps been undervalued, its experimental, "avant-garde" quality insufficiently recognized. Despite the fact that the Louvre panel has suffered from repainting more than the Uffizi version, it nevertheless shows to an ever greater degree the intuitive way in which Leonardo was using space, light, and shadow to produce a unified atmosphere and a sense of three-dimensional illusion heightened by the sfumato technique. It was to lead logically to the results obtained in *Ginevra de' Benci*, *Benois Madonna*, and, as a culminating triumph, *The Adoration of the Magi*, commissioned in 1481, when Leonardo was twenty-nine.

Reference has already been made to the page (of which the lower right corner is missing), on which Leonardo, already employing his famous "mirror" script, mentioned having begun his two Madonnas. This dates from between September and December 1478, providing students and critics with ample opportunity to air their ingenious views as to the identities of the two pictures concerned. Present opinion tends to dismiss the claims of *Madonna with the Carnation*, which, for stylistic reasons, is hardly compatible with this comparatively late date. In 1930, Suida and Degenhart attributed the so-called *Dreyfus Madonna* (in the Kress collection of the Washington National Gallery) to Leonardo. It is undeniably of high quality but seems more typical of the style of the aforementioned painting of the Madonna produced by various members of Verrocchio's *bottega* and, hence, is another unlikely contender. Other critics still regard this as a work by Lorenzo di Credi, while Shearman in 1967, has suggested Verrocchio. It is much more probable that there is a connection between Leonardo's note and a rich series of drawings (in the Uffizi, the Louvre, and the British Museum) that evince an entirely new compositional and psychological attitude toward this familiar subject. Undoubtedly, it is to this series that *Benois Madonna* (now in the Leningrad Hermitage) is related.

Before examining this sequence of drawings and *Benois Madonna* itself, it is important to refer to the page dated 1478. On it, apart from other jottings, are two studies of male heads and drawings of various types of mechanisms. The younger male's head on the right unquestionably reappears in *The Adoration of the Magi*, whereas the head of the older male, shown in profile, can be recognized as the precursor of a number of somewhat stylized heads of middle-aged and elderly men featured in the same picture. This is the earliest evidence of Leonardo's growing interest in the anatomy and the "psychology" of the human face; above all, he was intrigued with the idea of the face as the objective manifestation of the "movements of the mind." The drawings, therefore, bear witness to the burgeoning of feelings and ideas that were to reach exciting fruition in *The Adoration of the Magi* (preparatory drawings for which had begun three years previously). The same ideas are reflected in the unfinished *St. Jerome in Penitence* (now in the Vatican Gallery).

The mechanical drawings are also significant as early evidence of Leonardo's keen interest in completely different fields of activity. This would be explained, to some extent, by the opportunities available in Verrocchio's workshop for an enormous range of practical experiments in the area of the "minor arts," in architecture, and in elementary engineering. The *bottega* contained an array of devices for lifting, excavating, and carrying. Here Leonardo would have gained experience in "applied mechanics," and there is ample evidence that he was familiar with a range of practical activities involving the use of basic tools, devices, and "machines" such as the screw, the spring, the lever, the cogwheel, the pulley, the crank, and the

THE ADORATION OF THE MAGI

Oil and bistre on wood panel;
96 × 97 in (240 × 246 cm) 1481–2
Florence, Uffizi Gallery
This is a high altarpiece which Leonardo was commissioned to paint for the monastery of San Donato a Scopeto in 1481 but never delivered. In 1496 it was substituted for another work on the same subject by Filippino Lippi. The panel was left by Leonardo in the house of Amerigo Benci when he left for Milan. In 1621 it was discovered in the collection of Antonio de' Medici and on the death of his son Giulio formed part of the collection of the Medici Gallery of the Uffizi (1670). Later it appeared in the villa of Castello and found its way back to the Uffizi in 1794.

connecting rod. During the final decades of the fifteenth century, Leonardo's interests in such spheres of activity were to be richly documented, both in written and illustrated form, in the early manuscripts; but this single page of 1478 clearly shows that it was already during the last five years of his stay in Florence that he was branching out in new directions and that his interest was pragmatic, and not merely theoretical. There is further proof of this in the manner in which Leonardo presented himself to Ludovico (Il Moro). His attitude was more in the guise of an ''engineer'' versed in the arts of war and peace than of an ''artist.'' There are also certain pages of the Codice Atlantico, undoubtedly dating from the first Florentine period (by virtue of the fact that the writing runs conventionally from left to right) and by the inclusion of Tuscan names and transcriptions of Tuscan proverbs. Such pages contain drawings of mechanical devices and machines for lifting cannons.

Returning to Leonardo's art, I have already mentioned the standard representational style adopted by Verrocchio and his pupils in their treatment of the

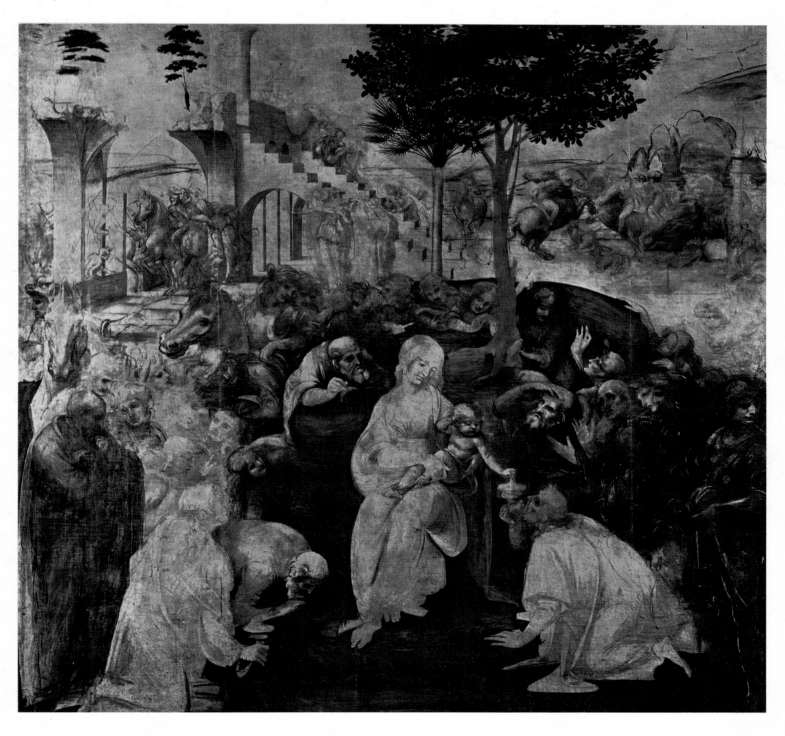

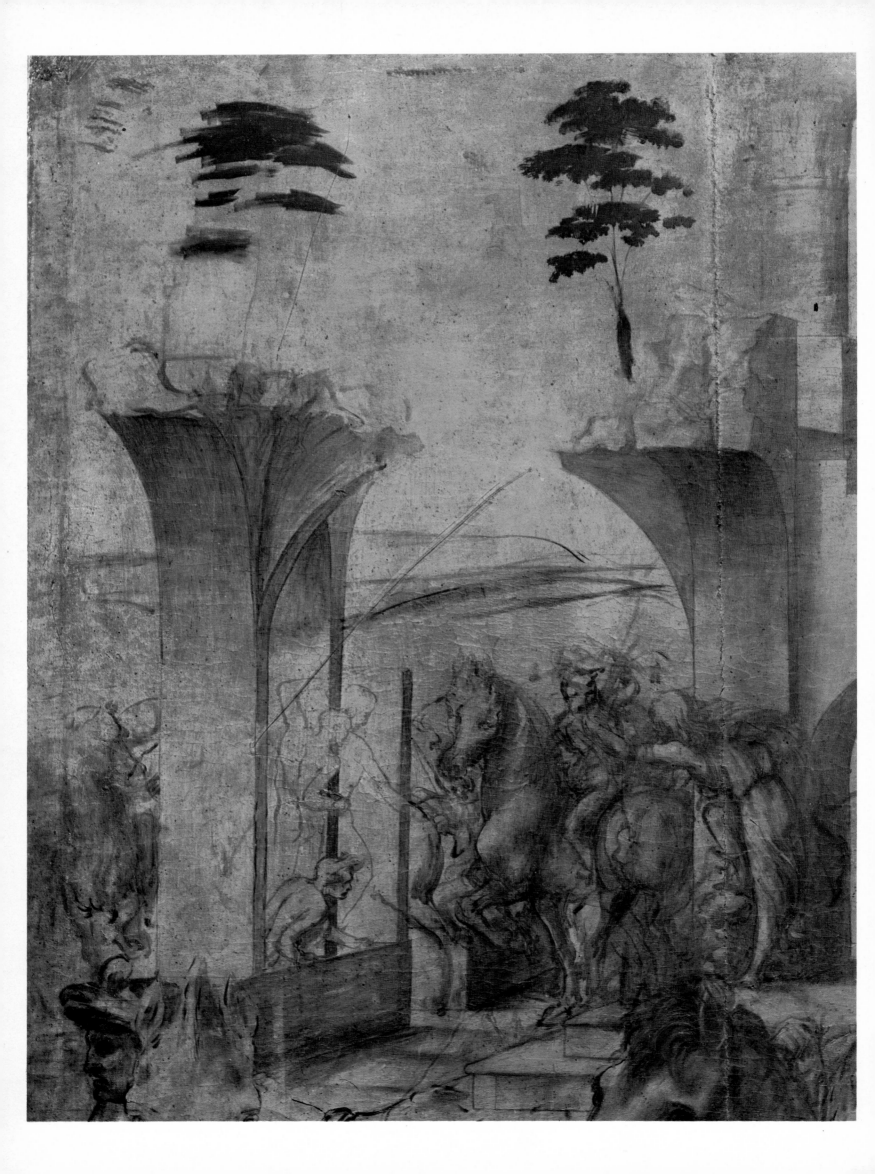

Madonna and Child theme. The figure of the Virgin, usually a frontal view, is invariably central to the composition, whereas the Christ Child occupies a subordinate position, being in a sense absorbed by the presence of the Virgin. In the aforementioned series of drawings, this relationship is dramatically reversed, both structurally and psychologically. The two figures, quite apart from their literal significance, become points of reference for a complex pattern of rhythms and moods and for pictorial elements of contrast and counterpoint. The overall effect works toward a harmony of composition that is to attain fullest expression in Leonardo's own *Virgin and Child with St. Anne*, in the Florentine paintings of the Madonna by Raphael, and in *Madonna Doni* by Michelangelo, from the first decade of the sixteenth century. There is also a deeper, more sensitive, natural relationship between Mother and Child, so that the human bond is accentuated at the expense of sacred narrative. This emphasis is underlined in the expressions, in the gestures, and

THE ADORATION OF THE MAGI
Facing page: Detail: arch with horsemen.
Pages 38–39: Another detail.

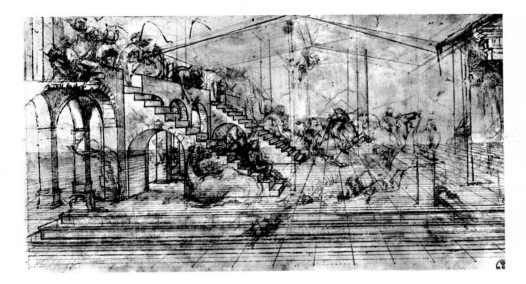
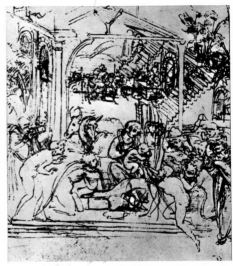

STUDY IN PERSPECTIVE FOR BACKGROUND OF "THE ADORATION OF THE MAGI"
Pen, sepia and white lead drawing on white paper; strokes from left to right; $6\frac{1}{2} \times 11\frac{7}{16}$ in (16.5 × 29 cm)
Florence, Uffizi Gallery, Drawings and Prints Collection.

STUDY FOR AN EARLY IDEA FOR "THE ADORATION OF THE MAGI"
Pen drawing on white paper; strokes from left to right; $11\frac{1}{4} \times 8\frac{1}{2}$ in (28.5 × 21.5 cm)
Paris, Louvre, Drawings Room
Acquired at the Galichon sale, May 1875.

in additional figures or details. In some of the drawings, for example, there is a cat (leading some critics to believe that one of the two Madonnas begun in 1478 may have been a lost *Madonna with the Cat*); and in one of the Louvre drawings, there is a fruit dish. The same applies to the more developed versions of the theme. Thus, in *Virgin of the Rocks* and in *Virgin and Child with St. Anne*, Leonardo includes St. John the Baptist, as a child, and the Lamb.

The so-called *Benois Madonna* (acquired by the Leningrad Hermitage in 1914 after its appearance, in 1909, as part of an exhibition of art treasures from a private collection owned by the widow of the French painter Léon Benois) was recognized by de Liphart, the director of the Hermitage, as an authentic Leonardo. Most critics agree with this attribution. The focal point of the three-dimensional composition, so beautifully coherent, is the interlaced pattern of hands, those of the Child encircling the Virgin's right hand, in which a flower is held. The comparison between this picture and *Madonna with the Carnation* reveals an entirely new approach to the subject. In the latter painting, the Virgin holds out a flower to the Child, but the episode, despite the picture's formal excellence, the luminous modeling of the Virgin's left hand, and the bold foreshortening of the Child's left hand, conveys a sense of detachment, traditional in the symmetry of the background with its double set of mullion windows. It is not by mere chance that there is only one window in *Benois Madonna*. It is placed in an asymmetrical position in the right background yet nevertheless forms a perfect luminous counterpoint to the beam of light illuminating the central group, protectively cocooned on three sides. Another novel feature of *Benois Madonna* is Leonardo's refined use of light and color, hitherto giving shape and depth to carefully constructed, symmetrical compositions but here employed with even subtler skill, never accentuated, perfectly adapted to the

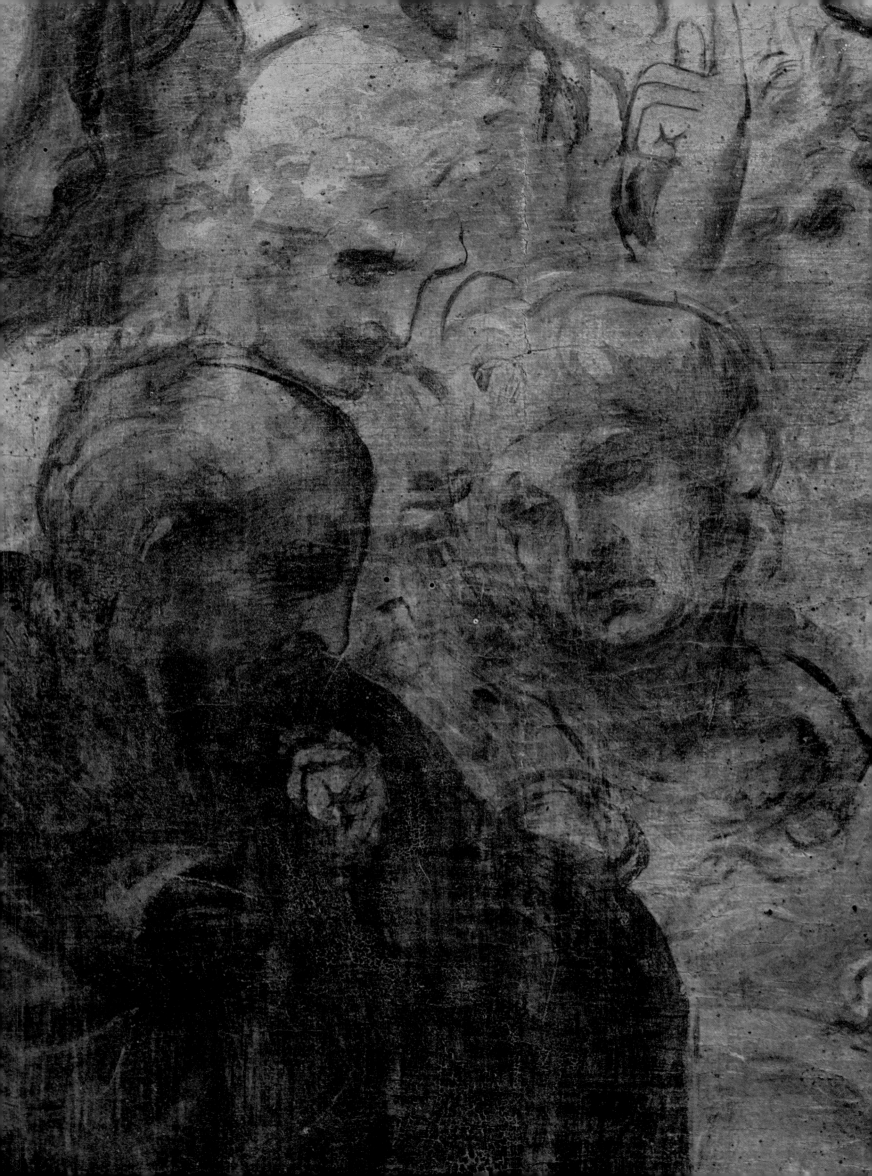

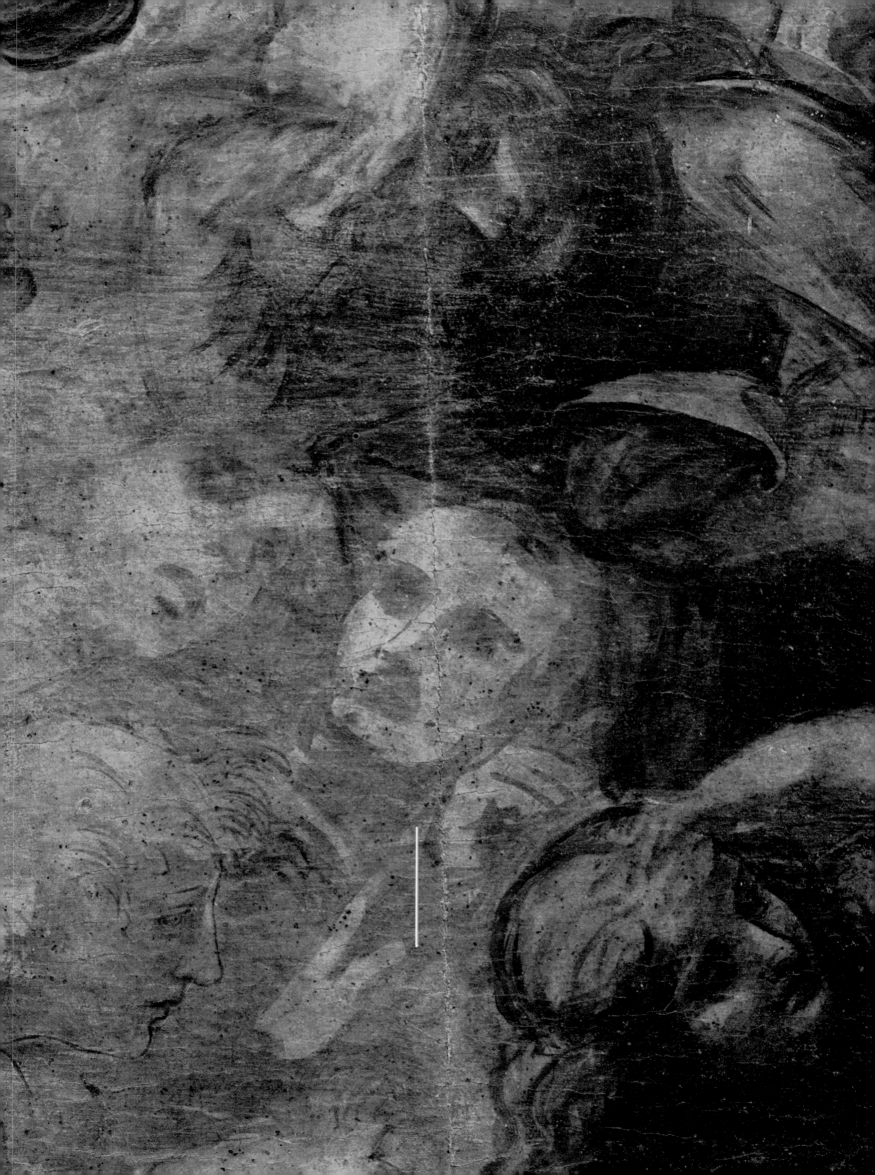

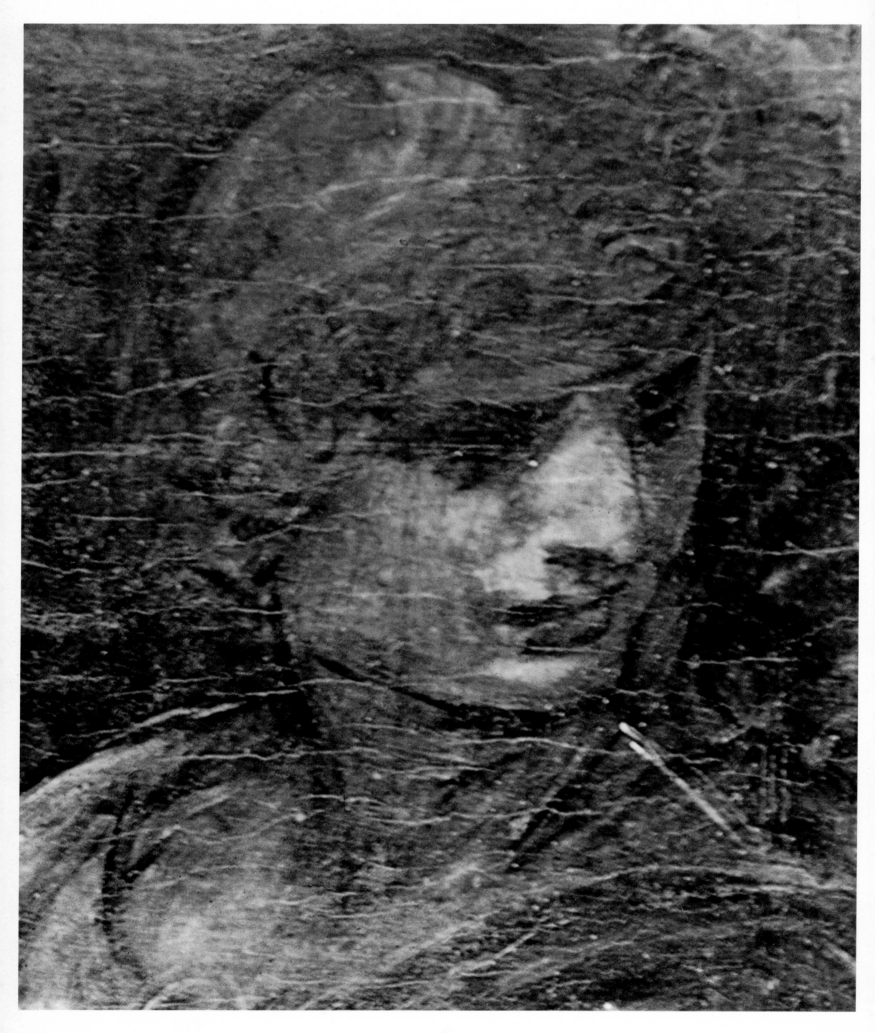

structural pattern, and all the more effective considering the incomplete, deteriorated state of the work.

The same characteristics are in evidence in a painting that, despite the probable mutilation of the lower part, is in a much better state of conservation. It is the portrait of a lady who is presumed to be, and hence entitled, *Ginevra de' Benci* (recently passed from the collection of the Princess of Liechstenstein into the Washington National Gallery of Art). Although it is obviously a profoundly original work of exceptionally high technical quality, it still gives rise to much critical controversy, both with regard to attribution and to the identification of the sitter, widely presumed to be Ginevra, the daughter of Amerigo Benci, as mentioned by various sources in the early sixteenth century and by Vasari himself. There has also been dispute as to the paintings precise place in the chronology of Leonardo's artistic output. The first critic to allude to the subject was Waagen in 1866. He was undecided as to whether the portrait was done by Leonardo or by his Milanese pupil Boltraffio. It was Bode who, on several occasions between 1882 and 1903, first came out unequivocally in favor of Leonardo and who identified the sitter as Ginevra de' Benci. Not until the 1920s did other leading art critics, such as Berenson and Adolfo Venturi, lend their support to this theory. They had previously held the traditional supposition that the painter was either Verrocchio or Lorenzo di Credi. Modern-day critics are virtually in complete agreement that the painting is a genuine Leonardo and that it can be ascribed to the first period in Florence.

There are several good reasons for identifying the sitter as Ginevra de' Benci, especially if the portrait dates from Leonardo's first stay in Florence when he was working in Verrocchio's studio. The presumed mutilation of the base of the panel may also provide a clue. Then, too, there is the interesting heraldic device on the back of the picture – a sprig of juniper (the Italian word *ginepro* is perhaps a reference to the sitter's identity) surrounded by a garland consisting of two interlaced branches of laurel and palm, and the whole symbol is linked by a scroll bearing the inscription "Virtutem Forma Decorat" ("Beauty adorns virtue"). The fact that the lower section of the panel, possibly unfinished, has been cut off suggests that the portrait, including bust and hands, could have borne a strong resemblance to Verrocchio's sculpture *Lady with the Primroses*, which, as has already been mentioned, resembles Leonardo's portrait of a lady presumed to be Ginevra de' Benci. Additional evidence stems from the fact that while in Florence, Leonardo, by his own written admission, was in contact with the Benci family. Indeed, Amerigo Benci was the first owner of *The Adoration of the Magi*, which was unfinished when Leonardo left Florence for Milan. As for the theory concerning the probable mutilation of about one-quarter of the lower part of the panel (consistent with the completion of the garland on the reverse side), some critics suggest that the finished portrait, including forearms and hands, would have borne a striking similarity to a marvelous silverpoint and white lead drawing of hands in the Windsor collection, while others see clear links with the Mona Lisa.

Whatever the truth, there is no denying that the portrait is remarkably original, both in the context of Florentine painting and Italian art as a whole. In conception and execution, it has clear associations with the great school of Flemish portraiture, predating by only a few years the paintings of Hans Memling, including his portrait of the Florentine Tommaso Portinari (in the Metropolitan Museum of Art, New York). This represents a significant and deliberate break with Italian tradition, as exemplified a decade earlier in Piero della Francesca's famous double portrait (now in the Uffizi) of Federigo da Montefeltro and his duchess Battista Sforza. Pursuing this line of thought, it is possible to trace a link between this portrait and the works of an earlier Italian painter renowned for his Flemish technique, Antonello da Messina, and, looking forward, to detect the same influence in the great portraits of Giorgione and Lorenzo Lotto. On the other hand, the main and complete version (there are two copies or variants attributed to Lorenzo di Credi) could be considered as leading directly to *Lady with an Ermine* (in the Cracow National Museum), then to the Mona Lisa, and eventually to the Raphael's female portraits dating from the first ten years of the sixteenth century. Among these are *Maddalena Doni* and *Gravida*, both in a way closer to *Ginevra de' Benci* than to the Mona Lisa.

Examination of the portrait, in its present state, reveals Leonardo's growing

THE ADORATION OF THE MAGI
Detail of the young man depicted on the extreme right of the picture.
Pages 42–43: Another detail.

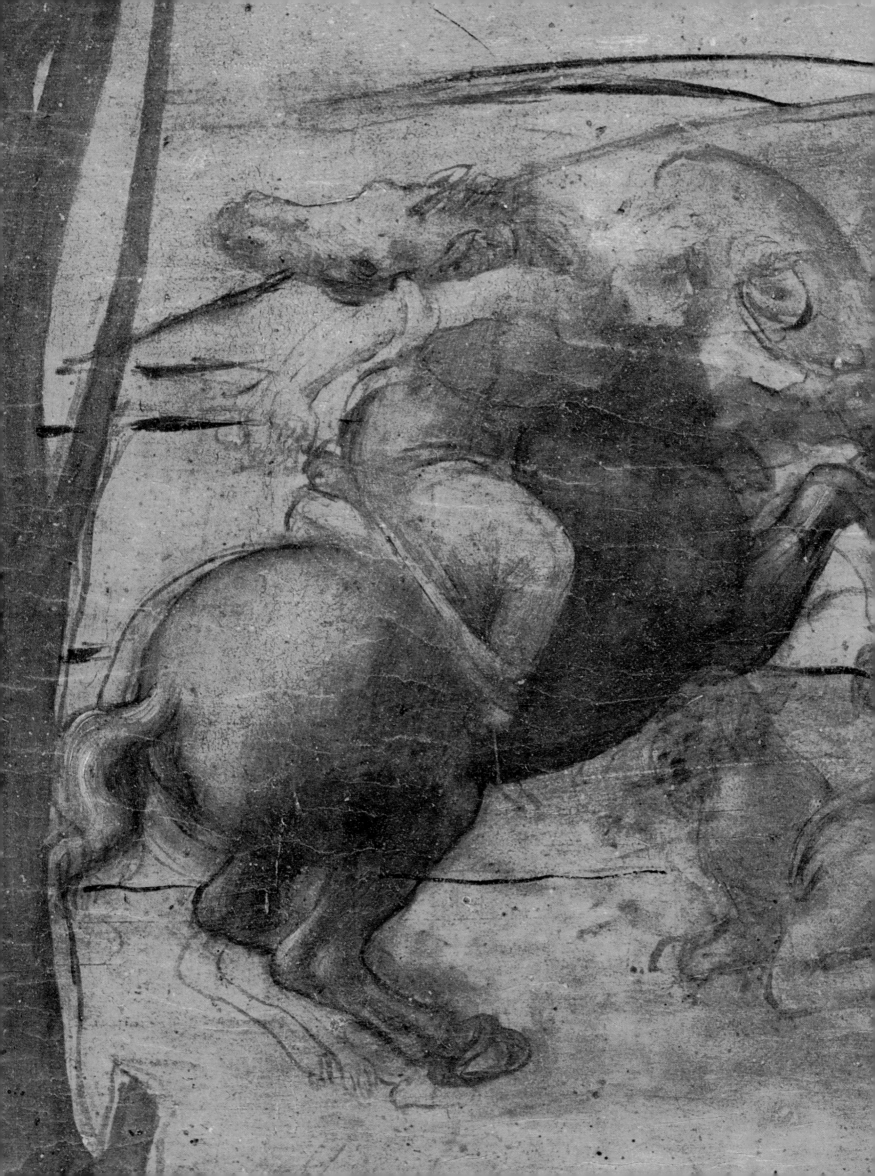

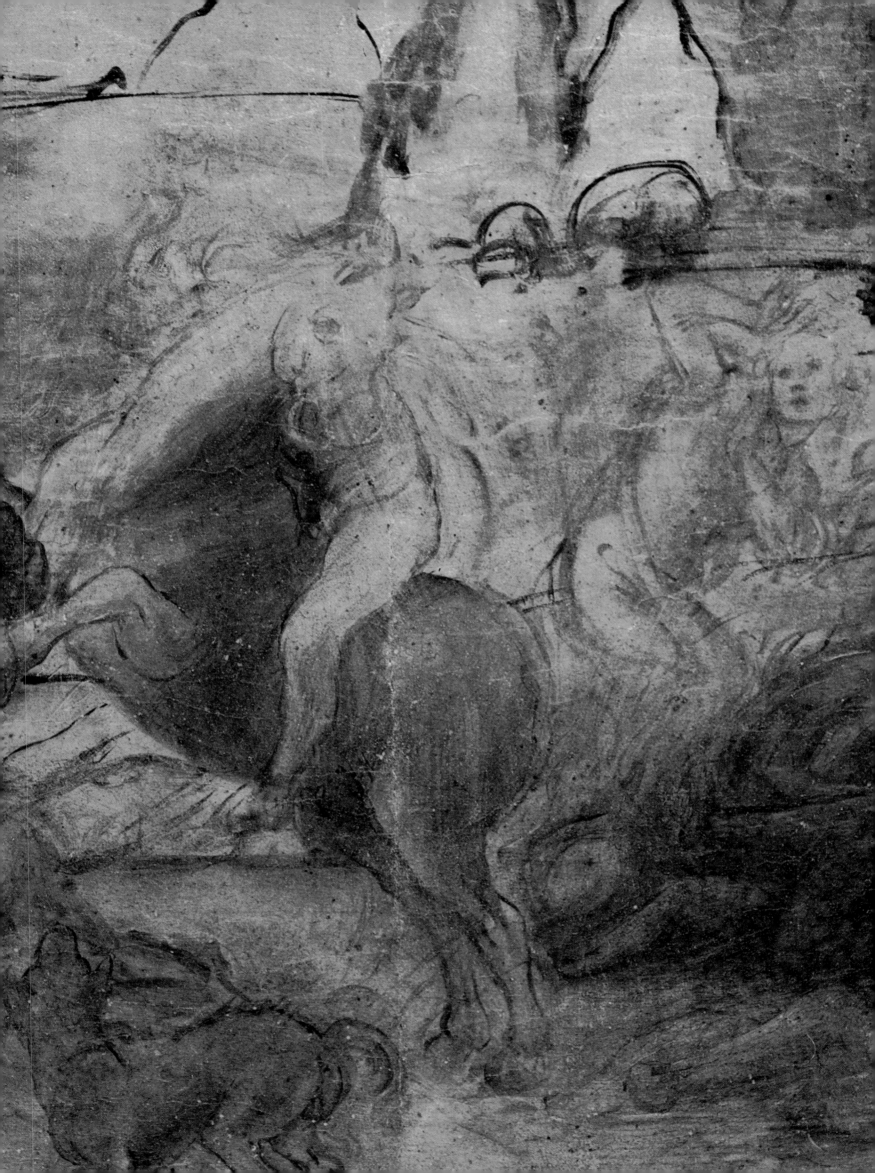

maturity and his new approach to the problems of representational art. Here, for the first time, is a conscious attempt to enlarge the range of artistic expression to envisage the subject in a wider context, as related to the outside world. In this intriguing work, Leonardo makes the observer an active participant in the creative experience, as he is to do more explicitly with the pointing angel in *Virgin of the Rocks* and the mysteriously smiling Mona Lisa. The face, with its delicate, copper blonde curls of hair, is firmly and sensitively modeled and stands out boldly from the dark, massed foliage of a huge juniper (again, surely, no coincidence). The browns and russet flecks of the trees are in turn etched against a radiant background of blue gold sky and of water and reddish vegetation. The same effects of depth, of contrasted shadow and light, and of dissolving color are to be found in the slightly earlier Uffizi version of *The Annunciation*, but the landscape here is more strongly naturalistic. This is clearly the work of a man who was already keenly interested in scientific phenomena and was edging toward an attempted synthesis of art and science. Almost forty years later, he was to record penetrating observations on the nature of leaves and plants and on the effects of direct reflected light and color upon objects. These notes are found in the so-called Manuscript G (in the Library of the Institut de France, Paris), transcribed by Francesco Melzi in the *Treatise on Painting*.

Leonardo and the Medici – *The Adoration of the Magi* and *St. Jerome*

There is good reason to believe that, between 1476 and 1478, Leonardo enjoyed a status of virtual autonomy in Verrocchio's workshop. That he was still there in 1476, the year in which he was involved in the case of alleged sodomy, is attested by mention of him "being with Andrea Verrocchio"; and on January 10, 1478, the Signoria of Florence (who, two weeks previous to this date, had approached Piero Pollaiuolo for a commission but apparently without result) invited Leonardo to paint a picture for an altarpiece destined for the Chapel of San Bernardo in the Palazzo Vecchio. This official commission suggests that the young artist was recognized as being wholly independent. Evidently, however, problems arose during the course of this assignment. Leonardo received an advance for the work in March 1478, but it seems unlikely that he ever progressed beyond a cartoon or perhaps a first draft. Later, the commission was given to Ghirlandaio (in May 1483, by which time Leonardo was in Milan) and finally painted by Filippino Lippi (whose version, dated 1485, is in the Uffizi). Yet the fact that the Signoria decided to give the commission to Leonardo shows that he, the natural son of Ser Piero, not yet twenty-six years old, an artist with intellectual leanings (despite the fact that, by his own admission, he "lacked book learning"), was already accepted and recognized in the city's cultural circles. His connections with the Bencis indicate that he had also caught the eye of wealthy patrons.

It is not easy to decide when Leonardo first came into touch with the Medicis. For them, too, 1478 was a crucial year. Cosimo the Elder died in 1464, and his son Piero, in 1469. Piero's sons Lorenzo and Giuliano were then invited by the Signoria of Florence to take over the government of the republic. It was a time of uncertainty and danger for many rulers of such newly constituted states. In 1476, the Lampugnani family of Milan had been responsible for the murder of Galeazzo Maria Sforza. This act created a competition for the succession, in which Ludovico (Il Moro) emerged triumphant. In Naples, there was to be an unsuccessful conspiracy of the "barons" against Ferdinand of Aragon in 1485. And, in 1478, there was violence in Florence. The Pazzi family, in league with the Riario and Salviati families, succeeded in assassinating Giuliano de' Medici but only wounded his brother Lorenzo, who thus strengthened his grip on government and introduced an apparently democratic constitution administered by a Council of Seventy. The real

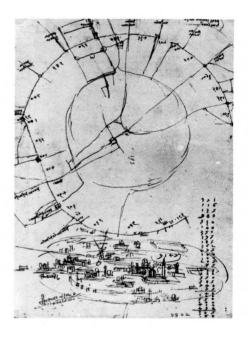

CIRCULAR PLAN OF MILAN
Pen drawing; $11\frac{1}{8} \times 8\frac{1}{16}$ in
$(28.3 \times 20.4$ cm)
Milan, Ambrosian Library
(Codice Atlantico, p. 73 *verso*-a)
This belongs to the period when Leonardo was at the court of Ludovico Sforza, in the capacity of painter, architect and engineer. The map shows the gates around the city walls. In the lower part of the drawing there is a perspective view of the town with the principal monuments, among them the Cathedral and the Sforza Castle.

CANNON FOUNDRY
Pen drawing on yellowish paper;
$9\frac{7}{8} \times 7\frac{3}{16}$ in (25×18.3 cm)
Windsor, Royal Library
(Inv. no. 12647)
This drawing dates from the Milanese
period when Leonardo was given the
responsibility by Ludovico the Moor of
supervising the casting of bronze
cannons.

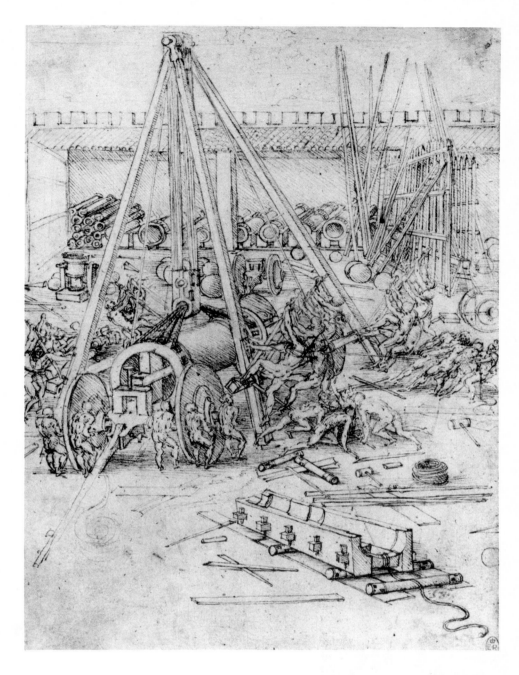

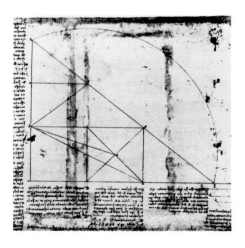

GEOMETRICAL STUDY
PERTAINING TO THE
DUPLICATION OF THE CUBE
Pen drawing $8\frac{1}{8} \times 11\frac{3}{8}$ in
(20.7×28.8 cm)
Milan, Ambrosian Library
(Codice Atlantico, p. **218** verso-b)
Studies in geometry, begun in Milan
partly as a result of Leonardo's
friendship with Luca Pacioli, were
pursued in increasing depth right up
to the last years of his life. Leonardo
looked to geometry for the logical and
scientific basis of his research and
for the pictorial representation of
natural "harmony."

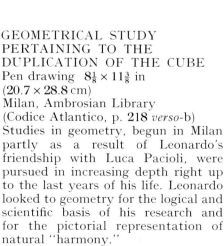

control of this council was vested in the faction of nobles supporting the Medicis. In
1479, Leonardo did a famous drawing (now in the Bonnat Museum, Bayonne) of the
hanged corpse of one of the conspirators, Bernardo di Bandino Baroncelli.

Having become sole ruler of Florence, Lorenzo the Magnificent embarked on a
"cultural policy," already symbolized between 1474 and 1476 by the foundation of
the Neoplatonic Academy headed by Marsilio Ficino, by his close connections with
Politian (who was appointed teacher of his son Piero), and by his patronage of
Botticelli. This last alliance brought to Botticelli a series of commissions
culminating in *Primavera* (*Allegory of Spring*). In 1480, Lorenzo acquired the land
near St Mark's, which he turned into the celebrated Medici Gardens, with its
collection of statues. It was in this "school of sculpture" that Michelangelo worked
toward the end of the 1480s. One source from the early sixteenth century, the
Anonimo Gaddiano (Anonymous Chronicler), author of fragmentary biographies of
Florentine artists, speaks vaguely of Leonardo as having also worked in the Medici
Gardens and asserts that the reason for Leonardo's move from Florence to Milan
was his talent for music, symbolized by the gift – a silver lute in the shape of a horse's
head – he gave to Ludovico the Moor.

All this information is rather vague and generalized, but it does suggest some kind
of relationship between Leonardo and Lorenzo, and it gives credence to the

assumption that Leonardo, among others, was involved in Lorenzo's typically prestige-seeking policy of "cultural export," specifically of lending artists to other friendly states. On the other hand, Leonardo was not a man to be easily manipulated or exploited and was unafraid of speaking his mind and stirring up controversy. He was fiercely critical of the sophistry and abstract intellectual speculation of what he called "false mental sciences"; rather, he put his faith in the logical, empirical evidence of the senses and the certainty of mathematics. This brought him into conflict with the prevailing attitudes of the Neoplatonists patronized by the Medicis and must have made it difficult for him to satisfy his cravings for knowledge, particularly in the scientific field. His concern was not with abstract metaphysics but with cosmic realities and universal values. This scientific research did not interfere with his artistic production, nor did he carry his speculation on intellectual or symbolic concepts into his art.

Nevertheless, although Leonardo firmly believed in the primary importance of visual communication in any work of art, *The Adoration of the Magi* (unfinished) contains an unprecedented wealth of universal symbolic meanings that are more profound and far-reaching than those found in Botticelli's explicitly allegorical paintings, which are typical Medicean products. The large, almost square panel measures ninety-six by ninety-seven inches and was commissioned for the high altar of the monastery of San Donato a Scopeto (outside Florence) in March 1481. When he set out for Milan in 1483, the painting remained incomplete. The foreground received more detailed attention than the background. Leonardo worked from right to left, so certain parts, such as the standing figure on the extreme right (painted in dark brown flecked with white lead, as intended for the whole picture) lacked only the final glaze, whereas other portions were only half finished, and the figures on and around the steps in the background were merely sketched in

BALISTA ON CARRIAGE WITH INCLINED WHEELS
Pen drawing; $7\frac{7}{8} \times 10\frac{5}{8}$ in (20×27 cm)
Milan, Ambrosian Library
(Codice Atlantico, p. 53 *verso*-b)
Study for a large crossbow, the huge arc of which is made up of layered sections, thus giving greater fire power. On the left are two versions of the spring mechanism.

with green earth imposed on the reddish and golden brown ground. Initially owned by Amerigo Benci, the panel belonged to Antonio de' Medici in the early seventeenth century, was acquired for the grand-ducal collection in 1670, came into the temporary possession of the Villa di Castello in 1700, and finally arrived at the Uffizi in 1794.

As already mentioned, Leonardo obviously gave much thought to the project long before he started it: he made use of drawings that date back to 1478. It is the first true representation of the Epiphany in the history of art and, with its emphasis on pure description and narrative, a complete departure from the iconographic tradition introduced in the late Gothic period. The dramatic appearance of Christ to the Gentiles assumes a significance all the more striking due to its powerfully naturalistic setting. Full play is given to the human passions. The architectural framework for the holy group (part of the original conception, as shown by a drawing in the Louvre) is relegated to the background, almost in a state of ruin (a symbol of man's frail achievements) paralleled by the absurd fighting of cavalry and foot soldiers. This naturalistic treatment of a religious theme, revolutionary in its transformation of traditional fifteenth-century conceptions of mass, space, and perspective, anticipates by some thirty years Raphael's paintings in the Vatican *Stanze* and Michelangelo's ceiling of the Sistine Chapel.

The composition, centered on the larger of the two trees and on the figures of the Virgin and Child, is conceived essentially as an architectural pattern of people – a crowd of all ages – arranged around the holy group as in an amphitheater. Their faces, some in shadow and some bathed in golden light, register a fascinating range of human emotions while they induge in a variety of activities – kneeling, gesticulating, arguing. The painting as a whole is anchored at the two front edges (heralding a convention that characterizes many paintings of the sixteenth century and beyond) by the old man on the left who is turning toward the Virgin and Child,

A PAGE OF REBUS
Pen drawing on white paper;
$11\frac{3}{4} \times 9\frac{7}{8}$ in (29.8 × 25 cm)
Windsor, Royal Library
(Inv. no. 12692 *verso*)
This series of written and illustrated fragments relates to notes for picture puzzles with which Leonardo entertained members of the Milanese court. Superimposed over the rebus is an architectural plan in which it is perhaps possible to recognise the "old court" (today the Royal Palace) where Leonardo had a laboratory.

STUDY OF A WAR MACHINE
Pen drawing on white paper;
$11\frac{1}{8} \times 8\frac{1}{16}$ in (28.2 × 20.5 cm)
Windsor, Royal Library
(Inv. no. 12652 *recto*)
In devising weapons for a naval battle, Leonardo exercised his imagination and came up with this mortar mounted in a boat, intended to fire incendiary missiles against the enemy.

as if summing up the observer's thoughts concerning the event, and by the youth on the right (possibly a self-portrait) who is inviting us, by gesture and expression, to "enter" the picture. The Virgin and Child, one of the sections of the painting that was not taken beyond the sketch stage, are isolated in a kind of niche. This area was surely intended to be accentuated by separate, strong lighting standing out against the sloping hill in which the first tree is rooted and the brighter background. The latter is drawn in deep perspective, as emphasized by the link between the smaller tree and the prancing horse, and this is in contrast to the flat, hollow treatment of the foreground. It symbolizes a world of error, confusion, fantasy, and self-delusion that is wholly ignorant of the dawning revelation of the New Testament. The ruins on the left, a crumbled colosseum or a "Tower of Babel," are the remains of a meticulously designed building; and the men responsible for this work of beauty are

locked in fruitless combat, tearing their world to shreds on a bare, rocky landscape similar to that of the contemporary *St. Jerome* and looking forward to that of *Virgin of the Rocks*.

The Adoration of the Magi, even in its unfinished condition, marked the peak of Leonardo's artistic achievement to date. It is entirely novel in its spatial, rather than conventionally linear, structure (obtained by light and shadow), its application of anatomical research to express emotions, its insight into the fundamentals of architectural design (later to provide a point of contact with Bramante), and its accuracy of geological observation. These same qualities, including the interest in anatomy, are evident in *St. Jerome* in the Vatican Gallery, for which the preparatory work is identical to that for *The Adoration of the Magi*. All we know of this panel is the record of a succession of owners. Originally in the Vatican, it came into the possession of the German painter Angelica Kaufmann, who worked in Rome, then belonged to Cardinal Fesch, uncle of Napoleon, and finally found its way back to the Vatican in 1845. Nevertheless, there can be no doubt that it is authentic or that it dates from the end of Leonardo's first stay in Florence. The only dissenting voice was that of Strzygowski, who, in 1895, suggested that it emanated from the first period in Milan, which would make it roughly contemporary with *The Last Supper*. This theory, which is certainly wrong, still does not basically alter the fact that in four pictures – *St. Jerome*, *The Adoration of the Magi*, *The Last Supper*, and *The Battle of Anghiari* – there is a steady development in the way Leonardo visualized and represented the human figure. This testifies to his passionate interest in this subject, first mentioned in a note, dated April 2, 1489, on a page from one of the Anatomy Manuscripts at Windsor. This fascination, which was both artistic and scientific, was a traditionally Florentine characteristic (one thinks of Pollaiuolo), but Leonardo carried it much further than his predecessors. He was, for example, intrigued by the dynamics of the "human machine" at various ages, and he saw the workings of the body as being inseparable from the feelings – the inevitable expression of psychic and emotional reactions.

The following early extracts from Anatomy Manuscript B from Windsor and Manuscript A from the Institut de France illustrate Leonardo's methodical approach to his subject:

"Of the nerves that raise the shoulders and that raise the head and those that lower it and that turn it and that bend it across:

"To lower the back. To bend it. To twist it. To raise it.

"You will write upon physiognomy." (Windsor 19018, Anatomy Manuscript B)

"You will make the rule and measurement of each muscle, and you will give the reason of all their functions and the manner in which they use them and who moves them." (Windsor 19044, Anatomy Manuscript B)

"The nerves with their muscles serve the tendons even as soldiers serve their leaders, and the tendons serve the common sense as the leaders their captain, and this common sense serves the soul as the captain serves his lord.

"So therefore the articulation of the bones obeys the nerve; and the nerve, the muscle; and the muscle, the tendon; and the tendon, the common sense; and the common sense is the seat of the soul; and the memory is its monitor; and its faculty of receiving impressions serves as its standard of reference." (Windsor 19019, Anatomy Manuscript B)

"Of the Conformity of the Limbs.

"Further, I remind you to pay great attention in giving limbs to your figures, so that they may not merely appear to harmonize with the size of the body but also with the age. So the limbs of youths should have few muscles and veins and have a soft surface and be rounded and pleasing in color; in men, they should be sinewy and full of muscles; in old men, the surface should be wrinkled and rough and covered with veins, and with the sinews greatly protruding." (Manuscript A, Institut de France)

"How a figure is not worthy of praise unless such action appears in it as serves to express the passion of the soul:

"That figure is most worthy of praise that by its action best expresses the passion that animates it." (Manuscript A, Institut de France)

MORTAR
Pen and bistre drawing; $7\frac{5}{8} \times 14\frac{5}{8}$ in (19.3×37.2 cm)
Milan, Ambrosian Library
(Codice Atlantico, p. 9 *recto*-a)
This enormous war machine, precursor of the modern cannon, was intended to be loaded, according to Leonardo's precise notes, with grenades filled with gunpowder and provided with numerous holes so that they would shatter on explosion into fragments.

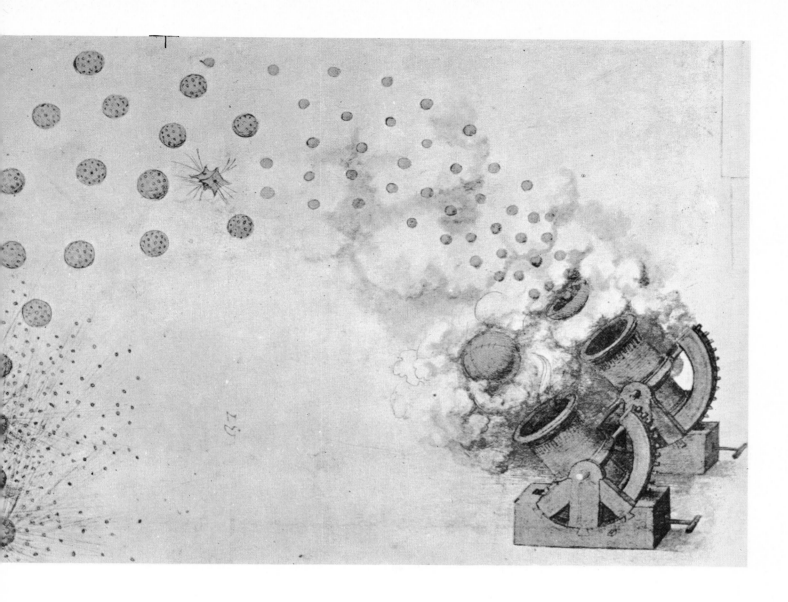

Some of the pages of Anatomy Manuscript B (at Windsor) date from Leonardo's first period in Milan. Those quoted above, with the exception of 19044, form a group together with the previously mentioned page dated 1489. Manuscript A (in the Institut de France) dates from 1492. So these notes were obviously jotted down during the period between *The Adoration of the Magi* (unfinished at this time) and *St. Jerome*, works done in Florence, and *The Last Supper*, painted in Milan. Apart from emphasizing the intrinsic importance of the vast amount of manuscript material left by Leonardo (even though a large part of it must have been lost), these pages typify the meticulous research procedures he adopted throughout his life. The early pages of Anatomy Manuscript B, as well as scattered notes in Manuscript B from the Institut de France (dating from around 1486) testify to the fact that Leonardo was at this period conducting his first independent investigations into the fields of anatomy, physiology, and biology, with a view to writing a book entitled *Of the Human Figure*, according to his note of April 2, 1489. The following plan for the book appears in Manuscript B:

"This work should commence with the conception of man and should describe the nature of the womb and how the child inhabits it and in what stage it dwells there and the manner of its quickening and feeding and its growth and what interval there is between one stage of growth and another and what thing drives it forth from the body of the mother and for what reason it sometimes emerges from the belly of the mother before the due time."

Yet *The Adoration of the Magi* and, to an even greater extent, the *St. Jerome* indicate that even in the early 1480s, Leonardo, though still more interested in "artistic anatomy" than in the theoretical and experimental aspects of the subject, was far ahead of contemporary artists in his determination to probe the innermost secrets of the human body, to investigate the sources of bodily energy, and to ascertain the manner in which movement depends on the structure and the

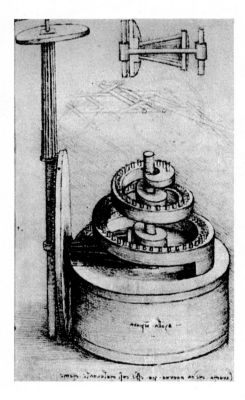

SKETCH OF A GRANDFATHER
CLOCK
Detail
Pen drawing on white paper;
$8\frac{7}{16} \times 5\frac{3}{4}$ in (21.4 × 14.6 cm)
Madrid, National Library
(Madrid MS I, p. 27 *verso*)
The grandfather clock, complete with
alarm, depicted here forms part of a
series of clock mechanisms dreamed up
by Leonardo.

SKETCH OF A MACHINE
Detail
Pen drawing; $11\frac{3}{16} \times 15\frac{3}{16}$ in
(28.4 × 41 cm)
Milan, Ambrosian Library
(Codice Atlantico, p. 393 *verso*-a)
An extremely accurate representation
of a spinning machine, with a winged
spindle. At top left is a drawing of the
apparatus for the automatic distri-
bution of the yarn.

MECHANISM
Detail
Chalk and pen drawing on white
paper; $8\frac{1}{16} \times 5\frac{3}{4}$ in (21.4 × 14.6 cm)
Madrid, National Library
(Madrid MS I, p. 45 *recto*)
In the upper half of the drawing there
is also a sketch of a mobile bridge or of a
roof with wooden poles.

SKETCH OF BALL-BEARINGS
Detail
Chalk and pen drawing on white
paper; $8\frac{1}{16} \times 5\frac{3}{4}$ in (21.4 × 14.6 cm)
Madrid, National Library
(Madrid MS I, p. 20 *verso*)
Another example of Leonardo's in-
terest in mechanics. Having studied
the principles of roller bearings dating
from antiquity as well as the effects of
friction, he devised the idea of a ring or
race in which the balls could rotate
freely. His idea was adopted again at
the end of the eighteenth century.

interrelationship of muscles, tendons, and bones. This was to lead to more intensive
research, in the latter part of the 1480s, to be used in the projected illustrated book
on human anatomy and biology. The idea of such a treatise (a few pages of which
date from around 1490) was revived some fifteen years later during Leonardo's
second stay in Florence, at about the time he painted *The Battle of Anghiari*, then
again around 1510, and still a little later. In their entirety, the pages comprise
Anatomy Manuscripts A, B, and C at Windsor. The observations in these
manuscripts go far beyond mere practical instructions for artists; they anticipate
the famous book on anatomy and early medicine written by the Belgian-born
Andreas Vesalius, physician to Charles V, and published in Basle in 1543.
Nevertheless, Leonardo was firm in his adherence to the basic ideas of the close
relationship between "action" – the "passion of the soul" – and "common sense"
and of their influence on muscular activity. These early speculations were given
formal expression in *The Last Supper*, which may be regarded as a genuine visual
treatise on the "science of human feelings."

Leonardo's "Universality"

It is known that Leonardo was in Milan on April 25, 1483, the date on which the contract was signed for the painting of the great altarpiece for the chapel of the Confraternity of the Immaculate Conception in the church of San Francesco Grande. The central section of this altarpiece was originally *Virgin of the Rocks* (now in the Louvre). Considering the state of progress of *The Adoration of the Magi*, contracted in March 1481, experts are agreed that Leonardo must have arrived in Milan in 1482. They arrived at this date by estimating (on the basis of his slow work rate) that he would have needed twenty-four or at most thirty months to complete the painting and by allowing for the actual move from city to city. More important than the precise date is the effect of this change of environment on Leonardo's thoughts and feelings. The ostensible reason for the move was, as suggested by the Anonimo Gaddiano, that he was sent as a "musician" to present a lute to Ludovico Sforza. This suggests a fairly amicable relationship between Lorenzo the Magnificent and Ludovico the Moor. But it is more likely that the real reason was that Leonardo was invited to Milan for the purpose of building for Ludovico an immense equestrian monument (the "bronze horse" mentioned in Leonardo's letter

to the Moor) in memory of his father, Francesco. Ludovico knew of Verrocchio's bronze statue of the Condottiere Colleoni in Venice, and there would be nothing unusual in his decision to approach the most gifted man in Verrocchio's workshop. Ludovico would have called on the services of a man who was known to be well versed in the principles of architecture, sculpture, and painting and who boasted in his letter that in these fields, "I can do as much as anyone else, whoever he may be." For his part, Lorenzo the Magnificent was habitually "exporting" artists as a matter of policy, and, in 1482, had dispatched his favorite painter, Botticelli, along with Ghirlandaio, Perugino, Piero di Cosimo, and Cosimo Rosselli, to Rome in order to paint the Biblical frescoes on the walls of the Sistine Chapel.

The main clues to Leonardo's move, however, may be found in his relationship with Lorenzo and in the fact that he felt stifled in Florence. A register of landed property dated 1480 shows that by then he was no longer living in the house of his father, who, by that date, had married his third wife, who had borne two sons (a situation that, after Ser Piero's death, was to lead to problems of inheritance in 1506–1507). A more decisive factor may have been the lack of accord between Leonardo's ideas and the attitudes prevailing within Lorenzo's court circle.

Leonardo might have felt the challenge of exercising his talents and proving his worth in new surroundings, and Milan appeared to be as well endowed with artists and other intellectuals as Florence itself. Indeed, Milan, affording wider scope for theory and experiment, since less wedded to traditional humanism, may have seemed a far more promising base of activity altogether. Finally, it is interesting to note that this period included the formulation of a new political ideology most comprehensively expressed by Machiavelli. The underlying concept centered on the tyrannical prince who superseded rival factions and exercised the "art of government" on a rational basis (thus heralding the absolute nationalism of the sixteenth century). It is perhaps no coincidence that Leonardo's vocation, from that time on, was to advise and serve a succession of such princes. Leonardo himself was a friend of Machiavelli (they were together with Cesare Borgia in the latter's central Italian campaigns of 1502). Prior to serving with the duke as architect and engineer-general, Leonardo had found a generous patron in Ludovico Sforza; and, in later years, he was to offer his varied talents to Francis I.

Besides ambitious undertakings in painting, sculpture, and engineering, Leonardo was expected to perform less demanding courtly duties. These lesser activities, which Leonardo never viewed with disdain, included making artwork for festivals and other special occasions, participating in musical entertainments as well as witty conversation and word play, and reciting epigrams and poetry (Vasari says that "he was the best reciter of improvised rhymes of his time.") Politically and culturally, there was a world of difference between the courts of the Medicis and of the Sforzas. The latter was to prove much more stimulating for a man of Leonardo's capabilities.

The famous letter of self-commendation that Leonardo wrote to Ludovico is contained in the Codice Atlantico (in the Ambrosian Library of Milan). Although

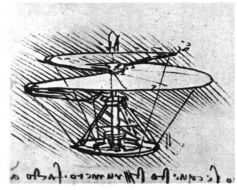

STUDY FOR AN "AERIAL SCREW" (HELICOPTER ?)
Detail
Pen drawing on white paper;
$9\frac{1}{16} \times 6\frac{5}{16}$ in (23×16 cm)
Paris, French Institute Library
(MS B, p. 83 *verso*).

STUDY FOR A FLYING MACHINE
Detail
Pen drawing; $9\frac{1}{16} \times 6\frac{5}{16}$ in (23×16 cm)
Paris, French Institute Library
(MS B, p. 74 *verso*)
There is another drawing of a flying machine, similar in every respect, in the Codice Atlantico, p. 302 *verso*).

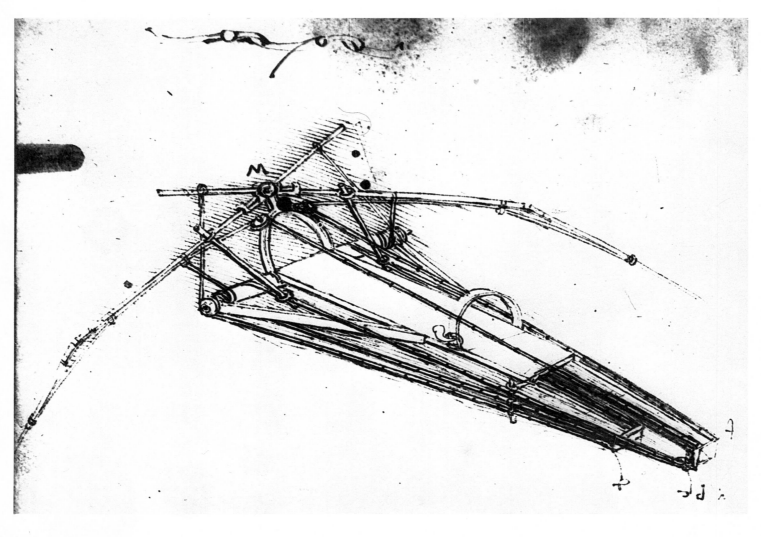

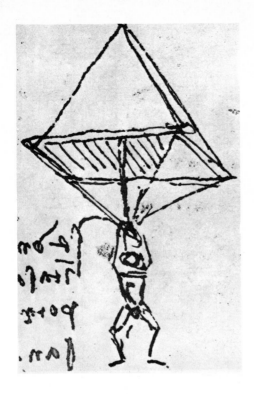

STUDY FOR A PARACHUTE
Detail
Pen drawing; $11 \times 8\frac{1}{16}$ in
$(28 \times 20.4$ cm$)$
Milan, Ambrosian Library
(Codice Atlantico, p. 381 *verso*).

DESIGN FOR A FLYING
MACHINE OPERATED BY A
MAN
Pen drawing; $9\frac{1}{16} \times 6\frac{5}{16}$ in
$(23 \times 16$ cm$)$
Paris, French Institute Library
(MS B, p. 80 *recto*).

not written in his own hand, it is generally agreed to be authentic. Apparently, no sooner had Leonardo arrived in Milan than he reminded the duke of his many talents. He presented himself, above all, as one of the "masters and inventors of instruments of war" – portable bridges, scaling ladders and assault machines, mines and explosives, cannons and mortars, naval weapons, siege tunnels, "covered chariots," catapults, and so forth. He also introduced himself as an architect and a hydraulic engineer as well as a sculptor "in marble, bronze, or clay" and a painter. On this basis, he offered his services for the commission of the "bronze horse." Leonardo's presentation of himself was not an idle boast. His knowledge of engineering and his familiarity with machines of war are solidly in evidence in the detailed notes and accurate drawings preserved both in the Codice Atlantico, dating from the first years in Milan, and in Manuscript B (in the Institut de France), the oldest of the codices dating from the mid-1480s. We know, too, that throughout the entire period of his first stay in Milan, until 1499, Leonardo applied his mind to a vast range of interests – civil and military architecture, hydraulic engineering, sculpture, theoretical and applied mechanics, ballistics, optics, the movement of water, the anatomy of the horse, and many other topics.

This brings us to the puzzling and much-discussed matter of Leonardo's "universality." As proved even by the most cursory examination of the writings and drawings in the manuscripts, Leonardo's interests and aptitudes swept a remarkably broad range. Before looking in detail at the wealth of written and illustrated material, it is worth considering the nature of this "universality," its merits and limitations, its relationship to Leonardo's cultural background, and the rapport between the artist and the scientist. It is an open question whether Leonardo, from the 1480s onward, really contemplated an organic "summation" of the natural sciences. Several contemporary experts have views on this point. In his essay on Leonardo in the *Encyclopedia of World Art*, Ludwig H. Heydenreich writes: "If there is one unifying principle in the great mass of notes and drawings left by Leonardo, it would seem to be an intention on his part to create nothing less than an encyclopedic exposition of human knowledge. Such an encyclopedia would have included optics as the necessary basis for correct perception, mechanics as the study of the physical forces within organic and inorganic nature, and biology as the study of growth and life, with anatomy as the study of the forms and energy active in the universe."

In the same entry in the *Encyclopedia of World Art*, E. Garin writes: "To attempt to derive an organic vision of life and reality, or indeed a systematic philosophy, from Leonardo's writings would be to misunderstand his work profoundly. His fragments do not constitute a philosophy in the technical sense. Nothing could be more mistaken than the effort that has, at times, been made to compare them to fragments of the writings of the Greek pre-Socratic philosophers – which are, in fact, scattered remains of what once were integrated works arranged to present a total vision of reality. Leonardo's literary remains are merely hasty notes on technique and construction, artistic memoranda, maxims and aphorisms, and notebooks with words and phrases that interested him. Rational chains of argument and the foundations provided by consciously elaborated principles – the very sinews of philosophy – are missing.

"Leonardo's scanty knowledge of Latin precluded direct access to the scientific work of his contemporaries. He was informed on matters that were debated and discussed, but the books he consulted were compilations, often out of date and mediocre in quality – Pliny in the vernacular translation of Landino, Ramusio's *Valturio*, Cecco d'Ascoli's *L'Acerba*, Brunetto Latini's *Trésor*. But this apparent limitation constitutes his strength. Leonardo's lack of access to traditional expositions freed him from the dead weight of a passive inheritance, to which he reacted with disdain and scorn.

"Yet, his thought, which remains perhaps his greatest innovation, is nonetheless based on certain specific points; these form the sole basis for an attempt to isolate his first principles."

In his introduction to the *Selected Writings of Leonardo da Vinci*, A. M. Brizio points out: "Anyone confronted for the first time with one of Leonardo's manuscripts initially experiences a sense of disorientation. There is no apparent

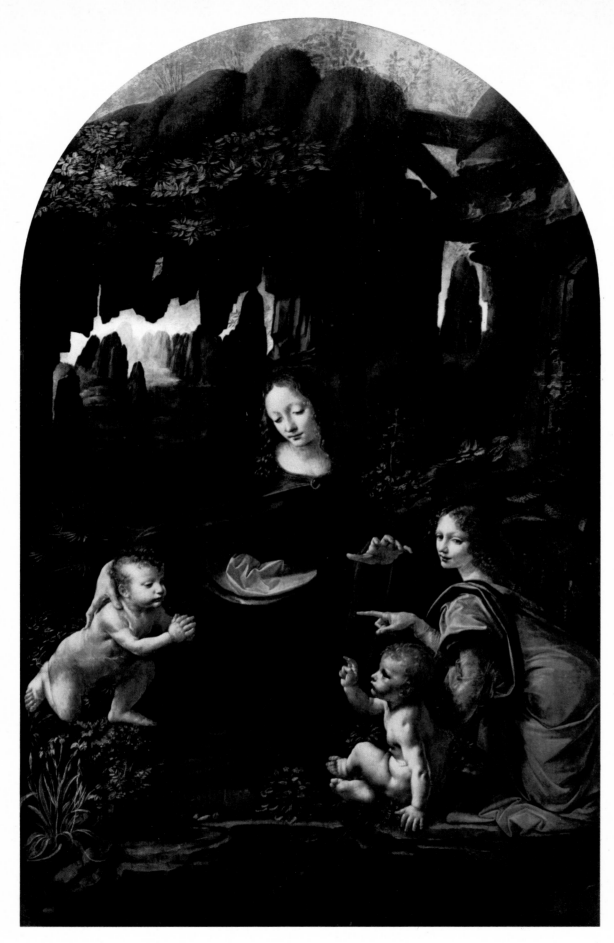

VIRGIN OF THE ROCKS
Oil on wood panel transferred to
canvas; $77\frac{1}{2} \times 48\frac{1}{2}$ in (198×123 cm)
Commissioned in 1483
Paris, Louvre.
Pages 56–57 and 60–61 : Two details.

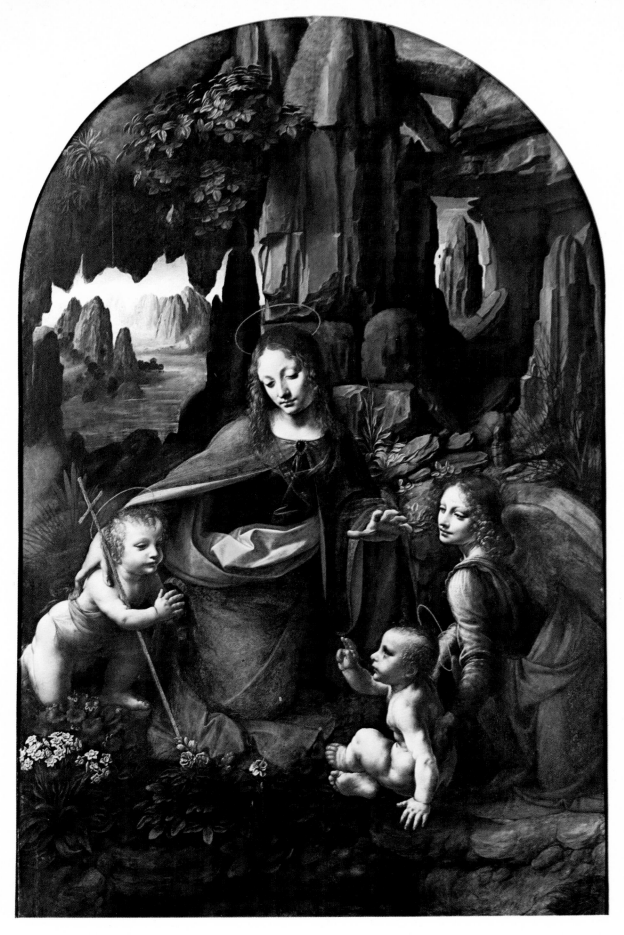

Ambrogio de Predis and Leonardo
VIRGIN OF THE ROCKS
Oil on wood panel; 75 × 47¼ in
(190 × 120 cm)
1503–6
London, National Gallery
The version located in the Church of
San Francesco Grande, Milan.

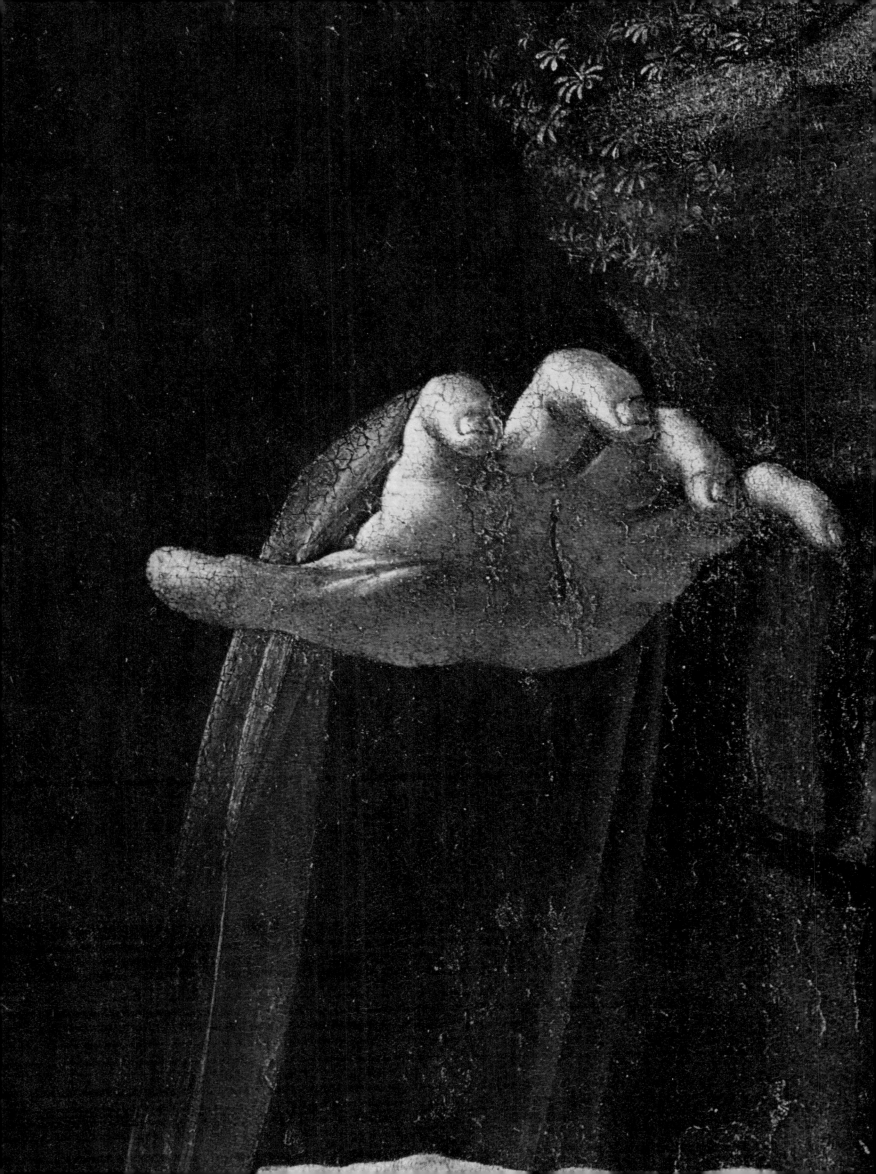

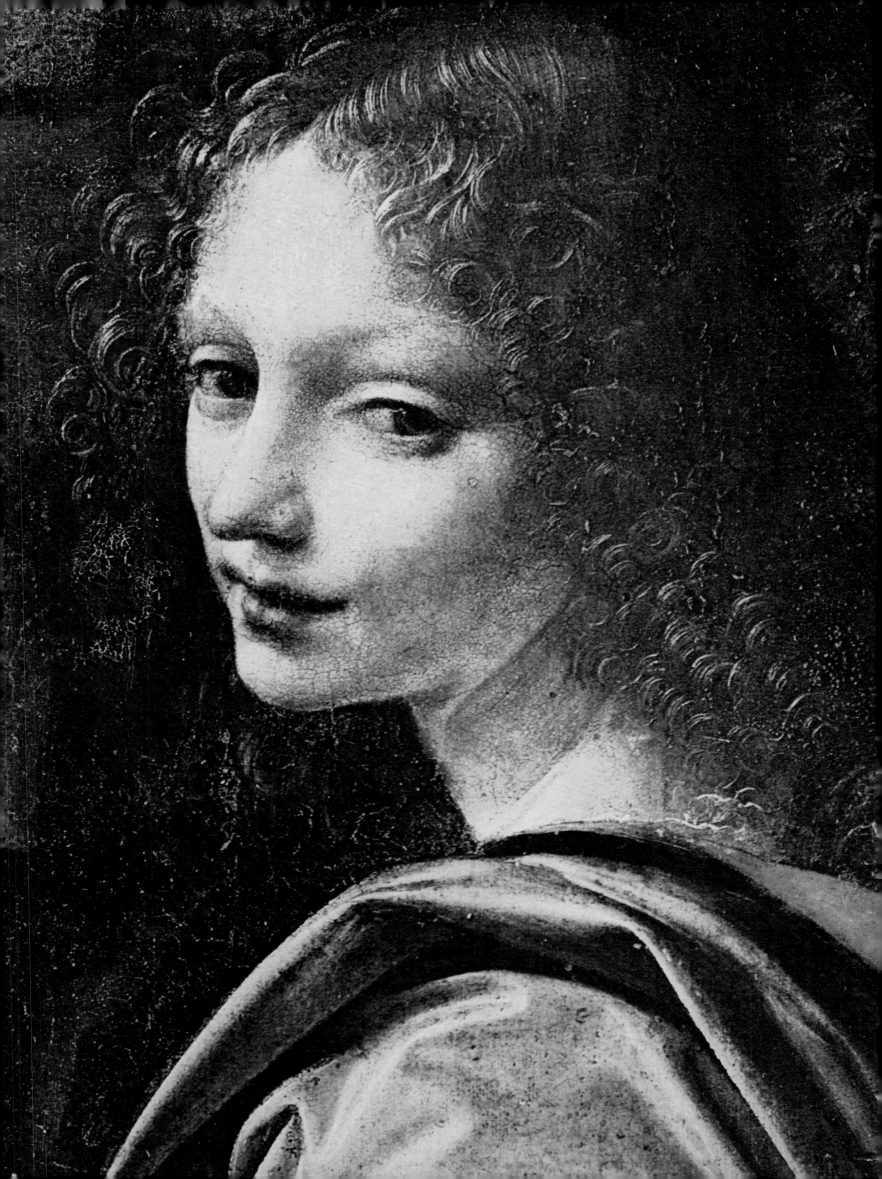

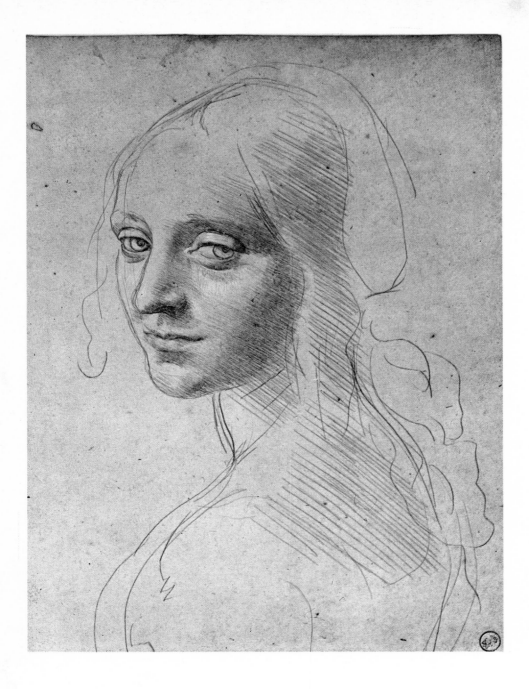

STUDY FOR THE ANGEL'S
HEAD IN "VIRGIN OF THE
ROCKS"
Silverpoint drawing on yellowish
paper; $7\frac{1}{8} \times 6\frac{1}{4}$ in (18.1 × 15.9 cm)
Turin, Royal Library (15572).

VIOLETS AND OTHER
FLOWERS
Pen and silverpoint drawing on
yellowish paper; $7\frac{3}{16} \times 7\frac{7}{8}$ in
(18.3 × 20 cm)
Venice, Academy
(no. 237).

order, no continuity of argument or developed reasoning; instead he will find, on the same page, a varied and disparate succession of comments, without any connecting links. The most meticulous record of an incident from everyday life – a story, a memorandum, a miscellaneous list of objects, an isolated fact – will be placed alongside a theorem, a striking observation of a natural phenomenon, a calculation on strength and resistance, a fable, a motto, and so forth. Alternatively, a demonstration beginning with a precise and thorough summary of premises, will then branch out in different directions and be intermingled with new elements that take the reader far from the point of departure. . . . Nevertheless, as one continues reading, comprehension dawns, and little by little the apparent confusion is dispelled. Gradually, a pattern of thinking emerges so compact and so persistent that the reader is entirely dominated by it, allowing himself to be guided through its endless meanderings. The arguments that had seemed so disparate and unconnected are now seen to derive from a single nucleus, the fruit of a formidably unified mental process."

A. Marinoni, in his essay on Leonardo, in *The Literary Heritage*, writes: "The characteristic feature of Leonardo's writings is their massive state of disorder. Although he planned a vast number of treatises, Leonardo almost always resorted to notes jotted down on the spur of the moment, often just a few scribbled lines, seldom running to more than a page. The same type of note will be repeated dozens of times in different manuscripts, or with slight modifications. Many of these notes are not intended for a reader but are simple memoranda for his own reference.

Furthermore, he frequently alternates original thoughts with transcriptions from the pages of other authors' books. ... He described himself as 'lacking book-learning,' meaning that he did not know Latin and that he was consequently unable to quote 'authorities.' He realized that his own native tongue, the Florentine dialect, provided him with an extensive vocabulary of words for visible and tangible objects, but in the context of everyday conversation in the *bottega*, there was only a limited choice of abstract nouns, adjectives, adverbs, and verbs, such as scholars might use, many of them derived from Latin. So he decided to collect lists of such words from grammars and dictionaries or from books that he happened to pick up. This was when he was forty years old. Later, he resolved to get down to studying Latin in earnest. ... His training in the sphere of mathematical sciences was also very flimsy. He never had much skill in calculating and there were glaring gaps, too, on the theoretical side. . . . Only in the years between 1496 and 1504 did Leonardo get to know and study Euclid; so, by the time he was fifty, he could claim to be as well versed in mathematics as he was in Latin. But whereas in Latin there is no real evidence of deep and continuous study, geometry developed into a genuine passion for the remainder of his life. . . .

"Leonardo owed much to those of his predecessors who had discovered the principles of perspective, who had proclaimed themselves devotees of light as the source of vision and, hence, of knowledge and who had inquired into the 'spiritual virtues,' namely the natural founts of physical energy – heat, force, and gravity – as the foundations of movement and of life. For him, space was not simply an empty container but a field of visible and invisible forces. . . . He developed his argument to the point of denying any real validity to traditional science and to proposing a new kind of science. The antithesis of scholarly poetry and 'unlettered' painting was resolved by his separation of such activities into two distinct areas. 'If poetry treats of moral philosophy,' he wrote, 'painting has to do with natural philosophy.' ... Moral and natural philosophy, therefore, are opposed, but the difference is largely one of method. The painter brought up in the school of mechanical arts uses the method of practical experiment in order to test the validity of the rules he has been taught. . . . On the other hand, practice on its own is not enough. . . . Only the mathematical sciences, with their geometrical theorems and numerical calculations, enable one to shape experiment into a system of theory that leads to true science, namely the new science as conceived by Leonardo. He is content to leave the scholars to study metaphysical problems and essential causes – praiseworthy activities but incapable of being put to the practical test and thus becoming the source of interminable controversy. ... Leonardo refused to bow to authority as such, refrained from meddling in metaphysics, and proclaimed the birth of a new science – offspring of a marriage between mathematics and experimental research."

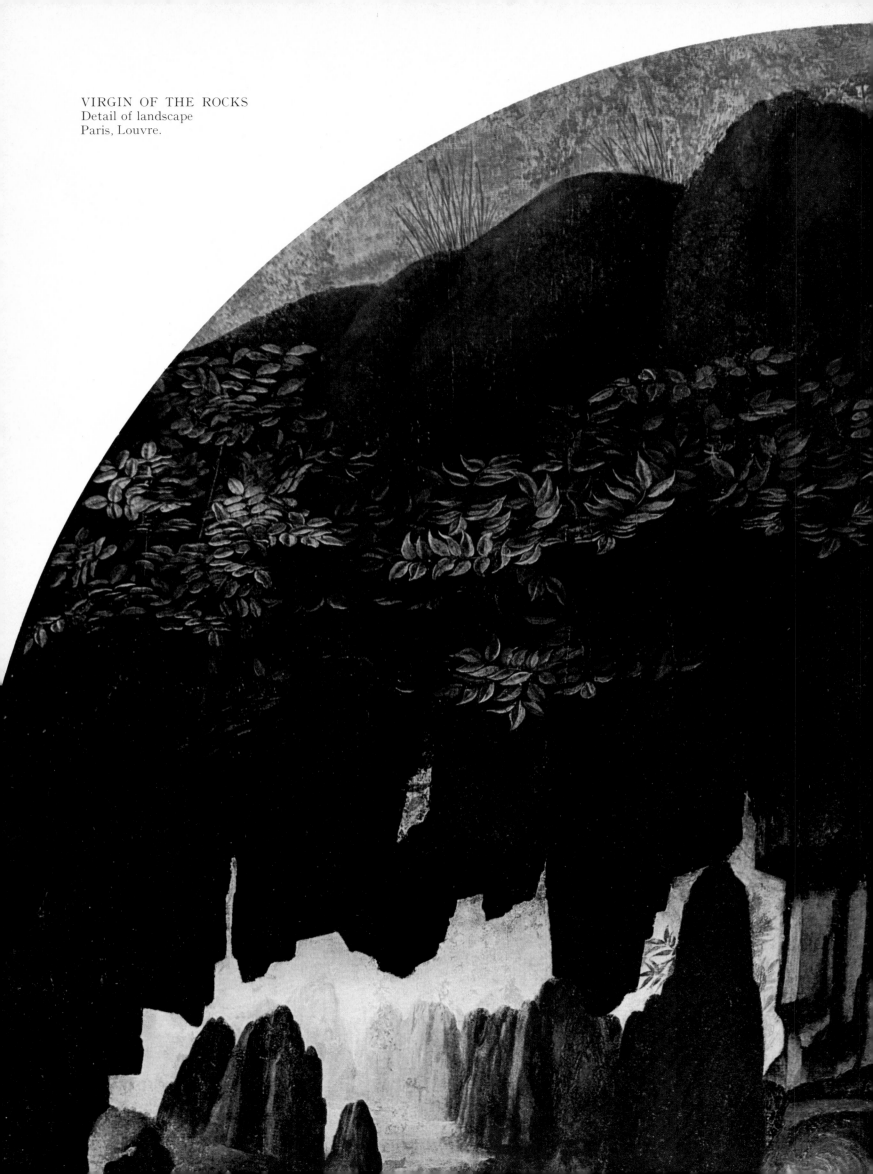

VIRGIN OF THE ROCKS
Detail of landscape
Paris, Louvre.

Leonardo's Manuscripts

There are more than 4,000 pages of Leonardo's writings and drawings available for modern study. Some are separate sheets, whereas others are grouped together in booklets or manuscript codices. In these pages, there is no distinction between art and science, and an attempt to make such a division would be irrelevant and alien to Leonardo's methods and mental processes. For him, a physical experiment, a technical idea, or a natural observation were associated simply by virtue of being facets of experience. Sometimes the point could most effectively be made in words; sometimes, by illustrations, and often, by a combination of both on the same page. We have already seen a striking example of this method in the case of the 1478 page (in the Uffizi), with its assorted notes and drawings.

The most important collections of loose pages are to be found in the Royal Library at Windsor, the Uffizi gallery in Florence, the Louvre in Paris, the Accademia in Venice, the Royal Library of Turin, the British Museum in London, the Bonnat Museum at Bayonne, the Metropolitan Museum of Art in New York, the Boymans Museum in Rotterdam, the Szépmüvészeti Museum of Budapest, and the Albertina in Vienna. The surviving codices are Manuscripts A, B, C, D, E, F, G, H, I, K, L, and M, as well as the two Ashburnham. Codices 2038 and 2037, contained in A and B in the Library of the Institut de France, Paris; the Codice Trivulziano in the Civica Trivulziona Library, Milan; the Codice *On the Flight of Birds* in the Royal Library, Turin; the Leicester Manuscript in the Library of Holkham Hall in England; the Arundel Manuscript in the British Museum; the Forster Bequest Manuscripts I, II, and III in London's Victoria and Albert Museum; and the Codice Atlantico in the Ambrosian Library, Milan. The last Codice, named for its great size, consists of 402 pages. Originally the first compilation was made by the sixteenth-century sculptor Pompeo Leoni, who built an immense scrapbook from 1,222 of Leonardo's manuscript sheets. These have recently been separated, restored, and remounted in twelve volumes, and a facsimile is in course of being published. This undertaking has confirmed current opinion that Leoni, rather than compiling his material from preexisting bound manuscripts and odd loose sheets, produced two hefty volumes from an assortment of loose pages. One of these volumes is the Codice Atlantico and the other made up of the sheets in the Royal Library at Windsor. Leoni seems to have divided up the drawings, between the two volumes, whereas some of the originals had appeared on a single page. It has been possible, however, for some of these to be reconstructed as executed by Leonardo. Finally, there are the so-called Madrid Manuscripts I and II in the National Library, Madrid, found by Ladislao Reti in 1965. These are presently in the course of publication.

The research and working methods of Leonardo are today sufficiently clear to explain the existence of two basic types of manuscript. The first consists of notebooks for memoranda. Leonardo always carried these with him and would jot down on different occasions writings and drawings of all kinds, so that a single sheet might record notes taken days or weeks apart and cover a wide variety of subjects. The second type of manuscript consists of copybooks. There is more order to the notes and drawings, which are sometimes devoted to a single theme but, in wholly characteristic fashion, related observations and sketches often appear alongside on the same page. Thus, notes on the mechanical theory of percussion might appear side by side with comments on ballistics and optics and observations on hydrology with remarks concerning the flow of eddies or the anatomy of the nervous system. On other occasions, the notes might be totally unrelated to one another. Among the latter type of manuscript is the Paris Manuscript C (1490), which deals with the theory of shadows, optics, perspective, and hydrology. The second part of the Forster Bequest Manuscript II (1495) is concerned with movement and weight; and the first part of the Forster Bequest Manuscript I (1505), with plane and solid geometry. Among the subjects discussed in the Leicester Manuscript (dating from the second period in Florence) are hydrology, flight, geology, and fossils. The Codice *On the Flight of Birds* is self-explanatory and was originally linked with Manuscript B, in which there are miscellaneous pages dealing with war machines and

LADY WITH AN ERMINE
Oil on wood panel; $21\frac{1}{4} \times 15\frac{1}{2}$ in
(54×39 cm)
Cracow, National Museum
This portrait has been identified, being so attested by a number of contemporary sources, as that of Cecilia Gallerani, mistress of Ludovico the Moor. The painting was acquired by Prince Adam Czartoryski towards the end of the eighteenth century for his wife's art collection in Pulany Castle. It was later taken to Paris and was finally returned to Cracow between 1870 and 1875. At first attributed to Leonardo in 1889, this judgement has now been almost unanimously accepted.

architecture (although these stem from about twenty years earlier). The Anatomy Manuscripts at Windsor are also a self-contained entity. The Madrid Manuscript I is of the homogeneous type, comprising two series of booklets, each containing ninety-six pages (although there are eight pages missing from the first set). The first series is devoted to applied mechanics and various kinds of machines; and the second, to mechanical theory. These date from 1493 and 1497.

The Madrid Manuscript II is typical of the first type of manuscript. The first 140 pages consist of relief maps and sketches of the valley of the Arno from Florence to the sea (1503–1504); studies and calculations for the fortifications of Piombino, with

Leonardo or school (Boltraffio?)
PORTRAIT OF A MUSICIAN
Oil on wood panel; $17 \times 12\frac{1}{4}$ in
(43×31 cm)
About 1490
Milan, Ambrosian Gallery
This was described in the Ambrosian catalogue of 1686 as "a half portrait of the Duke of Milan in a red cap, executed by B. Luini," subsequently corrected to "Leonardo." In the 1798 catalogue mention is made of the "school of Luini" but in the nineteenth century the obvious similarity of the picture to the *Portrait of a Lady with a Pearl Hairnet* led critics to ascribe both panels to Leonardo, the sitters assumed to be Ludovico the Moor and Beatrice d'Este respectively. In 1904 the commission responsible for re-organizing the Ambrosian Gallery removed the repainted parts of the lower section of the picture and brought to light the hand holding a sheet of music. Attribution is today controversial. The panel is in a fine state of preservation.

transcriptions from Francesco di Giorgio Martini (end of 1504); investigations into hydrology and aerology (done at sea); observations on geometry, with transcriptions from Luca Pacioli and the vernacular version of Euclid; and studies on the flight of birds, extracts of which were subsequently transcribed by Leonardo's pupil and heir Francesco Melzi for the compilation of *The Treatise on Painting*. There are also various personal notes, such as the record of the great storm that erupted on June 6, 1505, while Leonardo was working on *The Battle of Anghiari*; the claim to have discovered a method of squaring the circle on the night of San Andrea in 1504; and the precious list of books left in Florence on his departure for Piombino. The last seventeen pages, not all of the same format, contain writings and drawings, dating

from 1491 and 1493, done partly in ink and partly in red chalk. These notes and sketches were subsequently linked, by Leoni, to others of a similar date that are part of a larger series. All are devoted to the casting of the Sforza monument.

I have analyzed the Madrid Manuscript II in order to show a typical example of Leonardo's method of collating information in notebooks and also to give some idea of the difficulties experts have faced in sorting out manuscript material as Leonardo had left it. Thus, the pages of the Madrid Manuscript I are numbered in his own handwriting, as perhaps are the first 140 miscellaneous pages of the Madrid

Leonardo (?)
HEAD OF A GIRL
Rough sketch on wood panel in umber on white lead preparation; $10\frac{5}{8} \times 8\frac{1}{4}$ in $(27 \times 21$ cm$)$
Parma, National Gallery
This work, fairly well preserved, belonged to the collection of the Parma painter Callani, from whose son the city gallery acquired it in 1839. Ricci considered it to be a skilful eighteenth-century imitation, possibly by Callani himself, whereas Aldolfo Venturi positively attributed it to Leonardo.

Manuscript II. These may be regarded as having been virtually untouched. But others have been partially rearranged, as in the case of the last seventeen pages of the Madrid Manuscript II. A clue to Leonardo's intentions is to be found in a note written on the first right-hand page of the Arundel Manuscript: "Begun in Florence in the house of Piero di Braccio Martelli today 22 March 1508. This is a collection without order, made up of many sheets, which I have copied here, hoping afterward to arrange them in order in their proper places, according to the subjects of which they treat."

The first mention of the manuscripts comes from Leonardo himself or from people closely associated with him. In 1498, Father Luca Pacioli explicitly mentions a "book of pictures and human movements," already completed, and a work of "local movement," almost finished. In the aforementioned list of books left in Florence in 1504, Leonardo refers to a "book of horse sketches for cartoons" (perhaps early

studies for the Sforza statue or for *The Battle of Anghiari*). He also mentions a "book of my words," which may be an allusion to the pages (from around 1490) in the Trivulzio Manuscript that contains lists of vernacular terms (some with definitions) or to certain pages of Manuscript I (Institut de France), dating approximately from 1497–99, that includes conjugations of Latin verbs. More important is his unheaded list of fifty books, subdivided according to size (including twenty-five "small," two "larger," and twenty-five "very large"). This may indicate the existence of his manuscripts at that date, in addition to the two explicitly mentioned.

Francesco Melzi inherited all the manuscripts in Leonardo's possession at his death and kept them in his villa at Vaprio. From some of these came the extracts that an amanuensis made up into the Codex Vaticanus (Urbinas) 1270, known as *Leonardo's Treatise on Painting*, at the end of which are enumerated the eighteen manuscripts each with a mark, used for the compilation. Of these, seven, including the Madrid Manuscript II, are identifiable. This constitutes less than half. The last owner of a large collection of Leonardo's manuscripts, Pompeo Leoni, endeavored to number them in order and to mark them alphabetically with single and then double letters. Today, there are nineteen codices bearing these characteristic numbers and letters. The highest number is forty-six, and the highest letter is SS; but this, of course, does not necessarily mean that they ended at this point. If we compare the number of surviving manuscripts with the list supposedly prepared by Leonardo (remembering that this was in 1504, fifteen years before his death), together with those used by Melzi for his compilation and those numbered and lettered by Leoni, then the conclusion must be that at least two-thirds have been lost, even allowing for the recent discovery of the Madrid Manuscripts I and II.

After Leonardo's death at Amboise, the manuscripts were inherited by Francesco Melzi. It cannot be taken for granted that this was a complete collection. Dürer, for example, certainly knew of and possibly owned some loose sheets and booklets by Leonardo; and Cellini referred to a treatise on perspective in his possession. In any event, Melzi took great care of them, which cannot, unfortunately, be said of his son Orazio, who, after his father's death around 1570, began dispersing them among the members of the Mazenta family. The bulk of the manuscripts (except, for example, the present Paris Manuscript C, which remained in the possession of Cardinal Federico Borromeo, who later handed it over to the Ambrosian Library), together with a large number of loose pages, were recovered, by Pompeo Leoni, who took them to Spain. What happened to them after that is only partially known. The so-called Madrid Manuscripts I and II obviously remained there and, at the beginning of the eighteenth century, were in the library of Philip V. The collection of Leonardo's manuscripts owned by Thomas Howard, duke of Arundel, came wholly or partly from Spain during the first half of the seventeenth century. Some of them later found their way into the English royal collections; but exactly when this happened is not known, for they were only rediscovered in the latter half of the eighteenth century. These 779 sheets, found in a chest in the Royal Palace at Kensington, were reduced to 600 and are now at Windsor. Others went to make up the existing Arundel Manuscript, which was acquired, in 1831, by the British Museum and is presently in their custody.

In Spain, Pompeo Leoni's collection eventually came into the hands of Juan de Espina. Most of the sheets were returned to Milan in 1604. Some were acquired by Count Galeazzo Arconati, who, in 1636, presented them to the Ambrosian Library, which already owned Manuscript C. At this point, there were ten codices, in addition to the Codice Atlantico. Arconati later presented the library with Manuscript D but retained the Trivulzio manuscript, which passed into the keeping of Count Trivulzio in 1770. In the twentieth century, the Trivulzio Manuscript, along with the entire library, came into the possession of the city of Milan. In 1671, Codice K was donated to the Ambrosian Library by Orazio Archinte. The rich heritage of the Ambrosian Library was plundered by Napoleon's henchmen in 1796. Only the Codice Atlantico was returned; the other twelve manuscripts remained in Paris. During the nineteenth century, Count Guglielmo Libri stole Manuscripts A and B from the Institut de France, but these were duly recovered. The booklet dealing with the *Flight of Birds* found its way, by various routes, into the hands of Theodor

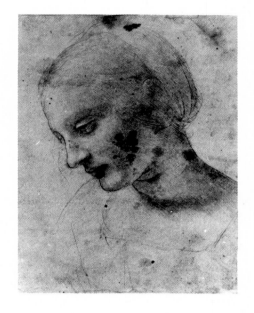

STUDY OF A FEMALE HEAD
Silverpoint drawing on green prepared paper; $7\frac{1}{8} \times 6\frac{5}{8}$ in
$(18.1 \times 16.8$ cm)
Paris, Louvre, Drawings Room
(Inv. no. 2376).

School of Leonardo
VIRGIN AND CHILD
(LITTA MADONNA)
Tempera on wood panel transferred to canvas; $16\frac{1}{2} \times 13$ in $(42 \times 33$ cm)
Leningrad, Hermitage
Owned by the Visconti, it was inherited by the Litta family of Milan; in 1865 it was acquired by Tsar Alexander II for the Hermitage.

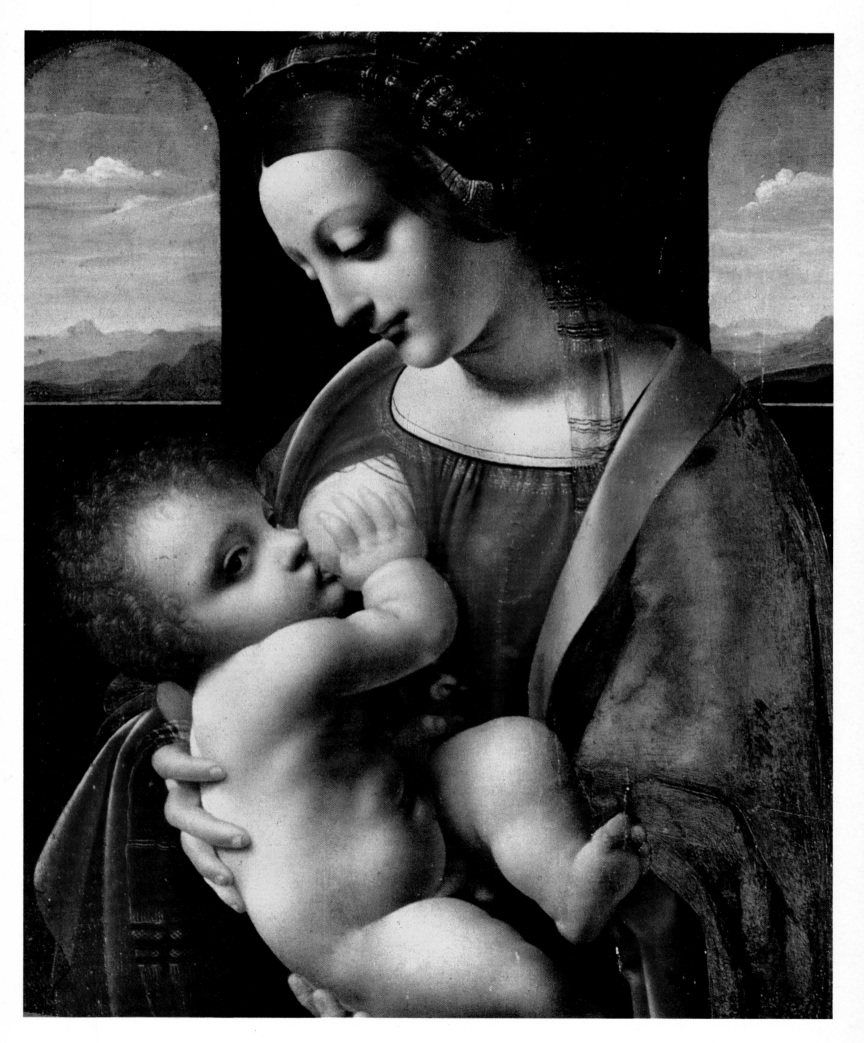

Sabachnikoff, who presented it to Queen Margherita. It is now in the Royal Library, Turin.

As for the other English manuscripts, the Forster Bequest Manuscript was donated in 1876 to the Victoria and Albert Museum, Kensington, by John Forster, who had acquired it from Lord Lytton, who obtained it in Vienna. The Leicester Manuscript belonged to the painter Giuseppe Chezzi and was purchased in Rome during the early part of the eighteenth century by Thomas Coke, then Lord Leicester.

Finally, there was a rich collection of Leonardo drawings owned by Venanzio de Pagave in the second half of the eighteenth century. These subsequently came into the possession of the painter and secretary of the Accademia of Brera, Giuseppe Bossi, who was an expert on Leonardo. The collection eventually found their way to the Accademia in Venice.

The Codice Atlantico

The drawings collected by Pompeo Leoni in the Codice Atlantico cover almost the entire creative gamut of Leonardo's life – from the years just prior to his departure for Milan up to his final sojourn in France at the court of Francis I. Perhaps the most famous drawings are those of weapons, projectiles, war machines, spinning machinery, and various devices designed to replace or complete manual labor. Of more practical importance than the so-called mechanical inventions (which, being more spectacular are better known to the layman) are the descriptions and drawings of mechanisms and machine tools, together with theoretical and experimental observations on such topics as power, movement, weight, and percussion. "Violence consists of four things, namely weight, force, impetus, and percussion." (Codice Atlantico, 1492). "Force and gravity together with material movement and percussion are the four accidental powers by which the human race . . . seems to reveal itself as a second nature in this world; seeing that by the use of such powers all the visible works of mortals have their existence and their death." (Arundel Manuscript). It is worth stressing this second proposition, which shows how Leonardo habitually shied away from abstractions, always keeping in mind the "works of mortals" Specifically, this is pointed out by his belief in the close association between theoretical and applied mechanics.

A large number of the drawings in the Codice Atlantico, as well as related figures in the Windsor Manuscripts, date from the first period in Milan under the patronage of Ludovico the Moor, this is indicated by the style of the explanatory notes alongside them, and by similar drawings (the oldest of all, prior to 1400) contained in the Paris Manuscript B and in the first part (those dating from 1493–97) of the Madrid Manuscript I. They also coincide with the various activities that Leonardo mentioned in his letter to Ludovico.

In the years leading up to World War II, when Italy was swept by a wave of nationalistic fervor and war hysteria, it was fashionable to emphasize Leonardo's role as a prophetic, precursory genius. The interest aroused by the Milan Exhibition of 1939 was concentrated largely on the scale models derived from Leonardo's drawings. Obviously, when Leonardo outlined his ideas for ingenious devices and assault vehicles that might give their possessor a tactical advantage in any local war, he never envisaged the lethal effects they would one day have when mass-produced. But his "anticipations" of the submarine and the armored car, the diving suit and the parachute, the helicopter and the glider, the grenade and the machine gun, understandably fascinated a public that had readily believed the rumor that Guglielmo Marconi had invented a "death ray." The models suggested that Leonardo's propositions might have been technically workable; but they totally obscured the purely conceptual significance of the "inventions" in relation to the

Ambrogio de Predis (?)
PORTRAIT OF A WOMAN WITH A PEARL HAIRNET (BEATRICE D'ESTE)
Oil on wood panel; $20 \times 13\frac{3}{8}$ in (51×34 cm)
Milan, Ambrosian Gallery
Mentioned in the bequest of Federico Borromeo (1618) to the Milan Academy – constituting the nucleus of the present-day Ambrosian Gallery – as a portrait of "the Duchess of Milan, from the waist up, executed by Leonardo." Brought as such to Paris in 1796, the portrait was identified as that of Beatrice d'Este. When returned to Milan, the picture was coupled with the presumed portrait of Ludovico Sforza, later recognized as *Portrait of a Musician.*

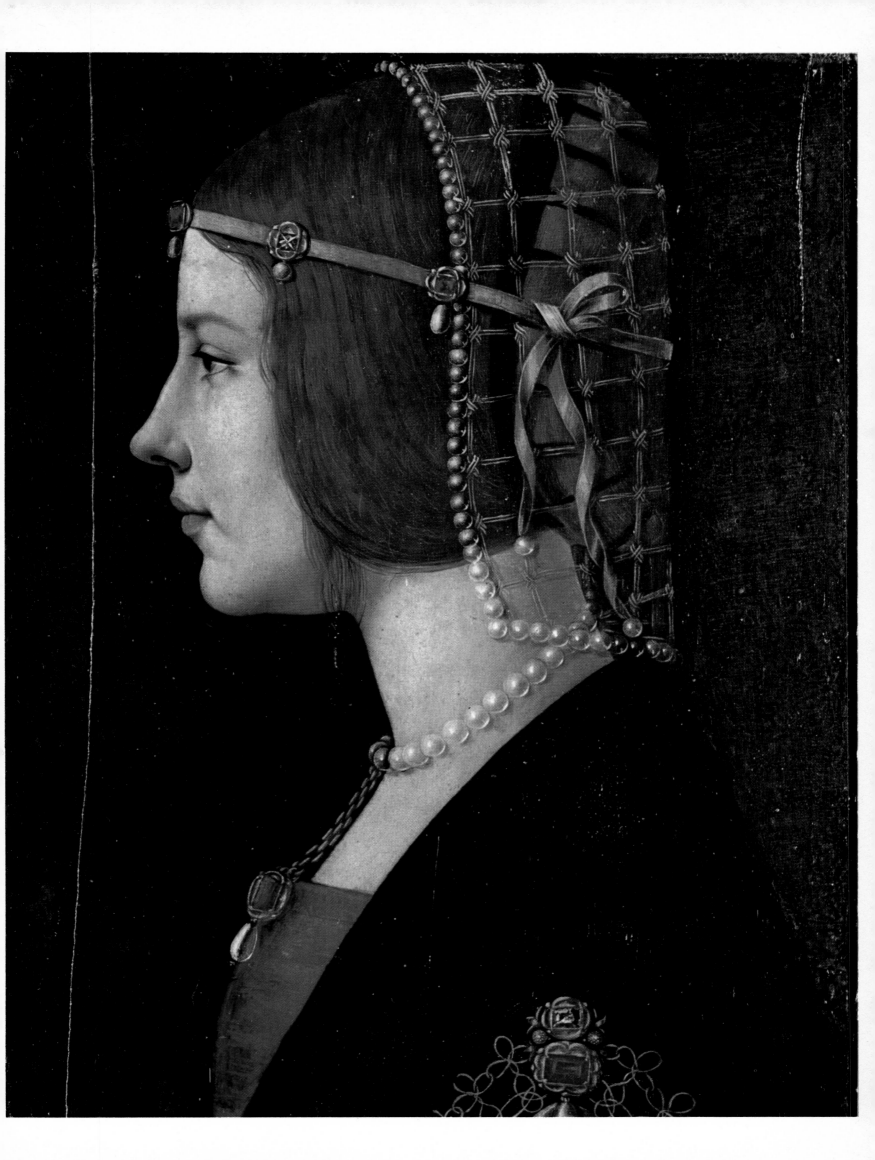

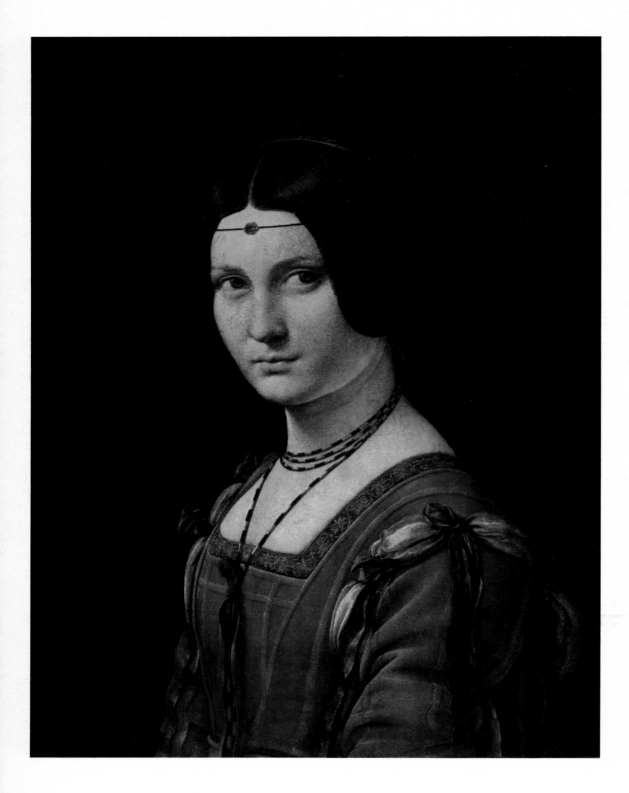

scientific knowledge and technological achievement of Leonardo's age.

Hindsight has indeed shown that numerous inventive features of Leonardo's drawings heralded "things to come"; but the main impression is one of seemingly unlimited flights of imagination and intellect. Leonardo had no thoughts of posterity; he was anxious, above all, to astonish and gratify Il Moro, his future patron, and to prove that the projects mentioned in his letter were not just empty boasts. On a less lofty plane, it was very much the same kind of impulse that led him to invent mechanical "toys" for courtly entertainments, including musical devices, which were, in a more literal sense, precursors of those "automata" that became so typical of sixteenth-century mannerism.

As already pointed out, Freud detected emotional inhibition as the root cause of Leonardo's relentless search for knowledge; and it is entirely consistent with Leonardo's stated views and known temperament that the marvelous, scrupulously

detailed designs of war machines, especially of artillery, were motivated by this perpetually nagging need for investigation and discovery. He himself recoiled from violence and cruelty and, undoubtedly, had no thoughts of the damage and suffering that might result from the practical application of his machines. He shared the general feeling of the age that war was an "art" – the proper pursuit of the mercenaries who formed the core of what were the first real professional armies. It was characteristic of the man that he should have regarded a weapon, above all else, as a reinforcement of a soldier's physical strength and power. He could, at the same time and in a completely detached manner, view a firearm as the most practical means of verifying his theories on ballistics.

In the fields of mechanics and engineering, Leonardo's principal contribution as a genuine innovator was to continually test theories by experimentation and to indicate the ways in which such verified theories could be put to everyday use. This is evident from many of the codices and, particularly, from the recently rediscovered Madrid Manuscript I, which is a veritable tract on applied mechanics. His methods far outstripped the traditional practices of contemporary experts such as Francesco di Giorgio Martini and Giuliano da Sangallo, men who jealously guarded their "secrets" for constructing models of machines designed for specific purposes. As attested by the mechanical drawings on the page dated 1478, Leonardo was already examining such problems in Florence. He was correlating theories of force and movement with the workings of basic mechanical devices that were adapted for use in all types of machines. The founder of the modern theory of mechanics in the second half of the nineteenth century, the German Franz Reuleaux, affirmed that only in 1724 had Jacob Leupold made a valid distinction

STUDY FOR THE SFORZA MONUMENT
Charcoal and pen drawing on pinkish paper; $8\frac{13}{16} \times 6\frac{5}{16}$ in (22.4 × 16 cm)
Windsor, Royal Library
(Inv. no. 12360)
This is assumed to be one of the first ideas for the equestrian monument to Francesco Sforza, with a rearing horse.

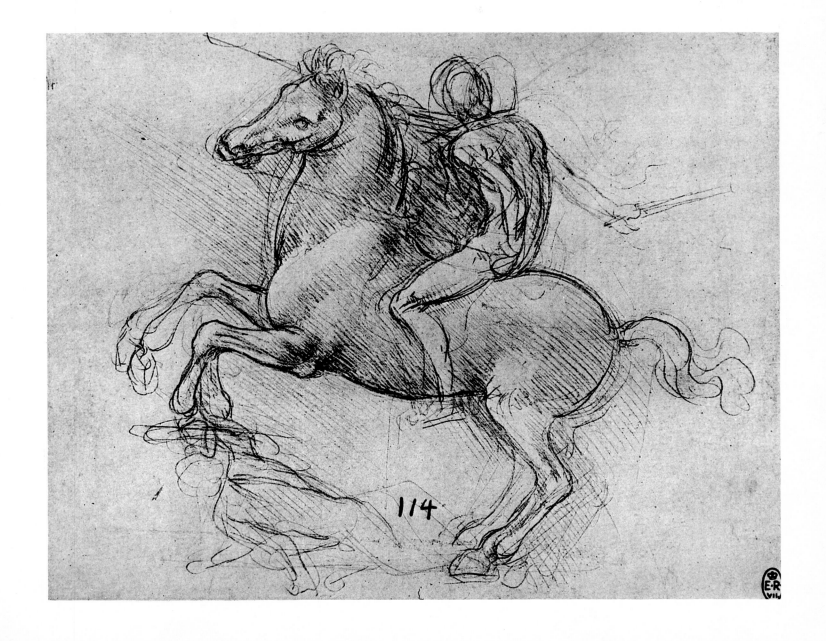

between mechanical parts and specific machines. Yet, leading authorities on this aspect of Leonardo's work, Arturo Uccelli and Ladislao Reti, have shown most convincingly that more than two centuries earlier, Leonardo had explained and clarified the difference between "mechanical elements," individually described, and "machines."

One page in the Madrid Manuscript I (linked with one in the Codice Atlantico) is most illuminating in this respect: "We shall discuss here the nature of the screw and of its lever and how it (the screw) shall be used for lifting rather than for thrusting and how it has more power when it is simple and not double, and thin rather than thick, when moved by a lever of the same length and force. We shall briefly discuss the many ways there are to use screws, the various types of endless screws, and the many motions that are performed without screws but which serve the same purpose; how the endless screw shall be combined with toothed wheels and how to use many screws together. We shall examine the nature of their nuts and if they are more useful having many threads or less. We shall also speak of inverted screws that by a single motion thrust and pull a weight, and screws that, by turning them only once, will rotate the nuts more than once. And, likewise, we shall discuss a great many of their effects and the variety of their labors and strengths and slowness and swiftness. Account too will be given of their nature and their uses, their composition, levers, and utility. Their method of construction will also be discussed, how to put them to work, and how some people were deceived because they ignored the true nature of the screw. All such instruments will generally be presented without their armatures or other structures that might hinder the view of those who will study them. These same armatures shall then be described with the aid of lines, after which we shall discuss the levers by themselves, the strength of supports, and their durability and upkeep. We shall also deal with the differences existing between a lever operating with constant force, that is the wheel, and the lever of unequal power, that is the straight beam, and why the former is better than the latter, more compact and convenient than the former. We shall also discuss the ratchet wheel and its pawl, the flywheel and the impetus of its motion, the axles and their wear; ropes and pulleys, capstans and rollers, will also be described."

Ladislao Reti has found that of the twenty-two basic lists of mechanical appliances mentioned by Reuleux, some twenty are actually described and drawn in the Madrid Manuscript I. They include screws, taps, bearings, hinges, joints, axles, cables, belts, chains, levers, connecting rods, wheels, various types of gear, valves, tubes, springs, cams, and pulleys. In addition, there are pump cylinders and pistons in the Codice Atlantico. In this respect alone, Leonardo may be regarded as a pioneer of mechanical science and technology, anticipating by more than two

STUDY FOR THE MOLD OF THE SFORZA HORSE IN THE CASTING PIT
Pen drawing on white paper;
$8\frac{7}{16} \times 5\frac{3}{4}$ in (21.4 × 14.6 cm)
1493–4
Madrid, National Library
This study, relating to the casting of the Sforza equestrian statue, shows the position of the mold, flanked by several furnaces. The molten bronze is poured into the channels between the furnaces and the mold.

PROFILE OF A HORSE WITH INDICATIONS OF MEASUREMENT
Silverpoint drawing on blue prepared paper; $12\frac{3}{4} \times 9\frac{5}{16}$ in (32.4 × 23.7 cm)
Windsor, Royal Library
(Inv. no. 12319, detail of lower part of page)
The line of writing parallel to the sketch of the horse reads: "big jennet of Messer Galeazo." The reference is to Galeazzo Sanseverino, captain in the service of the Moor.

HOLLOW MOLD FOR THE HEAD OF THE SFORZA HORSE
Red chalk drawing; $8\frac{7}{16} \times 5\frac{3}{4}$ in
(21.4 × 14.6 cm)
Madrid, National Library
(Madrid MS II, p. 157 *recto*)
This is one of seventeen pages in the manuscript devoted to the casting of the horse. The mold comprises two pieces, held together by iron bands.

centuries the Age of Enlightenment, which, in turn heralded the Industrial Revolution (although admittedly his conception of "motive force" tended – and all the more as his career progressed – to be confined to the sphere of metaphysics and cosmology). The quoted page from the Madrid Manuscript I is significant in showing how clearly he saw the relationship between mechanical theory and mechanical contrivances and machines. What was even more revolutionary were his ideas as to how machine tools should be used for making actual machines – "in what way one should do this." In the Madrid Manuscript I, in the Codice Atlantico, and in the Paris Manuscript B, there are references to machines for drilling, threading, wiredrawing, and making sheet metal.

A final point worth emphasizing is the concise precision of Leonardo's written instructions and the clarity of the accompanying figures of appliances and machines. The drawings are given a three-dimensional appearance by means of parallel lines of shading, which make them far more real and vivid than similar contemporary diagrams, such as those of Giuliano da Sangallo. The underlying intention, whether in the written description or the illustration, is always to provide the clearest and most accurate explanation of the functions and workings of the appliances and machines. This is the reasoning behind the decision to show them, where possible, "without their armatures or other structures that might hinder the view." Also, this is why, in many cases, Leonardo makes use of methods associated with architectural design, such as his showing of ground plans, elevations, and bird's-eye views.

Architecture is another area of activity (likewise envisaged in the same letter to Ludovico) in which Leonardo soon busied himself after the move to Milan. For the time being, he devoted his time to military architecture, occupying himself with plans for the fortifications of Pavia, Vigevano (Il Moro's favorite residence), and Milan. The experience proved to be worthwhile in later years, namely, in 1502–1503, when he became military engineer and cartographer to Cesare Borgia (Il Valentino) and at the end of 1504, when he was "borrowed" from the Florentine Republic by Jacopo IV Appiani, governor of Piombino. For evidence of Leonardo's architectural work during the first period in Lombardy, we have four reference sources – a number of dated documents; many pages in Manuscript B, with related pages in the Codice Atlantico; Heydenreich's theory concerning the preparation of a treatise on architecture; and Leonardo's known connections with Bramante.

Turning first to the documents, there are records from the period of 1487–90 of payments made to Leonardo for designing a wooden model for the construction of the *tiburio* (central cupola) of Milan Cathedral, a model realized by Bernardino Maggi di Abbiategrasso. Then, in June 1490, he was in Pavia, together with the architect and military engineer Francesco di Giorgio Martini, by permission of Il Moro. He was there on the invitation of the city authorities, who wanted his advice on problems related to the building of a new cathedral. There is no firm evidence that Leonardo's ideas for Pavia Cathedral were ever followed. The building was substantially based on Cristoforo Rocchi's wooden model, which has survived to this day and had certainly existed in 1490. A few structural simplifications not seen in the model have been attributed to Bramante, who had been involved with the project two years earlier.

Regarding the Milan Cathedral, Manuscript B and the Codice Atlantico contain drawings of arches and vaults that are clearly related to the *tiburio* project. It is clear from the drawings that Leonardo contemplated transforming the traditional Lombard-Gothic polygonal *tiburio* into a double-calotte cupola in the style of Brunelleschi but with a vertical emphasis, evidently taking into account the already existing shape and structure of the cathedral's apse and presbytery. It may be that it was this deliberate break with local tradition that led the Tuscan-born Leonardo, in 1490, to withdraw his model on the pretext of it needing alterations. Soon afterward, he received his fee from the cathedral authorities, and a month later the ducal secretary informed the city fathers of Pavia that Leonardo was free of any obligations.

It is characteristic of the way in which Leonardo's ideas proliferated that the specific assignment for the *tiburio* led him to branch out unexpectedly into a series of studies on statics, especially relating to the weight, strengths, and weaknesses of

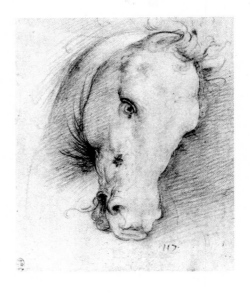

SKETCH OF A HORSE'S HEAD
Red chalk drawing, heightened with white; on red paper; $6\frac{1}{2} \times 5\frac{5}{8}$ in (16.5 × 14.2 cm)
Windsor, Royal Library
(Inv. no. 057).

ANATOMICAL STUDY OF A HORSE
Silverpoint drawing on blue paper; $8\frac{7}{16} \times 6\frac{5}{16}$ in (21.4 × 16 cm)
Windsor, Royal Library
(Inv. no. 12321).

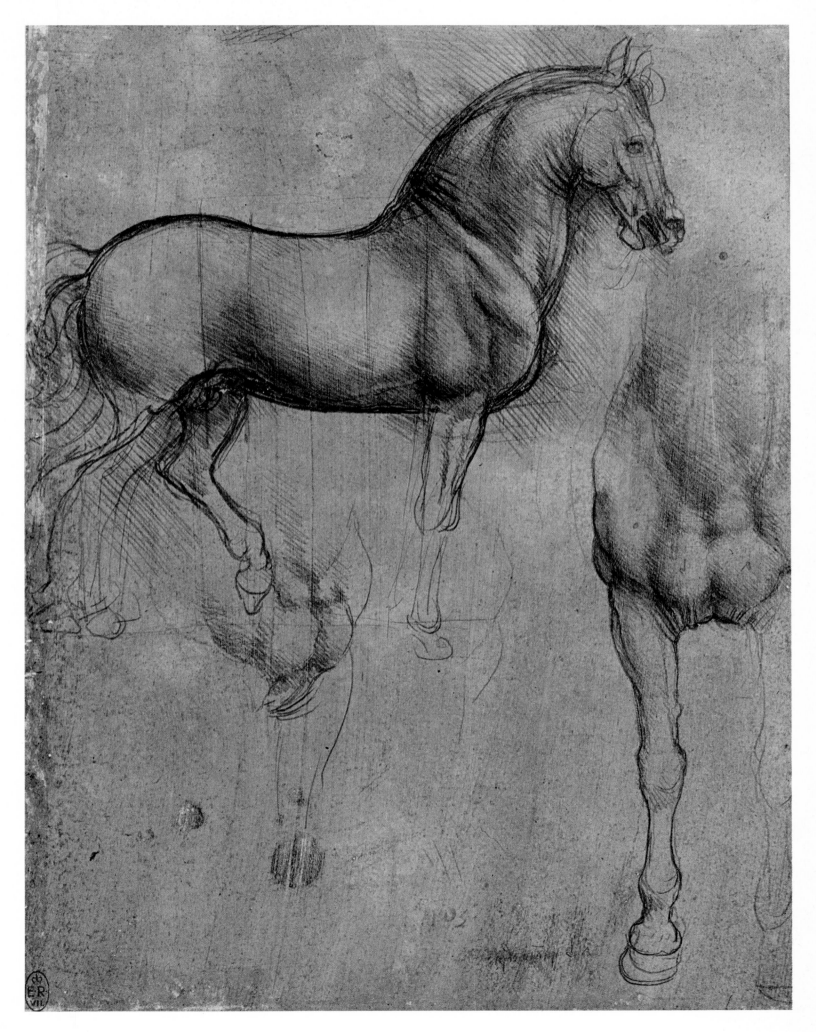

arches. He continued his efforts in this area beyond 1490. In addition to references in Manuscript B and the Codice Atlantico, ideas on this subject are found in Manuscript A (1492), in the second part of Forster Bequest Manuscript II (1495), and in Madrid Manuscript I (1493–97). There is a marvelous definition in Manuscript A, under the heading "What is an arch?" that reads: "An arch is nothing other than the strength caused by two weaknesses; for the arch in buildings is made up of two segments of a circle, and each of these segments, being in itself very weak, desires to fall, and as the one withstands the downfall of the other, the two weaknesses are converted into a single strength." On the same page, Leonardo takes into account both vertical thrusts ("The arch will break in that part which passes through the middle below the center") and horizontal thrusts ("The arch will be the weaker for being suspended sideways, with the result that when the weight is not bearing down on the feet of the arch, the arch will not last long"). Leonardo's preoccupation with vertical thrusts on the center of gravity is probably due to his faith (typical of a Tuscan-trained architect and engineer) in the system of chains as anchors against horizontal thrusts. This method was introduced by Tuscan architects.

These studies of statics as applied to the science of building, possibly originating with the *tiburio* project but extending far beyond it, are linked with one of the most significant series of written observations and drawings in Manuscript B. This material had given rise to Heydenreich's theory concerning a projected treatise on architecture, the second part of which was to contain two chapters devoted to the causes of collapse in buildings and the nature of the arch. The first part of the treatise was to deal with the typology of sacred and secular buildings and with architectural proportions. This hypothesis has been accepted by many modern architectural historians and critics. Such a treatise would have been profoundly original in two respects, both of which are strongly suggested in the pages of Manuscript B. The work itself would have been unlike any other produced in the fifteenth century; instead, it is more like those published in the sixteenth century, ranging from Serlio to Palladio and Scamozzi. In its allegiance to central-plan building, it would have focused on the fundamental feature of the "new architecture" of the High Renaissance that was introduced by the architect of St Peter's, Bramante.

There are several fifteenth-century works that may have influenced Leonardo, assuming he was familiar with them. *De re aedificatoria*, written in Latin by Leon Battista Alberti and modeled on Vitruvius, was a typically humanist production and not likely to have interested him. On the other hand, Filarete's *Trattato d'architettura*, although inspired by Alberti, might have been in accord with his taste. This work took an empirical approach, contained graphic representations of building models and projects for town planning (albeit Utopian), and emphasized the practical need for a commissioning patron (in Filarete's case, Francesco Sforza, father of Il Moro). Whether Leonardo ever looked as it we do not know. It is, however, a certainty that the first manuscript verion of Francesco di Giorgio Martini's *Trattato di architettura civile e militare* did find its way into Leonardo's hands, for this version (the Codice Ashburnham 361 in the Laurentian Library, Florence) contains marginal notes by Leonardo himself. The treatise is divided into seven books, the principal one being the fifth volume on military architecture, which Leonardo partially transcribed into the Madrid Manuscript II. The drawings that appear in the margins of the pages are completely covered in writing.

What was genuinely novel in Leonardo's approach to the subject was his insistence that the drawing or diagram take absolute precedence over the written description, the latter invariably being instructive in character. In conception and design, Leonardo's notes on architecture look forward to sixteenth-century treatises on the subject. These later works, nevertheless, are still modeled on Vitruvius, whereas Leonardo, judging by the material that has survived, seems not to have followed the author of *De architectura*. This was not because of unfamiliarity, for Vitruvius appears in Leonardo's later lists of books, notably in Manuscript F (1508) and in the third part of Manuscript K (1509–1512).

Regarding his plans for buildings, Leonardo presents the reader with a series of "hypotheses," rather than projects. The structures are generally shown from above

STUDY FOR THE REAR PART OF A HORSE
Red chalk drawing on whitish paper; $8\frac{3}{8} \times 6\frac{1}{8}$ in (21.2 × 15.5 cm)
Windsor, Royal Library
(Inv. no. 12333).

STUDY FOR THE CASTING OF THE SFORZA MONUMENT
Red chalk drawing on white paper; $8\frac{7}{16} \times 5\frac{3}{4}$ in (21.4 × 14.6 cm)
Madrid, National Library
(Madrid MS II, p. 154 *recto*)
This drawing appertains to the transport of the mold to the casting pit. Below it is a note in which Leonardo describes the method he intends to use for lowering the mold into the pit.

STUDY FOR THE CASTING OF THE SFORZA MONUMENT
Red chalk drawing; $9\frac{5}{8} \times 6\frac{5}{8}$ in (24.5 × 16.9 cm)
Milan, Ambrosian Library
(Codice Atlantico, p. 216 *verso*-a).

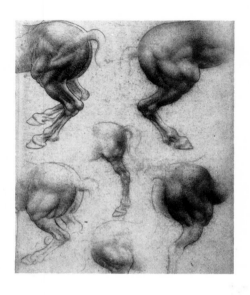

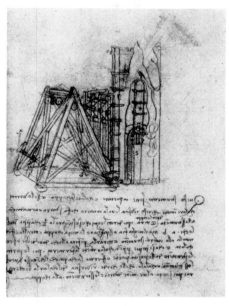

or in cross section and are placed alongside the relevant ground plan, the main features of which are rapidly sketched in. As in his drawings of machines, Leonardo was not greatly concerned with providing detailed and precise representations of buildings. Rather, he regarded the illustrations as "instructional" models. As Heydenreich points out: "They (the drawings) demonstrate for the first time the basic forms of architectural representation employed during the Renaissance. This includes the exploration of perspective representation of exterior and interior as well as the fully developed cross section. The use of central perspective as a means of visualizing an architectural composition was perfected by Leonardo to the point of competing with a three-dimensional model."

In his designs for churches, Leonardo generally took as his model the central-plan type of building, the nucleus being polygonal, cube-shaped with rounded corners, or sometimes cylindrical. Alternatively, the perimeter is cube-shaped. The structure is usually covered by a dome, rarely by a *tiburio*. Around the central area are grouped sections of smaller dimension. These are placed either in a somewhat random but compact, unified pattern, in diminishing size from center to periphery, or on a more complex and symmetrical plan, in accordance with "major" and "minor" rhythms. The drawings seem to sum up Leonardo's basic conceptions of architectonic composition, firmly based on the validity of central planning.

Modern historians have rightly seen the early sixteenth-century central-plan building as the culminating achievement of Italian Renaissance architecture. It represents the full flowering of the seed first planted by Brunelleschi in Florence during the early part of the fifteenth century. This building plan is epitomized in Bramante's chapel of San Pietro in Montorio, in Rome, and in his plan for rebuilding St. Peter's. The pioneering work for this architectural style had been done in Florence during the 1430s and 1440s. The Camaldolese church of Santa Maria degli Angeli, which Brunelleschi did not complete, was the first central-plan church to be built. The inside of the church was octagonal; the outside, sixteen-sided. The other important building was the tribune of Santissima Annunziata by Michelozzo di Bartolomeo. This addition to the church was intended to be a memorial chapel to the Gonzagas. The plans of these churches, with side chapels extending from the center, are echoed in more than one of Leonardo's models. When Leonardo was ten years old, Alberti had built San Sebastiano in Mantua and finished Michelozzo's tribune in S.S. Annunziata for the same patron who had commissioned Michelozzo – Ludovico Gonzaga. This was of a different type – polygonal in design – but certainly Leonardo was familiar with it.

An event of key significance was the meeting in Milan of Leonardo and Bramante. It is a fruitless exercise to speculate about the degree of influence the one had on the other. It is sufficient to view their meeting as a mutually beneficial encounter between two gifted men of different talents and temperaments. Leonardo was the "original" thinker, a man who theorized on architectonic forms and on practical matters of balances, weights, and stresses in building. Bramante, six years older than Leonardo, had been a painter, but his architectural career in Milan (1480–99), influenced to a great extent by Alberti during his early years in Urbino, established his reputation as a worthy successor to Brunelleschi. It is impossible to say which one of the men first made a profound study of that masterpiece of late classicism, San Lorenzo in Milan, to which there are references by Leonardo in the Codice Atlantico. Certainly Bramante, in his additions to Santa Maria delle Grazie, played down the existing longitudinal plan of the church by placing the raised tribune triumphantly in a central position. Leonardo, on the other hand, in the models that he based on longitudinal planning, anticipated the proposals made by Raphael and Antonio da Sangallo the Younger for modifying Bramante's design for St Peter's. They were in favor of adhering to the early Christian longitudinal plan of the original St. Peter's. In the event, Bramante's central-plan design was to culminate in the immense dome subsequently built by Michelangelo.

What Leonardo and Bramante certainly shared was a symbolic conception of the "temple" as a place of worship, conjuring up a Utopian vision of a building that is a compromise between classicism and Christianity and paying no heed whatsoever to the rising tide of the Reformation. In this respect, Leonardo was, as Vasari claimed, more of a philosopher than a Christian. The models that he prepared of covered

RULE FOR THE PROPORTIONS
OF THE HUMAN FIGURE,
ACCORDING TO VITRUVIUS
Pen drawing; $13\frac{1}{2} \times 9\frac{5}{8}$ in
(34.4×24.5 cm)
Venice, Academy.

STUDY OF SKULLS
Pen drawing; $7\frac{1}{2} \times 5\frac{1}{4}$ in (19×13.3 cm)
1489
Windsor, Royal Library
(Inv. no. 19057 *verso*).

STUDY OF SKULLS
Pen drawing; $7\frac{1}{2} \times 5\frac{1}{4}$ in (19×13.3 cm)
1489
Windsor, Royal Library
(Inv. no. 19057 *recto*).

amphitheater-temples, so-called places for preaching, undoubtedly placed him beyond the pale of orthodoxy. In a sense, he anticipated by a couple of centuries the revolutionary Utopias presided over by "goddess reason." There remain a few really enigmatic points, as, for example, the analogy between certain drawings in Manuscript B and the completed Cathedral of Sibenik in Yugoslavia that was built in the second half of the fifteenth century by Juraj Dalmatinac (Giorgio Orsini Dalmata) and Niccolo da Firenze. Then, too, in some of Leonardo's models, the central area is crowned by a ring of small domes (indicating the radial arrangement of the chapels inside the church); and the inclusion of apses, untypically Florentine, suggests late Byzantine and Venetian influences.

In one sphere of architecture, however, Leonardo parts company with Bramante and displays complete individuality and originality. This departure comes in town planning, or, to be more precise, envisaging the growth of towns in relation to environment, population, and political importance. In the fifteenth century and in the first half of the sixteenth century, a number of proposals (most of them Utopian fantasies) were made for building "ideal cities," including Filarete's model city, the Sforzinda, planned for the father of Ludovico the Moor's, Piero de' Medici. They tended to be little more than symmetrical, geometric patterns of projected towns. The plans were often drawn in perspective but without any consideration of variables arising from geological and environmental realities. The towns might differ in detail but all were conceived with the vague conception that they would cater to a harmoniously balanced, Utopian society. The only example of a practical town project was Biagio Rossetti's plan for Ferrara that was commissioned by Duke Ercole d'Este I. For this project, provision was made for prospective "lots," with churches and palaces marked as indications of the projected regular pattern of streets and buildings.

Leonardo's approach to the subject was predictably different from the traditional treatments of the problem. His thoughts concerning town planning are contained in a number of pages (written, for the most part) in Manuscript B and, particularly, in one page from the Codice Atlantico that is a kind of letter to Ludovico. Here there is no idealized geometrical plan, no theorizing, but simply a concrete proposal for building a town on a determined site in Lombardy – an area well furnished with natural water and with man-made canals dating back to the battle of Legnano. It was typical of Leonardo to realize that these canals could be used for internal communication and trade, for the irrigation of farmland, and even as a potential source of revenue through the "sale" of water. There are penetrating comments on various aspects of hygiene as well as observations on economics and politics; and Leonardo attaches drawings of different sections of the town that show proposed connections between the buildings and the public thoroughfares. In view of the actual financial position of the duchy of Milan and of the known political and administrative views of Il Moro, Leonardo's project might well be regarded as Utopian, but it cannot be called "abstract" or "idealized."

Leonardo's plan stresses the primary importance of nearby rivers and canals from a functional and hygienic viewpoint, for he saw these internal waterways as being used not only as "roads" for commerce but also for carrying away waste matter. He also envisages a dual road system: the lower one would be on the same level as the canals and would be used for the comings and goings of vehicles and "ordinary people" and the upper one would be provided for "gentlefolk" (no advocation here of a happy, classless Utopia but rather a cool, objective acceptance of social differences). The private dwellings, too, are to be built on two stories, the lower one having direct access to the road carrying the traffic and, therefore, reserved as a working and storage area and the upper one, on the same level as the "better-class" street, for accommodation, with hanging courtyards. In one drawing, the lower story is shown directly connected with the canal, which, in its course through the city, is planned, by means of a system of sluices, to run above the level of the surrounding countryside in order to allow complete control of the water flow into the rivers.

In his written proposal to Il Moro, Leonardo outlines his building program and justifies it on grounds of economic and political expediency: "Give me authority whereby, without any expense to you, it may come to pass that all the lands obey

GROTESQUE HEADS
Pen and red chalk drawing on white paper; $8\frac{9}{16} \times 6\frac{1}{16}$ in $(21.7 \times 15.4$ cm)
Windsor, Royal Library
(Inv. no. 12491).

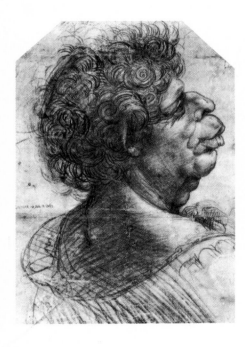

GROTESQUE HEAD
Charcoal drawing; $15\frac{3}{8} \times 11$ in
$(39 \times 28$ cm)
1503–04
Oxford, Christ Church Picture Gallery
According to Berenson this head might be the one mentioned by Vasari as that of "Scaramuccia the gypsy captain, which afterwards belonged to Messer Donato Valdambrini, left to him by Giambullari."

their rulers. . . . The first renown will be eternal together with the inhabitants of the city built or enlarged by him. . . . And nothing is to be thrown into the canals; and every barge is to be obliged to carry away so much mud from the canal; and this is afterward to be thrown on the bank. Construct in order to dry up the canal and to clean the (lesser) canals. All people obey and are swayed by their magnates (lesser nobility), and these magnates ally themselves with and are constrained by their lords in two ways, either by blood relationship or by the tie of property; blood relationship when their sons, like hostages, are a surety and a pledge against any suspicion of their faith; the tie of property when you let each of them build one or two houses within your city, from which he may draw some revenue; and he will draw from ten cities of five thousand houses with thirty thousand habitations, and you will disperse so great a concourse of people, who, herding together like goats one upon the back of another filling every part with their stench, sow the seeds of pestilence and death. And the city will be of a beauty equal to its name and useful to you for its revenues and the perpetual fame of its growth."

There is some difference of opinion as to how this passage should be interpreted.

The tone is undoubtedly Machiavellian, with its allusions to the use of hostages as sureties, of economic advantages, and of landed and domestic property as instruments for enabling the "prince" to exercise control over his provincial nobility. Rented houses are evidently intended to be standardized in design; "five thousand houses with thirty thousand habitations" suggests that each house should have living accommodations for six people. What is debatable is whether Leonardo's proposal was for a "new city" to the south of Milan (the note contains a vague reference to the "municipality of Lodi") or for a scheme of modernization and reclamation that would relieve overcrowding in the medieval city of Milan, namely in the area inside the Visconti city walls and around the canals. The general theme of the letter, with its emphasis on financial and political benefits likely to accrue from the encouragement of house and property development "within your city" (Milan) by Lombard "magnates," suggests that Leonardo had the reclamation project in mind. This would entail an internal slum-clearance project followed by the erection of the five thousand houses for rental and investment by the noble families of ten Lombard cities, all of which would bolster the fortunes of the duchy and its reconstructed capital.

PROFILE OF A WARRIOR IN ARMOR
Silverpoint drawing on cream prepared paper;
$11\frac{1}{4} \times 8\frac{1}{4}$ in (28.5 × 20.7 cm)
London, British Museum.

Pages 82–83
GROTESQUE HEADS
Detail
Pen drawing on yellowish-white paper; $10\frac{1}{4} \times 8\frac{1}{8}$ in (26.1 × 20.7 cm)
Windsor, Royal Library
(Inv. no. 12495 *recto*).

The *Virgin of the Rocks – Sfumato*

Examination of the first Lombard Manuscripts and of related pages in the Codice Atlantico, dating from the same period, indicates that, after arriving in Milan, Leonardo quickly adapted to the new political and cultural environment of Duke Ludovico's court. He appeared to be determined to prove his worth both as a painter and a sculptor. Mention has already been made of the painting of the Madonna that Il Moro probably commissioned from Leonardo for Matthias Corvinus, king of Hungary, in 1485. Apart from that, the only painting definitely attributable to Leonardo in Milan during the 1480s was *Virgin of the Rocks*. Although there is a great deal of documentary information about this work, much controversy has been aroused by the fact that there are two versions of the picture, one in the Louvre and the other in London's National Gallery. The differences are slight but significant and are evident in iconography, color and, above all, lighting

The story of the painting is complex and highly intriguing. On April 8, 1480, the Brotherhood of the Conception of the Church of San Francesco Grande in Milan commissioned from Giacomo del Maino a carved wooden altarpiece decorated with bas-relief figures. It consisted of a central panel and two empty, rectangular side-panels that were subsequently to be painted. The altarpiece was duly completed; and, on April 25, 1843, the Brotherhood commissioned Master Leonardo da Vinci and the brothers Evangelista and Giovanni Ambrogio de Predis to gild the sculptured figures and paint the panels. The central section was to depict the Madonna and Child in oils. The work was to be completed by December 8, 1843, the day of the Feast of the Conception. The fee was fixed at 800 imperial lire, but allowance was made for an additional amount to be settled in the future by three assessors from the Brotherhood. From then on, almost every aspect of the event is supposition. Evangelista de Predis died in 1490 or 1491. In an undated document, presumed to have been written between 1491 and 1493, Leonardo and Ambrogio de Predis requested the intervention of the duke of Milan. They asked him to pay them the balance of their fee now that the painting was finished or to see that new assessors would be appointed. Alternatively, they requested permission to have the picture surrendered to them by the monks, since they had a potential buyer who had offered 100 ducats (400 lire) for "Our Lady made by the said Florentine." The request apparently fell on deaf ears. In 1499, Ludovico was ejected by the French; but, in 1503, de Predis entered the dispute, although, once again, it remained unresolved. Finally, de Predis arranged a new settlement in 1506.

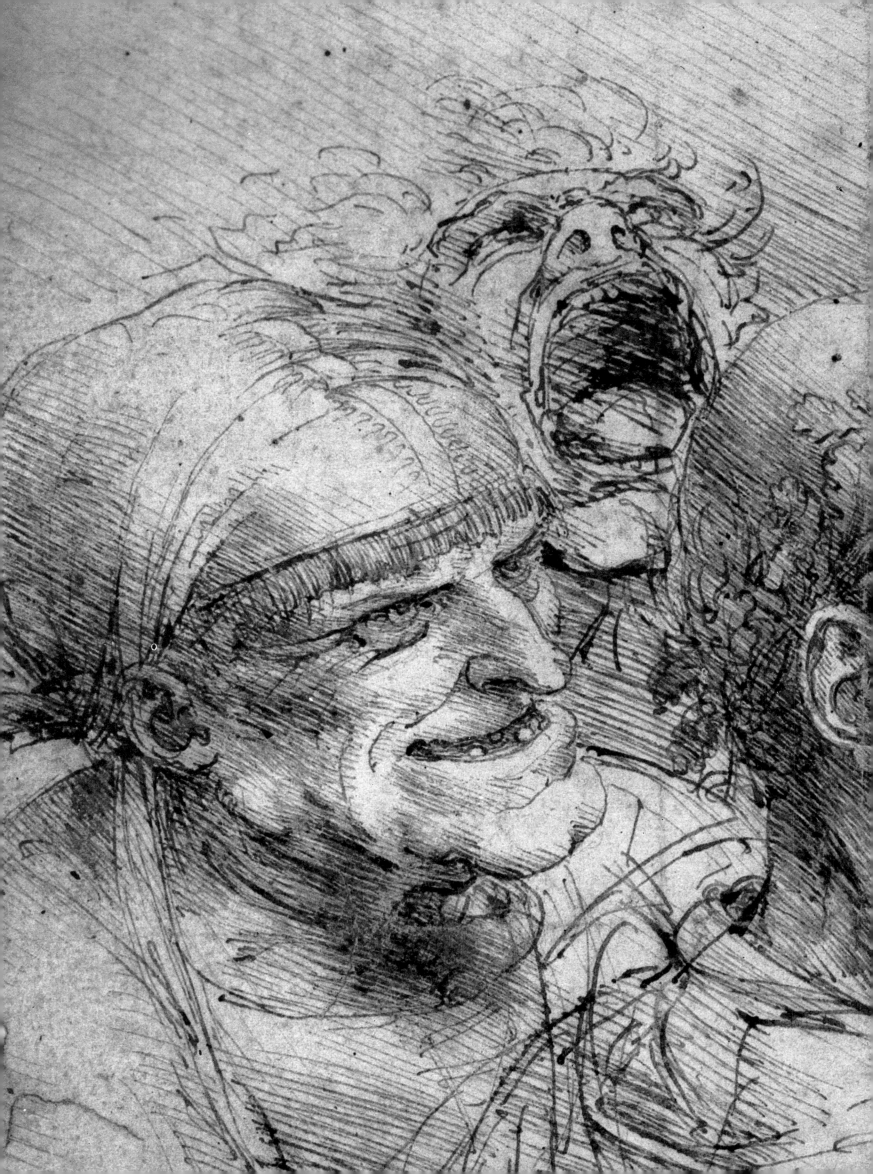

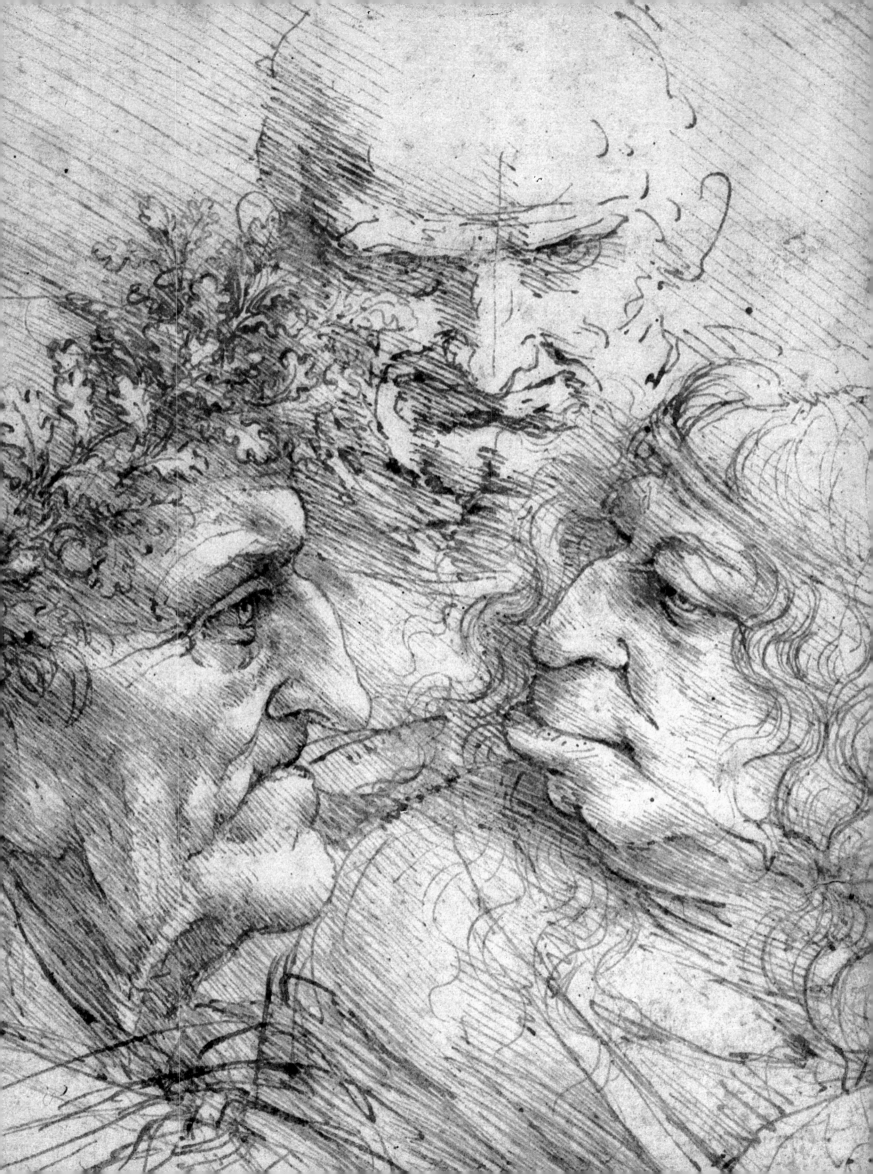

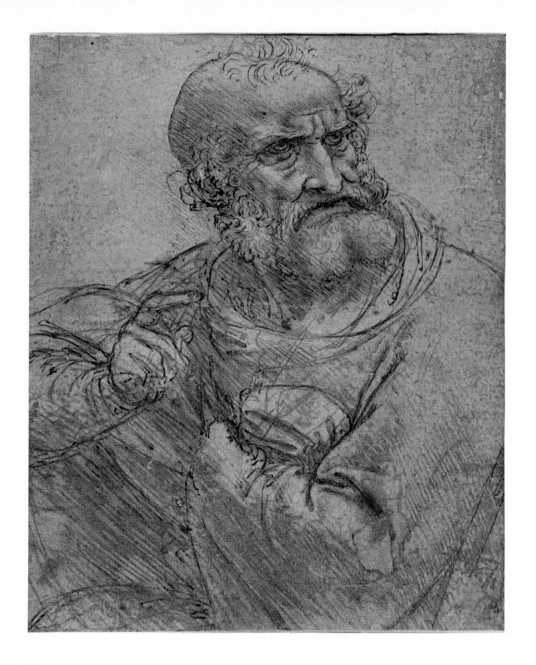

STUDY FOR THE HEAD OF AN
APOSTLE, POSSIBLY ST.
PETER, FOR "THE LAST
SUPPER"
Pen and silverpoint drawing on blue
prepared paper; $5\frac{11}{16} \times 4\frac{7}{16}$ in
(14.5×11.3 cm)
1495–8
Vienna, Albertina, Drawings
Collection.

STUDY FOR THE HEAD OF AN
APOSTLE, POSSIBLY JUDAS
Red chalk drawing on red paper;
$7\frac{1}{16} \times 5\frac{7}{8}$ in (18×15 cm)
Windsor, Royal Library
(Inv. no. 12547).

At this point, a surprising fact was revealed. Although the work had appeared to
be completed, it was now admitted to be unfinished. De Predis, with Leonardo's
agreement, undertook to complete it or have it completed within two years. For
this, he was to receive an additional 200 lire, and this sum was duly collected, again
with Leonardo's consent, in 1508. In 1785, the panel was bought from San
Francesco Grande by the English painter Gavin Hamilton. By then, it was in poor
condition and was commonly attributed either to Leonardo or to Luini. After
several changes of ownership, it reached the National Gallery in 1880. The wings of
the altarpiece, comprising *Angel Musicians* by de Predis, were acquired, in 1798, by
the Melzis of Enil and then came into the possession of the National Gallery in 1898.
The painting that was completed between 1506 and 1508 was the one that had been
commissioned in 1483. The controversy that raged during the 1490s seems to have
stemmed not from the fact that the picture was unsatisfactory but from the lack of
agreement on the additional payment.

The majority of modern critics consider the picture in the National Gallery as
having been only partially painted by Leonardo. The other version, in the Louvre, is
undoubtedly by Leonardo. It certainly dates from an earlier period than the London
painting and belonged to the French royal collections during the sixteenth century.
However, it is not mentioned by Cardinal Luis of Aragon and his secretary Antonio
de Beatis when they visited Leonardo at Cloux in 1517. The Louvre painting,
therefore, must correspond to the original commission. It either remained in
Leonardo's studio throughout the period of the controversy or perhaps was handed
back by the Brotherhood just before the new version (finished in 1506–1508), was

substituted. Lord Clark is one of several critics who subscribes to the theory that Leonardo took the original painting with him from Florence to Milan, but this seems doubtful on two counts. First, the almost identical dimensions of the two pictures both fit the available space on del Maino's altarpiece, which had been commissioned and completed prior to Leonardo's arrival in Milan. Second, the theme symbolizes the Immaculate Conception according to the medieval legend (of Eastern origin) of the meeting of the two children – Jesus returning from Egypt and John from the desert. This is consonant with a widely diffused cult then prevalent in Milan. It is hard to believe that Leonardo, while working in Florence, would have had the same idea.

The arresting feature of the Louvre painting, clearly related to two immediately preceding works – *St. Jerome* and *The Adoration of the Magi*, even though these were unfinished – is the clearly announced intention of combining the highest degree of naturalism in the scientific sense (landscape, atmosphere, and light) with the

STUDY FOR THE HEAD OF AN APOSTLE, POSSIBLY ST. BARTHOLOMEW
Red chalk drawing on red paper;
$7\frac{5}{8} \times 5\frac{13}{16}$ in (19.3 × 14.8 cm)
Windsor, Royal Library
(Inv. no. 12548).

STUDY FOR THE HEAD OF ST. JAMES THE GREAT
Red chalk and pen drawing on white paper; $9\frac{15}{16} \times 6\frac{3}{4}$ in (25.2 × 17.2 cm)
Windsor, Royal Library
(Inv. no. 12552, detail).

maximum measure of formal, classical balance in structural terms. The real wonder and fascination of the work derives from the marvelous way in which the viewer is persuaded, almost as if by a self-generating process, to see it as an entity from the center outward, from core to surface, and the manner in which he is "invited" to discover in minutest detail the complexities of the composition's rhythms in three-dimensional space. One is aware of the subtlest mystical and psychological associations in the relationship between the Virgin and the Christ Child – her left hand appearing to be raised in benediction and protection – and between her and the young St. John, who seems to be gently urged by the Virgin to kneel down in order to receive her blessing. In this context, the angel fulfills a role unprecedented in the history of the visual arts (certainly more coherently than the youth who performs a comparable function in *The Adoration of the Magi*). For here, the angel, virtually exhorting worship and devotion, is explicitly associated both with the internal world of the picture and the external world of the viewer.

The natural surroundings, which gave rise to the popular name for the painting, contribute overwhelmingly to the mystical and psychological implications of the work. They also serve as a filter for the natural light in the background, more effectively even than the junipers framing the portrait *Ginevra de' Benci*. This provides the picture with that "underwater" atmosphere so frequently mentioned by critics, its spatial and compositional structure and which is a feature which envelopes the compact group of figures. It represents the first fully developed example of what critics define as Leonardo's "geological" landscape that extends beyond the bounds of time and human history. Indeed, in the years following *Virgin*

THE LAST SUPPER

Tempera on wall; about
15 × 28 ft (460 × 880 cm)
Milan, Refectory of Convent
of Santa Maria delle Grazie

Begun in 1495, the work was
completed two years later,
according to contemporary
records. Only a few years
afterwards its condition was
obviously deteriorating as a
result of humidity. The most
effective attempts at restor-
ation took place in the present
century, initially in 1908
when, thanks to L. Caven-
aghi, the painting technique
was definitively revealed – a
strong tempera on a complex
two-layered ground. After
aerial bombardment in 1943
which partially destroyed the
refectory, the work was again
restored by M. Pelliccioli.

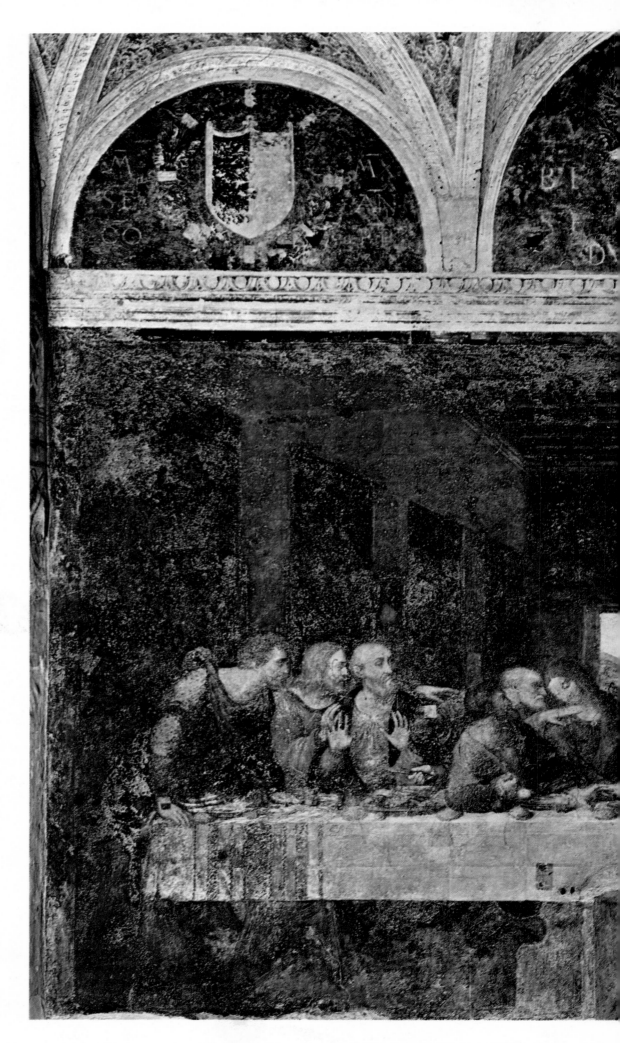

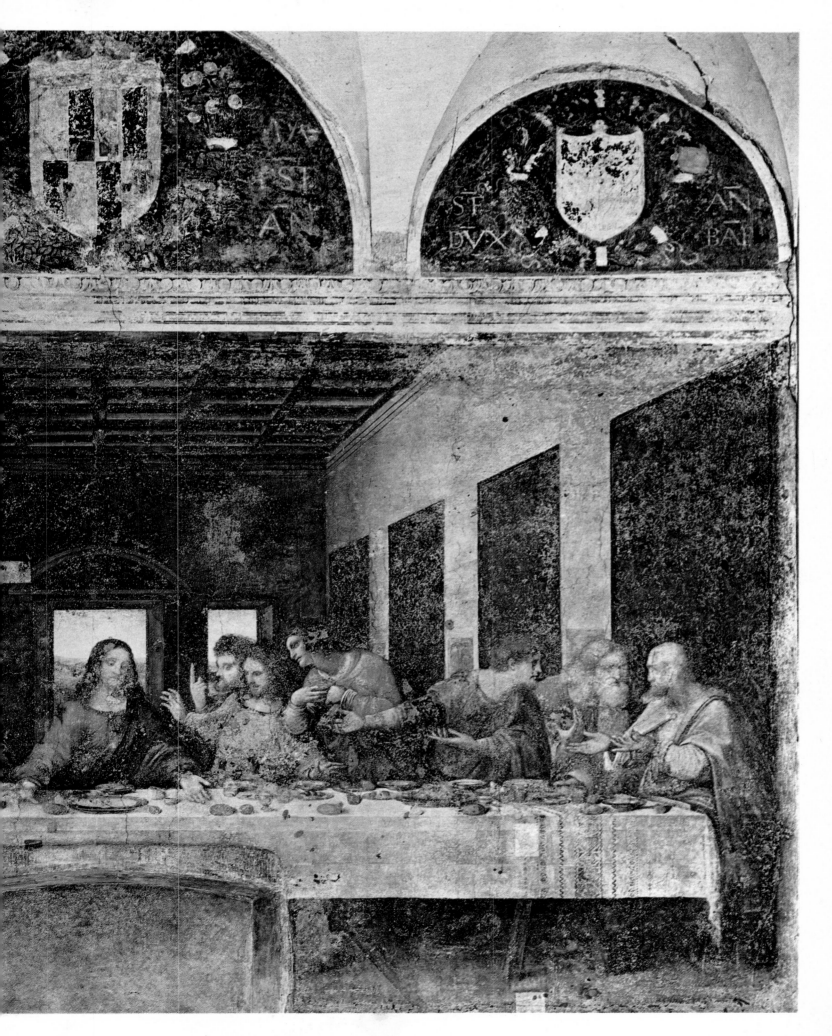

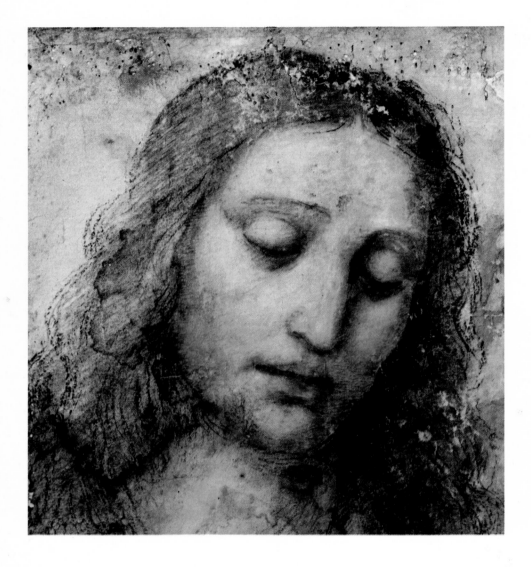

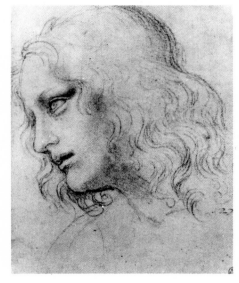

of the Rocks until the end of his life, Leonardo evinced considerable interest in geology, fossils, the structure of the earth, and the dynamic effect of waters in molding that structure. The figurative results of Leonardo's thinking on such topics are vividly conveyed in this "geological" landscape, which is again an indispensable feature of the Mona Lisa and *Virgin and Child with St. Anne*. In *Virgin of the Rocks*, the problem is posed in somewhat different, less "cosmic" terms. The symbolic meaning of this world of rocks and "spontaneous" vegetation is self-evident, but it is worth stressing that the mysterious, visionary quality of the picture has a direct precedent in the comparable rocky environment of *St. Jerome*.

It is interesting to note that, once again, Leonardo departed from traditional treatments of a hallowed subject. In *St. Jerome*, he had depicted the saint as a hermit, rather than as a cenobite in his cell. *Virgin of the Rocks* places the legendary encounter on the borders of a desert – the rocky Sinai desert of the Old and New Testaments. This must have been a deliberate choice, particularly in the planning of a work that, for intellectual if not emotional reasons, Leonardo wished to handle with due devotional respect. It is now generally accepted that the painting dates from 1483–86, so that it would have served as Leonardo's introduction as a painter to Milanese society outside the closed circle of Duke Ludovico's court.

Leonardo had always been intrigued by optical phenomena such as atmosphere and light as well as by anatomy and human movement. They were subjects that he considered worthy of study in their own right and in relation to the special problems of the artist. The first manuscript references to a projected treatise on painting date from the late 1480s. *The Adoration of the Magi* had shown a great advance in pictorial quality that anticipated sixteenth-century painting; but it was now surpassed for sheer technical skill and experimental boldness by *Virgin of the Rocks*, which epitomized the revolutionary nature of Leonardo's thinking on pictorial composition.

In simplified terms, the basis of this revolution in painting was the technique now described as "sfumato," namely the imperceptible transition from light to dark tones. In the *Treatise on Painting*, Leonardo defines it as a method whereby "your light and shade blend without strokes and borders, looking like smoke." The technique was founded on the interrelationship of balanced pyramidal masses (perspective being based on the transmission of images to the eye by pyramidal lines), color effects based on the intensity of atmospheric light, and what Leonardo defined as "primary," or "primitive," shadow and "derived" shadow. The following quotations from various manuscripts summarize his thoughts on light and shade:

"Darkness is the absence of light. Shadow is the diminution of light. Primitive shadow is that which is attached to shaded bodies. Derived shadow is that which separates itself from shaded bodies and travels through the air." (Manuscript C).

"Shadow is the withholding of light. It seems to me that the shadows are of supreme importance in perspective, seeing that without them opaque and solid bodies will be indistinct, both as to what lies within their boundaries and also as to their boundaries themselves, unless these are seen against a background differing in color from that of the substance; and, consequently, in the first proposition, I treat of shadows and say, in this connection, that every opaque body is surrounded and has its surface clothed with shadows and lights; and to this I devote the first book. Moreover, these shadows are in themselves of varying degrees of darkness, because they have been abandoned by a varying quantity of luminous rays; and these I call primary shadows, because they are the first shadows and so form a covering to the bodies to which they attach themselves, and to this I shall devote the second book. From these primary shadows there issue certain dark rays, which are diffused throughout the air and vary in intensity according to the varieties of the primary shadows from which they are derived; and, consequently, I call these shadows derived shadows, because they have their origin in other shadows, and of this I will make the third book." (Codice Atlantico).

In the passage directly above, the reference to opaque and solid bodies implies that, without the link between light and shade, the internal details of forms cannot be determined and the actual outlines of shapes cannot be discerned in the absence of color contrasts. The allusion to shadows being "abandoned by a varying quantity of luminous rays" touches on the fundamental principle of sfumato as a gradual lessening of light intensity.

The following passages all come from Manuscript A in the Institut de France:

"Of the choice of light that gives a grace to faces. If you have a courtyard that, when you so please, you can cover over with a linen awning, the light will then be excellent. Or when you wish to paint a portrait, paint it in bad weather, at the fall of the evening, placing the sitter with his back to one of the walls of the courtyard. Notice in the streets at the fall of the evening when it is bad weather the faces of the men and women – what grace and softness they display! . . . Of shadows in the far distance. Shadows become lost in the far distance, because the vast expanse of luminous atmosphere that lies between the eye and the object seen suffuses the shadows of the object with its own color."

"What shadow and light are. Shadow is the absence of light; it is simply the obstruction caused by opaque bodies opposed to luminous rays. Shadow is of the nature of darkness; light is of the nature of brightness. The one hides and the other reveals. They are always in company attached to the bodies. And shadow is more powerful than light, for it impedes and altogether deprives objects of brightness, whereas brightness can never altogether drive away shadow from bodies, that is, from opaque bodies."

"How the condition of the atmosphere affects the light and shadows. That body will present the strongest contrast between its lights and shadows that is seen by the strongest light, such as the light of the sun or at night by the light of a fire; but this should rarely be employed in painting, because the work will remain hard and devoid of grace. A body that is in a moderate light will have but little difference between its lights and shadows; and this comes to pass at the fall of the evening or when there are clouds: works painted then are soft in feeling, and every kind of face acquires a charm. Thus, in every way, extremes are injurious. Excess of light makes

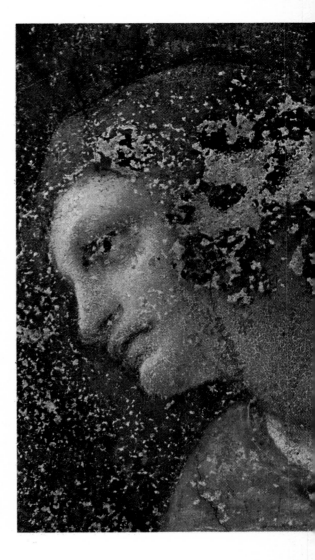

THE LAST SUPPER
Detail: St. Philip.

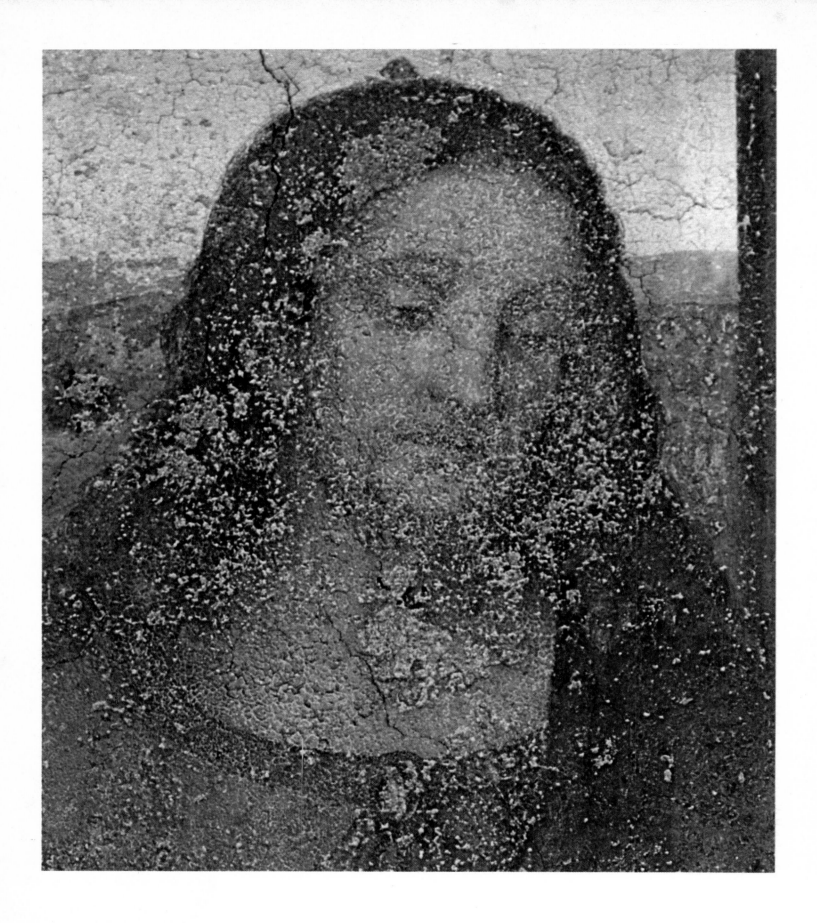

things seem hard; and too much darkness does not admit of our seeing them. The mean is excellent.''

These quotations all date from a period a little later than *Virgin of the Rocks*, and they underline, again and again, the vital importance to the painter of understanding the delicate optical effects of light and shadow. They are fundamental, too, for appreciating the logical reasoning that led Leonardo to adopt the sfumato technique and the manner in which he put it into practice. The two basic concepts of shadow, ''primary'' and ''derived,'' and the gradual transition of light to complete absence of light are repeatedly expressed in the references to

"softness," "hardness," and so forth. It is significant that Leonardo's methods – gradations of color and illusions of depth obtained by the play of external light on a "shadowy" space, balanced in turn by a luminous background opposed to direct contrasts of light and shade and juxtaposed colors – were adopted by Michelangelo. The "grace" and "softness" thus achieved likewise prepared the ground, in different ways, for the atmospheric tonality of Giorgione and for the mellow delicacy (albeit with sentimental overtones) of Correggio. *Virgin of the Rocks*, therefore, is a landmark in Leonardo's mental and creative development and proof that the Florentine style of art had definitely assumed ascendancy.

The new way in which Leonardo painted the human figures in *Virgin of the Rocks* was also to have repercussions far beyond the Alps. In Flanders, for example, this manner of portraying women and children was adopted by artists ranging from Bernard van Orley to Jan Mabuse; some decades later, it manifested itself in the French mannerist painting of the Fontainebleau school.

The second version of *Virgin of the Rocks* (in London) has to be discussed separately because modern critics agree that Ambrogio de Predis was mainly responsible for the picture. Opinions vary as to how much was done by Leonardo. Ambrogio was the younger of two brothers and slightly younger than Leonardo. Certain of his portraits, including miniatures, reveal qualities similar to those of Leonardo, yet his style has obvious affinities with traditional Lombard art. This picture is certainly not a mere copy or replica but is an independent, variant version. Thus, the angel's right hand is not pointing, as in the Louvre picture, but is helping to support the Christ Child; there is a cross in the arms of St. John; and the angel does not turn toward the viewer. There are also several stylistic variations. The group of figures is more prominent, self-contained, and compact but less smoothly rhythmical. The separate components are more precisely delineated and the sfumato effect of light and shade less in evidence, so that the figures seem sharply etched against the rocks behind them, and not so intimately enclosed as in a grotto. The rocks frame a blue green background of sky and foliage, not golden green as in the Louvre version. It is impossible to decide whether these differences in composition and treatment of light are due to the changing ideas of Leonardo himself over the years, assuming that he allowed de Predis to be responsible for the actual painting of the London version. Whatever the reason, the shadows in this painting are somewhat dull, and the picture as a whole lacks that impalpable sense of "atmospheric space," which is such a striking feature of the Louvre version.

The Milanese Portraits

THE LAST SUPPER
Detail: head of Christ.
Pages 92–93:
Detail of the apostles St. Bartholomew, St. James the Less and St. Andrew.

Apart from the authorship of the second version of *Virgin of the Rocks*, there has been lively critical discussion, too, about a series of paintings, chiefly portraits, which may either have been done partially or wholly by Leonardo or by various artists who frequented his "studio" in Milan. These artists were Giovanni Boltraffiio (born in Milan in 1467), Bernardino de' Conti (born in Pavia in 1450), and the young Gian Giacomo Caprotti (the Salaino), who was in Leonardo's house from 1490 (when aged ten) to 1500. *Head of a Girl* with "dishevelled hair" (acquired by the Parma National Gallery in 1839) has feminine features wholly typical of Leonardo's work. The shape of the face is something between an oval and a reversed triangle; the eyeballs are accentuated; the nose is long; the fleshy lips are set in a faint smile; and the chin is prominent and rounded. These features are similarly reproduced in the marvelous silverpoint and white lead sketch for the head of the angel in *Virgin of the Rocks* (Royal Library of Turin), with sfumato gradations ranging from parallel cross-hatching to deep shadow on the cheeks. *Head of a Girl* is a sketch in umber (with highlights) on wood, and critics have failed to agree on its attribution. Thus, Adolfo Venturi ascribes it to Leonardo; Suida accepts the participation of

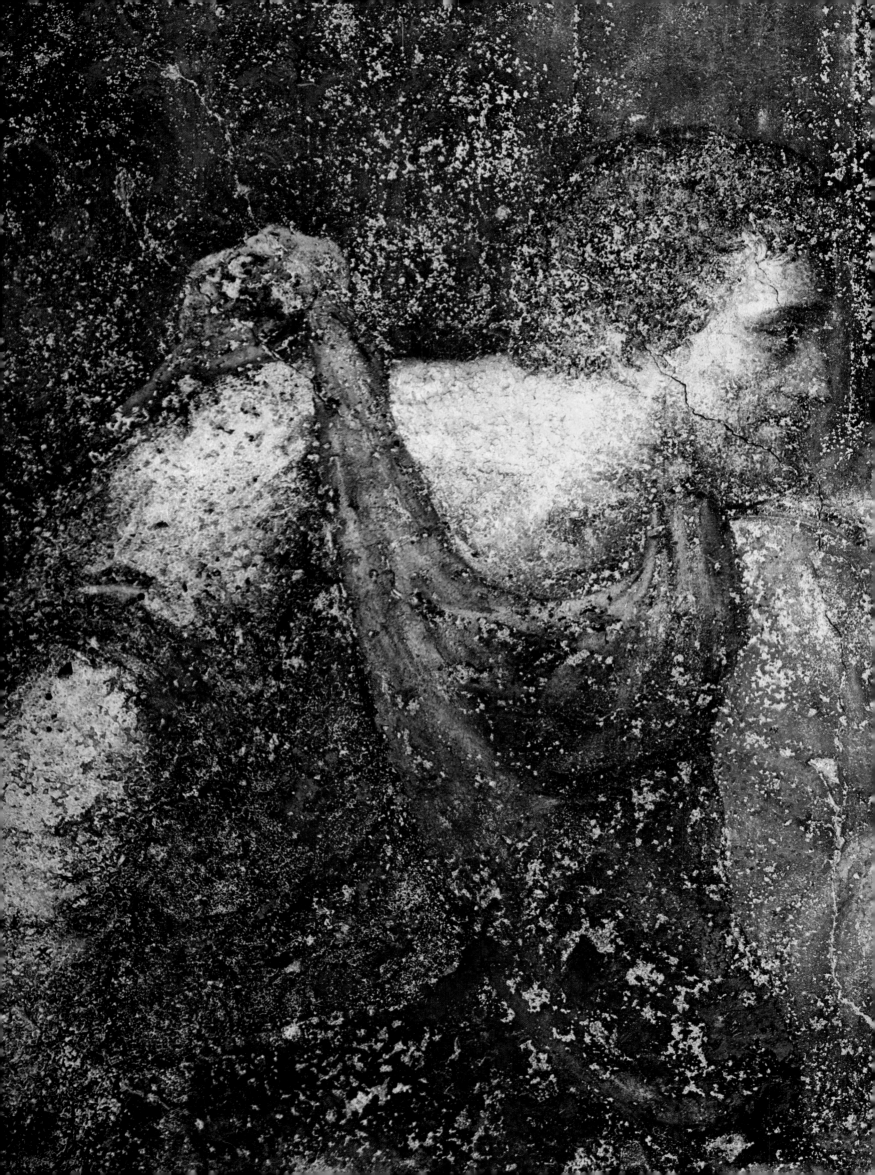

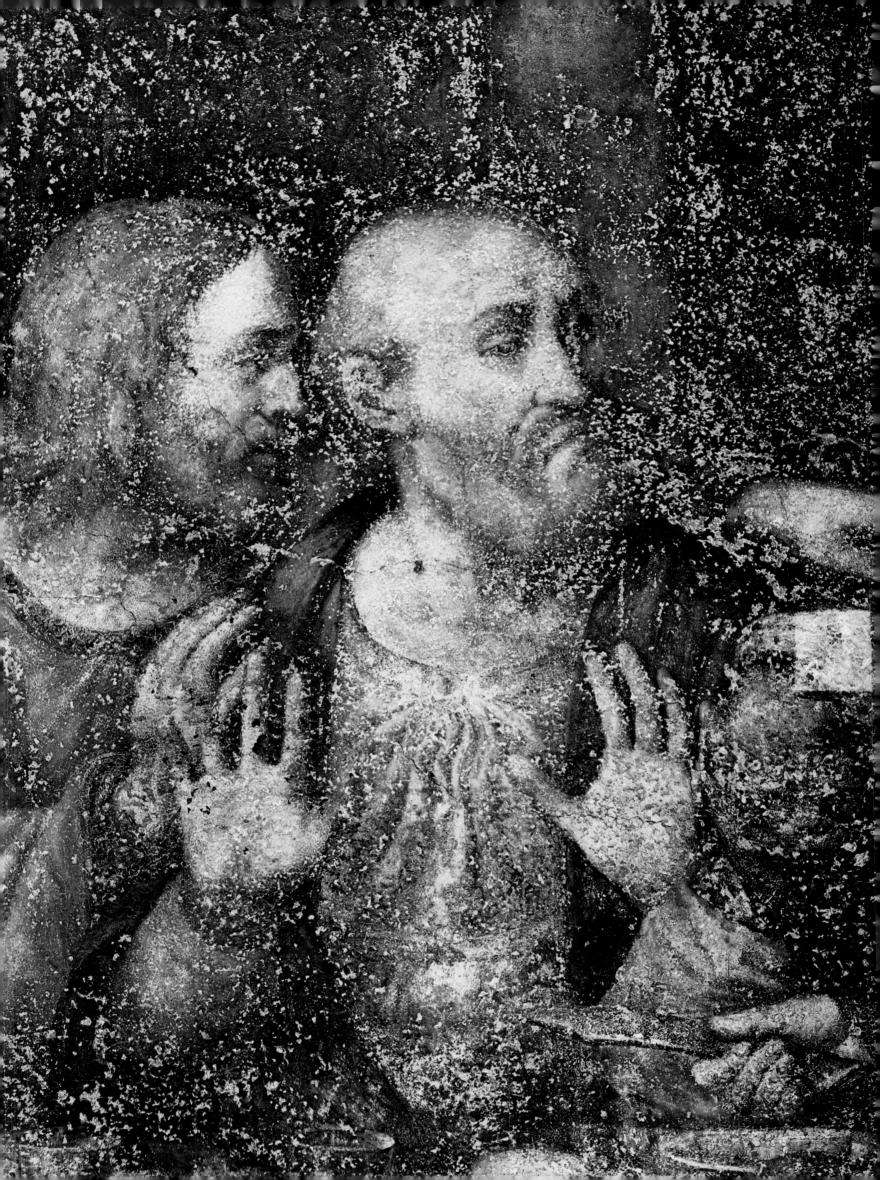

Leonardo's school; and Corrado Ricci pronounces it to be a skilful late eighteenth-century imitation done, perhaps, by its former owner, the Parma artist Gaetano Callani.

The critics are more solidly in agreement about *Litta Madonna*, once owned by the Viscontis, then by the Litta family in Milan, and finally acquired, in 1865, by Czar Alexander II for the Hermitage. Most of them refuse to accept that Leonardo painted it, although Goldscheider, in 1952, suggested that Leonardo was mainly responsible, with some assistance from Boltraffiio. Other experts have ascribed it to de' Conti, de Predis, Marco d'Oggiono, or Boltraffio alone, while some have suggested that it was painted by the entire "studio" and was based on a drawing or cartoon by the master. Undoubtedly, the Madonna's head shows close links with a beautiful silverpoint and white lead drawing in the Louvre (formerly in the famous Vallardi collection). It is similar to the head of the angel in Turin and is certainly by Leonardo. Nevertheless, the personalized objectivity of the drawing has become more abstract in the painting. This strongly suggests that the painting is a studio work. The main interest of *Litta Madonna* is in the representation of the Virgin and Child, framed here by two symmetrical windows. Although this is reminiscent of Leonardo's Florentine Madonnas, particularly *Benois Madonna*, the style, especially in the case of the muscular Child, is more typically Lombard in the manner frequently employed by local artists, including Boltraffio.

There is an opposite consensus of opinion in the case of *Lady with an Ermine*, which toward the end of the eighteenth century belonged to Prince Adam Czartoryski's collection in Pulany Castle, Poland. It was transferred to Paris in 1830 and then returned in the 1870s to the original owner's collection in Cracow. In 1889, it was pronounced to be the work of Leonardo. Antoniewicz, in 1900, first suggested that this was a youthful portrait of Cecilia Gallerani, the elegant, cultured mistress of Ludovico the Moor, that, in 1498, Celia had sent to Isabella d'Este. Cecilia was a friend of Leonardo's, and support for the identification of the sitter comes both from the depiction of the ermine (the ducal symbol) and from a pun on the Greek word for ermine, which is similar to the surname Gallerani. Whereas critics once suggested de Predis and Boltraffiio as alternatives, they now generally agree that this is a genuine Leonardo.

Even without such clues it would be hard to think of anyone else who could have achieved such perfect pictorial balance between the sharply illuminated portions of the painting (the face, shoulders, and sinewy hand of the sitter as well as the muzzle and flank of the ermine) and sections in which the sfumato technique is used with consummate mastery. The pale, unobtrusive colors stand out effectively from the dark background. The incisiveness of the painting is reminiscent of the Flemish school, and there are resemblances, too, to the work of the Flemish-influenced Antonello da Messina, who had probably visited Milan. Just as noteworthy is the surprising innovation of portraying the girl holding an animal, establishing a pattern that was to be repeated in Michelangelo's "counterpoint" and that culminated in sixteenth-century mannerism.

In the top left corner of the picture is an inscription dating from around 1800. It reads: LA BE LE FERONIERE – LEONARD D'AWICI. This indicates that the work had once been associated with a famous painting in the Louvre, assumed to be by Leonardo, and thought (wrongly) to be a portrait of the lady known as "La Ferronnière," mistress of Francis I. Further confusion arose from the fact that there was another similar picture, also in the Louvre. This is genuinely a portrait of La Ferronnière that was once attributed to Leonardo but today is generally ascribed to Bernardino de' Conti.

As for the first of these Louvre pictures, still commonly entitled *La Belle Ferronnière*, opinion has veered away from Leonardo. However, both Venturi and Borensen have continued to press his claim, and Clark opts for a "studio" painting in which Leonardo had a hand. Other critics favor the "studio" independently of Leonardo, or suggest Boltraffio as the artist. Radiographic investigations made since World War II have revealed substantial repainting. The hair, for example, has been extended to cover the ear. The preparatory technique is comparable to that of the Mona Lisa, although the wooden support, of oak, is different, and this is unlike any method known to have been used by Boltraffio. The quality of the work, judging

STUDY OF A LILY
Watercolor with touches of white lead and outlined with pen; 12$\frac{3}{8}$ × 7 in (31.4 × 17.7 cm)
Windsor, Royal Library
(Inv. no. 12418).

94

STUDY OF A SPRIG OF
MULBERRIES
Red chalk drawing, retouched in
white; 6⅛ × 6⅜ in (15.5 × 16.2 cm)
Windsor, Royal Library
(Inv. no. 12419).

DYER'S GREENWEED, OAK
LEAVES AND ACORNS
Red chalk drawing on pink paper;
7¼ × 6 in (18.4 × 15.2 cm)
Windsor, Royal Library
(Inv. no. 12422).

chiefly by the facial expression, is certainly inferior to that of the Cracow *Lady with an Ermine*, but the similarity of the two faces was sufficiently striking to suggest that the Louvre picture might be a second portrait of Cecilia Gallerani done about a decade later, thus dating from around the end of Leonardo's first period in Milan.

Two other portraits, painted in the 1490s (both in the Ambrosian Gallery, Milan) have likewise aroused controversy among the experts. During the nineteenth century, they were assumed to be the portraits of Ludovico and of his wife Beatrice d'Este. Actually, only the female portrait is recorded as having formed part of Cardinal Federico Borromeo's bequest that laid the foundations of the gallery in 1618. The portrait of the man is first listed in the catalog of 1686 as a work by Luini. Restoration of the latter picture at the beginning of the present century revealed, beneath a repainted section in the lower-right corner, that the man's hand was holding a manuscript with musical notation. This discovery led to it being retitled *Portrait of a Musician*. It has been suggested that the sitter was the illustrious Franchino Gaffurio (choirmaster of Milan Cathedral), known to have been a friend of Leonardo. This undermined the theory that the subjects of the two portraits were the duke and the duchess. Experts then gave free rein to their imagination in trying to identify the lady. They put forward the claims of numerous court personages, including, of course, Cecilia Gallerani. Nor could they decide who actually painted the pictures. Both Clark and Heydenreich named Leonardo in the case of *Portrait of a Musician*, while other critics have suggested de Predis and

CREEPING CROWFOOT, STAR OF BETHLEHEM, WOOD ANEMONE AND LEAFY-BRANCHED SPURGE
Red chalk and pen drawing on yellowish paper; $7\frac{13}{16} \times 6\frac{5}{16}$ in (19.8 × 16 cm)
Windsor, Royal Library
(Inv. no. 12424)
Thought to be connected with the lost *Leda* (first decade of 16th century).

Boltraffio. With regard to the female portrait, Leonardo has generally fallen from favor. Many attribute it to de Predis; and Longhi, basing his opinion on cultural and historical evidence, advances the claim of the Ferrara painter Lorenzo Costa.

In fact, despite its evident sensibility and subtlety of technique, the portrait of the lady shows a style markedly different than that associated with Leonardo at this period. This is particularly shown by the spatial structure and the sfumato effect of light and shade. The face is sharply delineated and placed against a background in which the shadowy quality (showing signs of haste rather than patient absorption) is quite unlike that in the *Lady with an Ermine*. Support, however, for ascribing the picture to Leonardo during his Milan period stems from the characteristic gold-thread decoration on the edge of the sleeve, suggesting a knot or osier *motif*, this was sometimes used by the master in less-demanding endeavors, as in the decorative work for allegorical diversions at the ducal court.

In *Portrait of a Musician*, the luminous modeling of the face (reminiscent of the second version of *Virgin of the Rocks*) is worthy of the master, but the cursory treatment of the background and the dry contrast of light and shade on the finely modeled hand cast doubt on Leonardo's authorship. Nevertheless, the portrait points to the likelihood of an interchange of ideas between Leonardo and his pupils in Milan, in the tradition of Antonello da Messina (as exemplified in the so-called *Condottiere* in the Louvre and the *Portrait* in the Sabauda Gallery, Turin, formerly in the Trivulzio collection), and Antonello's followers in Venice, especially Giovanni Bellini. This interchange is noticeable in the authenticated portraits by Boltraffio.

ANEMONE AND OTHER
RANUNCULACEAE
Pen drawing on gray paper, slightly
tinted with pink; $3\frac{7}{16} \times 5\frac{9}{16}$ in
(8.7 × 14.1 cm)
Windsor, Royal Library
(Inv. no. 12423).

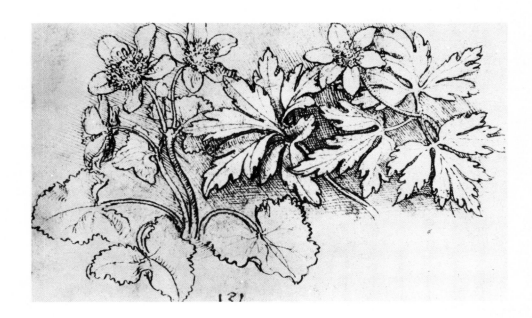

The Sforza Monument and the Problem of Casting

In the interval between this series of portraits and *The Last Supper*, some ten years later, Leonardo devoted much time and effort to the planning of the bronze equestrian monument of Francesco Sforza. The final section of the Madrid Manuscript II shows that he was on the verge of getting down to actual work on the statue. A page in Manuscript C bears the note: "On the 23rd day of April 1490, I began this book and recommenced work on the horse." Apart from the reference in the letter to Il Moro, this note indicates that Leonardo had already been making plans for the project. First mooted by Ludovico's brother and predecessor Galeazzo Maria Sforza, the plans, in fact, had been under consideration as far back as 1473.

Certain drawings at Windsor, dating from the early years in Milan, show that Leonardo was originally playing with the notion of a rearing horse trampling a vanquished soldier. This was similar in conception to one of the figures depicted in the background fighting of *The Adoration of the Magi*. Representing a mounted warrior in this manner was a revolutionary idea, both in relation to "classical" tradition (as exemplified in the *Marcus Aurelius* statue in Rome, the *Regisole* in Pavia, and the Greek horses transported from Constantinople to Venice) and to "modern" usage (as represented by Donatello's *Gattamelata* in Padua). It was an idea that he was to adopt again during his second stay in Milan for the projected monument to Marshal Gian Giacomo Trivulzio.

This design concept is embodied in a bronze statue of a horse and nude rider wearing a classical helmet (in the Szépümevészeti Museum, Budapest). Some critics attribute it to Leonardo or to one of his pupils. The exuberance of the modeling and the luminosity of the surfaces seem to transcend Michelangelo in anticipating baroque sculpture. We have no information as to the intended location or the envisaged size of the monument, but since Galeazzo Maria Sforza apparently had in

STUDY OF LINKS
Red chalk drawing. Detail of a page including studies of fusion in pen on yellowish paper, the whole page measuring $10\frac{3}{8} \times 7\frac{1}{4}$ in
(26.3 × 18.4 cm)
Windsor, Royal Library
(Inv. no. **12351** *verso*).

mind an open-air site "in some part of our castle of Milan" and clearly visualized it on a massive scale, it is probable that Il Moro and Leonardo were thinking along similar lines. From the start, the statue was undoubtedly planned in bronze, like the one that Leonardo's teacher, Verrocchio, had recently done of Condottiere Colleoni in Venice. The Windsor drawings include sketches of rearing horses divided into sections to show the iron frame inside the bronze after the casting process.

In a letter dated July 20, 1489, Pietro Alemanni, Lorenzo de' Medici's agent in Milan, wrote to his lord on behalf of Il Moro to announce a change in plan. Ludovico expressed doubts as to whether Leonardo would be able to complete the statue and now requested Lorenzo to find one or two alternative sculptors to construct what he called a "worthy sepulcher" (implying a mausoleum monument) consisting of a "colossal bronze horse with the Duke Francesco in armor." Some time after 1490, Leonardo had evidently made a clay model of what the court poets described as the "colossus." The height of the model, to the nape, is mentioned in the Madrid Manuscript II and, in 1497, was noted by Luca Pacioli. Both sources cite the dimension as 12 *braccia*, equivalent to 7.20 meters, or just over 25 feet. This is larger than the *Marcus Aurelius* (4.26 meters, or 14 feet), the *Gattamelata* (3.20 meters, or 10½ feet), and the *Colleoni* (4 meters, or just over 13 feet).

It was probably because of the enormity of the structure and the associated problems of statics and casting methods that Leonardo now decided to revert to tradition by choosing the "classical" style of horse. This is indicated by a series of drawings from Windsor and from the Codice Atlantico. Furthermore, in the Madrid Manuscript II, there are notes relating to the problems of casting the horse, these begin with one dated May 17, 1491, and end with another that reads: "This day, the 20th of December 1493, I have decided to cast the horse without tail and lying on its side (in the casting pit)." Yet, on another page of the same manuscript, possibly of later date, Leonardo outlines, in text and drawings, a casting process involving several furnaces and shows the horse upside down in the pit. It is significant, nevertheless, that in November 1494, when Leonardo seemed ready to go ahead with the casting, Ludovico sent about 158,000 pounds of metal, which had been collected for the horse project, to Ercole d'Este in Ferrara in order to manufacture

SINOPIA
Tempera on wall
Milan, Sforza Castle
Two large monochrome fragments were discovered in **1954** in the course of repairs to the east wall of the Sala delle Asse. From them experts have concluded that Leonardo intended to begin decorating the walls of the room, depicting the trees from which branched the foliage covering the ceiling.

Pages 100–101:
SALA DELLE ASSE
Detail of decoration on ceiling
Tempera on wall
1495–8
Milan, Sforza Castle.

cannons! It is very probable, as we shall see, that the project was abandoned not because of Leonardo's technical problems but because of Ludovico's inability to finance it.

In this specialized field of metal casting, Leonardo once more proved himself a genuine innovator, bringing his prodigious gifts as an artist, a scientist, and an engineer to focus on the matter at hand. His research into anatomy and proportion helped him to determine an ideal shape for the statue; and his appreciation of the technical difficulties led him to devise a method whereby the horse could be cast in one piece, necessitating movable frames for transporting the model and lowering the mold for casting into the pit. Procedural problems are discussed and splendidly illustrated with red charcoal drawings in the Madrid Manuscript II. The traditional method of metal casting was still being mentioned in Pomponio Gaurico's *De sculptura* in 1504. Procedures similar to those of Leonardo were not described until the mid-sixteenth century by Cellini and Vasari. These were preceded only by Vannoccio Biringucci in his reference book on metallurgy *Li dieci libri della pirotechnia* (1530–35), which dealt exclusively with firearms. It is only much later, in 1743, that we find material substantially identical to that in the Madrid Manuscript II. This source is a book by G. Boffrand that contains written descriptions and engravings of the huge statue of Louis XIV (6.82 meters, or $22\frac{1}{4}$ feet high), built by the Swiss sculptor Keller.

The classical method of metal casting, adopted in the Renaissance by Donatello and Verrocchio, was the *cireperdue*, or "lost wax," procedure. The fire-clay mold was covered with wax and enclosed in a fire-clay "jacket." The model was then lowered into the casting pit, and the liquefied bronze melted the wax. If the statue was large, it was cast in pieces and then welded together to produce the finished work.

Leonardo decided to retain the clay model he had made of the horse (it was later to be used for target practice by the crossbowmen of Louis XII and so destroyed) and to try casting it in a single piece. To do this, he took an impression of the model in pieces, namely a hollow plaster mold, and reassembled it in two shells. On the inside of the mold, he spread a uniformly thick layer of malleable material, wax or clay (which he called the "thickness"), estimating the amount of bronze required for casting. The outside of the hollow mold was fastened by iron bands (as shown in the extraordinarily powerful drawing of the horse's head in the Madrid Manuscript II), and the inside was similarly reinforced with iron pins, partly intended to remain within the statue after casting. Next, he planned to make a terra-cotta core – the actual model for casting – to be suspended inside the mold and separated from its wall by the "thickness" (to be substituted by the bronze). This core was to be propped up by the pins. It is not clear, from notes in the Codice Atlantico and the Madrid Manuscript II, whether Leonardo planned to make a wax counter-model in order to perfect the model for casting; but this is probable. Over everything was molded the casting jacket in fire-clay, linked to the core by the protruding iron pins. The molten bronze would flow, in a single cast, into the cavity between jacket and core, the wax counter-model having been removed.

Leonardo knew that the enormous size of the projected statue would necessitate the preparation of a very large, deep casting pit; and here the experience of the geologist reinforced that of the technician. On the same page dated December 20, 1493, he adds to his explanation for casting the horse on its side: "Because the horse measures 12 *braccia*, if I cast it upside down, the water might be as close as one *braccio*." This indicates that he had made a study of the nature of the soil around Milan and the depth of the phreatic layer. From such knowledge stemmed a series of logical and inventive proposals – the need to heat the core in order to eliminate traces of humidity, to bake the jacket so as to make it similarly impermeable (perhaps to do this separately, with a view to breaking it into pieces), to insert iron pins between the core and the jacket, and to construct wooden frames for transporting and lowering the model both for the initial firing and the final casting. Both of these stages are illustrated in the Madrid Manuscript II and the Codice Atlantico. Then, too, there were the considerations as to the best position of the model in the pit – on its feet, on its side, or upside down. Finally, he even envisaged the possible use of several furnaces, a system that was to be employed in the following century.

PORTRAIT OF ISABELLA
D'ESTE GONZAGA
Charcoal drawing, with touches of red chalk, on white paper;
$24\frac{3}{4} \times 18$ in (63×46 cm)
About 1500
Paris, Louvre
The work was acquired by the Louvre in 1860 from the Vallardi collection. The state of preservation is poor.

STUDY OF A FEMALE HEAD
Silverpoint drawing on pink paper;
$12\frac{5}{8} \times 7\frac{7}{8}$ in (32×20 cm)
Windsor, Royal Library
(Inv. no. 12505)
Perhaps a study for the portrait of Isabella d'Este Gonzaga.

Returning to the possible cause for the project not reaching fruition, we can dismiss Michelangelo's malicious suggestion (as reported by the Anonimo Gaddiano) that Leonardo was incapable of putting his ideas into practice. It is far more likely that Il Moro's ambitious and expensive military plans put an end to the scheme. On a page of the Codice Atlantico, dated 1496, alongside what was evidently a minute of a letter to Il Moro, there is this melancholy note: "Of the horse I will say nothing because I know the times." There is an equally gloomy statement on the cover of Manuscript L, from around 1500, after disaster had struck Ludovico: "The duke lost his State, his personal possessions, and his liberty, and none of his enterprises have been completed."

The time spent on independent research into human and animal anatomy was not wasted. During the years when he was working on the Sforza monument, Leonardo was on close terms with members of the Milanese nobility. One of Ludovico's captains, Galeazzo di Sanseverino, owned private stables, and there is a reference in the Windsor Anatomy Manuscripts to "a big jennet" and a "Sicilian stallion," both belonging to "Messer Galeazzo." Also in the Windsor Manuscripts are some marvelous drawings of horses in silverpoint on blue paper as well as detailed measurements of equine proportions and bodily parts. On a page of the Codico Atlantico, he writes: "The Florentine bay of Messer Mariolo, a big horse, has a fine neck and a very fine head. White stallion belonging to the falconer has fine haunches and is at the Porta Comasina. Big horse of Cermonino belongs to Signor Giulio." Also linked with the Windsor drawings is a page in the Madrid Manuscript II (included in the section on casting) that shows the right forefoot and neck of a horse in red chalk, with subtle effects of chiaroscuro.

Leonardo reembarked on this form of research after 1500, at the time of painting *The Battle of Anghiari* and again during his second stay in Milan when he was commissioned to do the Trivulzio monument; and, as already mentioned, in 1504, he listed a "book of horse sketches" among his manuscripts. It is a striking fact that, whereas the resumption of studies for the Sforza monument and the concomitant investigations into equine anatomy go back to 1490, we find, in one of the oldest pages of the Anatomy Manuscripts at Windsor, the following note: "On the 2nd day of April 1489, the book entitled *On the Human Figure*." This is the latest date mentioned in the great mass of material at Windsor devoted to human anatomy (to which are linked many pages in the Codice Atlantico); and some dozen pages are obviously related to this first period in Milan. The rest date from the time that Leonardo resumed his studies on anatomy, biology, and physiology in the first two decades of the sixteenth century.

It is, however, certain (as previously mentioned in connection with *St. Jerome* (in the Vatican) that, from the beginning, Leonardo clearly had in mind a detailed program of inquiry, explanation, and illustration. He was later to develop his ideas in the pages of the Anatomy Manuscripts A, B, and C, the most recent complete edition of which was edited by Kenneth Clark and C. Pedretti in an 1968. Perhaps one can identify such a program in Luca Pacioli's reference, in 1498, to a "book of pictures and human movements"; or possibly the mathematician-monk is alluding to the *Treatise on Painting* assembled by the faithful Francesco Melzi. This work includes a number of rapidly sketched but highly effective drawings of human bodies in movement. The latter claim (and, indeed, it seems the most likely) is expounded by André Chastel, one of the major contemporary experts on Leonardo. In any event, the pages of the *Treatise* range characteristically over a multitude of topics. Notes on perspective and on light and shadow are presented alongside experimentally verified propositions on optics; and intermingled with suggestions as to how to represent human passions and feelings are inquiries into muscular movement in relation to the skeleton and nervous system. In similar fashion, the studies of horses that Leonardo first made in the stables of the Milanese nobility in connection with the Sforza monument were later utilized for *The Battle of Anghiari*. But for this work, they were used as a basis for metamorphic sketches (as in certain of the Windsor pages) that underlined the common "bestiality" of man and animal.

The earliest anatomy drawings at Windsor, therefore, date from the 1490s. The most remarkable ones are those devoted to the human skull and the so-called

PREPARATORY STUDY FOR "VIRGIN AND CHILD WITH ST. ANNE"
Pen and chalk drawing on white paper; $4\frac{3}{4} \times 4$ in (12.1×10 cm)
Venice, Academy (230)
This could be an intermediate idea between the London cartoon and the Paris panel.

VIRGIN AND CHILD WITH ST. ANNE AND THE INFANT ST. JOHN THE BAPTIST
Charcoal cartoon with touches of white lead and soft *sfumato* effects of chiaroscuro; $55\frac{3}{4} \times 39\frac{3}{4}$ in (139×101 cm)
1498–9 (?)
London, National Gallery
This is the only cartoon by Leonardo, together with the one portraying Isabella D'Este, which has survived. After various changes of ownership it came into the possession of the National Gallery in 1966.
Pages 106–107: Detail.

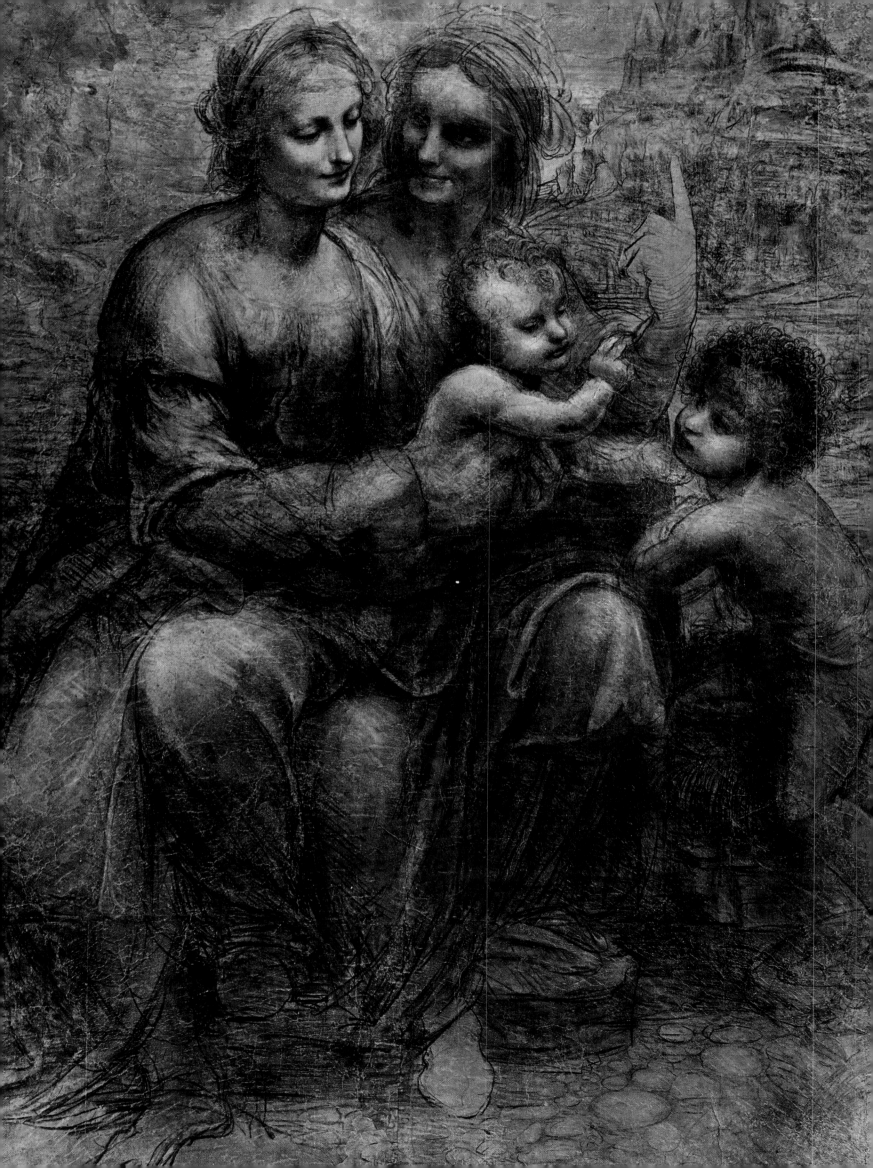

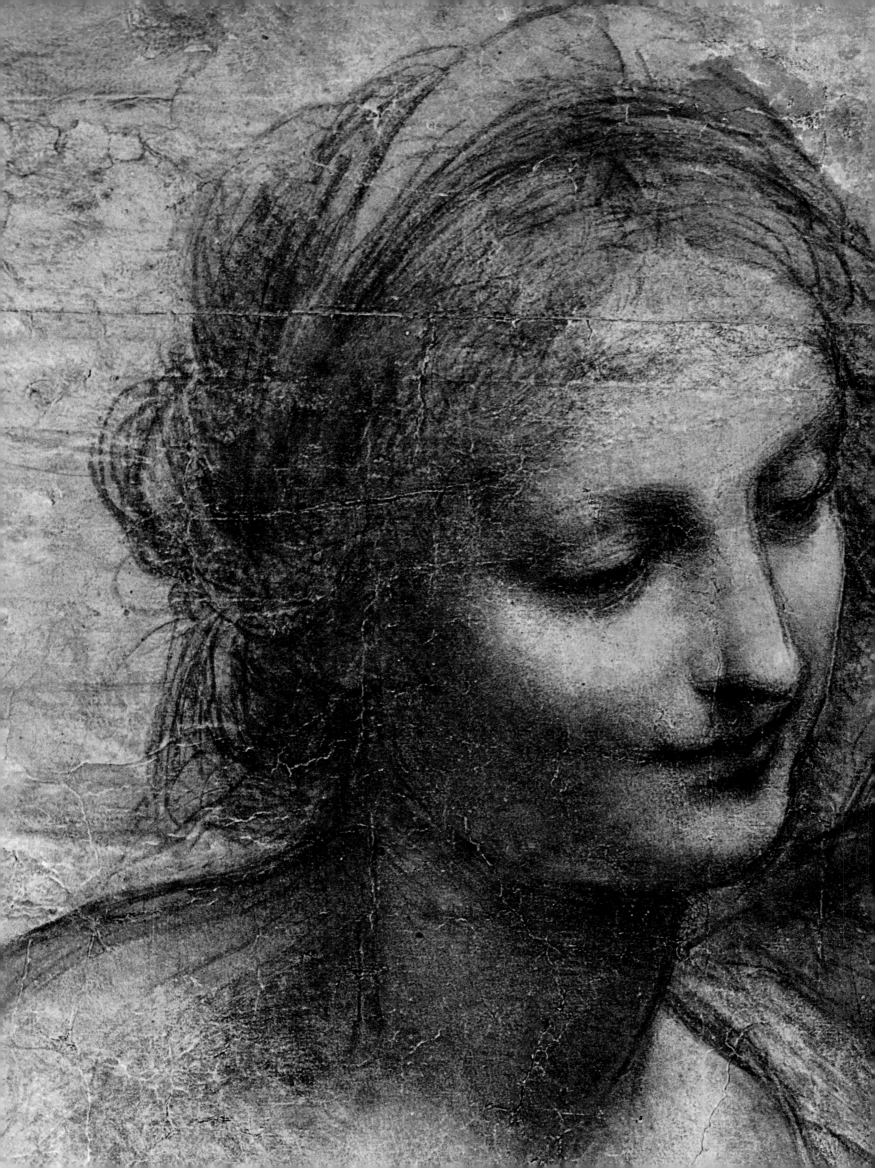

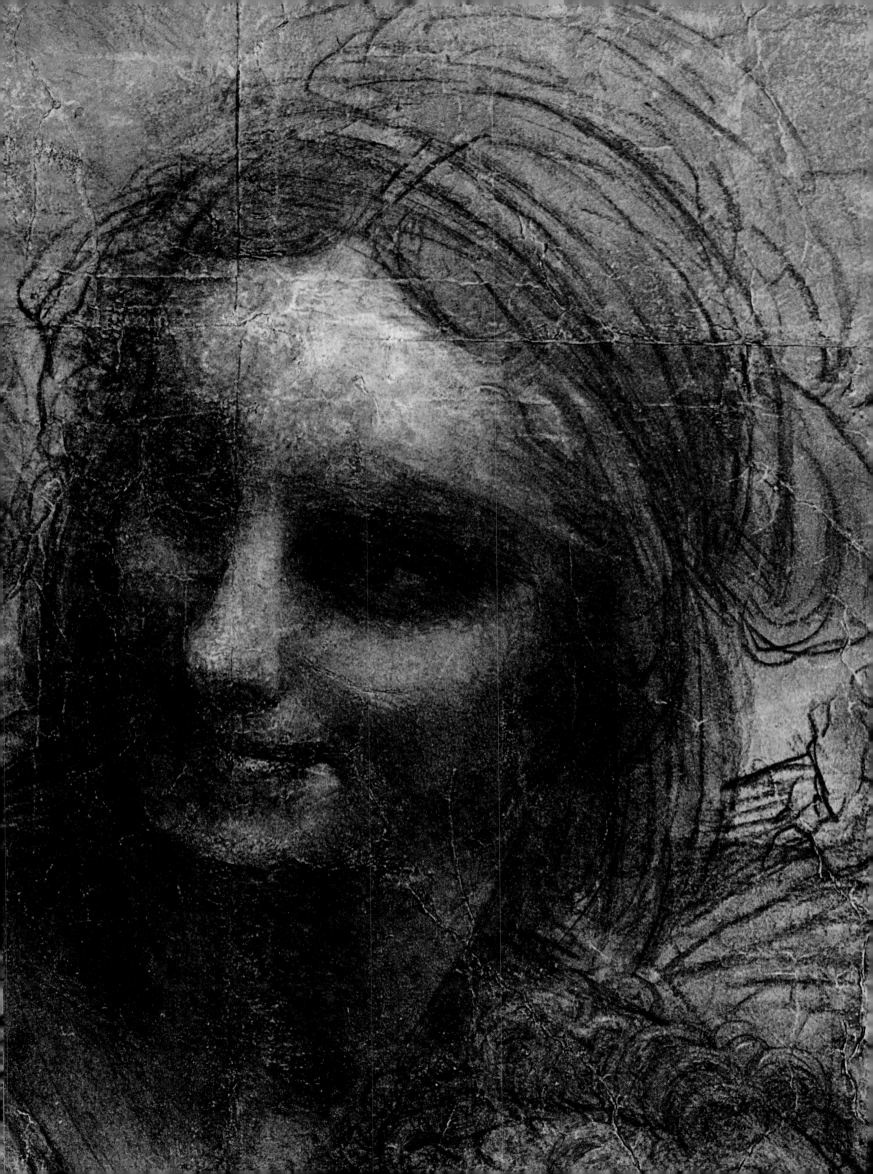

caricatures or grotesques (most of which are at Windsor but some, too, are in the Codice Atlantico and other collections). These heads were to become justly famed, and contemporary artists were soon turning out imitations, several of which were attributed in the nineteenth century to Leonardo himself. Dürer knew of them, as is evident from his *Young Jesus with the Doctors*, among other examples, in the Thyssen-Bornemisza collection at Castagnola in Lugano. Dürer painted this in 1506 in Venice. Leonardo had visited the city six years earlier. The heads are not caricatures in the sense only understood in the late sixteenth and seventeenth centuries but are further vivid examples of Leonardo's unfailing interest in physiology, psychology, and anatomy. The heads demonstrate the infinite variability of the human facial expression. There was no question of satire in what was simply another aspect of inquiry into the human condition along the lines of the comparison between poetry and painting that appears in Manuscript A (1492): "Suppose the poet sets himself to represent some image of beauty or terror, something vile or foul, or some monstrous thing in contest with the painter and suppose, in his own way, he makes a change of forms at his pleasure, will not the painter still satisfy the more? Have we not seen pictures that bear so close a resemblance to the actual thing that they have deceived both men and beasts?"

The Last Supper

All these studies of anatomy, bodily movements, facial expressions and human passions, together with the investigations into the phenomena of space, light, and perspective, found harmonious fulfillment in *The Last Supper*, which Leonardo painted on the wall of the refectory of Santa Maria delle Grazie in Milan. This was one of several works commissioned by Duke Ludovico for the monastery and certainly was the most important commission entrusted to Leonardo. In 1492, Bramante undertook the reconstruction of the east side. By 1495, the new refectory had been completed. Donato da Montorfano had painted a fresco of the *Crucifixion* on the wall opposite that reserved for Leonardo.

The circumstances relating to the commission are vague. It has been assumed that Leonardo repainted part of the *Crucifixion*. As reported by Vasari, Leonardo added to it the portrait heads of Ludovico and Beatrice d'Este. In a letter dated 1497, Il Moro begged Leonardo to complete *The Last Supper* so that he could 'then apply himself to the other wall of that refectory." But it is impossible to establish the truth of this. Baroni's theory that Leonardo received the commission for *The Last Supper* prior to 1495, while the refectory was actually being built, seems more plausible. The painting, even in its present sorry state, harmonizes so perfectly with its surroundings from the viewpoint of size, perspective, and lighting (it is illuminated only by a series of windows in the larger wall to the left), that it may even be supposed that Leonardo had some say in proffering advice on the building of the rectangular refectory itself. In any event, the fresco was probably begun in 1495, and the aforementioned letter from Il Moro to Marchesino Stampa, dated June 29, 1497, indicates that work was well advanced by then. Furthermore, the description contained in Luca Pacioli's dedicatory letter to his book *De divina proportione* (February 8, 1498), in which he also mentions the height of the model of the Sforza horse, suggests an almost finished painting.

So much for the background facts or suppositions. The rest of the story is a sad one. Hardly twenty years later, the fresco was found to be deteriorating, and it was to be further damaged as a result of hasty, ill-advised attempts at restoration. In 1517, Antonio de Beatis, who had visited Cloux with Cardinal Luis of Aragon, noted the first signs of damage caused by the dampness of the wall and the surrounding atmosphere, accurately pinpointing the immediate reason for the deterioration. In the second half of the century, Vasari and then Lomazzo placed the blame on

Leonardo himself for having resorted to an experimental technique: painting in oils (which is untrue) on an unsuitable ground (partly true). It was this theory that led to the disastrous restorations and repainting of the eighteenth and part of the early nineteenth centuries. Scannelli, in the mid-seventeenth century, noted that the decay was far advanced as a result of condensed humidity, the spread of mold, and the flaking away of the color from the surface. Subsequently, he remarked that the condition of the fresco was clearly affected by weather and atmospheric humidity and that the entire surface was damp to the touch and covered by mold.

Only toward the end of the nineteenth century was the problem approached scientifically, by means of physical and chemical analyses. It was now proved that Leonardo had used not oils but a standard type of strong tempera. The cause of the trouble had been the inappropriate nature of the ground – a complex, two-layered composition containing a large quantity of plaster and, thus, highly susceptible to physical and chemical changes aggravated by the damp surroundings. All of these factors had caused damage to the fresco. As a result of this analysis, Cavenaghi attempted a strengthening and salvage operation in 1904–1908 but was hampered by the limited techniques then available. Ironically, it took a war for the painting to be "rescued." In 1943, aerial bombardment half-destroyed the refectory, but the wall with Leonardo's fresco, protected by sandbags, was left intact. Postwar reconstruction created ideal conditions for Pelliccioli to restore the picture literally flake by flake. He removed the repainted sections and treated the original picture surface. The result was an exposure of as much as was left of Leonardo's authentic work.

One can still get an impression, from what survives of the fresco, of the luminous quality of the composition. (It is lit directly by natural light filtering through the refectory windows on the left.) The luminosity is reflected in the large white, painted tablecloth, reinforced by the pictorial light entering by the three apertures in the background, and heightened by the bright colors and skilful use of space. Even when it was in its worst condition, the work must have seemed remarkable for its geometrical precision and perspective, for its intuitive treatment of masses and space in relation to the actual setting, and for the subtle grouping of the human figures. But only as a result of restoration has it been possible to appreciate the expressiveness of the faces and to evaluate the true emotional and spiritual implications of the work. In this strikingly naturalistic context, the reactions of the apostles are dramatically conveyed. They have scarcely had time to digest the announcement that there is a traitor among them, and the central figure of Christ is already isolated, preparing to offer Himself as the sacrificial victim, the Lamb of God. For this reason, *The Last Supper* has rightly been regarded as the first true conceptual and visual representation of the Sacrament of the Eucharist. In this sense, it anticipates, both technically and imaginatively, Raphael's *Stanze* and Michelangelo's Sistine Chapel. It emphasizes the fact that, for eloquence and power, the visual medium was at least the equal of the spoken and written word.

Modern critics have unanimously stressed the extraordinary way in which the gestures and movements of the apostles, grouped in threes, heighten the drama and reinforce the compositional rhythms, all of which come to bear on the central, pyramidal figure of Christ. This, indeed, was clear from the start to Pacioli, who was in constant touch with Leonardo himself. Pacioli states: "It is impossible to envisage the apostles paying greater attention to the sound of the voice of ineffable truth, saying, *Unus vostrum me traditurus est*; and these movements and gestures among themselves, which bespeak their passionate and sad amazement at the words, are worthily and faithfully represented by our Leonardo." We also have the testimony of the painter himself in the Forster Bequest Manuscript II (1495–97), in which he apparently refers to his original notions for the attitudes of the apostles, especially those to the left of Christ the "speaker" and the first group of three to the right, of which only a few were retained in the final version: "One who has been drinking and left the cup in its place and turned his head toward the speaker." (This perhaps refers to Judas.) "Another twists the fingers of his hands together and turns with stern brows to his companion." (This is John.) "Another with hands opened showing their palms raises his shoulders toward his ears and gapes with astonishment." (This refers to Andrew.) "Another speaks in the ear of his neighbor,

Pages 110–111:
VIRGIN AND CHILD WITH
ST. ANNE AND THE INFANT
ST. JOHN THE BAPTIST
London, National Gallery
Detail.

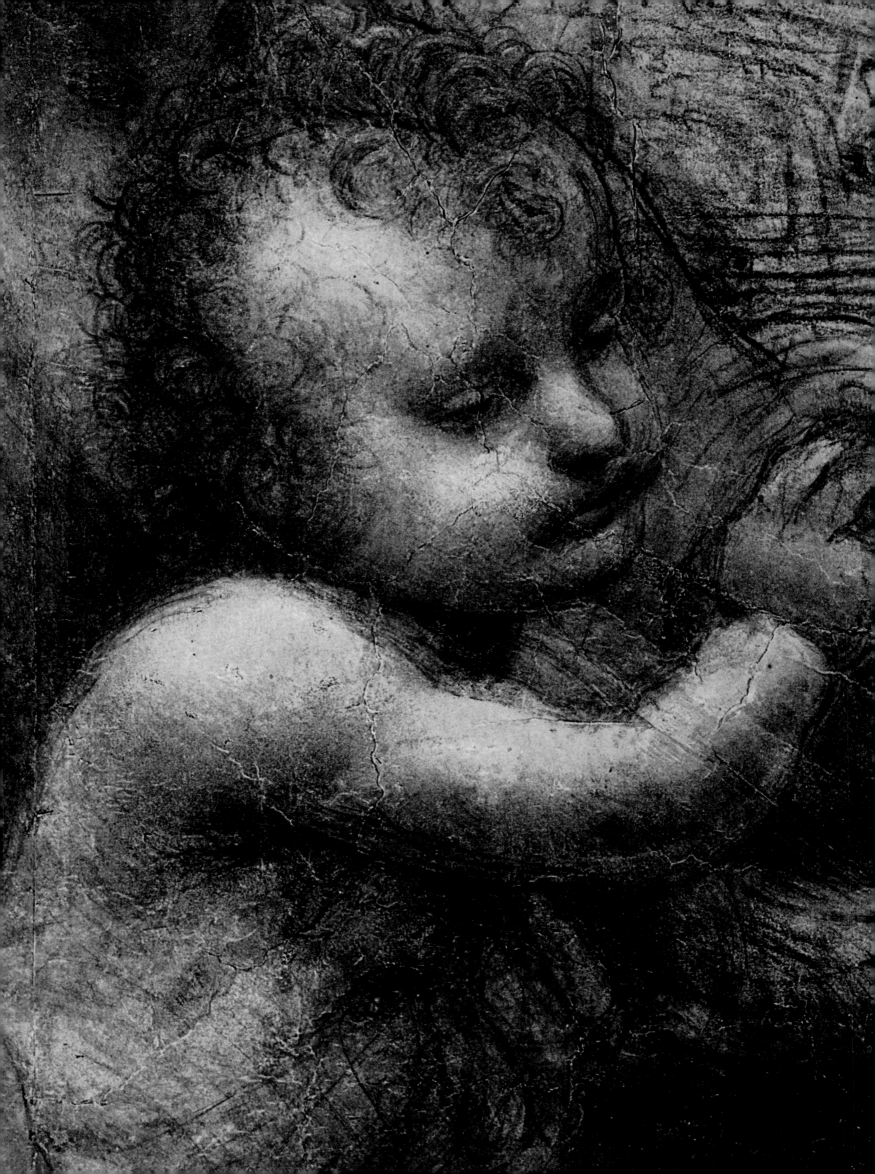

and he who listens turns toward him and gives him his ear, holding a knife in one hand and, in the other, the bread half divided by this knife. The other, as he turns holding a knife, overturns with this hand a glass over the table. Another rests his hands on the table and stares.'' (This is Bartholomew on the extreme left.) ''Another breathes heavily with open mouth. Another leans forward to look at the speaker and shades his eyes with his hand. Another draws himself back behind the one who is leaning forward and watches the speaker between the wall and the one who is leaning.'' (The last phrase may correspond to the first triad on Christ's right that consists of Thomas, James the Great, and Philip.)

The emphasis on wine and bread, symbolizing the Eucharist, is very pronounced; but even more remarkable is the dominating presence, suggested but not underlined, of the "speaker," who is the central reference and origin of all the gestures and attitudes so concisely yet vividly portrayed in the other protagonists. It is sheer intuitive genius that isolates the calm figure of Christ amidst the apostles and their turmoil of conflicting feelings. It is hard to visualize the effect of the original painting, when the natural light from the left side illuminated the painted wall on the right. This would have thrown into relief the larger than life-size figures and given an added sense of depth to the refectory itself. It must have been marvelously theatrical, particularly in conjunction with the upper lunettes decorated with garlands and Sforza coats of arms. But there could be no doubt that the focal points of the whole composition were the blue and red garments and the head of Christ, bathed in the soft light of the sky seen through the door in the background. It is from His head that all the lines of perspective radiate horizontally to embrace the triads of apostles and to form a geometrical pattern unifying every part of the fresco.

Leonardo's extraordinary inventiveness as an "engineer" was really wasted on a patron whose megalomanic policy was to culminate in disaster, just as the inner qualities that inspired him to paint *The Last Supper* were incomprehensible to the munificent protector of the churches of Sante Maria delle Grazie and the Certosa di Pavia. Indeed, throughout his first period in Milan, Leonardo threw himself enthusiastically into all the worldly activities of the Sforza court, with its love of luxury and elegance. The atmosphere was reaching to rival that of the Visconti *signoria* that Francesco Sforza had finally overthrown in 1450. According to Vasari: "By the splendor of his magnificent appearance, he comforted every sad soul, and his eloquence could sway men first to one side, then to the other, in a conversation. His personal strength was prodigious; and, with his right hand, he could bend the clapper of a knocker or a horseshoe as if they had been of lead." Handsome and energetic, Leonardo was a musician, a singer, an improviser of verses, an inventor of devices and riddles (there are entire pages of them, written and drawn, at Windsor) the author of fables and allegories, and the organizer of tournaments and spectacles for special occasions. Between the ages of thirty and fifty-five, this remarkable man, who spent so much of his time in studies and experiments and who numbered among his friends Bramante, Gaffurio, and Luca Pacioli, frittered away many years in court life (apart from a brief eclipse, for obscure reasons, in 1496–97).

The manuscripts dating from the first Milan period, especially many pages in the Codice Atlantico, Forster Bequest Manuscripts, and Manuscript H (around 1494), contain a wealth of fables, tales, allegories, aphorisms, prophecies, written and illustrated devices and verses, some original and others derived from sources such as Dante, Petrarch, Cecco d'Ascoli (*L'Acerba*), and the *Fior di Virtu*. The following are from the Codice Atlantico: "As iron rusts from disuse, stagnant water loses its purity and, in cold weather, becomes frozen, so does inaction sap the vigor of the mind." That comes from a group of aphorisms; and the following is a typical fable: "Once upon a time the razor, emerging from the handle that served it as a sheath and placing itself in the sun, saw the sun reflected on its surface, at which sight it took great pride, and turning it over in its mind, began to say to itself, 'Am I to go back anymore to that shop from which I have just now come away? No, surely! It cannot be the pleasure of the gods that such radiant beauty should stoop to such vile uses! What madness would that be which should induce me to scrape the lathered chins of rustic peasants and to do such menial service? Is this body made for actions such as these? Certainly not! I will go and hide myself in some retired spot, and there

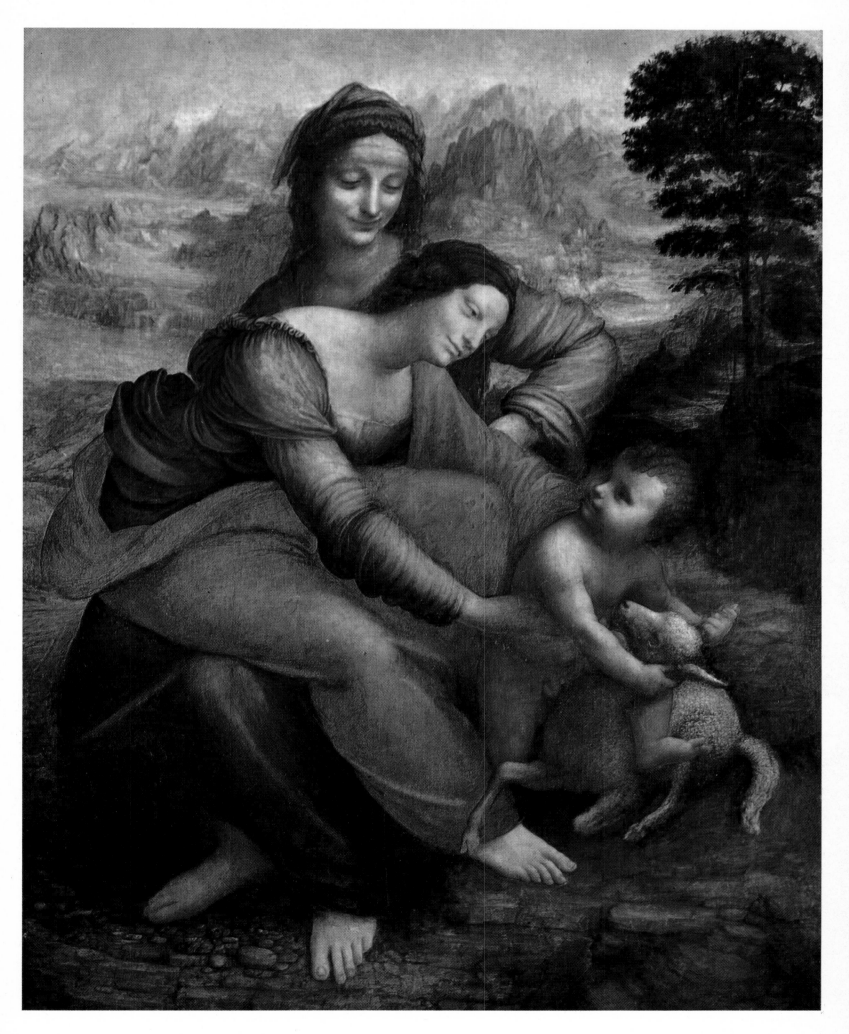

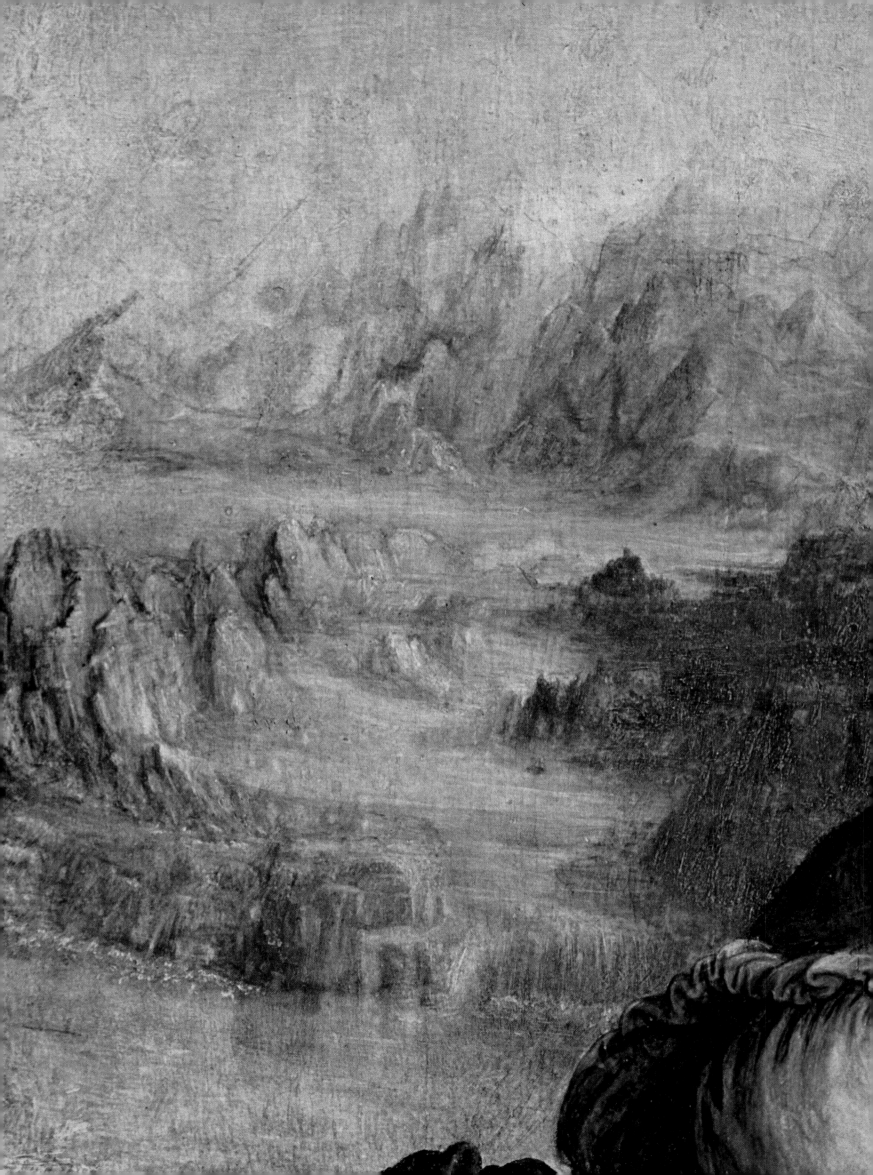

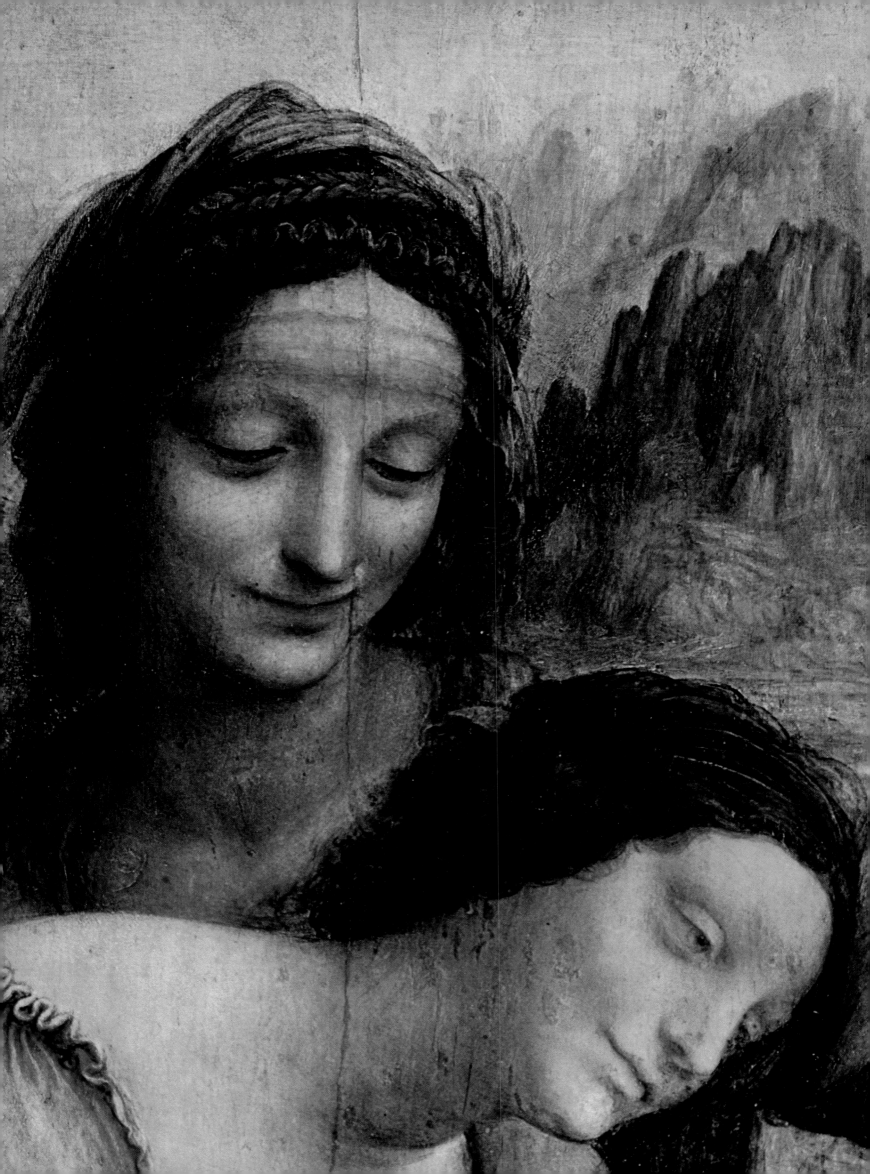

pass my life in tranquil ease.' And so, having hidden itself away for some months, returning one day to the light and coming out of its sheath, it perceived that it had acquired the appearance of a rusty saw and that its surface no longer reflected the sun's radiance. In vain, with useless repentance, it bemoaned its irreparable hurt, saying to itself, 'Ah, how much better would it have been to let the barber use that lost edge of mine that had so rare a keenness! Where now is the glittering surface! In truth, the foul insidious rust has eaten it away!' The same thing happens with minds that, instead of exercise, give themselves up to sloth; for these, like the razor, lose their keen edge, and the rust of ignorance destroys their form.''

Here are some further observations: "Whoever in discussion cites authority (Leonardo's bête noire) uses not intellect but rather memory. ... O thou that sleepest, what is sleep? Sleep is an image of death. Oh, why not let your work be such that, after death, you become an image of immortality, as in life you become when sleeping like unto the unfortunate dead?'' "Man and the animals are merely a passage and channel for food, a tomb for other animals, a haven for the dead, giving life by the death of others, a coffer full of corruption. ... Rarely does he who walks well fall.''

In a different vein is this short anecdote: "A man, spotting a woman decked out for a tournament, looked at his plank bed and cried out, seeing his lance, 'Alas, this is too small a worker for such a large workshop!'" This is from Manuscript F, dated 1508, but there are similar scurrilous stories in Manuscript C, from the Sforza period. From Manuscript H comes the remark: "Good Report soars and rises to heaven, for virtuous things find favor with God. Evil Report should be shown inverted, for all her works are contrary to God and tend toward hell.''

The final example is an allegory from a page at Windsor: "Truth – the sun. Falsehood – a mask. Innocence – Malignity. Fire destroys falsehood, that is sophistry, and restores truth, driving out darkness. Fire is to be put for the destroyer of every sophistry, and the revealer and demonstrator of truth, because it is light, the banisher of darkness that is the concealer of all essential things. Fire destroys all sophistry, that is deceit; and maintains truth alone, that is gold. Truth in the end cannot be concealed. Dissimulation profits nothing. Dissimulation is frustrated before so great a judge. Falsehood assumes a mask. Nothing is hidden beneath the sun. Fire is put for truth because it destroys all sophistry and lies, and the mask for falsity and lying by which the truth is concealed.''

Among the studies for allegorical costumes and heraldic devices for feast days, tournaments, and spectacles is the following excerpt from the British Museum Arundel Manuscript. "On the left side let there be a wheel and let the center of it cover the center of the horse's hinder thigh-piece, and in this center should be shown Prudence, dressed in red, representing Charity, sitting in a fiery chariot, with a sprig of laurel in her hand to indicate the hope that springs from good service. On the opposite side, let there be placed, in like manner, Fortitude, with her necklace in hand, clothed in white that signifies ... and all crowned, and Prudence, with three eyes. The housing of the horse should be woven of plain gold, bedecked with many peacocks' eyes, and this applies to all the housings of the horse and the coat of the man. The crest of the man's helmet and his hauberk of peacocks' feathers, on a gold ground. Above the helmet, let there be a half-globe to represent our hemisphere in the form of a world and on it a peacock, with tail spread out to pass beyond the group, richly decorated, and every ornament that belongs to the horse should be of peacocks' feathers on a gold ground to signify the beauty that results from the grace bestowed on him who serves well. In the shield, a large mirror to signify that he who really wishes for favor should be mirrored in his virtues.''

There is documentary evidence of Leonardo's "production" for the grandiose Festa del Paradiso in 1490 to mark the wedding of Il Moro's nephew and nominal duke, Gian Galeazzo Sforza, and Isabella of Aragon. He also had a hand in the equestrian masquerade in the house of Galeazzo di Sanseverino in 1491 (for which he designed the costumes mentioned in the passage just quoted) to celebrate the marriage of Ludovico and Beatrice d'Este. In the same year, he helped stage a comedy on the theme of the amours of Jove and Danae, as based on a text by the Moor's chancellor Baldassare Taccone, in honor of the wedding of Anna Sforza and Alfonso d'Este.

MAP OF THE COURSE OF THE ARNO
Pen and watercolor drawing;
$8\frac{7}{16} \times 11\frac{1}{2}$ in (21.4 × 29.2 cm)
1503
Madrid, National Library
(Madrid MS II, p. 52 *verso* and p. 53 *recto*)
The map, covering two pages, shows the Arno and the area of military operations around Pisa.

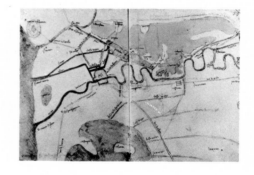

AREZZO AND THE CHIANA VALLEY
Chalk, pen and bistre drawing;
$8\frac{1}{4} \times 11\frac{1}{16}$ in (20.9 × 28.1 cm)
Windsor, Royal Library
(Inv. no. 12682)
A topographical relief map of the valley and the city, perhaps done while Leonardo was serving with Il Valentino in 1502–3.

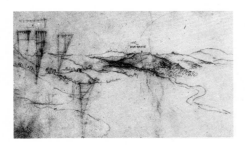

General references to these carnivals and pageants are to be found in the splendid costume drawings in the Windsor collection, although Kenneth Clark now ascribes these to a later period, during Leonardo's last stay in France at the court of Francis I. Such diversions were typical of the times (it is worth recalling the two *Triumphs* that Piero della Francesca painted on the reverse of the portraits of Federigo da Montefeltro and Battista Sforza). Leonardo seems to have conformed to a neo-Gothic style of decoration that was characteristically northern. This was the prevailing taste at the court of Emperor Maximilian of Austria, who was married to Il Moro's niece Bianca Maria; and the emperor retained the services of the artist Dürer in the same manner as Ludovico employed Leonardo. The entwined knots and osiers, already mentioned in relation to the putative *Portrait of Beatrice d'Este*, were motifs typical of this courtly taste. Vasari alludes to these less significant activities, too, but he adopts a rather supercilious, ironic tone, not necessarily out of spite but probably because of an inability to understand the boundless scope and variety of Leonardo's interests. In Vasari's view, all such peripheral diversions were bound to be detrimental to "artistic productivity." Thus: "He spent much time in making a regular design of a series of knots, so that the cord may be traced from one end to the other, the whole filling a round space."

Apart from writings and drawings, there is one surviving piece of evidence of Leonardo's "courtly" activity, namely the decoration of the Sala delle Asse in the Sforza Castle, Milan, where the same knots appear as a gold motif intersected by branches and leaves. As now restored, this decorative work is an interesting and unique example of a form of artistic activity that was, by definition, transitory but that, in this instance, provided Leonardo with an opportunity to establish a permanent record of his skills. There are two letters written by Il Moro to his intimate friend Gualtiero da Bascapé. In them, he mentions Leonardo's decorative pursuits, dated 1495 and 1498, in the Castle. One of them specifically refers to the Sala delle Asse, a room on the ground floor of the tower facing northeast. At some undisclosed time, the room was plastered. The decayed fragments of the original decorative work were rediscovered in 1893 and were drawn by Luca Beltrami. In 1901–1902, Beltrami supervised the restoration program. The entire decorative pattern was painstakingly remodelled, following the line of the rediscovered fragments, by E. Rusca.

Leonardo, almost certainly with the assistance of his pupils, conceived the idea of a trompe-l'oeil transformation of the arched ceiling of the Sala, comprising sixteen lunettes, into a latticework of branches and foliage stemming from trunks painted on the side walls. These naturalistic motifs were rhythmically intertwined with "knots," all converging at the top toward the heraldic crest of Ludovico Il Moro. Four large central tablets were covered with writing in celebration of the duke's military exploits. The entire production was similar to the heraldic decoration of the lunettes above *The Last Supper*, on which Leonardo was working at about the same time. The original impression, with its rhythmical, treelike pattern sweeping across the great arched ceiling, must have appeared to be a marvelous example of "natural architecture." It had the atmosphere of those outdoor carnivals and courtly diversions for which Leonardo had provided decorative effects, yet it was modeled on that precise neo-Gothic in origin tradition of decoration that prevailed in northern Europe. It was a style that was readopted in 1518–19, possibly under the influence of Leonardo and Mantegna, by Correggio, in his decoration of the ceiling of the Abbess's Parlor in the convent of San Paolo at Parma, and by Parmigianino, around 1523, when he decorated the ceiling of Paola Gonzaga's room in the Castle of Fontanellato.

The naturalistic quality of these branches and leaves is reflected in Leonardo's wonderful botanical drawings, the finest of which are in the Windsor collection. The majority of these admittedly derive from a later period. According to experts, they date from the early decades of the sixteenth century and relate to the studies for *Leda* or are associated with the botanical notes and illustrations contained in Manuscript G (1511–15). Some drawings, however, were certainly done during the first Milan period, as, for example, a magnificent page in the Venice Accademia. Furthermore, on a page of the Codice Atlantico, generally attributed, on the evidence of the handwriting, to the beginning of this Milan period, there is a list of

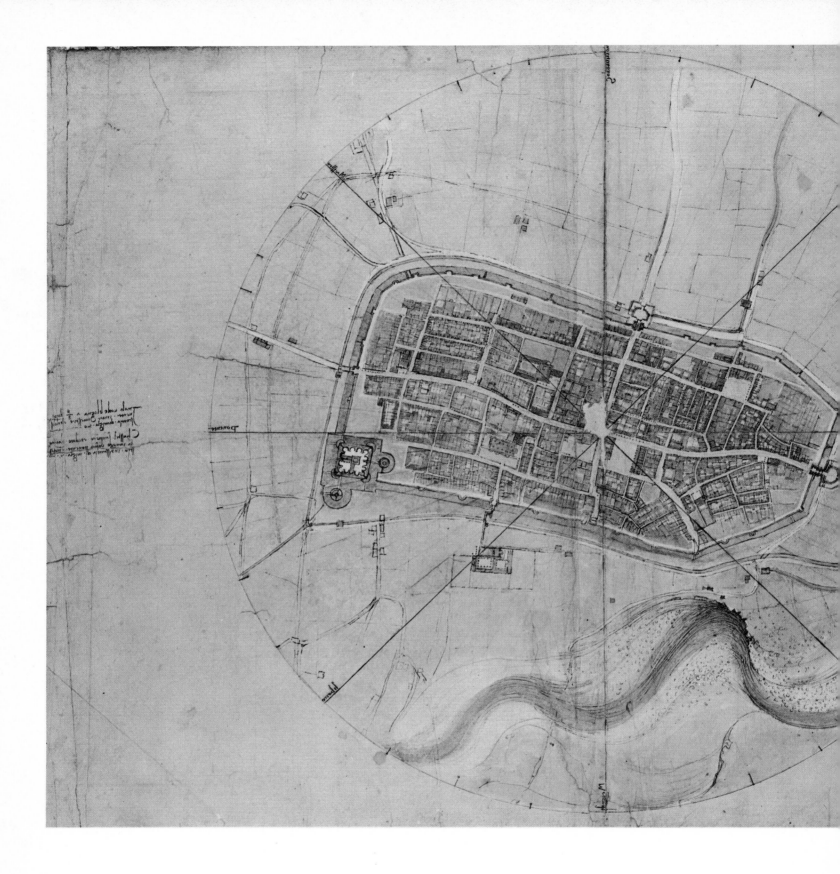

his own works that includes "Many flowers drawn from Nature." The clearest testimony, however, to Leonardo's talent for naturalistic painting at this stage of his life is offered by the vegetation in *Virgin of the Rocks*.

The repainting of the Sala delle Asse in 1901–1902 unfortunately obscured the naturalistic effect of the original decorative scheme; and it was not until further restoration, which was attempted in 1954–56 and concentrated on the lunette and the groin in the northeast corner of the room, that the real quality of Leonardo's decoration came to light. It was now clear that the original draft, in tempera, was hardly visible and that the mass of greenery was less dense than suggested by Rusca's repainting. There had been more space between the constituent parts so that the interlacing of branches and gilded knots was more sharply defined. Of even greater interest was the discovery of two large monochrome sections on the walls

PLAN OF IMOLA
Pen and watercolor drawing;
$17\frac{3}{8} \times 23\frac{3}{4}$ in (44 × 60.2 cm)
1502
Windsor, Royal Library
(Inv. no. 12284)
The local names of the winds appear, in Leonardo's own hand, clockwise from north-east to north, as follows: "Grecho/Levante/scirocho/Mezzodi/libecco / Ponente / Maesstro / Septan-trione."

that depicted intertwined roots and trunks arising from geological formations of earth and rock. Beltrami, in fact, had noticed these but had judged them, mistakenly, to be later decorative experiments. Actually, these wall motifs testify, without any shadow of doubt, to Leonardo's very presence in the room, since no one else, apart from his great contemporary Dürer, was capable of executing a work of such high technical precision and imaginative scope. But quite apart from the exceptional quality revealed in these fragments, there is a strongly suggested sense of excitement and restless movement that communicates itself subjectively to the observer, who is confronted by these serpentine writhings of organic nature over inorganic forms, and objectively in the overall conception of the room. Presumably, Leonardo, although his terms of reference were limited to the ceiling, intended the decorative scheme to involve the whole room, with the trunks rearing up from the walls. The conception was fundamentally and wholly decorative, yet it was a forerunner, in abbreviated, experimental guise, of those cataclysmic visions of nature transformed into cosmic cycles of life and death that characterized the drawings of *Deluges,* dating from Leonardo's last period. As Heydenreich has rightly pointed out, the turbulent element of these decorative sketches anticipates, both in idea and in practice, the dramatic, expressive "conflict" between "nature" and "art" that is a feature of mannerist poetry. It manifests itself in visual terms more than thirty years later in Giulio Romano's Sala dei Giganti, in the Palazzo del Té at Mantua.

The *Virgin and Child with St. Anne*

In 1499, the forces of Louis XII of France invaded the duchy of Milan, driving out Ludivico the Moor. Among those who left the city were men of letters, art, and science attached to the court. These included Leonardo, Pacioli, and Bramante. Eighteen years of work and service to Il Moro had certainly not made Leonardo rich. In recognition of fees due, Ludovico had made him a gift, in the summer of 1498, of a

PROJECT FOR A FORTRESS
Detail
Pen drawing; $8\frac{1}{2} \times 11\frac{9}{16}$ in
(21.6 × 29.4 cm)
Milan, Ambrosian Library
(Codice Atlantico, p. **48** *recto*).

suburban vineyard between Santa Maria delle Grazie and San Vittore al Corpo. This was to be restored to him by the French in 1507. Prudently, Leonardo had sent 600 gold florins for safekeeping to the Hospital of Santa Maria Nuova in Florence. Now he embarked on a wandering life that enabled him occasionally to combine artistic professionalism and scientific versatility. Although, by this time, he clearly enjoyed a reputation for "universality" throughout northern and central Italy, he seemed to be continually searching for something. He may have been looking for a settled environment with cultural associations that would provide an outlet for his many-faceted talents. Such an atmosphere would have been similar to the one he had been compelled to abandon in Milan. By personal inclination (and it was more a matter of character and temperament than politics or ideology), the first Milanese experience had led him eventually to equate that ideal environment with the figure of a

protective lord or sovereign. It may be that he was consciously or subconsciously seeking a patron as he traveled northward, before returning to republican Florence and then once in his native land to other cities. During this time, he did not lack recognition and obtained a number of commissions; but it was not until 1507 that he returned to Milan in the company of Louis XII and Charles d'Amboise.

The first phase of this nomadic interlude occurred in Mantua, where he met Isabella d'Este, wife of Gian Francesco Gonzaga. There is mention in letters of two portraits (whether drawn or painted is not known), one retained in Mantua and presented, in 1501, by Isabella's husband to an unidentified person and the other taken to Venice by Leonardo himself. The duchess pleaded with Leonardo vainly for some years to do a new portrait of her. In 1860, the Louvre acquired the Vallardi collection, including a large cartoon (sixty-three-by-forty-six centimeters, or twenty-five-by-eighteen inches) in charcoal and red chalk, with additional touches of red and yellow. It was riddled with small holes for pouncing, signifying the last phase of preparation prior to painting. It depicts the bust and head of a woman, which Yriarte, in 1888, suggested could be identified as one of the two portraits of Isabella. After some doubts in the early twentieth century, this theory is now accepted by most authorities. The head is in profile, and some critics have compared it with the putative *Eleanora d'Este* in the Ambrosian Library. This is untenable not only because the modeling of the face in the former portrait is unmistakably typical of Leonardo (the slightly spherical shape of the eyeball is sufficient proof) but also because of the generous mass of hair and the fullness of the three-quarter-view bust. The portrait perfectly represents an intermediate stage between the youthful *Ginevra de' Benci* and the mature *Mona Lisa*. Associated with this picture, likewise for physical reasons, is a vigorous silverpoint drawing of a female head from Windsor.

In due course, Leonardo traveled on to Venice, where, in March 1500, he met a friend of Isabella d'Este, Lorenzo Gusnasco. The only relic of this visit is the draft of letter (contained in the Codice Atlantico) written by Leonardo to the Venetian Senate. In it, he proposed a method of defending the surrounding country against Turkish attacks from Bosnia. Back in 1492–93, Turkish troops had invaded the valley of the Isonzo near Villach. Now Leonardo suggested flooding the Isonzo valley with its strategic strong point of the Gorizia Bridge, dominating the only main road in the area. A note on the same page mentions "Ponte di Gorizia/Vilpago alta," and accompanying sketches indicate that Leonardo had actually visited Gorizia and Vipava, on the old Roman road over the Nauporto Pass.

Despite the absence of documentation, it is significant that Leonardo was in Venice in 1500, when Giorgione was twenty-two years old, and that the latter's style, based on the effects of color and light, soon showed signs of having absorbed the lesson of Leonardo's sfumato, not to mention the more precise resemblances of his *Laura* in Vienna and his *Judith* in Leningrad. It is worth recalling, too, that Dürer, during his own stay in Venice, may also have been influenced by Leonardo.

In August 1500, there is evidence that Leonardo, having sent his belongings to Vinci the previous year, was now back in Florence. He was the guest of the Serviti della Santissima Annunciata and received from the monks a commission for an altarpiece. This is how Vasari describes the work: "At length he drew a cartoon of the Virgin and St. Anne with a Christ, which not only filled every artist with wonder, but, when it was finished and set up in the room, men and women, young and old, flocked to see it for two days, as if it had been a festival, and they marveled exceedingly. The face of the Virgin displays all the simplicity and beauty that can shed grace on the Mother of God, showing the modesty and humility of a Virgin contentedly happy in seeing the beauty of her Son, whom she tenderly holds in her lap. As she regards it, the little St. John at her feet is caressing a lamb, while St. Anne smiles in her great joy." There is another description by Father Pietro da Novellara, dated April 3, 1501: "He painted Christ as a child of about a year old, stretching almost out of his Mother's arms and seizing a lamb, apparently about to embrace it. His Mother, half-rising from the lap of St. Anne, seizes the child to pull it away from the lamb." There is an obvious discrepancy between these two descriptions, one of which refers to a group of four around the lamb and the other mentioning only three, also with the lamb.

Pieter Paul Rubens
COPY OF "THE BATTLE OF
ANGHIARI"
Chalk and pen drawing retouched in
gray gouache and white lead;
$17\frac{13}{16} \times 25\frac{1}{16}$ in $(45.2 \times 63.7$ cm)
Paris, Louvre, Drawings Room
(20271)
This is the most famous copy of a
completely lost work which the gonfa-
loniere Soderini commissioned Leon-
ardo to paint in 1503. It was to have
decorated a wall of the Grand Council
room of the Palazzo Vecchio in Flor-
ence. The theme of the Battle of
Anghiari was chosen to mark the
victory of the Florentines against the
Milanese troops of Filippo Maria Vis-
conti in 1440. Leonardo abandoned the
work in 1505/6.

Today we know that there are two versions of the *Virgin and Child with St. Anne* –
the cartoon in charcoal and white lead (in the National Gallery, London) and the
unfinished panel in oils (in the Louvre). The story of the former version begins in the
middle of the seventeenth century. It is not possible to vouch for the accuracy of the
reference by Lomazzo to a cartoon, probably but not certainly the one in question,
owned by the Milanese painter Bernardino Luini. Luini was influenced by Leonardo
and was, in fact, responsible for a copy in oils of this subject (now in the Pinacoteca
Ambrosiana). The cartoon was then reputedly passed on to Bernardino's son
Aurelio. More trustworthy is the reference by a Milanese merchant, collector, and
art expert named Father Sebastiano Resta to an initial draft of the work, dating
from before 1500, in the possession of the Counts Arconati in Milan. Resta,
incidentally, believed himself to be the owner of the original cartoon, but this has
actually proved to be a good contemporary copy of the Louvre panel (now in the
Szépmüvészeti Museum, Budapest). The cartoon was acquired by the Casnedi

family and later by the Sagredo family in Venice. They sold it to the English
ambassador, Robert Udny, in 1763; and, in 1791, it appeared at Burlington House,
home of the Royal Academy. Finally, it was acquired by the National Gallery in
1966.

The cartoon does not correspond to either of the descriptions of the Florentine
version, for it contains the figure of St. John but not of the lamb. Modern critics have
therefore tended to accept Resta's evidence and assign it to the final years of the
Milan period. The panel in oils was taken by Leonardo to France (it was seen in his

possession by de Beatis in 1517) and later brought back to Italy by Leonardo's heir Francesco Melzi. It is not known how it found its way to Casale, but it was there, during the second war of Montferrat in 1629, that Cardinal Richelieu discovered it. He offered it to Louis XIII in 1636, and it was acquired by the Louvre in 1810. The subject matter of the panel fits the description by Novellara (who uses the term *painted*, not *drew*) but not that of Vasari.

Some modern authorities, having agreed that the London cartoon must have been drawn prior to 1500 because of the contradictory written descriptions, have suggested that there may have been two cartoons, both of which were lost. They saw the first cartoon as being the one mentioned by Vasari as having aroused the admiration of the citizens of Florence (representing a halfway phase between the National Gallery cartoon and the Louvre panel) and the second as being the one that Novellara describes, as a cartoon for the panel itself. But remembering that Novellara used the word *painted*, one can arrive at yet another possible conclusion. Critics, basing their opinion on stylistic grounds but without any definite evidence, tend to think that Leonardo did part of the work on the Louvre panel between 1506 and 1510, during his second visit to Milan. However, it is possible that after doing the cartoon mentioned by Vasari, Leonardo began sketching the panel at a much earlier date. (The much reiterated argument about Leonardo's slow work-rate can hardly be sustained here, for it was not invariably true. After all, Berensen has claimed that the portrait of Isabella, in its immediacy, may well have been done at a single sitting; and in this case, too, we are dealing with a cartoon, not a painting.) In that case, Novellara might have seen and described the iconological plan of the panel itself in April 1501, and not what has been assumed to be a cartoon. If either theory is correct, it is worth stressing the remarkable fact that Leonardo, soon after doing the cartoon described by Vasari (which conveyed his general intentions if not all the structural details) and presumably flattered by its public reception, immediately went on, within a matter of months, to draw or paint a later, different version. Thus, the advance in structural conception and pictorial quality that is evident in the transition from the London cartoon to the Paris painting may have occurred within a comparatively short period.

This helps us to understand the exact meaning of the "dissatisfaction" that, according to a number of sources, Leonardo felt toward his artistic achievement. This is mentioned by the Anonimo Gaddiano: "He had very fine inventions but did not paint many things, because he never admitted to himself that he was satisfied and therefore his works are very rare." The point is emphasized by Vasari: "His knowledge of art, indeed, prevented him from finishing many things that he had

HORSEMEN WITH STANDARDS
Charcoal drawing on white paper stained yellow; $6\frac{5}{16} \times 7\frac{3}{4}$ in
(16×19.7 cm)
Windsor, Royal Library
(Inv. no. **12339**)
A preparatory study for *The Battle of Anghiari*.

Leonardo (?)
STUDY OF HORSEMEN
Pen drawing on white paper;
$6\frac{11}{16} \times 4\frac{15}{16}$ in (17×12.5 cm)
Florence, Uffizi Gallery, Drawings and Prints Collection.

REARING HORSE WITH
OUTLINE FIGURE OF THE
RIDER
Red chalk drawing on pink-tinted
paper; $6 \times 5\frac{5}{16}$ in (15.3 × 14.2 cm)
Windsor, Royal Library
(Inv. no. 12336).

begun, for he felt that his hand would be unable to realize the perfect creations of his imagination." Certainly the notebooks contain a considerable amount of self-criticism, as one might expect of such a perfectionist. Again, the striking feature of the development of *Virgin and Child with St. Anne* is the continual urge, regardless of material or public success, to experiment, to transform, to improve, and to evolve new ideas and techniques.

The London cartoon may, at the same time, be regarded as a summation of Leonardo's experience during his first period in Milan, from the *Virgin of the Rocks* to *The Last Supper,* and as a foretaste of new artistic conceptions soon to be formulated by his contemporaries. One of the most notable examples is Michelangelo's two *tondi,* sculpted in bas-relief. Both of these depict the Virgin, the

Christ Child, and St John. One was carved for Bartolomeo Pitti (Bargello, Florence) and the other for Taddeo Taddei (Royal Academy, London). Another famous example is Michelangelo's *tondo* of the Holy Family, the so-called *Madonna Doni* (in the Uffizi), painted for Angelo Deni. All three date from 1503–1505. There are also drawings by Michelangelo (in the Ashmolean Museum, Oxford, and in the Louvre) that are variant versions of Leonardo's *St. Anne*. Then, too, there are the great paintings of the Holy Family done by Raphael during his last years in Florence, before being summoned to Rome in 1508.

When Leonardo returned to Florence in 1500, he found the place greatly changed. Lorenzo the Magnificent had died in 1492; and, in 1494, his son Piero had been forced to leave as a result of the invasion of Charles VIII of France. A rigorous republican theocracy, dominated by Savonarola, had then been set up. It was very different in character from the humanistic government of the Medicis. In 1498, Savonarola was excommunicated by the Borgia Pope Alexander VI and was then hanged and burned. In the ensuing years, the uncertainties of a republican oligarchy gave Pisa the opportunity to break loose from Florentine domination and favored the aggressive expansionist policies of the papal state, first under Alexander VI and his son Cesare ("Il Valentino"), who, in 1501, wrested the city of Piombino from Jacopo IV Appiano and then under Julius II. Of the artists of Leonardo's own generation, some were still active but hampered by a cultural climate that *The Adoration of the Magi* had briefly shattered twenty years previously. They included Lorenzo di Credi, Piero di Cosimo, Perugino, Botticelli, and Filippino Lippi. Although the cultural and idealistic attitudes of the two last-named artists were opposed, they displayed stylistic resemblances. Both were staunch defenders of the now-outmoded traditions of Florentine art, although they preserved some of its unorthodox, antinaturalistic features that were to blossom again in mannerism. The stimulus of new ideas, more in keeping with Leonardo's own, came from younger men. They included Dominican Bartolomeo della Porta (born in 1472), who, after going through a personal crisis caused by the death of Savonarola, began painting again in 1504, and the youthful Andrea del Sarto (born in 1486). Raphael arrived in Florence in 1504. His links with Leonardo were strictly professional – a simple question of stylistic influence.

Michelangelo's relationship to Leonardo was much more complicated. There is no doubting that the two were rivals. Michelangelo, now twenty-six years old, came

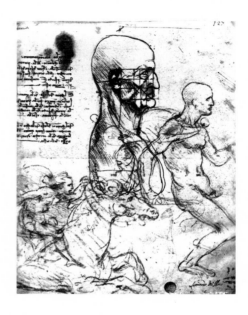

STUDY OF HUMAN
PROPORTIONS AND
HORSEMEN
Pen and red chalk drawing;
11 × 8¾ in (27.9 × 22.3 cm)
Venice, Academy
Modern critics consider that the studies of the proportions of the human torso date from around 1490, while the horsemen relate to preparations for *The Battle of Anghiari*.

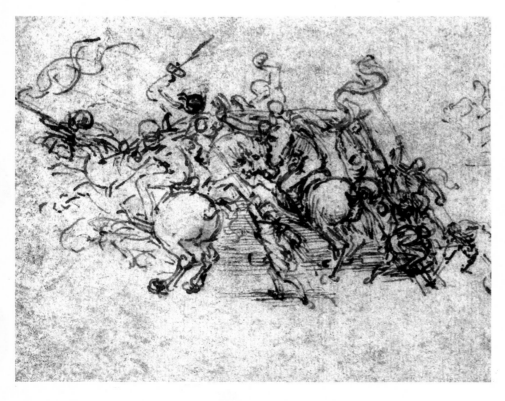

STUDY FOR A BATTLE WITH
CAVALRY AND INFANTRY
Pen drawing on yellowish paper;
6½ × 6 in (16.5 × 15.3 cm)
Venice, Academy
(page 215 *recto*)
Detail of a page of studies for *The Battle of Anghiari*.

STUDY OF TWO GROUPS OF
FIGHTING HORSEMEN
Pen drawing on yellowish paper;
5¹¹⁄₁₆ × 6 in (14.5 × 15.2 cm)
Venice, Academy
(page 215 A *recto*, detail)
A preparatory sketch for *The Battle of Anghiari*.

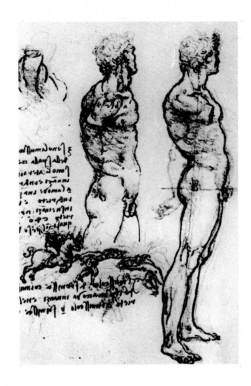

STUDY OF NUDES
Red chalk drawing, most of the
outlines reworked in ink, on white
paper; $6\frac{5}{16} \times 6$ in (16 × 15.2 cm)
Windsor, Royal Library
(Inv. no. 12640, detail).

from a noble family and was the son of the resident magistrate of Caprese in Tuscany. He had returned from Rome to Florence at the beginning of 1501, a few months after the arrival of Leonardo. He already had to his credit the *Pietà* in St. Peter's, and, in August, he was commissioned by the city's wool guild and the building administration of the Cathedral of Santa Maria del Fiore to sculpt *David*. During Michelangelo's first years in Florence, there were clear hints of Leonardo's influence, including an explicit counterpositioning of masses, particularly evident in the coloration and lighting of *Madonna Doni*. But a clash was inevitable. Without exaggeration, there was first of all, an absolute contrast of personalities. Michelangelo was excitable and excessively emotional, whereas Leonardo was withdrawn, almost apathetic, and coldly analytical. Even more important was the fact that, culturally, they were diametrically opposed to one another. Michelangelo was a sculptor, architect, painter, and ardent poet in the Danteesque tradition. He was a product of the court of Lorenzo the Magnificent, a humanist and "professional artist" par excellence. Although he had spent a brief period in Ghirlandaio's *bottega*, Michelangelo's cultural roots were not in the great Florentine workshops with their multifarious interests and activities but in the classical, humanist traditions of the Medici Gardens. These traditions were shaken but not destroyed by Savonarola and were subsequently strengthened in Rome. We have already seen how Leonardo's fundamental ideas, his "naturalism," and his diversity of interests were antithetic to such a philosophy. Furthermore, Leonardo's private and public attitudes, his apparent squandering of natural gifts, and the allegedly slow pace of his work were a constant source of annoyance to a man of Michelangelo's temperament. With his customary astuteness, Stendhal made this observation, though in reference to the ideology of romanticism: "The ardent spirit of the sculptor swept away all difficulties with a kind of frenzy that delighted the connoisseurs; they much preferred Michelangelo, who worked fast, to Leonardo, who was always promising."

Returning to the *St. Anne* cartoon in London, it is possible to detect thematic and stylistic links with all the earlier artistic enterprises of the first Milan period. The unity of the pyramidal composition is here seen to perfection. It is far more fluently and compactly realized than in the less obviously schematized *Virgin of the Rocks*. The representation of the two women and the two children is also far more accomplished, with overtones that are missing in the other picture. There is a suggestion of recalled fulfillment in the gesture of blessing made by the Child; and the

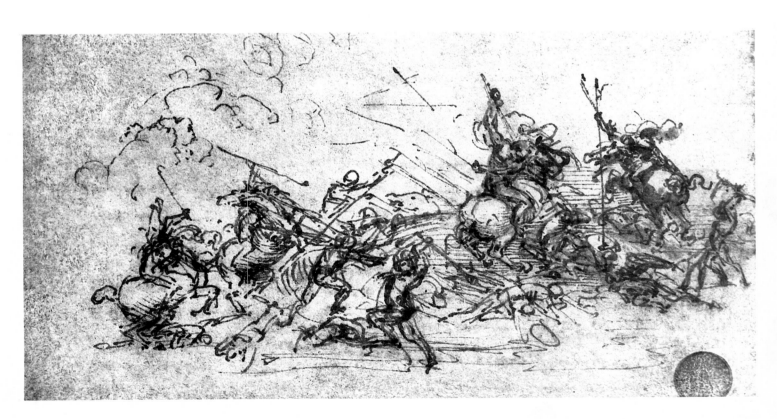

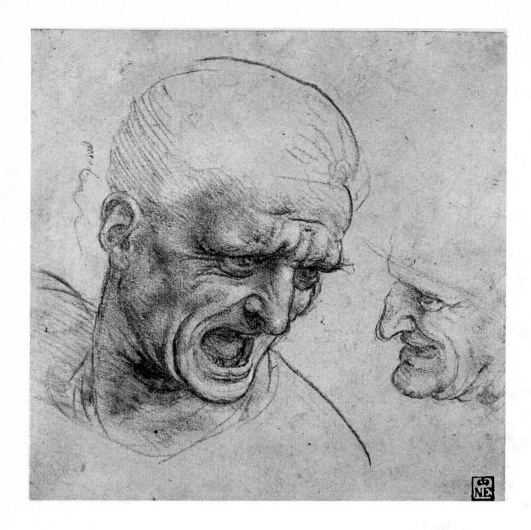

STUDY FOR HEADS OF
WARRIORS
Silverpoint and charcoal drawing,
with touches of red chalk, on white
paper; $7\frac{9}{16} \times 7\frac{3}{8}$ in (19.2 × 18.8 cm)
1503–5
Budapest, Szépmüvészeti Museum
Connected with *The Battle of Anghiari*.

STUDY FOR THE HEAD OF A
WARRIOR
Red chalk drawing on pink paper;
$8\frac{15}{16} \times 7\frac{5}{16}$ in (22.7 × 18.6 cm)
1503–5
Budapest, Szépmüvészeti Museum
A preparatory study for *The Battle of
Anghiari*.

finger of St. Anne, pointing to heaven, introduces more complex problems of
symbolic representation. It is reminiscent of the gesture of the angel in *Virgin of the
Rocks* (although here shown at a forty-five-degree angle) and of Thomas in *The Last
Supper*. It will recur in Leonardo's last painting, the disturbing *St. John the Baptist*
in the Louvre. What is the real significance of this gesture? It is worth noting that
Novellara's description of the definitive version of the *St. Anne* has been
interpreted in symbolic terms. St. Anne is identified with the Church on earth, which
attempts to prevent Mary pulling Jesus away from the sacrificial Lamb (symbol of
the Passion, hence from the Passion itself) necessary for the salvation of mankind.
In the cartoon, where the symbolism is less overt, St. Anne's gesture, alluding to the
divine necessity of the coming sacrificial destinies of Jesus and John, assumes
mystical and prophetic significance. Such an interpretation is perhaps supported by
the "shadowy" expression on St. Anne's face and the appearance of an enigmatic,
mysterious smile (the mystery being suggested, above all, by the luminous
treatment of her face in comparison with Mary's). This smile later adorns the face of
the *Mona Lisa* (though for very different, less meaningful reasons) and that of *St.
John the Baptist*. Less indulgent of such interpretations, A. M. Brizio has under-
lined the contrast between the two faces of Anne and Mary: "The impact of the ex-
pression of St. Anne as it emerges from the shadows, endowed with all wordly
knowledge, compared with the much younger, innocent expression of the Virgin . . ."

It is in such features and in its overall feeling of naturalism that the *St. Anne*
cartoon marks a forward development in relation both to *Virgin of the Rocks* and *The
Last Supper*. The setting, on close examination, proves to be similar to that of *Virgin
of the Rocks*. This includes the presence of water, touched in with white lead, at St.
John's shoulders. But the monumental impact of the group of figures is much
stronger, both because it occupies a larger area of the picture surface and because it
is thrown into relief by the balanced effects of sfumato and contrasting light and
shade. It was this aspect of the work, even more than the pyramidal structure, that
so impressed the Florentines, including Michelangelo, that it is reasonable to
suppose that the lost cartoon described by Vasari could not have differed greatly
from this version.

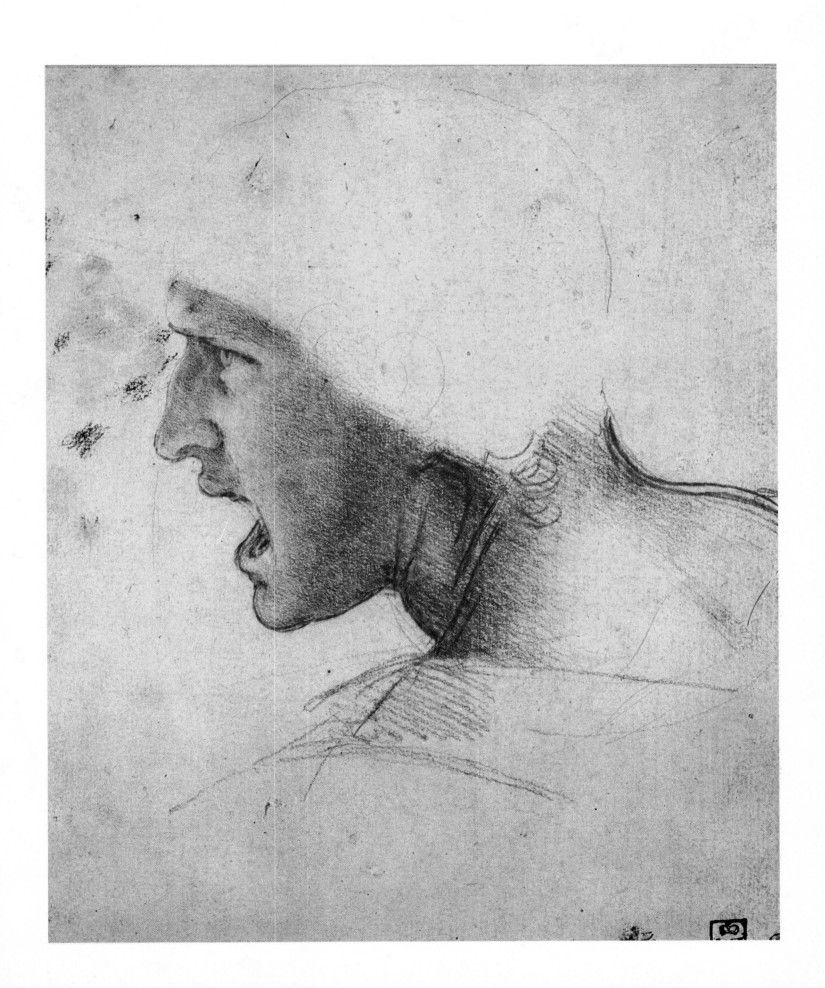

Prior to this cartoon, Leonardo had treated sacred history in a naturalistic manner, as seen in *The Last Supper* and, on a legendary level, in *Virgin of the Rocks*. To this is now added symbolic meaning (St. Anne's pointing finger being only the clearest example), but a much stranger feature is the explicit visual representation of Anne and Mary as a single, indissoluble, two-headed body. This practice was later echoed, although in more extrinsic, naturalistic terms, in the sculpted groups of Andrea Sansovino in Sant' Agostino, Rome (1512), and of Francesco Sangallo in Orsanmichele, Florence (around 1526). Furthermore, without wishing to enter into realms of interpretation that might be controversial, one must stress the undeniable fact that, in this cartoon, for the first time, the emphasis on "revelation" and "sacred imagery" is absolute in the sense that it is devoid of any narrative, historical, or legendary associations but does have psychological and emotional overtones based on common human experience. It marks a revolution in Leonardo's thinking and attitude, a kind of return to a prehumanistic spirituality (which demonstrates his deep interest in new perspectives). This is expressed in simple, naturalistic language that is entirely consistent with Leonardo's overall conception of the world around him. Quite apart from any formal influence, it was the emotional and spiritual content of the work that most deeply affected Michelangelo and Raphael, both of whom found the means of expressing such ideas visually in even more comprehensive, sublime terms.

What is only hinted at in the cartoon is explicitly stated in the definitive version. An intermediate stage is recorded by a drawing in the Venice Accademia. Here, in a much more compact group, St. John has already been replaced by the lamb; and the compositional problems of the work are concentrated on the head of St. Anne, which is shown in two different positions, both of them prominent. There is also a marvelous drawing of the head of St. Anne (at Windsor) that, in Kenneth Clark's opinion, conveys more of the true "human mystery" than the "artificiality" of the Louvre panel. In this latter version, St. Anne's head, with its even more enigmatic, meaningful smile, is placed in dynamic contrast to the bust and left arm (only this one being visible) and becomes the vertex and pivot of the entire pyramidal composition. From this point radiate flowing lines that are chiefly directed to the right and base of the picture. These are formed by the bending body and outstretched arms of Mary, continued by a replica, on a lesser scale, of the same gesture on the part of the Child (counterbalanced by the head turned toward the mother), and extended to the figure of the lamb. There are other significant features in the way Leonardo has placed the foreleg of the lamb over the foot of Mary in the form of a cross, and in the line that runs down from right to left between the lamb and the left foot of St. Anne to a central point at the front of the picture. This gives the illusion of a continuous spatial gradation from the most distant point of the group (St. Anne's head) to the closest (her foot), so that, in fact, the basic impression is not so much that of a pyramid as of a rhombus intersecting the cross formed by the divergent bodies of Anne and Mary. The essential features of these structural considerations are clearly present in Novellara's "narrative" description, indicating, without any doubt, that such compositional innovations, looking toward the future, especially mannerism, date back at least to 1501.

The planning of the lighting and color effects of the Louvre panel was certainly of later date. The meticulous application of atmospheric sfumato suggests a partial return to naturalism, although the landscape in the background is "geological" and timeless. But the formal, abstract logic of the composition is conditioned, in effect, by the "universal" light emanating from the upper left-hand part of the picture. In Manuscript A (1492), there is the following note: "When you are drawing from nature, the light should be from the north, so that it may not vary." This lighting underlines the fundamental points of reference for the group of figures and for the vectors of the entire composition. This is shown by the head of Anne; the head, shoulder, and bust of Mary; the head, shoulder, and right arm of the Child; the muzzle and neck of the lamb; and the right foot of Mary and the left foot of Anne. Intellectually and symbolically, it anticipates mannerist art, but there are more immediate echoes in Raphael's experimental works that date from his last years in Florence. Michelangelo, too, recalled the final version of the *St. Anne* in the *Pietà* of Santa Maria del Fiore in Florence.

MONA LISA
Oil on poplar panel; $30\frac{1}{4} \times 20\frac{7}{8}$ in (77×53 cm)
1503–5
Paris, Louvre
The panel was acquired by Francis I, appeared at the Tuileries in 1800 and was taken from there to the Louvre on Napoleon's orders in 1805.

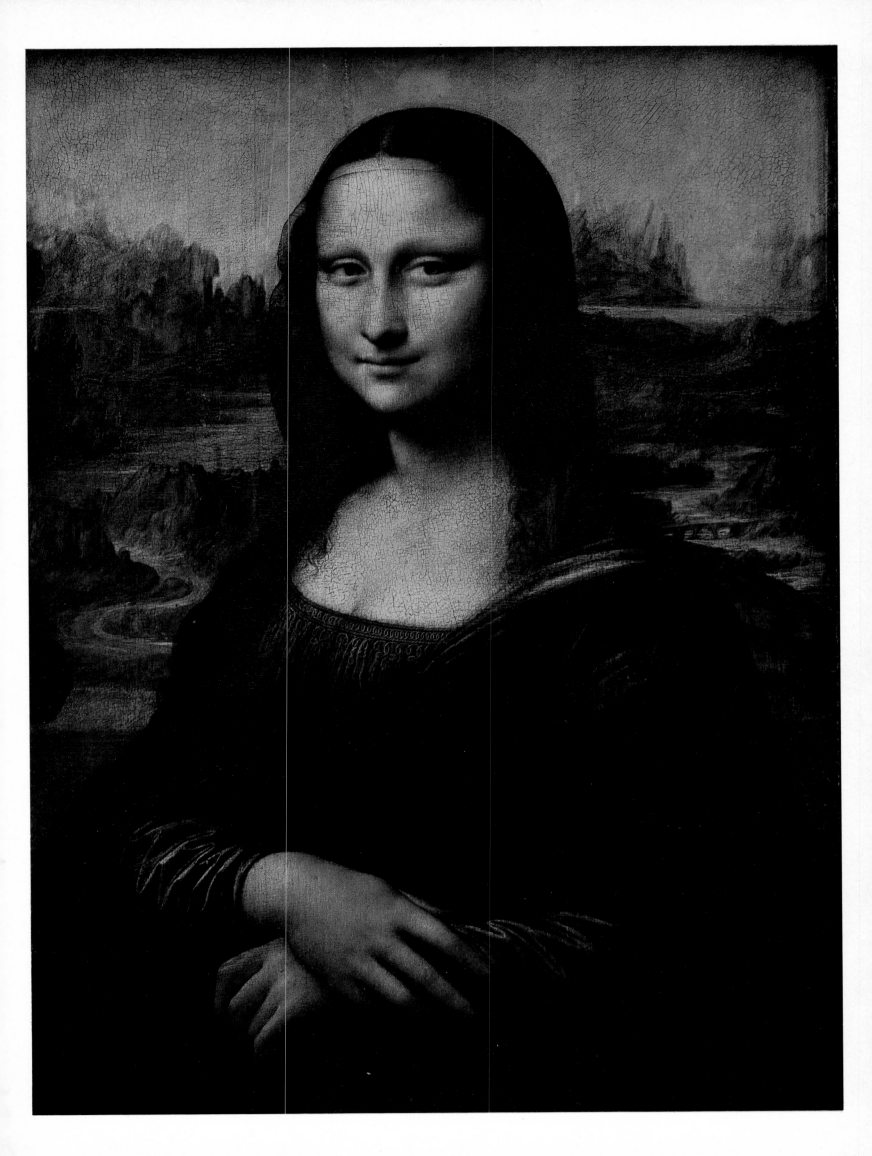

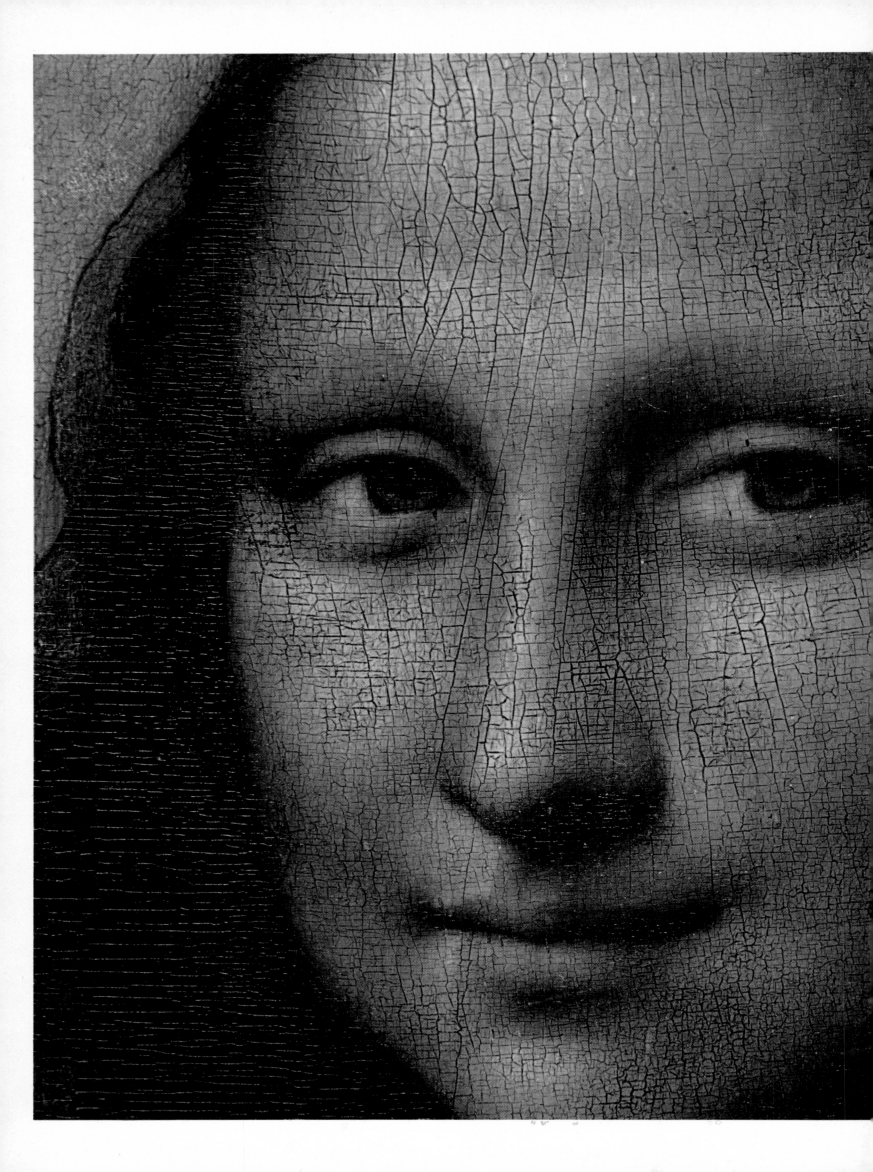

In the Service of Cesare Borgia

Leonardo did not stay long in Florence. In the summer of 1502, he entered the service, as "architect and chief engineer," of Cesare Borgia, son of Pope Alexander VI, created Duc de Valentinois by the king of France, and subsequently known as "Il Valentino." The Florentine oligarchy, with commendable diplomacy but clearly with a view to retaining his goodwill and keeping him at a distance, had made him a paid condottiere; which explains Machiavelli's presence with him as their representative. Leonardo remained with Il Valentino until the spring of 1503, a few months before the latter's fortunes and authority crumbled as a result of his father's death. The activities Leonardo engaged in during this period are partially recorded in Manuscript L and in some of the Windsor drawings. Subsequently, he returned to Florence and in June to July of 1503 was in the siege lines outside Pisa. His placement here was at the request of the Gonfalonier Piero Soderini, who had been urged by Machiavelli to conscript Leonardo in the republic's service as military engineer. While the siege was in progress, Leonardo traveled through the low valley of the Arno, where he made drawings and topographical sketches. He had intended to submit a plan for a large navigable canal extending from the Arno at Florence, through Prato, Pistoia, and Serravalle and rejoining the river at Vico Pisano.

This activity on behalf of Florence, already noted in the Windsor drawings and in the Codice Atlantico, has recently been documented in the Madrid Manuscript II (as I have previously mentioned in speaking of the Leonardo manuscripts in general). The Madrid Manuscript II also provides hitherto unknown information about Leonardo's journey to Piombino in November to December of 1504 to visit Jacopo IV Appiani, who had recovered the city after the ruin of Il Valentino. Here again, Leonardo had been preceded by Machiavelli, who, in April of that year, had obtained Appiani's assurance of neutrality in Florence's campaigns against Pisa and Siena. So it was no accident that Leonardo arrived some six months later to offer suggestions and proposals for the land and dock fortifications of Piombino. He had resurrected schemes previously designed for Il Moro (hence the drawings of military architecture in Manuscript B) and later for Il Valentino.

Leonardo's architectural and engineering expertise was evidently employed both for peaceful and warlike purposes. We do not know for certain whether he played a part in drawing up a project designed to force the city of Pisa into surrender. The plan was surely superhuman, considering the available manpower and practical labor involved. It envisaged drying up the course of the Arno through Pisa by constructing two diversionary canals on both sides of the besieged city. Characteristically, his studies into engineering and architecture branched out in other directions, especially into geography and topography. The revolutionary consequences of this are recorded in the Windsor collection and in the Madrid Manuscript II. While in the service of Il Valentino, Leonardo traveled to Imola, Cesena, Rimini, Urbino, Pesaro, Piombino, and through Romagna, the Marche, and Tuscany – territories conquered in the course of the lightning campaigns of the tyrannous condottiere, who were supported by the Church and by Louis XII of France. There are topographical sketches of Imola, Cesena, and Urbino; a marvelous and famous map of Imola; and presumably the two maps of the Val di Chiana and the river basin of the Arno. The last-named map is of exceptional quality, both for the area covered in such precise detail and for the relief impression of hills and mountains, shown in brown and seen from above, as if, in Heydenreich's words, "he had actually built and piloted his own flying machine." The same method is employed in two maps of the Arno valley in the Madrid Manuscript II, one probably relating to the siege of Pisa and the other certainly connected with the Florence-Vico Pisano canal, which is also referred to in a map at Windsor and one in the Codice Atlantico.

The technical basis of Leonardo's method is described by Heydenreich in the *Encyclopedia of World Art*: "Aside from the land-registry maps in common use (schematic plans of entire cities or individual sections of the countryside) or the portolano charts used by mariners, an exact method of cartographic representation was unknown in Leonardo's time. He was apparently first in attempting to combine

MONA LISA
Detail of face.
Pages 132–133: Detail of hands.

pictorial and planimetric representation, unifying image and measurement in an important step toward modern cartography. His plan of the city of Imola ... is the first city plan to be consistently worked out from an imaginary vantage point. This is no longer the 'church-tower perspective' seen in the famous plan of Venice drawn by Jacopo de' Barbari (1500) but a comprehensive view of a landscape. The medieval circular scheme, with its division into individual sectors has been retained, but the circle now serves to delimit a real section of landscape as it might be seen from a balloon – a topographical as well as a pictorial entity. In his map of Tuscany ... the landscape formation is represented as a flat surface, with elevation shown by gradations of color ranging from the green of the valleys to the dark brown of the mountains. The map would thus fit perfectly into a modern atlas. ... Another of Leonardo's maps shows a part of Tuscany including Arezzo and Perugia. Mountains and fortified towns are indicated in three dimensions, other elements of the landscape remaining diagrammatic.''

Perspective, relief, and contours, obtained by the sfumato effect of color gradation, are combined with the conventional use of color. Thus, in the map of Imola, houses are marked in red; private areas, in yellow; public spaces, streets, and squares, in white; water, in blue; the flat countryside, in pinkish-yellow; the contour lines of hills, gray blue; and the woods are represented by open rings. Here again the skills and experience of the artist and the scientific researcher combine in unison. The scientific, empirical method is splendidly documented in the Madrid Manuscript II, in which there appear actual drawings of hills and mountains in the valley of the Arno and accompanying place names and landmark indications. Thus, in an entirely original manner, Leonardo devised a system of cartography comprising a collage of objective symbols based on firsthand observation and visual measurement. It is interesting to recall the youthful drawing of 1473 and to compare that view of the Arno valley, functional yet remarkably evocative in the use of atmospheric perspective, with some of the famous landscape drawings at Windsor, especially the one showing a storm over a valley, above which loom high mountains lit by the sun. Considering these drawings and the related background landscapes of the *St. Anne* and the Mona Lisa, one is struck yet again by the inseparability of Leonardo's interests and activities. Drawing and painting are here allied to topography and, eventually, to studies of natural and meteorological phenomena.

In Manuscript L, we read: "Painting. Foreshorten, on the summits and sides of the hills, the outlines of the estates and their divisions; and, as regards the things turned toward you, make them in their true shape." In the Arundel Manuscript, Leonardo writes: "Show a wind on land and at sea; show a rainstorm. In the morning, the mist is thicker up above than in the lower parts because the sun draws it upward; so with high buildings, the summit will be invisible, although it is at the same distance as the base. And this is why the sky seems darker up above and toward the horizon and does not approximate to blue but is all the color of smoke and dust. The atmosphere, when impregnated with mist, is altogether devoid of blueness and merely seems to be the color of the clouds, which turn white when it is fine weather. And the more you turn to the west, the darker you will find it to be and the brighter and clearer toward the east. And the verdure of the countryside will assume a bluish hue in the half-mist but will turn black when the mist is thicker. Buildings that face the west only show their illuminated side; the rest the mist hides. When the sun rises and drives away the mists and the hills begin to grow distinct on the side from which the mists are departing, they become blue and seem to put forth smoke in the direction of the mists that are flying away, and the buildings reveal their lights and shadows; and where the mist is less dense, they show only their lights, and where it is more dense, nothing at all. Then it is that the movement of the mist causes it to pass horizontally, and so its edges are scarcely perceptible against the blue of the atmosphere, and against the ground, it will seem almost like dust rising. In proportion as the atmosphere is more dense, the buildings in a city and the trees in landscapes will seem more infrequent, for only the most prominent and the largest will be visible. And the mountains will seem few in number, for only those will be seen that are farthest apart from each other, since, at such distances, the increase in the density creates a brightness so pervading that the darkness of the hills is divided and quite disappears toward their summits. In the small adjacent

School of Leonardo
"BORGHESE" LEDA
Canvas; 44 × 34 in (112 × 86 cm)
Rome, Borghese Gallery.

School of Leonardo
"SPIRIDON" LEDA
Canvas; 52 × 30¾ in (132 × 78 cm)
Rome, State Gallery
In 1623 Cassiano del Pozzo saw at Fontainebleau a *Leda* alleged to be by Leonardo, describing it in minute detail. All traces of this picture subsequently vanished. Among the known variants on this theme, the one illustrated here was in the collection of the Marquis de la Rozière in 1874. It then came into the possession of the Baron de Roublé, whose widow handed it over to Ludovico Spiridon, hence its name. The Spiridon heirs sold it to Hermann Goering but it was reclaimed by the Italian government after the Second World War.

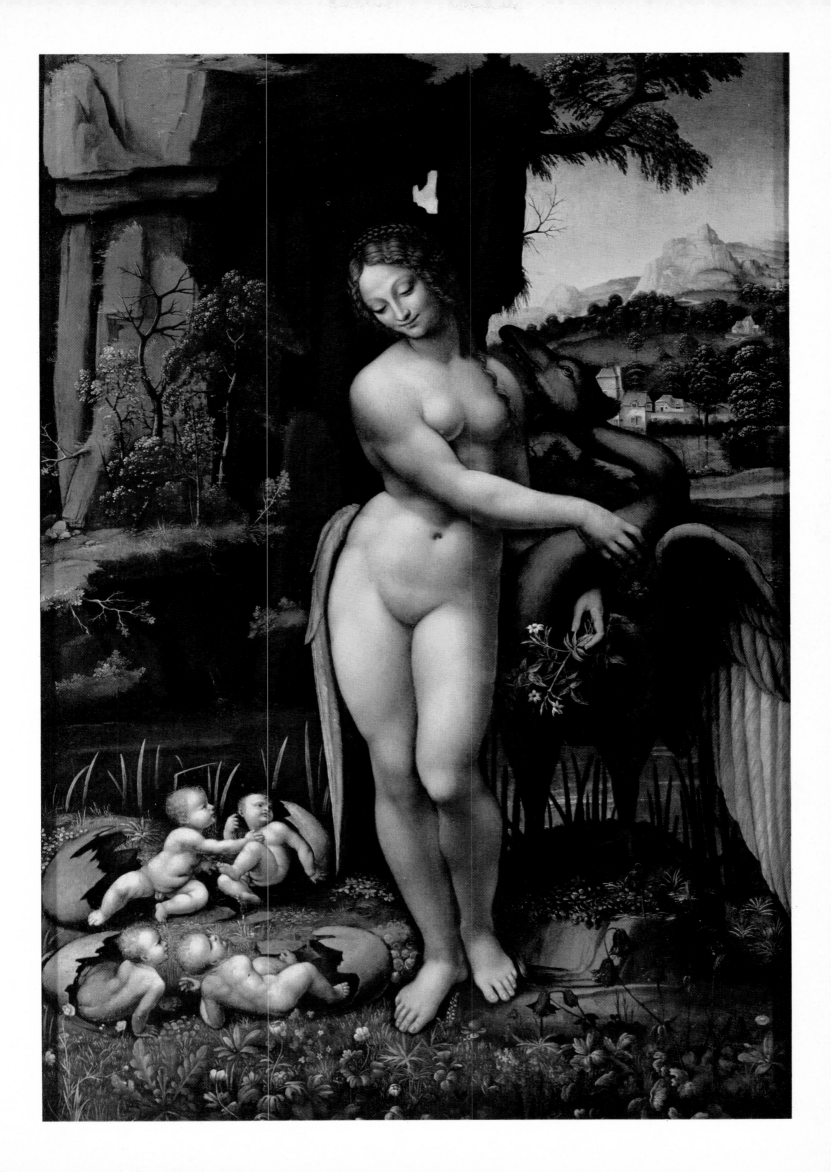

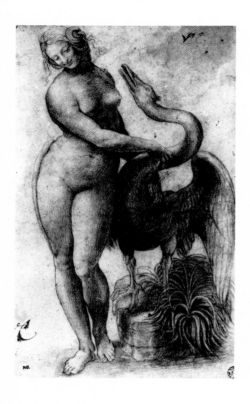

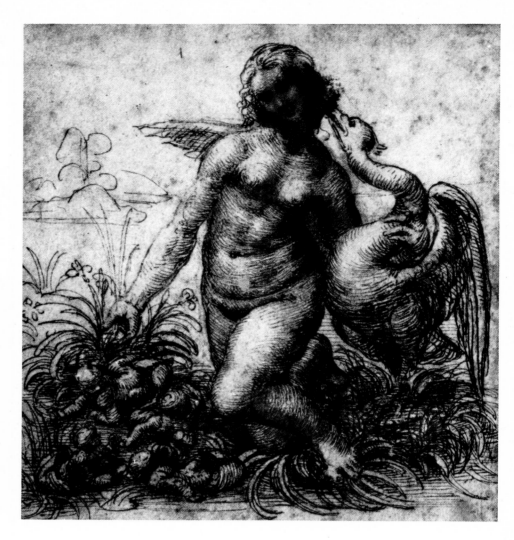

School of Leonardo
COPY OF LEDA AND THE
SWAN
Paris, Louvre.

STUDY OF LEDA AND THE
SWAN
Pen and bistre drawing on yellowish-
white paper; $6\frac{5}{16} \times 5\frac{1}{2}$ in
$(16 \times 13.9$ cm)
Devonshire Collection, Chatsworth
Reproduced by permission of the Trus-
tees of the Chatsworth Settlement.

hills, it cannot find such foothold, and, therefore, they are less visible and least of all at their bases.''

Another excerpt from the Arundel Manuscript reads: ''On one occasion above Milan, over in the direction of Lake Maggiore, I saw a cloud shaped like a huge mountain, made up of banks of fire, because the rays of the sun that was then setting red on the horizon had dyed it with their color. This great cloud drew to itself all the little clouds that were round about it. And the great cloud remained stationary, and it retained the light of the sun on its apex for an hour and a half after sunset, so enormous was its size. And about two hours after night had fallen, there arose a stupendous storm of wind. And this, as it became closed up, caused the air that was pent up within it, being compressed by the condensation of the cloud, to burst through and escape by the weakest part, rushing through the air with incessant tumult, acting in the same way as a sponge when squeezed by the hand underneath the water, for the water with which it is soaked escapes through the fingers of the hand that squeezes it and rushes swiftly through the other water. So it is with the cloud, driven back and compressed by the cold that clothes it round, driving away the air with its own impetus.''

The other topic featured during the years 1502–1504 is military architecture. That Leonardo expended a great deal of time and energy in this field is indicated (quite apart from other sources of evidence) by the transcriptions he made of large sections of the manuscript treatise of Francesco di Giorgio Martini in the Madrid Manuscript II. In the sphere of secular and sacred architecture, Leonardo had come into direct contact with the great Bramante. Their meeting was probably to their mutual advantage. And now, in the more specialized area of military architecture, he had the good fortune to meet and exchange views with men, who, following the invention and development of firearms and explosives, were helping to inaugurate a period of Italian predominance in the art of military architecture. The pioneer in

136

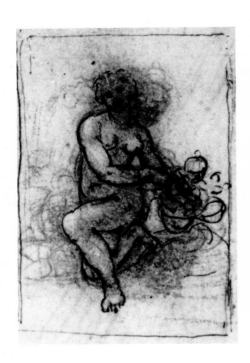

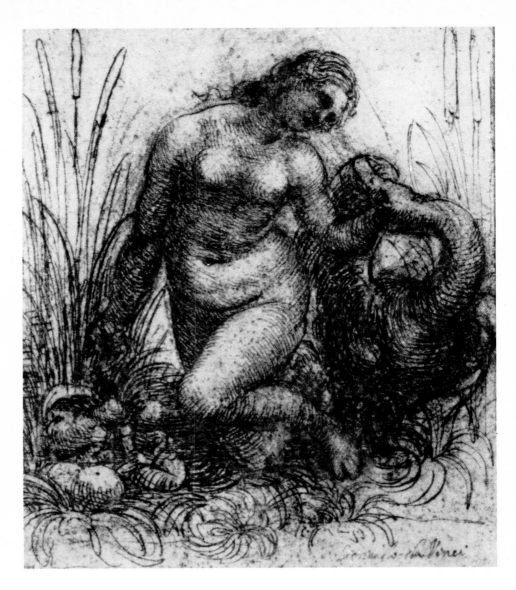

STUDY WITH FIGURE OF LEDA
Pen drawing over chalk preparation;
$14\frac{7}{8} \times 10\frac{3}{8}$ in (37.7×26.3 cm)
Windsor, Royal Library
(Inv. no. 12337 *recto*, detail).

STUDY OF LEDA AND THE SWAN
Pen and charcoal drawing;
$4\frac{15}{16} \times 4\frac{5}{16}$ in (12.5×11 cm)
Rotterdam, Boymans – van Beuningen Museum.

this field was Francesco di Giorgio himself, especially when in the service of Montefeltro, and he was emulated by the Sangallos (Giuliano and his nephew Antonio the Younger), whom Leonardo encountered at the siege of Pisa. These were the men who introduced the complex system of fortifications with bastions and buttresses, frequently reinforced by ramparts, that were used for the protection of walls that were increasingly threatened by enemy artillery and with gun platforms for the defending forces. Leonardo's engineering experience with firearms, coupled with his research on ballistics, made him an invaluable adviser, initially to Il Moro (although without any noticeably practical results), then to Il Valentino, and finally to Jacopo Appiani.

His suggested projects, as demonstrated by illustrations in Manuscript B and the Madrid Manuscript II, were based substantially on the concepts of the aforementioned architects. The plans included systems of castle fortification incorporating towers, ramparts, ravelins, bastions, casemates, trenches, palisades, and similar protective structures for the main walls. The emphasis was on rounded rather than angular forms in order to minimize the effectiveness of an artillery barrage. A fine red chalk drawing in the Madrid Manuscript II shows a bird's-eye view of a characteristic fortress that is not built so high as to present the enemy with a clear target from a distance. Also, there is a progressive reduction in the size of the towers from the center outward. In the same manuscript, there is the comment: "The secondary towers must be low and wide, covered by a vaulted and beveled roof, at a very obtuse angle, in order to deflect the transversal shots." This fundamental consideration led Leonardo to devise a famous project that was revolutionary for its time and indeed not discussed again in practical terms until the nineteenth century. Some drawings in the Codice Atlantico show that what Leonardo had in mind was a huge "bunker-type" fortress. The plan was based on concentric circles that contained underground tunnels and on the construction of a

main bastion with four additional projecting forts in front of the walls, which were semicircular and curved outward. All this was covered with roofing similarly curved toward the outside and diminishing in height from the innermost ring. Finally, there was to be a higher central keep accommodating direct-firing artillery pieces with mobile barrels. In a caption to one of the drawings, Leonardo explains the reason for this series of defense lines at different levels: "The defender has as many lines to strike at the enemy as the latter has in his attack." Having lost one defense line, the garrison can continue firing down at the enemy from an elevated position.

The Battle of Anghiari

Back in Florence after his period with Cesare Borgia, Leonardo alternated his work as an architect and engineer with an ambitious new painting project. In April 1503, the Gonfalonier Piero Soderini entrusted him with the task of painting a fresco for the hall of the Palazzo Vecchio (the Grand Council of the Signoria) on the subject of *The Battle of Anghiari*. This painting refers to the victory, on June 29, 1440, of the Florentine and papal forces, commanded by Giampaolo Orsini, over the Milanese troops of Filippo Maria (last of the Visconti), under the leadership of Niccolo Piccinino. Leonardo worked on his cartoon in the Sala del Papa at Santa Maria Novella for some part of 1504; then, in February 1505, he set up his mobile scaffolding for the fresco. A note in the Madrid Manuscript II, dated June 6, 1505, reads: "I began coloring in the Palazzo" and then goes on to record a violent storm that damaged the cartoon. Although some critics take this to mean that the fresco was started on June 6, Brizio more accurately dates the commencement of the work to be June 13, taking it to coincide with that of the storm.

Leonardo intended to paint the fresco on a stucco ground, as described in a book by Pliny. He made an experiment on a panel and found the results, after drying with heat from a brazier, to be encouraging. Unfortunately, when heat was similarly applied to the actual fresco, only the lower part of the painting dried, and the oil colors from above merged and dripped. The work was abandoned in 1505 or 1506, and, in June 1506, Leonardo left for Milan. What survived of the fresco was protected by a railing in 1513 and was eventually covered over, in 1557, with a fresco by Vasari. The cartoon, showing the central episode of the standard, was also lost.

In the second half of 1504, Michelangelo was commissioned to paint *The Battle of Cascina* for the same council hall. This was to commemorate the victory, on July 30, 1364, of the Florentines against the Pisans, who were commanded by Giovani Acuto. Michelangelo worked on the cartoon until March 1505, when he was summoned to Rome by Julius II to execute the latter's tomb; but he probably completed it between the time of his "flight" from Rome to Florence, in April 1506, and his reconciliation with Julius II at Bologna the following November. This cartoon, too, has been lost.

Fortunately, there are surviving drawings of both works as well as contemporary copies of the cartoons or parts of them. In the case of Leonardo's work, there is one copy in the Uffizi that may have been based on the actual fresco; and there is the famous copy by Rubens in the Louvre that is really a skilful interpretation of Leonardo's version in the painter's own style. Although, perhaps, not absolutely faithful to the original, it does show a deep, dramatic understanding of the "animal" power and energy that Leonardo surely intended to convey. Furthermore, we have several written descriptions, the finest of them being that of Vasari, that indicate Leonardo "designed a group of horsemen fighting for a standard, a masterly work on account of his treatment of the fight, displaying the wrath, anger and vindictiveness of men and horses; two of the latter, with their front legs interlocked, are waging war with their teeth no less fiercely than their riders are fighting for the standard. One soldier, putting his horse to the gallop, has turned around and, grasping the staff of

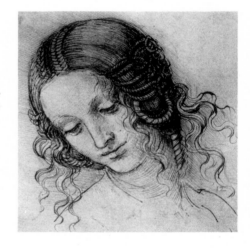

STUDY FOR THE HEAD OF LEDA
Pen drawing with a little watercolor on yellowish paper; $7 \times 5\frac{13}{16}$ in
(17.7×14.7 cm)
Windsor, Royal Library
(Inv. no. 12518).

STUDY FOR THE HEAD AND HAIR OF LEDA
Pen drawing with a little watercolor on white paper; $7\frac{7}{8} \times 6\frac{3}{8}$ in
(20×16.2 cm)
Windsor, Royal Library
(Inv. no. 12516).

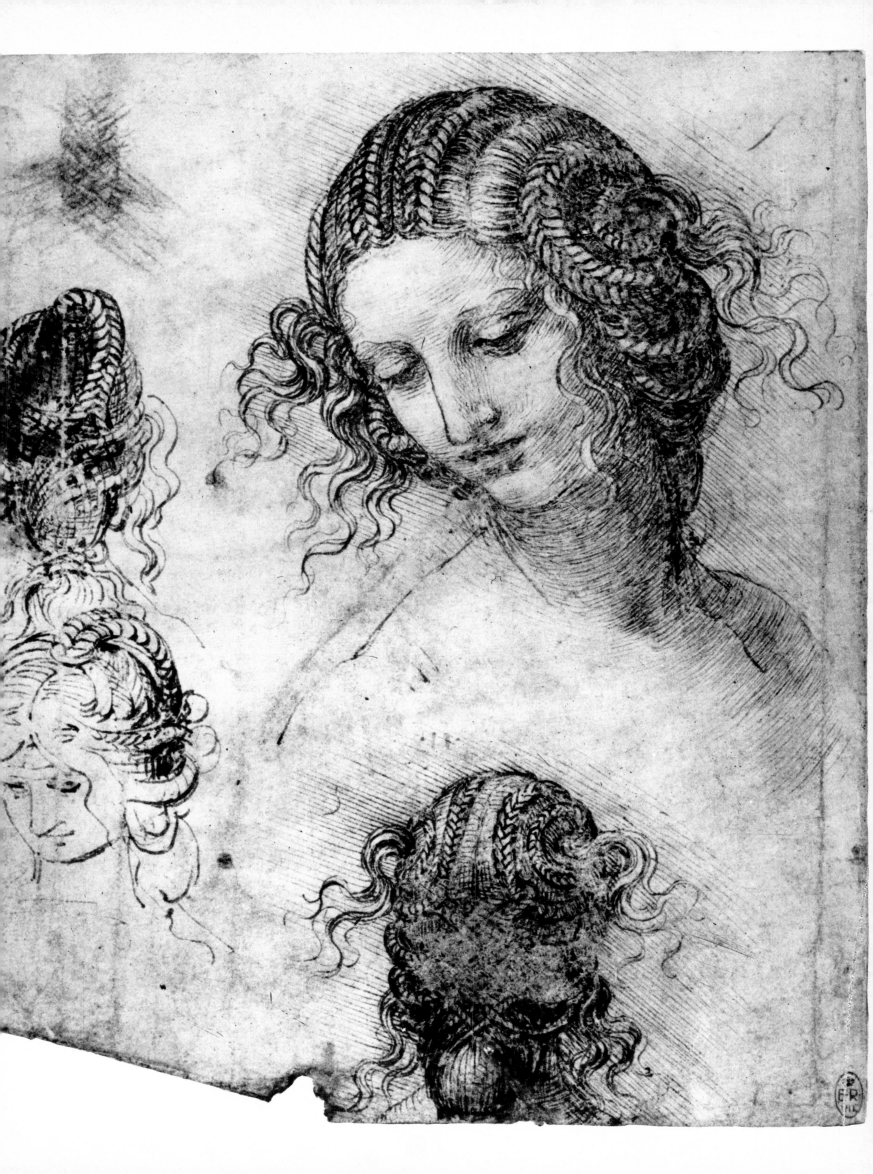

STUDIES FOR THE TRIVULZIO EQUESTRIAN MONUMENT
Charcoal and pen drawing on pale pink paper; $8\frac{13}{16} \times 6\frac{5}{16}$ in (22.4 × 16 cm)
Windsor, Royal Library (Inv. no. 12360).

STUDY FOR THE TRIVULZIO EQUESTRIAN MONUMENT
Red chalk drawing, partially gone over with pen, on white paper; $8\frac{9}{16} \times 6\frac{5}{8}$ in (21.7 × 16.9 cm)
Windsor, Royal Library (Inv. no. 12356 *recto*).

STUDY FOR THE TRIVULZIO EQUESTRIAN MONUMENT
Pen drawing on white paper; $11 \times 7\frac{13}{16}$ in (28 × 19.8 cm)
Windsor, Royal Library (Inv. no. 12355).

the standard, is endeavoring by main force to wrench it from the hands of four others, while two are defending it, trying to cut the staff with their swords. An old soldier in a red cap has a hand on the staff, as he cries out, and holds a scimitar in the other and threatens to cut off both hands of the two, who are grinding their teeth and making every effort to defend their banner. On the ground, between the legs of the horses, are two foreshortened figures who are fighting together, while a soldier lying prone has another over him who is raising his arm as high as he can to run his dagger with his utmost strength into his adversary's throat; the latter, whose legs and arms are helpless, does what he can to escape death. The manifold designs Leonardo made for the costumes of his soldiers defy description, not to speak of the scimitars and other ornaments, and his incredible mastery of form and line in dealing with horses, which he made better than any other master, with their powerful muscles and graceful beauty." This last reference to "graceful beauty" cannot allude to the specific episode of the fierce struggle for the standard but obviously testifies to Leonardo's general skill in representing horses, this indicates that Vasari must have been familiar with Leonardo's drawings, either by repute or direct observance, and may have actually looked at that "book of horse sketches" listed by the master in 1504.

Vasari's description, as with the copies of the cartoon and the fresco, is evidently restricted to the episode of the fight for the standard. There is a slight discrepancy, for although he mentions "four" horsemen defending the banner, he describes only

the two who appear in the copies. The head of one of these warriors appears in the preparatory drawing on a page from the Szépmüveszéti Museum, Budapest. It is drawn on the reverse side of a study for the head of the "old soldier in a red cap." If we can rely on the copy in the Uffizi, the fresco, when it was abandoned, must have lacked only the figure of the soldier on all fours defending himself with his shield (at lower left), for, although not mentioned by Vasari, he appears in all the other copies.

There has been much conjecture among modern critics as to the likely general structure of the fresco in Leonardo's original conception, just as there has been about the Michelangelo cartoon, a copy of which, by Aristotele da Sangallo, exists in the Duke of Leicester's collection at Holkham Hall. They have come to the unanimous conclusion that neither the struggle for the standard nor, in Michelangelo's case, the episode of the Florentine soldiers being surprised naked by a false alarm while bathing in the Arno, could have been large enough to cover the broad spaces allotted to the frescoes in the council hall. In addition, there is the fact that such public commissions would surely have called for a much grander and comprehensive treatment of the respective themes. The difficulty is that, although we possess a relatively large amount of documentary and literary information, we do not have a single precise indication of where in the hall the frescoes were to be painted or of their projected dimensions. Not surprisingly, this has given rise to a number of suppositions and theories, some of which are contradictory.

The most recent investigations, based on careful rereading of the documentary evidence and on examination of the original drawings, both by Leonardo and Michelangelo, have been made by Isermeyer. He is not concerned with the comparative merits of the two works. But having carefully scrutinized the official contract drawn up by the Signoria on May 4, 1504, Isermeyer comes to an interesting conclusion about the Leonardo commission. Under this agreement, the artist was authorized, whenever he considered it opportune, to begin the fresco in the hall, or, to be precise, "that part of the said cartoon that he had designed and supplied." Terms of payment were agreed and the deadline for completion of the whole cartoon was deferred until February 1505. It is possible that Leonardo, having been paid for the movable scaffolding to be used for the fresco, held up the remainder of the cartoon until he had done his tests, first on a wooden panel and then on the wall itself, for painting the portion of the cartoon he had already drawn. This corroborates the general opinion that the struggle for the standard constituted only a part of the envisaged fresco. Vasari himself declared that this was merely the central "group" of a much vaster scene planned by the painter; and in Isermeyer's view, it made up about one-third of the whole. The overall conception of the work is suggested by a number of drawings at Windsor and, above all, by four beautiful sketches in the Accademia at Venice. These drawings are remarkable for their dynamic expression of violence of humans and animals, ferociously and inextricably locked in combat.

Finally, there is a famous and very significant extract from Manuscript A (thus dating from the 1490s) entitled "The way to represent a battle." This passage throws light on Leonardo's very clear and detailed ideas about the possible treatment of such a theme. It is quoted here in full:

"Show first the smoke of the artillery mingled in the air with the dust stirred up by the movement of the horses and of the combatants. This process you should express as follows: the dust, since it is made up of earth and has weight, although, by reason of its fineness, it may easily rise and mingle with the air, will, nevertheless, readily fall down again, and the greatest height will be attained by such part of it as is the finest, and this will, in consequence, be the least visible and will seem almost the color of the air itself.

"The smoke that is mingled with the dust-laden air will, as it rises to a certain height, have more and more the appearance of a dark cloud, at the summit of which the smoke will be more distinctly visible than the dust. The smoke will assume a bluish tinge, and the dust will keep its natural color. From the side whence the light comes, this mixture of air and smoke and dust will seem far brighter than on the opposite side.

"As for the combatants, the more they are in the midst of this turmoil the less they will be visible, and the less will be the contrast between the lights and shadows.

STORM OVER A VALLEY
Red chalk drawing on white paper;
$7\frac{7}{8} \times 5\frac{7}{8}$ in (20 × 15 cm)
Windsor, Royal Library
(Inv. no. 12409).

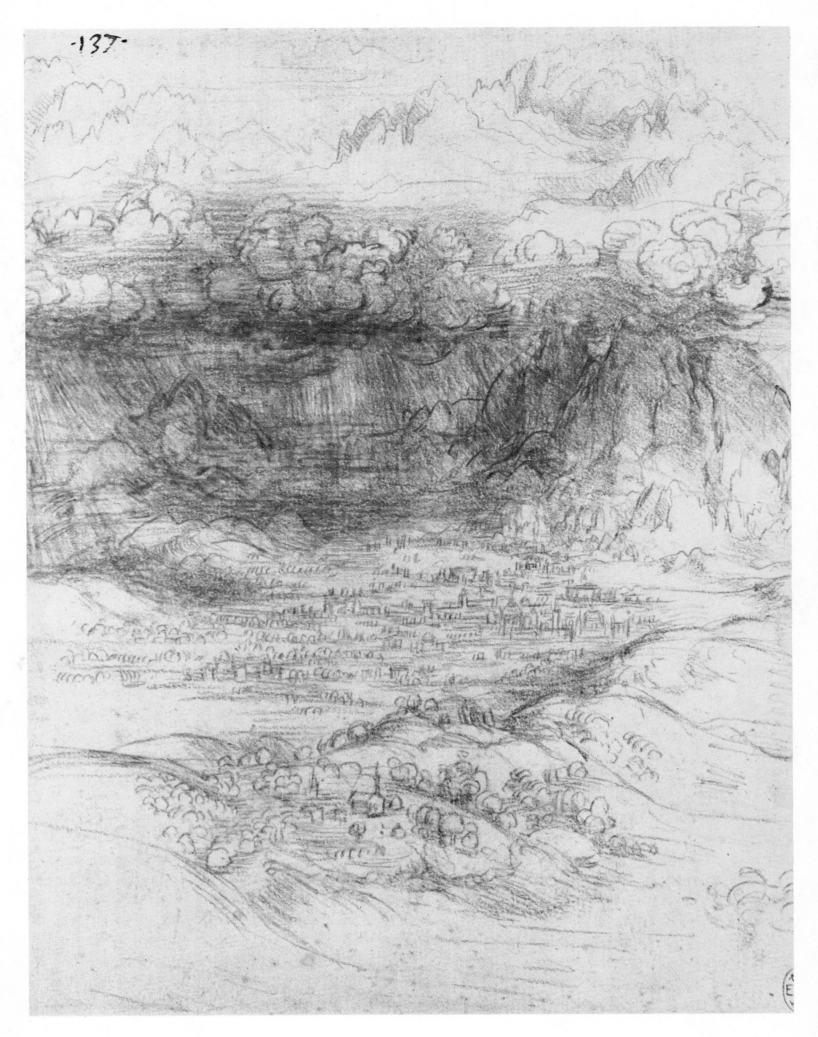

You should give a ruddy glow to the faces and the figures and the air around them, and to the gunners and those near to them, and this glow should grow fainter as it is farther away from its cause. The figures that are between you and the light, if far away, will appear dark against a light background; and the nearer their limbs are to the ground the less they will be visible, for there the dust is greater and thicker. And if you make horses galloping away from the throng, make little clouds of dust as far distant one from another as is the space between the strides made by the horse, and that cloud which is farthest away from the horse should be the least visible, for it should be high and spread out and thin, while that which is nearest should be most conspicuous and smallest and most compact.

"Let the air be full of arrows going in various directions, some mounting upward, others falling, others flying horizontally; and let the balls shot from the guns have a train of smoke following their course. Show the figures in the foreground covered with dust on their hair and eyebrows and such other level parts as afford the dust a space to lodge.

"Make the conquerors running, with their hair and other light things streaming in the wind and with brows bent down; and they should be thrusting forward opposite limbs, that is, if a man advances the right foot, the left arm should also come forward. If you represent anyone fallen, you should show the mark where he has been dragged through the dust that has become changed to bloodstained mire, and round about in the half-liquid earth, you should show the marks of the trampling of men and horses that have passed over it.

"Make a horse dragging the dead body of his master and leaving behind him in the dust and mud the track of where the body was dragged along.

"Make the beaten and conquered pallid, with brows raised and knit together, and let the skin above the brows be all full of lines of pain; at the sides of the nose, show the furrows going in an arch from the nostrils and ending where the eye begins and show the dilatation of the nostrils that is the cause of these lines; and let the lips be arched, displaying the upper row of teeth, and let the teeth be parted after the manner of such as cry in lamentation. Show someone using his hand as a shield for his terrified eyes, turning the palm of it toward the enemy, and having the other resting on the ground to support the weight of his body; let others be crying out with their mouths wide open and fleeing away. Put all sorts of armor lying between the feet of the combatants, such as broken shields, lances, swords, and other things like these. Make the dead, some half-buried in dust, others with the dust all mingled with the oozing blood and changing into crimson mud; and let the line of the blood be discerned by its color, flowing in a sinuous stream from the corpse to the dust. Show others in the death agony grinding their teeth and rolling their eyes, with clenched fists grinding against their bodies and with legs distorted. Then you might show one, disarmed and struck down by the enemy, turning on him with teeth and nails to take fierce and inhuman vengeance; and let a riderless horse be seen galloping with mane streaming in the wind, charging among the enemy and doing them great mischief with his hooves.

"You may see there one of the combatants, maimed and fallen on the ground, protecting himself with his shield, and the enemy bending down over him and striving to give him the fatal stroke; there might also be seen many men fallen in a heap on top of a dead horse; and you should show some of the victors leaving the combat and retiring apart from the crowd, and with both hands wiping away from eyes and cheeks the thick layer of mud caused by the smarting of their eyes from the dust.

"And the squadrons of the reserves should be seen standing full of hope but cautious, with eyebrows raised, and shading their eyes with their hands, peering into the thick, heavy mist in readiness for the commands of their captain; and so, too, the captain with his staff raised, hurrying to the reserves and pointing out to them the quarter of the field where they are needed; and you should show a river, within which horses are galloping, stirring the water all around with a heaving mass of waves and foam and broken water, leaping high into the air and over the legs and bodies of the horses; but see that you make no level spot of ground that is not trampled over with blood."

Naturally it is impossible, even judging by the drawings and copies, to arrive at

STUDY OF FEET
Charcoal drawing on dark gray
paper; $8\frac{11}{16} \times 5\frac{7}{8}$ in (22×15 cm)
Windsor, Royal Library
(Inv. no. **12535**).

Copy by Leonardo
STUDY OF CHILDREN
Red chalk drawing
Chantilly, Condé Museum.

any valid conclusions concerning the original plans for *The Battle of Anghiari*. For example, the overall details of composition and coloring are debatable. But it is legitimate to suppose that it was broadly based on that graphic description of a battle scene – the clear blue of the sky being clouded and darkened by the dust from the battlefield and by the smoke of the firearms and merging with the browns and reds of the muddy ground and the blood-soaked combatants. It would have been dramatically realistic and would have provided ample opportunity for Leonardo to exploit the fruits of accumulated knowledge in many fields. He would have drawn on his studies and observations on light, atmosphere, and meteorological conditions and on the research into human and animal movement as well as anatomy and physiognomy that had occupied him during the period in Milan. It was a scene expressing a mood of terror and exhaustion rather than of rage and ferocity. The

foreground figures, the victors and the vanquished, are shown in close-up and stand out sharply from the main, confused mass of combatants, who are partially obscured by the smoke and dust. Judging by the Venice sketches and the copies of the episode of the fight for the standard, it seems plausible (although there is no proof) that Leonardo was thinking in terms of a grand-scale painting based on the description written ten years previously. The Venetian sketches are done in brown and black ink, and the effects of shading tend to fuse the individual figures, so that one can only make out the shapes of arms, lances, and standards emerging from the tangled crowd of warriors on foot and on horseback. The final version would have been on a monumental scale and analytical in the sense that it would have reflected the continuation of the new line of research that was to find expression in the definitive version of *St. Anne*. The emphasis would have been on the balance, blend, and contrast of movements and on visual display (verging on affectation in the decorative complexity of armor and helmets) reminiscent of the later frescoes of Filippino Lippi (an artist known to Leonardo) in the Strozzi Chapel of Santa Maria Novella, which were completed in 1502.

The "rivalry" between Michelangelo and Leonardo raises further interesting speculations. Michelangelo received his commission later and would have been able to refer to Leonardo's cartoon in working on his own. Critics have tended to underline the more superficial differences – the abstract, episodic tone of the Michelangelo version, exalting the nude figure in a variety of positions and movements, in contrast to Leonardo's allegedly "expressive savagery," more objectively faithful to the given theme. Actually, this is not the crux of the matter. It is unlikely that the remaining portions of Leonardo's composition would have differed radically, either in conception of size, from the central episode of the struggle for the standard. There was no essential disagreement between the two artists as to how to approach such a theme. Both of them accepted in principle that it would be treated in the new "grand manner" characteristic of the sixteenth century; and it was not by chance that a heroic nude figure by Leonardo in the Windsor collection, closely linked with *The Battle of Anghiari*, should bear a resemblance to Michelangelo's drawings for *The Battle of Cascina*. Thus,.although for quite a different reason, Leonardo also approached his celebratory subject in an abstract manner. His treatment was evidently more allegorical than objectively historical, since there was little relevance to the Florentine victory of sixty years earlier. Are we not justified in recognizing, that in this fresco, Leonardo was making an unequivocal statement, in metamorphic, visual terms, of war conceived as "bestial madness" (not condemned as such, for he was too indolent to assume a crusading role) and pessimistically acknowledged as an inescapable, universal truth?

In *The Last Supper*, Leonardo had developed his individual ideas about historical authenticity. He portrayed, with great skill and perception, the boundless variety of human emotions, the "grace and softness" of faces "in the streets at fall of evening." From what we can reconstruct of *The Battle of Anghiari*, it would appear that after finishing his pleasant stay at the court of Il Moro, Leonardo experienced a change in mental and emotional attitudes. He was gradually attracted toward the certainty of mathematical and natural sciences, of which humanity was only a projection, and leaned toward a process of investigation and analytical dissection of man as a physiological and biological machine, represented as a changing symbol. The final stage was to be the androgynous equivocation of *St. John the Baptist* and the swallowing up and disappearance of humanity in the cataclysm (origin and end of the cosmos) of the late *Deluges*, both in written and illustrated form. When Leonardo was lovingly studying and drawing the fine horses of the Milanese nobility, he could not have imagined ever producing the famous page of drawings for *The Battle of Anghiari* at Windsor. Before our very eyes, the head of a horse is amazingly transformed into that of a raging beast, nostrils drawn back to expose the teeth, then into the mask of a roaring lion, and, finally, into the profile of an agonized, howling man.

ANATOMICAL CHART OF THE PRINCIPAL ORGANS AND ARTERIAL SYSTEM OF THE FEMALE BODY
Pen and watercolor drawing over charcoal, on yellowish paper;
$18\frac{1}{2} \times 12\frac{15}{16}$ in (47×32.8 cm)
Windsor, Royal Library
(Inv. no. 12281 *recto*).

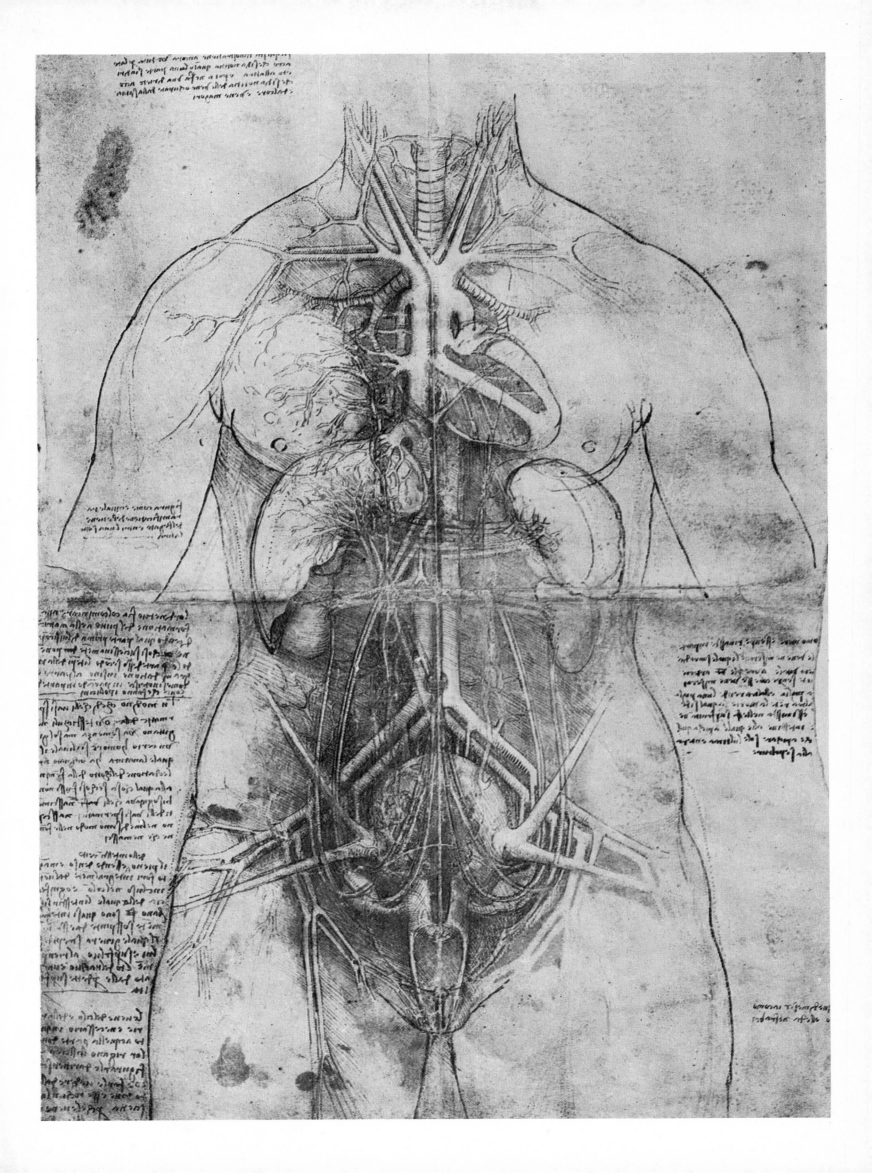

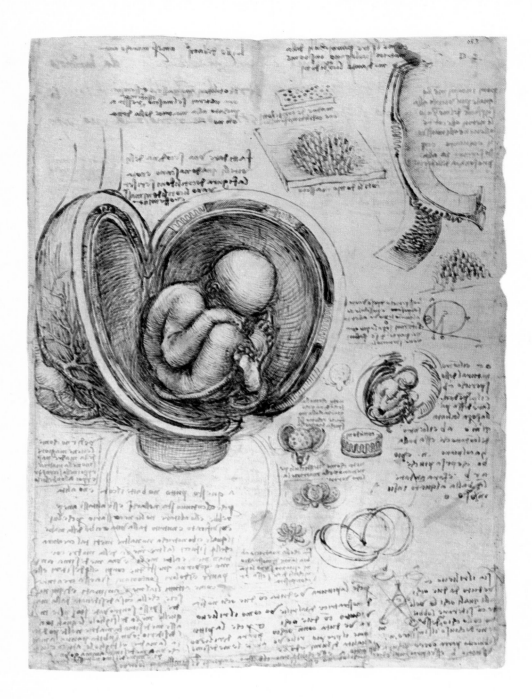

FETUS
Pen drawing; $11\frac{7}{8} \times 8\frac{7}{16}$ in
$(30.1 \times 21.4$ cm$)$
Windsor, Royal Library
(Inv. no. C. III 8, 19102 *recto*).

STUDY OF FETUSES
Pen drawing colored with red chalk
and charcoal; $11\frac{7}{8} \times 8\frac{9}{16}$ in
$(30.1 \times 21.7$ cm$)$
Windsor, Royal Library
(Inv. no. C. III 7, 19101).

The *Mona Lisa*

Modern critics agree that at about the same time as he was working on *The Battle of Anghiari*, Leonardo painted the female portrait the *Gioconda*, universally known as the Mona Lisa. The only positive documentary evidence is that the picture formed part of the collection of Francis I in 1517 and that it found its way from the royal collections into the Louvre in 1804. It is no more than an assumption, based on a statement by Vasari, that it was the portrait of Mona Lisa, wife of Francesco del Giocondo. One must bear in mind, too, that one of the three pictures seen by de Beatis at Cloux in 1517 (in addition to the *St. Anne* and *St. John the Baptist*) was the portrait of "a certain Florentine lady done from the life at the instance of the late Magnificent, Giuliano de' Medici." This uncertainty is, of course, reflected in other works attributed to Leonardo. Of all his surviving pictures, only two, *The Adoration of the Magi* in Florence and *The Last Supper* in Milan, are verified from reliable documents as being by him. In the case of the Mona Lisa, such doubts concerning identification amplify the "mystery" of the picture and the sitter's enigmatic smile.

The truth is that from the nineteenth century to this day, no work of art has been subjected to such a weight of extravagant descriptive literature. The reason why Vasari's description of the Mona Lisa cannot be accepted as proof positive of identification is that, even then, it gave rise to commonplace remarks about "art imitating nature." Nor has any famous picture achieved such enormous popularity, in a pejorative sense, as a result of mass-produced, low-priced, commercial reproductions. When the original painting was stolen in 1911 by an Italian mason (soon being found in Florence and restored to the Louvre), public reaction verged on hysteria. The excessive publicity bestowed on the picture has provoked an ironic, antibourgeois, antitraditionalist reaction on the part of some contemporary avant-garde artists (notably a destructive essay in 1914 by Robert Longhi, when he was associated with the futurist movement) and especially of the surrealists, culminating in the equivocal episode involving Salvador Dalí. He not only drew whiskers on a reproduction of the picture but also substituted his own eyes for those of the sitter. The production was a megalomanic piece of kitsch. Just the same, despite the popular cheapening of the painting and all the talk of "mystery" and "enigma," there is no denying the strength, the technical mastery, and the fascinating symbolic overtones of this justly praised work.

Baudelaire refers to the Mona Lisa in the following lines:

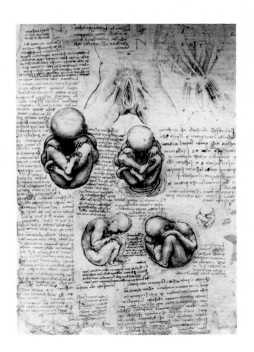

> *Léonard de Vinci, miroir profond et sombre,*
> *Où des anges charmants, avec un doux souris*
> *Tout chargé de mystère, apparaissent à l'ombre*
> *Des glaciers et des pins qui ferment leur pays.*

Walter Pater wrote: "She is older than the rocks among which she sits; like the vampire, she has been dead many times and learned the secrets of the grave; and has been a diver in deep seas and keeps their fallen day about her, and trafficked for strange webs with Eastern merchants; and, as Leda, was the mother of Helen of Troy, and, as Saint Anne, the mother of Mary; and all this has been to her but as the sound of lyres and flutes and lives only in the delicacy with which it has molded the changing lineaments and tinged the eyelids and the hands."

Both of these nineteenth-century authors pinpoint fundamental aspects of Leonardo's painting. Baudelaire recognizes the vital link between the figure and the primeval landscape in the background. Pater underlines the picture's repressed vitality and its suggestion of instability and change that excites all manner of illusions and fantasies. It has no relationship to reality, history, or psychology in literal terms; and by comparing the sitter with St. Anne and Leda, Pater stresses symbolic implications that have been enlarged on by other critics. Both he and Baudelaire sense that the antinaturalistic, equivocal, problematical features of the painting are tokens of its creative originality.

In the Mona Lisa, Leonardo extends his expressive range to the limits. He captures the impalpable transitions of light with unprecedented skill and evokes mood and atmosphere by posing the sitter, represented with the greatest formal simplicity, against a timeless background of infinite space. It was to serve as a model for later generations of portrait painters. Raphael was directly affected by it; and it is possible, though not certain, that in the second decade of the century, ripples of influence were reflected in the works of Lorenzo Lotto and Hans Holbein the Younger. Here, as in the *St. Anne* and *The Battle of Anghiari* (although they are, of course, poles apart), Leonardo conveys abstract symbolic meanings by stretching the bounds of naturalism. Indeed, he hints at the presence of supernatural forces. So the key to the "mystery" of the Mona Lisa must surely be sought not in external circumstances but within the mind and person of Leonardo himself. This effect is achieved by the treatment of atmospheric light that gives the impression of being infinitely changeable, so that the formal and psychological elements of the picture are not fixed or objectified in time and space. Thus in Manuscript A, we read: "Every shaded body fills the surrounding air with an infinite number of its images." "All bodies together and each of itself fill the surrounding air with an infinite number of their images that are all in all this air, and all in the parts of it, bearing with them the nature of the body, the color and the form of their cause."

As for the "mysterious smile," Heydenreich writes: "The famous and oft-

discussed smile of the sitter is the key to the apparent 'mystery' of the Mona Lisa. It represents the subtlest stage in the transition between a motionless, expressionless human face and the delicate enlivening. All expressive possibilities are open, and much has been read into the smile. Yet it produces no specific emotion, neither rejecting nor inviting, reflecting rather a state between nearness and distance, a sense of being apart." The symbolic significance of the figure is reinforced by the extraordinarily abstract quality of the lighting and forms of the "geological" background – an image of nature untouched by human presence, like the face of the moon (this, incidentally, inspiring a fine science-fiction story entitled *The Light*, by Poul Anderson, which appeared in the December 1959 Italian issue of *Galaxy*).

These are, in fact, the years from which date many pages of the Leicester Manuscript that contain a wealth of information on geology and palaeontology, on sea levels and the influence of the oceans in shaping the earth, on fossil shells, and so forth. The following extracts all come from this manuscript: "The bosom of the Mediterranean, like a sea, received the principal waters of Africa, Asia, and Europe; for they were turned toward it and came with their waters to the base of the mountains that surrounded it and formed its banks. And the peaks of the Apennines stood up in this sea in the form of islands surrounded by salt water . . . and above the plains of Italy where flocks of birds are flying today fishes were once moving in large shoals." "The Danube, or as it is called the Donau, then flows into the Black Sea, which used to extend almost as far as Austria and covered all the plain where today the Danube flows; and the sign of this is shown by the oysters and cockleshells and scallops and bones of great fishes that are still found in many places on the high slopes of the said mountains."

"Since things are far more ancient than letters, it is not to be wondered at if, in our days, there exists no record of how the aforesaid seas extended over so many countries; and if, moreover, such record ever existed, the wars, the conflagrations, the changes in speech and habits, the deluges of the waters have destroyed every vestige of the past. But sufficient for us is the testimony of things produced in the salt waters and now found again in the high mountains, sometimes at a distance from the seas."

Continuing on the same theme: "In this work of yours, you have first to prove how the shells at a height of a thousand *braccia* were not carried there by the Deluge, because they are seen at one and the same level, and mountains also are seen that considerably exceed this level, and to inquire whether the Deluge was caused by rain or by the sea in a swirling flood; and then you have to show that neither by rain that makes the rivers rise in flood nor by the swelling up of the sea could the shells, being heavy things, be driven by the sea up the mountains or be thrown there by the rivers contrary to the course of their waters."

"In the mountains of Parma and Piacenza multitudes of shells and corals filled with wormholes may be seen still adhering to the rocks, and when I was making the great horse at Milan, a large sack of those that had been found in these parts was brought to my workshop by some peasants. . . . Under the ground and down in the deep excavations of the stone quarries, timbers of worked beams are found that have already become black. They have been found during my time in the excavations made at Castel Fiorentino. . . . In Candia, in Lombardy, near to Alessandria della Paglia, while some men were engaged in digging a well for Messer Gualtieri, who has a house there, the skeleton of a very large ship was found at a depth of about ten *braccia* beneath the ground; and as the timber was black and in excellent condition, Messer Gualtieri thought fit to have the mouth of the well enlarged in such a way that the ends of the ship should be uncovered."

Finally, there is this passage from Manuscript E: "Of how the sea changes the weight of the earth. The shells of oysters and other similar creatures that are born in the mud of the sea testify to us of the change in the earth round the center of our elements. This is proved as follows: the mighty rivers always flow turbid because of the earth stirred up in them through the friction of their waters on their bed and against the banks; and this process of destruction uncovers the tops of the ridges formed by the layers of these shells, which are embedded in the mud of the sea where they were born when the salt waters covered them. And these same ridges were, from time to time, covered over by varying thicknesses of mud that had been

NUDE
Red chalk drawing on white paper;
$10\frac{5}{8} \times 6\frac{5}{16}$ in (27 × 15 cm)
Windsor, Royal Library
(Inv. no. 12596).

ANATOMICAL STUDIES
Pen drawing on white paper;
$11\frac{5}{16} \times 7\frac{11}{16}$ in (28.7 × 19.6 cm)
Windsor, Royal Library
(Inv. no. 19001 *verso*).

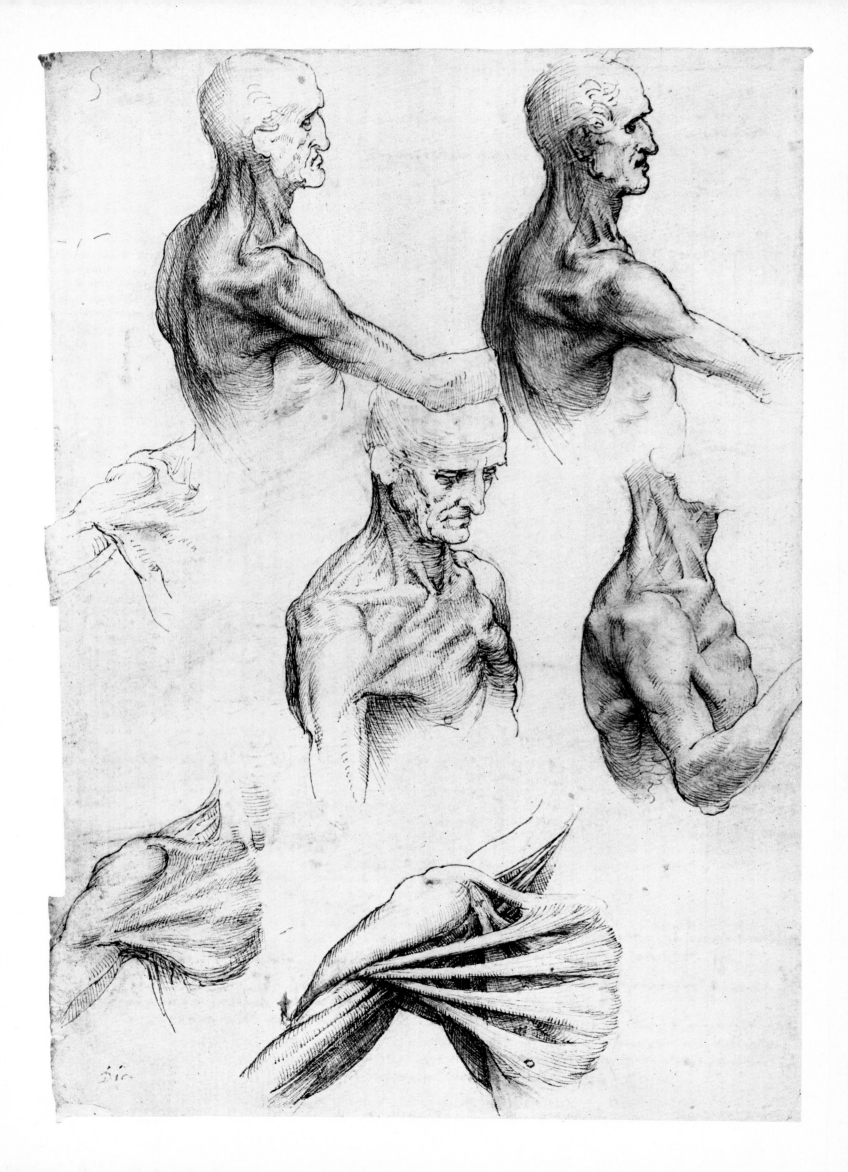

brought down to the sea by the rivers in floods of varying magnitude; and, in this way, these shells remained walled up and dead beneath this mud, which became raised to such a height that the bed of the sea emerged into the air. And now these beds are of so great a height that they have become hills or lofty mountains, and the rivers that wear away the sides of these mountains lay bare the strata of the shells, and so the light surface of the earth is continually raised, and the antipodes draw nearer to the center of the earth, and the ancient beds of the sea become chains of mountains."

Here was the beginning of a process that, as I have said, seemed to transform Leonardo's "image of the world" and that, I believe, is to be evident in his writings, drawings, and paintings from this time onward. From it emerged the man who, in Vasari's words, was more "philosopher than Christian." His unorthodoxy had not yet reached the point of expressing an intuitive awareness of the existence and development of natural objects, both inorganic and embryonically organic (fossils), prior to the appearance of man; but his writings and his visual concepts, from the time of the Mona Lisa to the late *Deluges*, indicate that such notions, at variance with traditional dogma, were formulating in his mind. So he was already hazarding what we would today describe as a "scientific" interpretation of the biblical account of the Flood and its consequences; and it is an interesting fact that, in attempting to explain such a phenomenon, he should have resorted to language and images reminiscent of the Bible itself.

Leda

Another form of unorthodoxy and a different type of abstract symbolism were to emerge from the images of Leonardo's *Leda*. Once again, there has been a great deal of critical speculation, based on the written and visual evidence that has survived, concerning a lost work. Written references comprise a vague, almost contemporary allusion by the Anonimo Gaddiano, a description by Lomazzo in 1584, and a mention of a painting on a panel in France that was described in some detail by Cassiano del Pozzo in 1623, when he visited the court at Fontainebleau. This painting was already in poor condition, and all traces of it were lost at the end of the century. Corresponding to this description is a panel that conforms to northern artistic tastes. This has led critics to assume that it might be a copy or variant version painted in collaboration by Leonardo's pupil Francesco Melzi and the Flemish artist Joost van Cleve. Having come from the de la Rozière collection, it was displayed at an exhibition in Paris in 1874. It then belonged to several owners before being acquired by Ludovico Spiridon in Rome. During World War II, this copy was briefly removed by Hermann Goering's minions and was recovered after the war by the Italian government.

This painting shows Leda embracing the swan. At her feet lie two broken eggs from which issue four newborn infants – Helen, Clytemnestra, Castor, and Pollux. A copy in the Borghese Gallery, Rome, shows a similar figure of a "standing" Leda but in completely different surroundings and with Castor and Pollux only. This has been variously attributed to Tuscan or Lombard artists, and one critic (Morelli) ascribes it to Sodoma. The head of Leda in this copy, even more than that in the Spiridon version, appears to be closer in style to two original drawings of heads in the Windsor collection, while the "standing" female figure, undoubtedly inspired a Raphael drawing dating from his period in Florence, provides evidence for thinking that the germ of the idea, at least, came to Leonardo at about the time of *The Battle of Anghiari* and the Mona Lisa. We have little proof, therefore, that Leonardo definitely transformed his idea for a drawing into a painting. Apart from the figures of Leda and the swan, the Spiridon panel and the Borghese Gallery canvas are wholly contrasted; and there is nothing to suggest that the picture mentioned by Lomazzo and seen in France by Cassiano del Pozzo was really by Leonardo and not,

ANATOMICAL STUDIES
Pen drawing; $11\frac{3}{16} \times 7\frac{3}{4}$ in
(28.4×19.7 cm)
Windsor, Royal Library
(Inv. no. 19003 *recto*, detail).

ANATOMICAL STUDIES
Pen drawing; $11\frac{1}{4} \times 7\frac{11}{16}$ in
(28.5×19.5 cm)
Windsor, Royal Library
(Inv. no. 19013 *verso*).

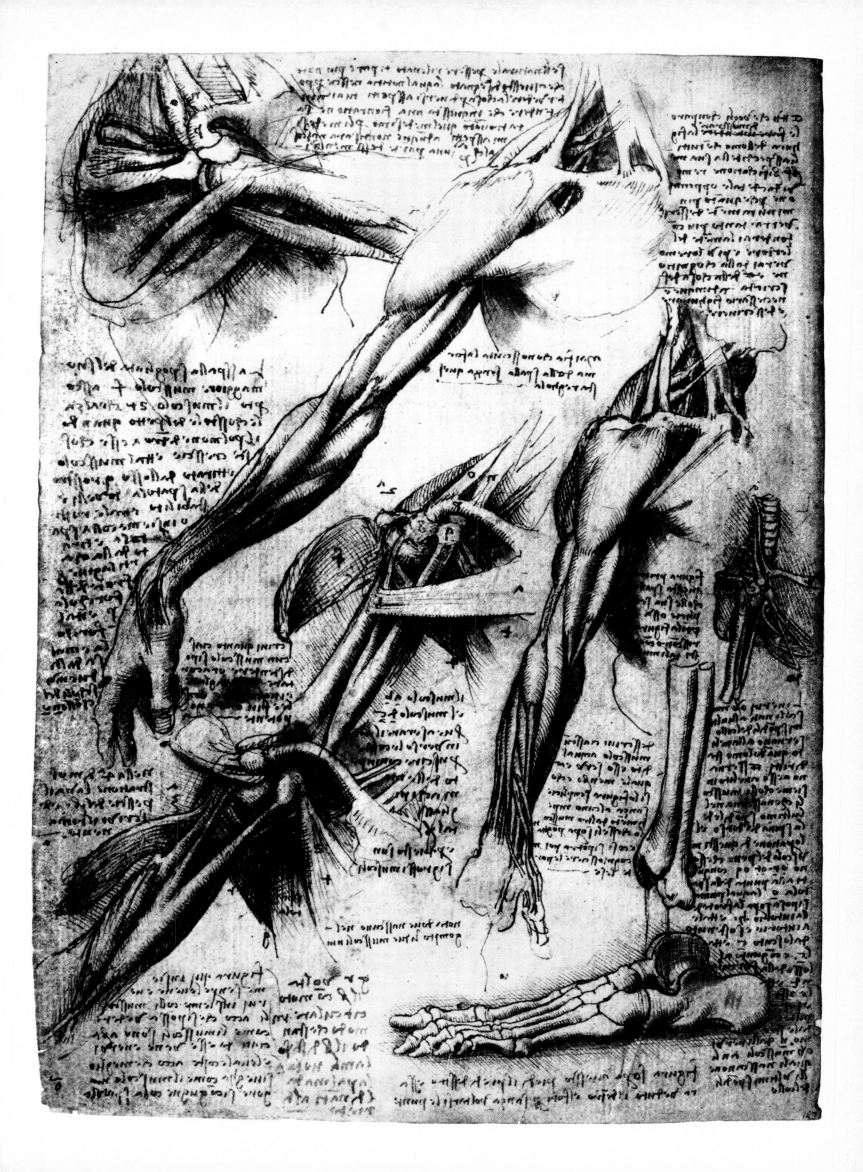

like the Spiridon version traditionally attributed to the master, a variation on the theme.

All the more precious, therefore, are two original drawings, extraordinarily powerful in their modeling, one in the Boymans Museum, Rotterdam, and the other at Chatsworth House. There is a similar sketch at Windsor. All three drawings are variations of Leda kneeling beside the swan, surrounded by luxuriant vegetation from which, in a tangle of plant and human forms, emerge the semidivine progeny of the pair. There is also a variant of this version (set in a landscape similar to that of the "standing" Leda in the Borghese Gallery), now in the collection of the Prince of Wied at Neuwied. Critics have attributed this to Giampietrino, a follower of Leonardo in his later period in Milan (1506–1507 and in 1508–13), suggesting to some experts that the "second" Leda may have been conceived at that time. Yet there is nothing to negate the theory that Leonardo may have been considering two different versions simultaneously. There are, in fact, associated features between the putative Spiridon and Borghese copies and the original drawings of the "kneeling" Leda. There are resemblances, too, to yet another version, generally agreed to be the only faithful copy of the "standing" Leda by followers of Leonardo. This one (in the Louvre) is a fine drawing that shows Leda and the swan only on an expanse of grass, the vegetation being similar to that of the "kneeling" Leda drawings. Other comparisons worthy of note are the similarities between the children in the Chatsworth drawing and the Spiridon panel and the resemblance of the hairstyle of the Rotterdam Leda to that of the head studies at Windsor. These are reasons that, in my opinion, make it difficult to assign dates to the "standing" and "kneeling" versions of the subject.

The classically statuesque style of the "standing" Leda has been pointed out by many critics, and undoubtedly it bears a resemblance to certain statues of Venus. This would explain the influence it had on Raphael (apart from the aforementioned drawing), culminating in the latter's fresco, the *Triumph of Galatea*, painted around 1511 in the Villa Farnesina, Rome. But it seems to me a mistake to attach any particular cultural significance to this coincidence, for it would imply a complete reversal of Leonardo's attitudes to humanism. I think it is much more probable that the *Leda* originated in a simple, sudden flash of inspiration. There would seem to be more truth in the assertion that, on the formal level, the "standing" Leda goes beyond the bounds of pure classical tradition in its representation of the human figure (a tradition most magnificently embodied, around the same time, by Michelangelo in his *David*), so that the surfaces seem to ripple and writhe with gentle movement, conveying different impressions according to the angle of viewing. It opens the way to the classical versus anticlassical arguments of manneristic art, and exercises an immediate influence not only on Raphael but on Michelangelo himself.

We know that Leonardo increasingly advocated an "un-Christian philosophy" concerning man and nature and indulged in symbolic imagery during the first decade of the new century. Bearing this in mind, it appears that the classicism (if such it is) of *Leda*, is revolutionary – a symbol of life as pure creativity, metamorphosed fertility, a source of marvel and mystery. It is tempting, in this particular case, to resort to the language used by earlier critics who defined Leonardo's genius in vaguely mystical terms, describing him as a "magician," for his mythical Leda is also Venus, Diana of Ephesus, *dea mater*. Certainly, Leonardo's distrust of metaphysics is here expressed visually in the most unmistakable manner. Thus, there is no extreme contradiction between *The Battle of Angiari* and *Leda*. Man is the projection and agent of nature both in his ability to destroy and create. His unique gift, exemplified supremely by Leonardo himself, is to be able to analyze this phenomenon critically, to see himself in relation to the natural world, to deal with realities rather than metaphysical notions, and to reveal his discoveries and visions in writing and art.

STUDIES OF WATER AND EDDIES
Pen and red chalk drawing on white paper; $11\frac{7}{16} \times 7\frac{15}{16}$ in (29×20.2 cm)
Windsor, Royal Library
(Inv. no. **12660** *recto*).
Facing page: verso of same page
Pen drawing.

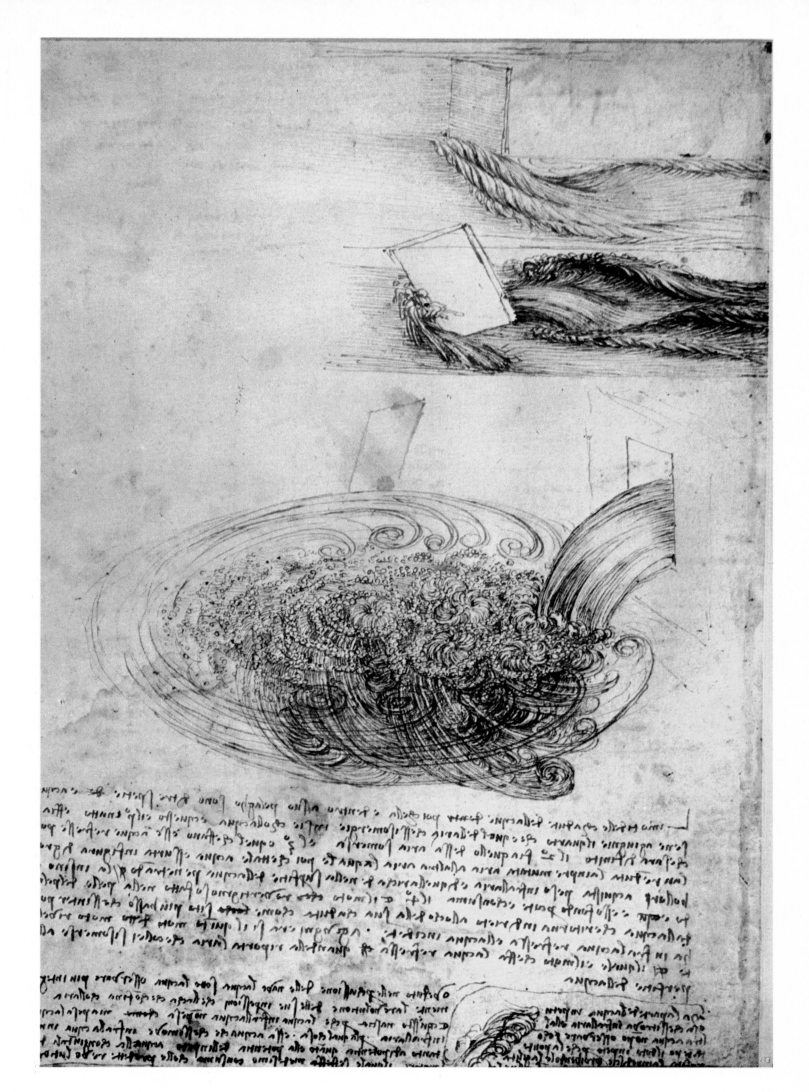

CODICE ON THE FLIGHT OF
BIRDS
Page 8 *recto*.
Turin, Royal Library
On this page, in addition to drawings of
birds, there is the following text in
Leonardo's handwriting:
"If the wing and the tail are too far
above the wind, lower half the opposite
wing and so get the impact of the wind
there within it, and this will cause it to
right itself.
"If the wing and the tail should be
beneath the wind, raise the opposite
wing and it will right itself as you
desire, provided that this wing which
rises slants less than the one opposite
to it.
"And if the wing and the breast are
above the wind, half of the opposite
wing should be lowered, and this will be
struck by the wind and thrown back
upwards, and this will cause the bird to
right itself.
"But if the wing and the back are
below the wind you ought then to raise
the opposite wing and expand it in the
wind, and the bird will immediately
right itself.
"And if the bird is situated with the
hinder part above the wind, the tail
ought then to be placed beneath the
wind, and thus there will be brought
about an equilibrium of forces.
"But if the bird should have its
hinder parts below the wind it should
enter with its tail above the wind and it
will right itself."

Pages 158–159:
VIEW OF THE ADDA AT THE TRE
CORNI
Pen drawing on yellowish-white paper;
$3\frac{15}{16} \times 5\frac{13}{16}$ in (10×14.7 cm)
Windsor, Royal Library
(Inv. no. 12399).

It is not surprising, therefore, that from the time of his second period in Milan, during the lonely and bitter years in Rome under Leo X and throughout the last residence at the French court of Francis I, Leonardo should have spent an increasing amount of time on research and experiment (to the almost complete exclusion of painting). It is also understandable that the gap between the various fields of interest should have narrowed steadily. This was evident both in his writing and drawing. In June 1506, he returned to Milan and stayed there until September 1513. (This is apart from a visit to Florence lasting from September 1507 to September 1508 and another short trip there in 1511, when he was involved with matters related to his father's estate.) Protected by Louis XII and Governor Charles d'Amboise, he recovered the vineyard given him by Ludovico the Moor. Surrounded by new friends and pupils, among them the young Francesco Melzi and the indispensable Salaino, he occupied his own house in Porta Orientale, a parish of San Babila. The commissions he continued to receive must have reawakened memories of those years with Il Moro. They included a second equestrian monument, various architectural projects – a villa for Charles d'Amboise and perhaps work on the then-rural church of Santa Maria della Fontana – and a number of hydraulic engineering plans.

One of his first commissions after arriving in Milan was an equestrian monument of Marshal Gian Giacomo Trivulzio, who had defeated Il Moro in 1499. It was to be a funerary mausoleum for the Trivulzio family chapel in San Celso. There are numerous drawings associated with this project, especially at Windsor, that show both the whole statue and the horse (although it is not always easy to distinguish such studies from those for the earlier Sforza statue) as well as a detailed calculation of the cost of work and materials in the Codice Atlantico. The striking difference between this and the previous project was that here the condottiere on horseback was to have been represented life-size and, thus, was to be smaller than the Sforza "colossus." The reason for the smaller size was that the bronze statue was intended to crown a marble temple-cum-mausoleum containing the sarcophagus. The building was also to be adorned with sculptures and bas-reliefs. Leonardo estimated that the total cost of labor and materials would be 1,582 ducats (including 432 ducats for "making model in clay and then in wax") for "the horse . . . with the man on it." The mausoleum would cost an additional 1,464 ducats – 389 ducats for the marble and 1,075 ducats for labor, including 100 ducats "for the statue of the deceased, to do it well."

Modern critics and, most recently, Giorgio Castelfranco, have tended to compare the plans for the two monuments and the postures of the horses but have not always sufficiently emphasized the exceptional quality and novelty of the model for the complete Trivulzio monument. The building was a prototype for sculptors up to the baroque age and, more immediately, for Michelangelo. Different sketches show variations in the comparative sizes of the sepulcher and the equestrian group as well as variant versions of the former, with its columns, half-columns, frieze and architrave, base, and corniced arches. In some sketches, the sepulcher is square with four faces (in the cost estimate, Leonardo provides for eight columns and eight decorative figures); in one drawing, it is circular, and in another, it is shown as a triumphal arch with minor side-fornices. The striking feature, however, of many of these sketches is the inclusion of lifelike figures that are manneristic in style. Among them is one that shows actual "captives," attached by suitable supports to the corners of the sepulcher.

The link between Leonardo and Michelangelo in this instance raises interesting questions. Michelangelo, as already mentioned, was called to Rome in March 1505 by Pope Julius II for the construction of his own sepulcher. Having made an initial plan and examined marble excavated from Carrara for the monument, Michelangelo, completely abandoned the project. He severed relations with the pope and returned to Florence in April 1506, before Leonardo's departure for Milan. Michelangelo's biographer Condivi described the project as "the tragedy of the

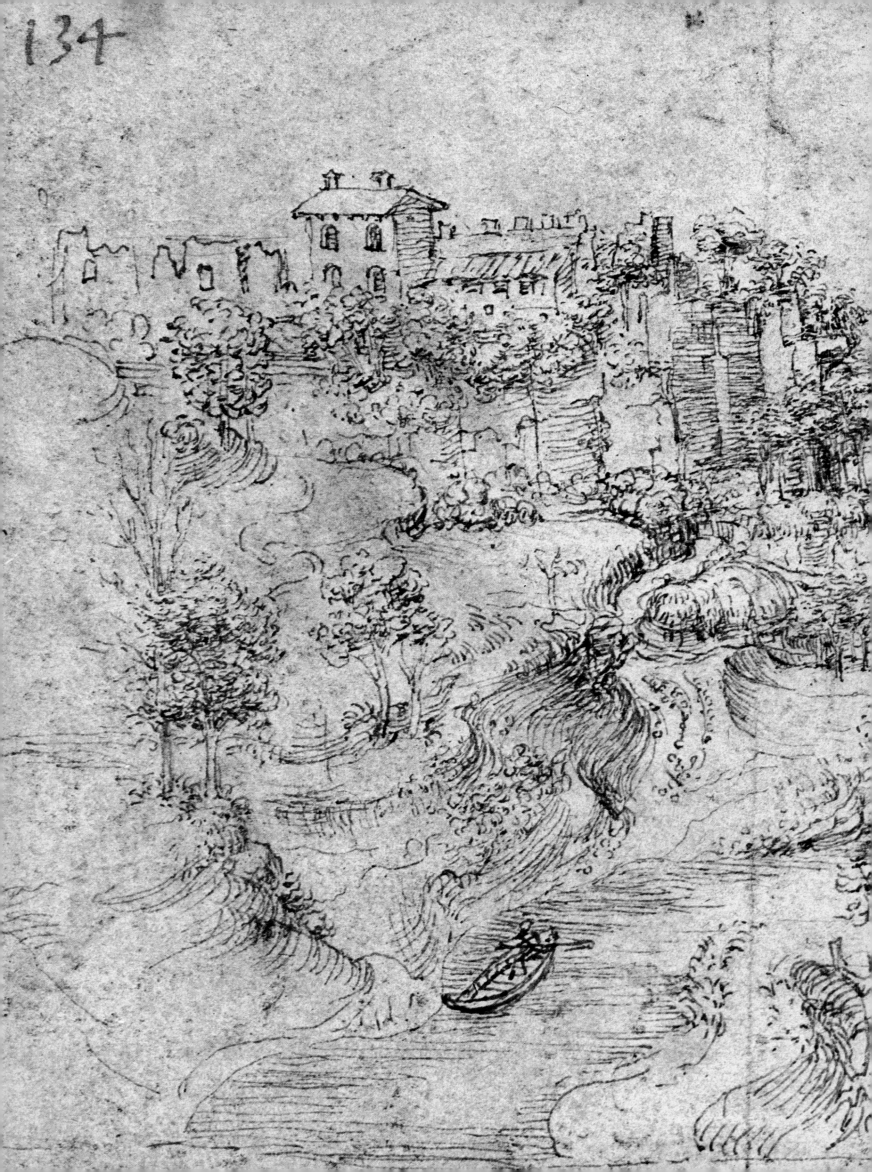

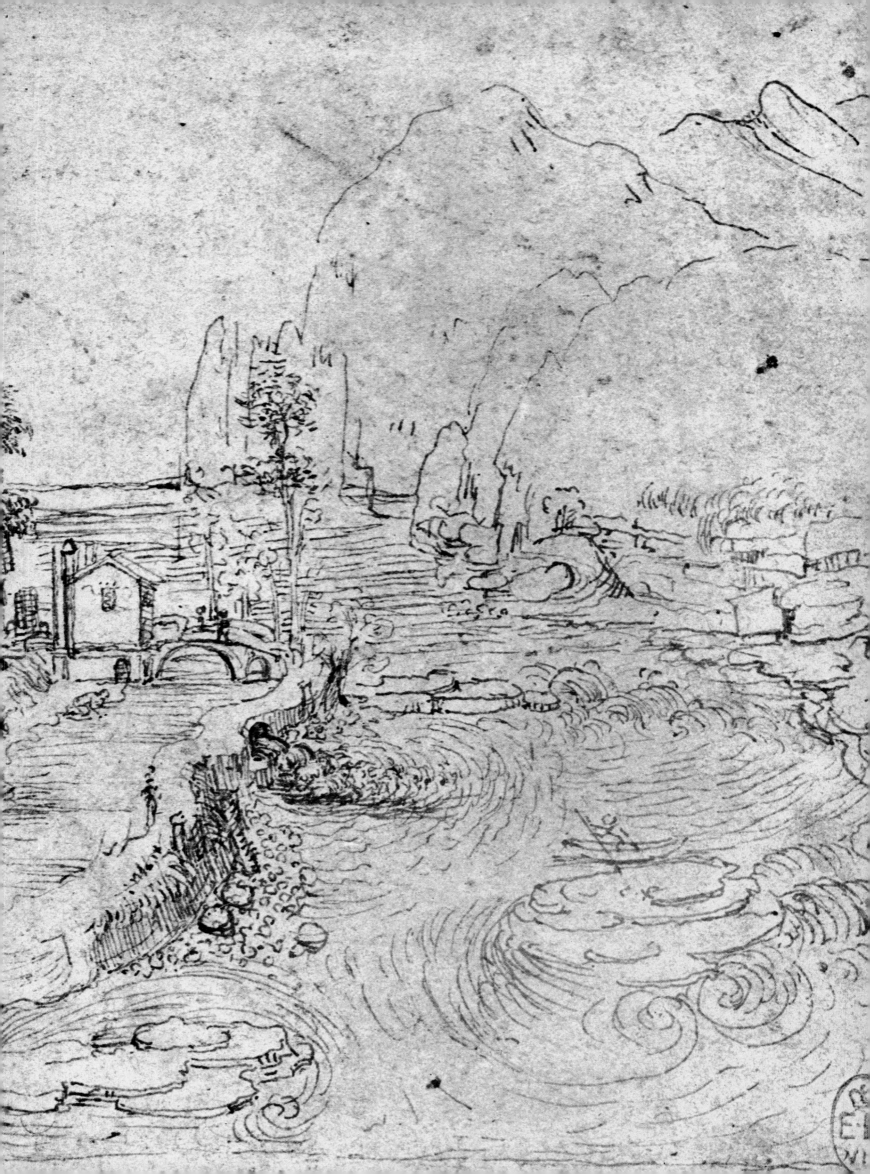

sepulcher," but it came full circle about forty years later, when Michelangelo constructed a wall tomb for the same pope. This project, erected in 1545 in San Pietro in Vincoli, was dominated by the wonderful statue of *Moses*. As originally conceived, the funeral chamber inside was to have been pyramidal and adorned with symbolic pieces of sculpture – including the *Captives* leaning against pillars in the lower part. The culminating point was the sarcophagus with a statue of the pope flanked by allegorical figures.

The two projects clearly had many features in common, despite the fact that they featured men from vastly different walks of life – one a pope seeking a sepulcher pure and simple and the other a condottiere, whose memory was to be honored with a tomb that was also designed as a celebratory monument. The distinction is important for several reasons. It was no secret that the two men were rivals, and, on this occasion, taking the date into consideration, it seems likely that Leonardo, prior to leaving Florence, familiarized himself with Michelangelo's drawings and that they were in his mind when he returned to Milan. But once again, the development of his plans underlined the fundamental differences between the ideas and methods of these great contemporaries.

Having obtained the Trivulzio commission, which was evidently similar to that of Pope Julius's, Leonardo cast his mind back to the thwarted dream of the Sforza monument. Michelangelo's plan, although revolutionary in structure, was orthodox in conception. Leonardo transformed it into a much more complex notion of a tomb and monument combined. Admittedly, it was not a wholly original idea. As much as a century and a half earlier in northern Italy, there had been precedents, namely the tomb-monuments of the great masters of Campione, especially that of Barnabò Visconti in Milan, as well as the Scaliger tombs in Verona; and it cannot be taken for granted that Leonardo had the typical humanist prejudices against the Gothic style. Furthermore, Donatello's *Gattamelata* in Padua was also a symbolic tomb-monument. In this context, the presence of "captives" in one of the drawings for the Trivulzio monument indicates that Leonardo conceived them with a particular purpose in mind, it was an idea quite unlike that of Michelangelo's counterparts. They were to be symbolic yet objectively real. The "captives" were a tribute to the exploits of the condottiere; they were comparable in implication to the conventional portrayal of defeated soldiers being trampled by horses and, thus, were the precursors of innumerable monuments, in a similar vein, of military leaders and princes. The famous *Captives* of Michelangelo are part of a much more literary "program" of symbolism that is ideal and universal but that, at the same time, reflects the personal, subjective thinking of the sculptor or perhaps of Michelangelo and Pope Julius II in conjunction.

The aforementioned reference to Donatello's *Gattamelata* brings us to a consideration of the bronze statue of Trivulzio. Had the project been carried through to its conclusion, it is a reasonable assumption that Leonardo, because of his dislike of marble, both in theory and in practice, would have entrusted such parts of the project to others. Milanese sculptors such as the brothers Mantegazza had vanished from the scene and so, too, had Benedetto Briosco. Amadeo was too much committed to the "old style," but this still left Cristoforo Solario ("Il Gobbo"), who had built the double tomb of the Moor and of Beatrice d'Este in the Certosa di Pavia monastery, and the even younger Agostino Busti, known as "Il Bambaia."

There is a drawing at Windsor that shows a dashingly vigorous, sturdy horse at the gallop. This is traditionally associated with Leonardo's earliest plans for the Trivulzio monument. The armed horseman has a condottiere's baton in his hand. The statue of Francesco Sforza was originally conceived in this pose, but it is clear that Galeazzo Maria and then Il Moro requested Leonardo to provide the likeness of a prince and duke. This drawing is similar to *Gattamelata*; and it might have been assumed that Leonardo, with typical consistency, would have followed up the ideas he had been forced to drop in relation to the Sforza monument. Instead, he suddenly altered his plans and returned to the notion of the condottiere on a rearing horse trampling a fallen enemy. This is an idea, incidentally, that he had toyed with in his initial plan for the Sforza statue, Thus, in a sense, Leonardo was completing the cycle. It is interesting, too, to note how Leonardo extended and exploited such ideas in his painting. In the wake of the abortive Sforza project had come *The Adoration of*

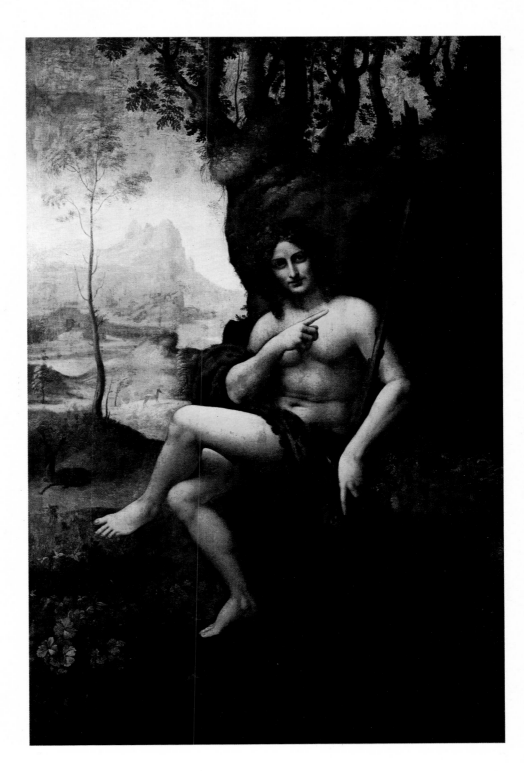

Leonardo (?)
ST. JOHN IN THE DESERT
Red chalk drawing on red prepared
paper; $9\frac{7}{16} \times 7\frac{1}{16}$ in (24×18 cm)
Once in the Museum of the Sanctuary
of the Holy Mount at Varese, this
drawing has recently vanished. Tolnay
attributed it to Leonardo, other critics
ascribing it to Cesare da Sesto. Poor
state of preservation.

School of Leonardo
BACCHUS
Canvas; $69\frac{3}{4} \times 45\frac{1}{4}$ in (177×115 cm)
Paris, Louvre
This work originally portrayed St.
John the Baptist. Towards the close of
the seventeenth century the painting
was no longer listed as a likeness of the
saint but as that of Bacchus, having
undergone considerable modifications.

the Magi, with its background of battling horsemen; now, having returned to a
similar subject for the Trivulzio commission, he elaborated the cavalry motif in the
central episode of *The Battle of Anghiari*. This was probably the period, too, when he
produced his "book of horse sketches." The drawings of horses for the Trivulzio
project differ in certain respects from those dating from the 1490s. They are more
consciously "artistic" and less "scientific" than the studies made during the first
Milanese period. This was in keeping with Leonardo's current research into anatomy
and the poetry of movement.

The Windsor Collection

It was in the course of this period in Milan that Leonardo developed his plans for a definitive treatise on anatomy. A note in the Windsor collection states: "This winter of the year 1510, I look to finish all this anatomy." The earliest pages devoted to this subject go back to around 1489, and others may date from the second visit to Florence, but the majority of the notes and illustrations on anatomy are from these later years. Although there is no positive documentary proof, it is very likely that Leonardo was assisted in his work by Marcantonio della Torre, doctor and anatomy professor at Pavia University. Of all the projects that engaged his interest during these years, it is obvious, from the systematic nature of the illustrations and the pagination and from the close relationship of writing and drawings in the Windsor Manuscripts A, B and C, that anatomy was the subject in which Leonardo was most keenly absorbed and that he had a very precise program mapped out in his mind. Mention has already been made of the first part of such a program. It is contained on a sheet of Manuscript B that dates back to 1489. The opening description of the child in the womb (previously quoted) continues as follows: "Then you should describe which are the limbs that grow more than the others after the child is born and give the measurements of a child of one year. Then describe the man fully grown and the woman and their measurements and the nature of their complexions, color, and physiognomy. Afterward, describe how he is composed of veins, nerves, muscles, and bones. This you should do at the end of the book. Then represent in four histories four universal conditions of mankind, namely joy, with various modes of laughing, and represent the cause of the laughter; weeping, the various ways with their cause; strife, with various movements expressing of killings, flights, fear, acts of ferocity, daring, homicide, and all the things connected with cases such as these. Then make a figure to represent labor in the act of dragging, pushing, carrying, restraining, supporting, and conditions such as these. Then describe the attitude and movement; then perspective, through the office of the sight or the hearing. You should make mention of music and describe the other senses. Afterward, describe the nature of the five senses. We shall describe this mechanical structure of man by means of diagrams, of which the first three will treat of the ramification of the bones; that is, one from the front that shows the positions and shapes of the bones latitudinally; the second as seen in profile and shows the depth of the whole and of the parts and their position; the third diagram will show the bones from behind. Then, we shall make three other diagrams from the same points of view with the bones sawn asunder so as to show their thickness and hollowness." This is associated with the wonderful drawings of the sections of the skull that date from 1489. "Three other diagrams we shall make for the bones entire and for the nerves that spring from the nape of the neck and showing into what limbs they ramify, and three others for the bones and veins and where they ramify, then three for muscles and three for the skin and measurements, and three for the women to show the womb and the menstrual veins that go to the breasts."

This plan was based on anatomical information that already implied an advanced state of research. In the later portion of the work, the plan for diagrams was to have included nine for the bones and muscles and six for the relative proportions of men and women (the latter showing a cross section of the reproductive organs), as opposed to only three for the nervous system and three for blood circulation. But the fascination of the drawings resides in the combination of elements that are old and new. In one sense, they are in the traditional line of anatomical art; in another, they open up avenues of exploration into the psychological and emotional roots of our physical expressions and movements, artistically exemplified in four "histories," and they also branch out into other fields such as perspective, through vision, and music, through hearing. Thus, already, around 1490, Leonardo looks forward to a meeting point between two apparently unconnected areas of study in formulating plans for treatises on anatomy and painting.

We come now to another passage from a page in the Windsor collection. This excerpt dates from the second period in Milan: "The order of the book. This plan of

STUDY OF A STORM AND A
SKIRMISH OF HORSEMEN
Pen over charcoal drawing on gray
paper; $10\frac{5}{8} \times 16\frac{1}{8}$ in (27×40.8 cm)
Windsor, Royal Library
(Inv. no. 12376).

162

mine of the human body will be unfolded to you just as though you had the natural man before you. The reason is that, if you wish to know thoroughly the parts of a man after he has been dissected, you must either turn him or your eye so that you are examining from different aspects, from below, from above, and from the sides, turning him over and studying the origin of each limb; and in such a way the natural anatomy has satisfied your desire for knowledge. But you must understand that such knowledge as this will not continue to satisfy you on account of the very great confusion that must arise from the mixture of membranes with veins, arteries, nerves, tendons, muscles, bones, and the blood, which of itself, tinges every part with the same color, the veins through which this blood is discharged not being perceptible by reason of their minuteness. The completeness of the membranes is broken during the process of investigation of the parts that they enclose, and the fact that their transparent substance is stained with blood prevents the proper identification of the parts that these cover on account of the similarity of the bloodstained color, for you cannot attain to any knowledge of the one without confusing and destroying the other.

"Therefore, it becomes necessary to have several dissections: you will need three in order to have a complete knowledge of the veins and arteries, destroying all the rest with very great care; and three others for a knowledge of the membranes (*panniculi*), three for the tendons, muscles and ligaments, three for the bones and cartilages, three for the anatomy of the bones, for these have to be sawn through in order to show which are hollow and which not, which are full of marrow, which spongy, which thick from the outside inward, and which thin. Thus, it may be that all these conditions will sometimes be found in the same bone, and there may be another bone that has none of them. Three also must be devoted to the female body, and in this there is a great mystery by reason of the womb and its fetus.

"Therefore, by my plan, you will become acquainted with every part and every whole by means of a demonstration of each part from three different aspects; for when you have seen any member from the front with the nerves, tendons, and veins that have their origin on the opposite side, you will be shown the same member either from a side view or from behind, just as though you had the very member in your hand and went on turning it from side to side until you had a full understanding of all that you desire to know. And so, in like manner, there will be placed before you three or four demonstrations of each member under different aspects, so that you will retain a true and complete knowledge of all that you wish to learn concerning the figure of man.

EXPLOSION
Charcoal and brown and yellow ink drawing; 6⅜ × 8 in (16.2 × 20.3 cm)
About **1515**
Windsor, Royal Library
(Inv. no. **12380**).

"Therefore, there shall be revealed to you here, in fifteen entire figures, the cosmography of the 'minor mondo' (the microcosmos or lesser world) in the same order as was used by Ptolemy before me in his Cosmography. And, therefore, I shall divide the members as he divided the whole, into provinces, and then I shall define the functions of the parts in every direction, placing before your eyes the perception of the whole figure and capacity of man insofar as it has local movement by means of its parts. And would that it might please our Creator that I were able to reveal the nature of man and his customs even as I describe his figure.

"And I would remind you that the dissection of the nerves will not reveal to you the position of their ramification nor into which muscles they ramify by means of bodies dissected either in flowing water or in lime water, because, although the origin of their derivation may be discerned without the use of the water as well as with it, their ramifications tend to unite in flowing water all in one bunch, just as does flax or hemp carded for spinning, so that it becomes impossible to find out again into which muscles the nerves are distributed or with which or how many ramifications they enter the said muscles."

The difference between this and the earlier passage, both from the viewpoint of concept and method, is very marked. The emphasis now is exclusively on the objective structure of the human body and its "natural" innermost essence, but there is a tremendous leap forward in thought and expression, to the "great mystery" of reproduction (reflected visually in the *Leda*). Apart from that, there is no great discrepancy between the 1489 plan of the book and the idea of "natural anatomy" expressed here. Taking this a step further, the hand of the dissector, with the utmost care and delicacy, opens the way to precise and detailed visual observation. The results are to be minutely "demonstrated" in the fifteen "entire figures" and in innumerable points of detail. In the logical development of this program, the scientific, operative procedures of the dissector and the painstaking scrutiny of the observer, as he copes with the problems posed by fragile, bloodstained membranes, are undifferentiated rather than correlated. So the approach of the earlier anatomical studies is in a certain sense revolutionized. Previously, the impulse toward research and experiment was intended to lead directly to a visual representation of movements and "feelings"; but now, all the accumulated experience of the operator-observer, to whom nothing is barred, becomes the instrument of the most detailed form of anatomical demonstration, by means of which Leonardo describes a genuinely three-dimensional approach to the subject: "... just as though you had the very member in your hand and went on turning it from side to side." The proposed method is also stratigraphic, as in this precept for the study of the foot: "Make a demonstration of this foot with the simple bones; then, leaving the membrane that clothes them, make a simple demonstration of the nerves; and then over the same bones make one of tendons, and then one of veins and artery together. And finally make a single one to contain artery, veins, nerves, tendons, muscles, and bones."

If this sounds coldly scientific, it is far from conveying the general mood and tone of Leonardo's precepts. In later years, he became increasingly introspective, wrapped up in himself and his research. Man is a microcosm and Leonardo the Ptolemy of human behavior, both emotional and rational, proud in possessing the moral strength (carried to unorthodox extremes) and the means of expression to carry his work through to a conclusion. Conscious of bringing to the subject the fruits of his personal experience in scientific and artistic matters, he writes: "And you who say that it is better to look at an anatomical demonstration than to see these drawings, you would be right, if it were possible to observe all the details shown in these drawings in a single figure, in which, with all your ability, you will not see nor acquire a knowledge of more than some few veins, while, in order to obtain an exact and complete knowledge of these, I have dissected more than ten human bodies, destroying all the various members and removing even the very smallest particles of flesh that surrounded these veins, without causing any effusion of blood other than the imperceptible bleeding of the capillary veins. And as one single body did not suffice for so long a time, it was necessary to proceed by stages with so many bodies as would render my knowledge complete; and this I repeated twice over in order to discover the differences. But though possessed of an interest in the subject,

DELUGE
Charcoal drawing on white paper;
$6\frac{7}{16} \times 8\frac{1}{4}$ in (16.3 × 21 cm)
Windsor, Royal Library
(Inv. no. 12378).

you may perhaps be deterred by natural repugnance or, if this does not restrain you, then perhaps by the fear of passing the night hours in the company of these corpses, quartered and flayed and horrible to behold; and if this does not deter you, then perhaps you may lack the skill in drawing essential for such representation; and even if you possess this skill, it may not be combined with a knowledge of perspective, while, if it is so combined, you may not be versed in the methods of geometrical demonstration or the method of estimating the forces and strength of muscles, or perhaps you may be found wanting in patience, so that you will not be diligent. Concerning which things, whether or no they have all been found in me, the hundred and twenty books (drawings?) that I have composed will give their verdict 'yes' or 'no.' In these, I have not been hindered either by avarice or negligence but only by want of time. Farewell."

In this perceptive analysis of the "medium," Leonardo recognizes the overriding problem of combining artistic and surgical skills. In addition to sheer manual dexterity ("skill in drawing"), a feeling for depth ("perspective"), and a sense of proportion ("methods of geometrical demonstration"), the student must also have a practical, and not merely theoretical, knowledge of the physical laws of dynamics. The following passage is equally enlightening in clarifying the mental process of a man, who, although opposed to metaphysics, was eager to pursue any inquiry into the phenomenon of human existence: "And thou, man, who by these my labors dost look on the marvelous works of nature, if thou judgest it to be an atrocious act to destroy the same, reflect that it is an infinitely atrocious act to take away the life of man. For thou shouldst be mindful that though what is thus compounded seem to thee of marvelous subtlety, it is as nothing compared with the soul that dwells within this structure; and in truth, whatever this may be, it is a divine thing that suffers it thus to dwell within its handiwork at its good pleasure and wills not that thy range or malice should destroy such a life, since in truth he who values it not does not deserve it. For we part from the body with extreme reluctance, and I indeed believe that its grief and lamentation are not without cause." Elsewhere Leonardo writes: "O you who look on this our machine, do not be sad that with others you are fated to die, but rejoice that our Creator has endowed us with such an excellent instrument as the intellect." These passages reflect the aging Leonardo's newly formulated belief in a vaguely defined cosmos wherein man is visualized as a "machine" or "instrument" – the symbol of a harmonious, rational, creative natural order. Man is the handiwork of a God who retains few links with traditional orthodoxy. But man is emphatically no mere "instrument" of his Creator. He is himself a "machine" of extraordinary quality and proficiency and thus proof of nature's rationality.

Despite the specialized form of Leonardo's anatomical studies, which were, as we have seen, closely linked with his artistic experience, it was characteristic of the man to extend his inquiries into parallel fields of research (even if, in this case, they did not go far beyond the theoretical stage). Thus, in investigating those aspects of the human body that demanded the most delicate treatment and entailed the hardest work, namely the nervous and blood-circulation systems, Leonardo was tempted to branch out in an entirely new direction. He conducted experiments on the movement of water and recorded his findings in written and illustrated form. A. M. Brizio has made an intensive study of this branch of Leonardo's activities, as has C. Zammattio in his examination of Leonardo's hydraulic engineering projects.

The earliest inquiries in this field date from the first Lombardy period and are mentioned in Manuscripts C, A, and I. Some can be traced back to Leonardo's second visit to Florence (recorded in the Madrid Manuscript II in the general context of dynamics). The majority, however, coincide with the second period in Milan and are featured in Manuscripts F and G, the third part of Manuscript K, in the Leicester Manuscripts, and in related pages from the Windsor collection and the Codice Atlantico.

Leonardo's observations about the movement of water appear under a variety of headings, such as "Water of the Sea and of Rivers," "Movement of Water in the Air and in Water," "Of the Raising of Water in Nature and by Artifice," and so forth. Again and again he displays a fascination for the phenomenon of eddies, and the following passage from Manuscript F is characteristic: "Eddies are always the

ST. JOHN THE BAPTIST
Wood panel; $27\frac{1}{4} \times 22\frac{3}{4}$ in (69 × 57 cm)
1513–16
Paris, Louvre
There is no doubting the authenticity of this painting, wholly the work of Leonardo. De Beatis saw it at Cloux in the painter's studio in 1517. It remained in France, in the royal collections, until Louis XIII exchanged it with Charles I of England for a Holbein and a Titian. After various changes of ownership it returned to the French royal collections and was acquired by the Louvre after the Revolution.

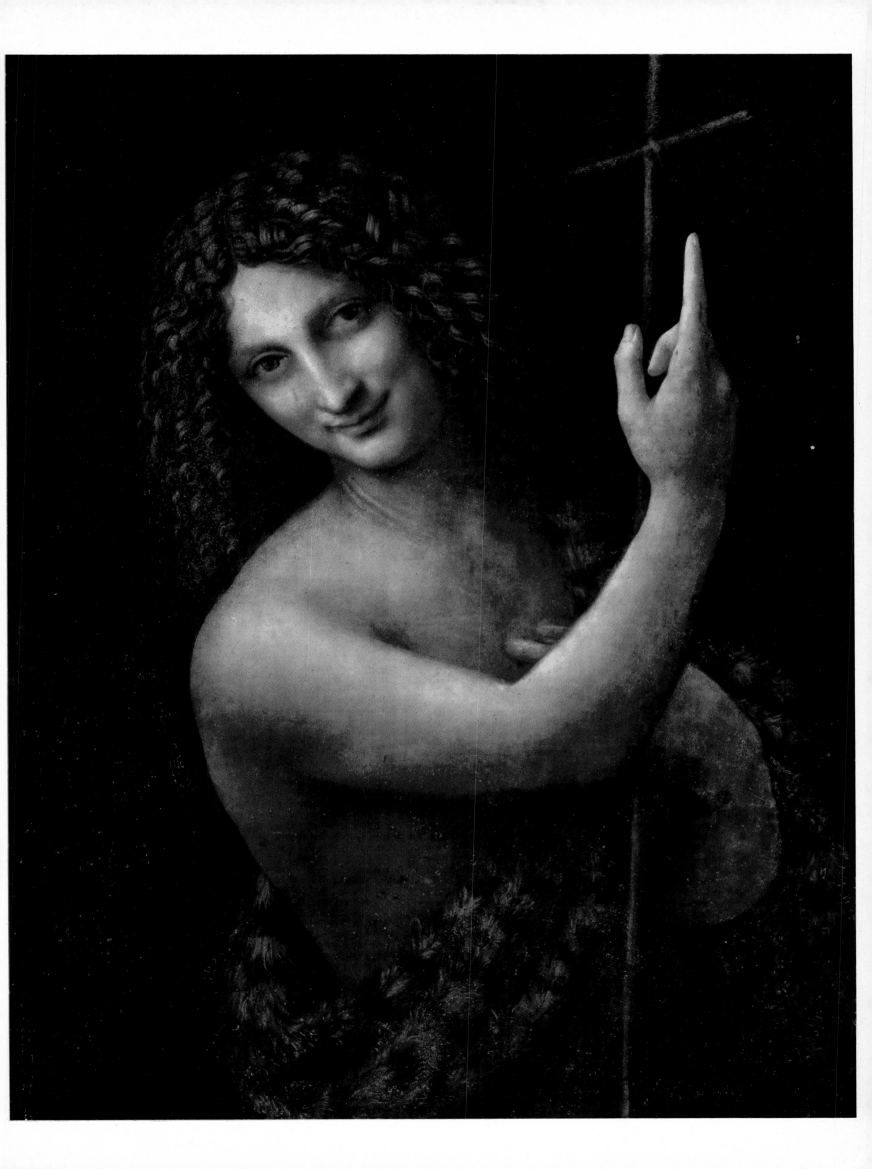

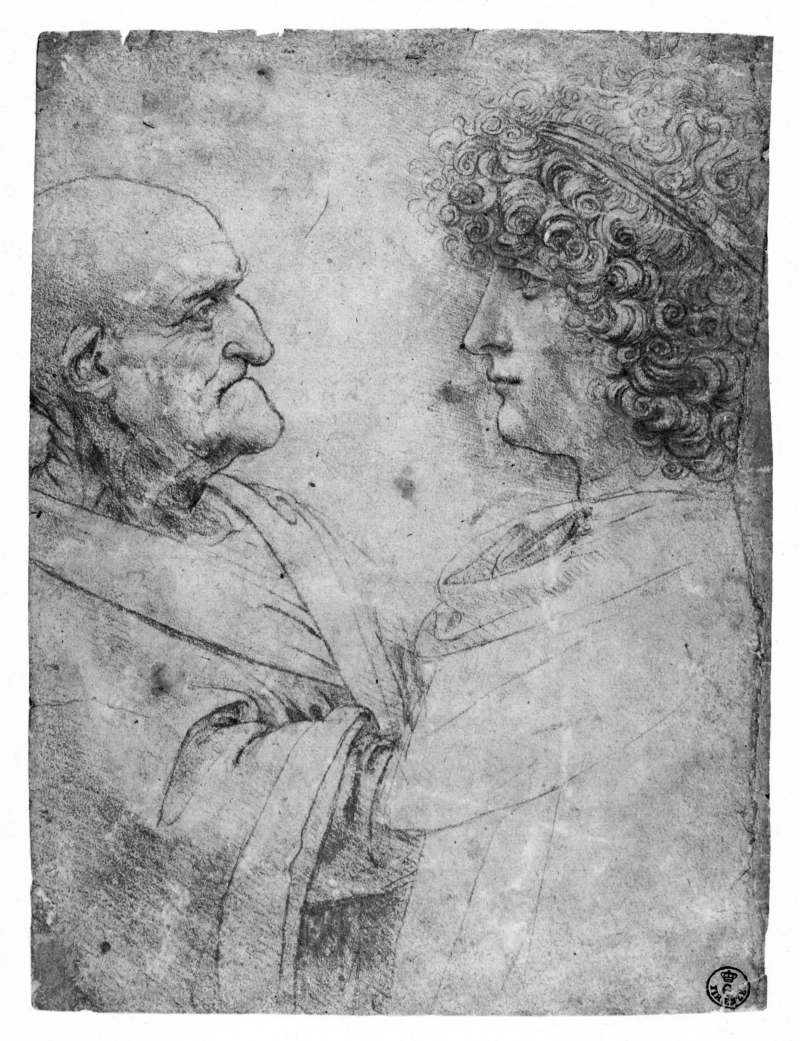

168

intermingling of two streams of water, that is, the falling and the reflex. All the water which in the currents of the rivers tarries behind the objects in these currents has no other exit than by contact with the aforesaid currents. The eddies which turn back are always those of the swiftest water. And the eddies that are turned in the direction that the stream is flowing are those of the water which tarries in the stream's course. Here the law of the waters in their eddies does not fail, because the water that becomes slow, turns back, and makes the eddies in the opposite direction to its movement, as do the eddies of the swiftest water. And for this reason these eddies, whether of the slow or of the rapid water, mingle together and redouble their power: but not entirely because the slow eddy in mingling with the swift becomes swifter than at first, and the swift eddy as it embraces and unites with that which is quicker acquires slowness. The hollow in the swift waters caused by the submersion of the eddies will point towards the approach of the waters, and in the slow waters it will point in the direction in which they are flowing."

One of the most fascinating features of this investigation is the close association detected by Leonardo between the human circulatory system and the characteristic movements of eddies and "columns of waves," namely those that form a constant angle with the main flow of the river. The metaphorical link of blood and water appears throughout his writings as, for example, in the Leicester Manuscripts, where he remarks: "The lake of blood that lies about the heart is the ocean. Its breathing is by the increase and decrease of the blood in its pulses, and even so in the earth is the ebb and flow of the sea." In the same manuscript he writes: "The waters range with perpetual movement from the lowest depths of the sea to the topmost summits of the mountains, not following the law of heavy things; and in this instance its action resembles that of the blood of animals which is always moving from the seat of the heart and flowing towards the summit of their head." Finally, in the Windsor collection, Leonardo describes the shape and purpose of the right ventricle, which expands and contracts, causing the blood "to revolve as it passes through the cells which are full of tortuous passages . . . without any angles, in order that the motion of the blood, not finding any angular obstructions, may have an easier revolution in its eddying course."

Heydenreich writes of these studies and drawings: "As always (in this field of hydraulics), Leonardo separated the concepts of substance and function. In numerous experiments, he analyzed water as matter, characterizing it as a flowing mass incapable of either altering its basic substance or of engendering its own motion. He was then led to differentiate the two states of motion that water might exhibit as a result of external conditions: stationary and progressive. The principal subject of his hydromechanical studies was the investigation of the forward movement of water and the principles of its flow. Leonardo was especially fascinated by the movements of eddies, which stirred his artistic sense by their beauty and organization; through them, he became conscious of the great variety of effects produced by the behavior of mechanical forces, which, from an initial cause, produce an unlimited number of effects . . . and his studies of eddies are among his most impressive works of graphic demonstration. . . . In order to assess these drawings properly, it is necessary to grasp the intellectual process by which they came into being. Even more remarkable than Leonardo's brilliance in unraveling the complex structure of eddies is his ability to give a clear account of both the formal characteristics and the functional properties of such a piece of 'water sculpture.' For Leonardo's drawing clarifies not only this fascinating play of forms but also the dynamics of the interplay of forces present in the constantly moving, yet basically unchanging, liquid body. . . . The method of graphic representation exhibited in his drawings of the eddy depends on the same principles followed in his late anatomical drawings – transparency and formal stylization. The conscious schematization by which a simultaneous analytic and synthetic visualization is achieved serves both an artistic and a scientific end. The eddy depicted as an ornament composed of lines of force is intended to express the harmony of form and of function as the effect of natural law."

In this context, it is interesting to compare the drawings of "intersecting waters" and "revolutions" with the feminine hairstyles of the heads of *Leda* at Windsor. Moreover, there is another page in the Windsor collection, noteworthy for what is

FACING PROFILES OF AN OLD MAN AND A YOUTH
Red chalk drawing on pink paper; $8\frac{5}{16} \times 6$ in (21.1 × 15.3 cm)
Florence, Uffizi Gallery, Drawings and Prints Collection (423)
Many critics have identified the young man, with his thick curly hair, as Salaino, Leonardo's pupil and constant companion.

assumed to be a self-portrait of the elderly Leonardo seated on a rock, that contains this observation: "Watch the movement of the surface of the water, how like it is to that of hair, which has two movements, one following the undulation of the surface, the other the lines of the curves: thus water forms whirling eddies, part following the impetus of the chief current, part the rising and falling movement."

These studies of water movement are always linked, significantly, with discussions and schemes associated with hydraulic engineering. I have already mentioned, in the section dealing with town planning, the importance that Leonardo attached to canal networks. In the course of that first Milan period, he was expected to busy himself on Il Moro's behalf with proposals for canals and sluices; and there is documentary evidence of his interest, in 1494, in drainage schemes on the Sforza estate near Vigevano. Mention has already been made of his stupendous plan, on which he was working around 1503, for a canal from Florence to Vico Pisano. An even more ambitious project, amply documented and dating from the second period in Milan, envisaged the construction of a canal between Lake Como and Milan that would be linked to the Spluga (Splügen), one of the major highways leading to Switzerland. The initial idea was to join the canal to the Lambro at Lecco by way of the small lakes of Brianza. The final plan envisaged a point of derivation on the Adda between Paderno and Trezzo, at a place where river navigation was blocked by the narrow passage of the Tre Corni. Taking advantage of this natural phenomenon, Leonardo proposed checking the course of the river by building a dam, probably with a mobile bulkhead, thus forming a "basin" that would enable the water level to be lowered in the direction of the plain of Lombardy, and constructing a canal tunneled through the Tre Corni itself. The scheme proved too complicated and risky, but, although it was never realized, traces of Leonardo's work are to be found in a smaller-scale project undertaken at the end of the sixteenth century. In the planning of this canal, Leonardo linked his studies of water and hydraulics to his knowledge of topography and cartography, the result being some beautiful sketches in the Codice Atlantico. But the most intriguing outcome of all this work was a wonderful panoramic drawing of the Tre Corni (in the Windsor collection), equalled in quality only by the contemporary drawings and watercolors of actual views by Dürer.

In the course of that second Milanese period, Leonardo spent much of his time on anatomical research and spared little thought for painting. I have already given possible reasons for the slow progress of work on the definitive version of *Virgin and Child with St. Anne* and on the unauthenticated *Leda*. This would have been the period when he first conceived the idea for a much-discussed work, nowadays not accepted as his own but as a studio painting based on a hypothetical prototype. This was *St. John the Baptist in the Desert*, seen and described by Cassiano del Pozzo at Fontainebleau in 1625. Showing the saint as a plumpish figure seated cross-legged in a shady nook, the painting was criticized for lack of respect and decency. It was retitled *Bacchus* at the end of the seventeenth century and, as such, now hangs in the Louvre. Far more interesting, and certainly of superior quality, is a red chalk drawing in the Museo del Sacro Monte in Varese. This, according to Tolnay, was done by Leonardo himself shortly after 1610; and there is a variant copy, attributed to Cesare da Sesto, in England.

Although this was an unproductive period for Leonardo, his circle of followers and pupils continued to be very active, and their work is interesting as a reflection of Leonardo's pictorial methods, his style of composition, and even his ideas. Boltraffio, De Conti, and Salaino were now joined by Leonardo's favorite and presumptive heir, Francesco Melzi, as well as by Cesare da Sesto, Marco d'Oggiono, Giampietrino, and several artists with a wider range of talent – the Vercelli-born Giovanni Antonio Bazzi ("Il Sodoma"), Bernardino Luini, and Andrea Solario.

WOMAN POINTING
Charcoal drawing on white paper;
$8\frac{1}{4} \times 5\frac{5}{16}$ in (21 × 13.5 cm)
Windsor, Royal Library
(Inv. no. 12581).

Rome – *St. John the Baptist* and the *Deluges*

In these later years, Leonardo became increasingly withdrawn and introspective, but, as before, Milan appeared to provide the congenial working conditions he had been seeking (all the more so in these years, since he now owned a house). But, once again, he found himself at the mercy of political and military events. At the end of 1511, Maximilian Sforza, son of Il Moro, having enlisted the support of the Emperor Maximilian I (who was married to Bianca Maria Sforza), invaded the duchy with his Swiss pikemen. This action involved Lombardy in the wider conflict between the emperor (allied to Henry VIII) and Louis XII. Il Moro had died in imprisonment in 1508. Leonardo had basked in the favors of the French king, who had annexed the duchy in 1499, but now that Louis himself was driven from Milan, Leonardo's position was once more precarious. In September 1513, he left Milan for the second time and was accompanied by Salaino and Melzi. His hopes were revived by the election of a Medici to the papacy – Cardinal Giovanni, who took the title of Leo X – and he looked, too, to the protection of Giuliano de' Medici, Duke of Nemours (who was to die in 1515). After a brief stay in Florence, he arrived in Rome in December and stayed at the recently completed Belvedere Palace in the Vatican, built by his friend Bramante, who died in 1514.

It was a strangely obscure period, particularly after the death of Giuliano. Leonardo could have maintained only tenuous links with the luxury-loving Leo X and his humanist friends and advisers. There was little possibility of fruitfully exchanging ideas with men such as Bembo or Bibbiena. The dominant figure in this cultural setting was Raphael, who was operating a well organized and extremely active studio, very different from the type of workshop in which Leonardo had been nurtured. Specialization was now the order of the day and Leonardo's multifarious talents were no longer in vogue. Apart from an important engineering and hydraulic project for the draining of the Pontine Marshes and another for replanning the port of Civitavecchia, Leonardo busied himself, in Vasari's words, with "innumerable . . . follies," which, from the description, may have taken the form of none-too-serious chemical experiments. But the manuscripts suggest that he also probed more deeply into the mathematical and geometrical problems initiated thirty years earlier in Milan with Luca Pacioli.

It is generally accepted that during this stay in Rome, Leonardo planned and at least began work on his half-length *St. John the Baptist*. He also devoted an increasing amount of time to serious studies on cosmology, hydrology, and aerology – subjects that comprised the theoretical basis for the first written and illustrated versions of the *Deluges*. The facts relating to this period are sparse, but Leonardo's activities appear to reflect, for the first time, a form of dissociation or inner dichotomy. Even more significantly, they seem to represent a complete rejection of the cultural and ideological values held dear by the papal court, which remained oblivious to the mounting wave of reform (Luther nailed his theses to the door of Wittenburg Church in 1517) similar to the solitary message of Michelangelo's work, beginning with the *Dying Slave* and *Rebel Slave* and culminating in the *Moses* for the tomb of Julius II. There was certainly a conflict in Leonardo's mind between old, cherished beliefs and new, disturbing visions. Although he still pinned his faith in logical certainty, in the often-repeated affirmation that mathematics and geometry were the true foundations of knowledge, he now allowed free rein to his imagination in the visionary *Deluges*. He came to regard the latter as somehow prophetic, an apocalyptic image (devoid of religious implications) of the final, universal catastrophe, stemming from the abolition of distinct limits among the constituent elements of the natural world. But I am of the opinion that, in these later visions, Leonardo saw no distinction between the beginning and the end of the cosmos, between creation and destruction. Time had no more meaning. Water, air, and earth were now one, formally symbolized in the image of whirlpools and spirals. In the words of Heydenreich: "Through a process of stylization, the various materials in nature – stone, water, clouds, air – are rendered virtually undistinguishable from one another and are thus reduced to their common material denominator. Invisible

YOUNG MAN IN MASQUERADE COSTUME
Pen and watercolor over charcoal drawing; $10\frac{5}{8} \times 7\frac{3}{16}$ in (27 × 18.3 cm) Windsor, Royal Library (Inv. no. 12575).

STUDY FOR A COSTUME
Charcoal drawing on white paper;
$8\frac{7}{16} \times 4\frac{7}{16}$ in (21.5 × 11.2 cm)
Windsor, Royal Library
(Inv. no. 12576)
Once thought to be connected with the
Sanseverino tourney to celebrate the
wedding of Il Moro with Beatrice
d'Este in 1491, these costume designs
are now believed to relate to a court *fête*
of Francis I, dating from after 1516.

COSTUME FOR A "WILD MAN"
Red chalk drawing on white paper;
$7\frac{1}{4} \times 5$ in (18.4 × 12.7 cm)
Windsor, Royal Library
(Inv. no. 1513 *recto*).

cosmic forces manifest themselves in the substances that they, the forces, motivate, compelling these substances to assume the forms in which they in turn act as prime movers, according to fundamental mechanical laws. Thus, the basic forces and functions of the cosmos are revealed through the basic cosmic substances.'' In short, chaos is envisaged as the beginning and the end of a nature that is self-directed and self-generating, but it is simultaneously recognized as logical and inevitable.

The Windsor drawings are accompanied by this famous passage: ''Description of the Deluge. First of all, let there be represented the summit of a rugged mountain, with certain of the valleys that surround its base, and on its sides, let the surface of the soil be seen slipping down together with the tiny roots of the small shrubs and leaving bare a great part of the surrounding rocks. Sweeping down in devastation from these precipices, let it pursue its headlong course, striking and laying bare the twisted and gnarled roots of the great trees and overturning them in ruin. And the mountains becoming bare should reveal the deep fissures made in them by the ancient earthquakes; and let the bases of the mountains be in great part covered over and clad with the debris of the shrubs that have fallen headlong from the sides of the lofty peaks of the said mountains, and let these be mingled together with mud, roots, branches of trees, with various kinds of leaves thrust in among the mud and

RIDER IN MASQUERADING
COSTUME
Pen over charcoal drawing, on
yellowish paper; $9\frac{7}{16} \times 6$ in
(24×15.2 cm)
Windsor, Royal Library
(Inv. no. 12574).

HEAD OF A WOMAN
Detail
Pen drawing on white paper;
$10\frac{15}{16} \times 7\frac{5}{16}$ in (27.8×18.6 cm)
Windsor, Royal Library
(Inv. no. 12670 *verso*)
Thought to be one of the last of
Leonardo's drawings.

earth and stones. And let the fragments of some of the mountains have fallen down into the depth of one of the valleys and there form a barrier to the swollen waters of its river, which, having already burst the barrier, rushes on with immense waves, the greatest of which are striking and laying in ruin the walls of the cities and farms of the valley. . . .

"But the swollen waters should be coursing round the pool that confines them and striking against various obstacles with whirling eddies, leaping up into the air in turbid foam and then falling back and causing the water where they strike to be dashed up into the air; and the circling waves that recede from the point of contact are impelled by their impetus right across the course of the other circling waves that move in an opposite direction to them, and, after striking against these, they leap up into the air without becoming detached from their base. . . .

"The rain, as it falls from the clouds, is of the same color as these clouds. . . . And if the great masses of the debris of huge mountains or of large buildings strike in their fall the mighty lakes of the waters, then a vast quantity of water will rebound in the air, and its course will be in an opposite direction to that of the substance that struck the water, that is to say, the angle of reflection will be equal to the angle of incidence. . . .

"The crests of the waves of the sea fall forward to their base, beating and rubbing themselves against the smooth particles that form their face; and, by this friction, the water, as it falls, is ground up in tiny particles and becomes changed to thick mist and is mingled in the currents of the winds in the manner of wreathing smoke or winding clouds and at last rises up in the air and becomes changed into clouds. But the rain that falls through the air, being beaten on and driven by the current of the winds, becomes rare or dense according to the rarity or density of these winds. . . . The waves of the sea that beat against the shelving base of the mountains that confine it rush, foaming in speed, up to the ridge of these same hills and, in turning back, meet the onset of the succeeding wave and, after loud roaring, return in a mighty flood to the sea whence they came."

The dissociation is undeniable. The passage, so logical yet so imaginative, is more of a vision than a description. There is a formidable array of detailed scientific observations, especially on hydrodynamics and aerology, punctuated now and then by textual insertions (not included in the above quotation) relating to previously mentioned scientific phenomena in the fields of optics, hydrodynamics, and gravity, little or completely unrelated to the "Deluge." That all this should have been envisaged and described in the atmosphere of Leo X's Rome is quite remarkable.

Equally revolutionary for its period was the portrait of *St. John the Baptist*, which Leonardo took with him to France. The picture remained in the royal collections and was later given by Louis XIII to Charles I of England in exchange for a Holbein and a Titian. It was subsequently recovered by the banker Jabach, then given to Mazarin, found its way back into the French royal collections, and finally was acquired by the Louvre.

Even allowing for the fundamental mood of spiritual and cultural skepticism prevailing at the court of Leo X, this unfinished painting was immediately, and for several decades to come, denounced as "indecent," even "licentious." It was not only the unequivocally androgynous features and physical appearance of Christ's precursor that shocked critics and observers but also the enigmatic nature of the smile and the pointing finger – in sum, the unorthodoxy of the work that, in its mystery and ambiguity, is perhaps the most subtly refined of all Leonardo's paintings. Virtually devoid of color (for time has rendered it so dark as to be almost invisible), the warmth of the tonalities can still be recognized; and the half-length figure has a deftness and firmness that is almost sculptural in effect. There is a marvelous overall balance of masses, too, achieved by the sfumato medium, with its shadows merging into complete darkness.

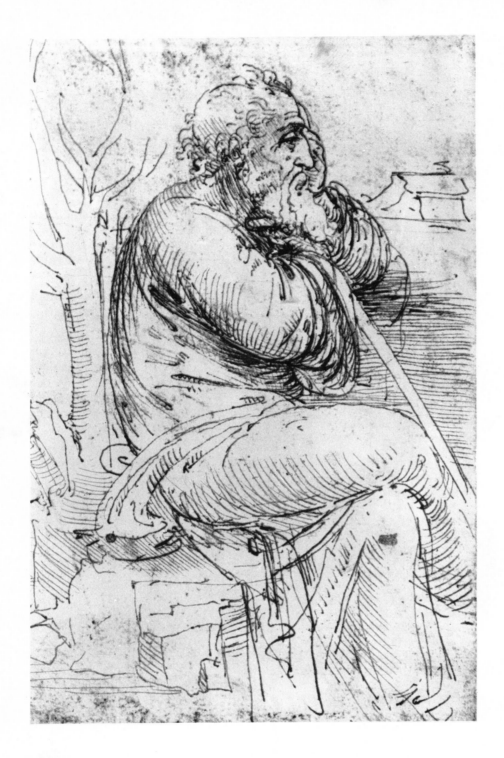

The Last Years

In the winter of 1516–17, Leonardo was invited to France by Francis I, his deep admirer, who, in 1515, had reconquered the duchy of Milan by routing the Swiss army at Marignano. The king clearly wanted Leonardo to live in close proximity, and to a man of sixty-five perhaps not even the familiarity of Milan could offer more attractive conditions of life and work. In practical terms, however, it was to be a period of ideas never realized and of projects too advanced in conception to find suitable application. Perhaps Leonardo himself looked on this last phase as a graveyard of abandoned works. But there were satisfactions as well. At Cloux, he had the company of Salaino, Melzi, and the maidservant Maturina. He had his three pictures and his precious manuscripts and notebooks. Respected and honored by the king and his entourage, he assumed, once again, the official functions of a court

artist and engineer. He designed the costumes for a masked ball, originally thought to be intended for the tournament of Sanseverino in 1491 and now held to have been created in his last years in France. He made architectural plans for the queen-mother's castle at Romorantin (some of the sketches for which look forward to the great palaces of later absolute monarchs); and linked with this was a vast reclamation project to be undertaken in the region of the Loire between Romorantin and Amboise. De Beatis, who visited Leonardo at Cloux with the Cardinal of Aragon on October 10, 1517, noted that his right hand was partially paralyzed but hastened to add that he was still able to draw.

On April 23, 1519, Leonardo made his will. He left his manuscripts and documents to Melzi, the "gentleman of Milan." The Milanese vineyard was to be shared between the two "servants," Battista de Vilanis and Salaino. A gown, a cap, and two ducats were left to the maid Maturina; and 400 scudi deposited at the Hospital of Santa Maria Nuova, Florence, were to go to his stepbrothers. On May 2, he died at Amboise. The legend that he expired in the arms of Francis I fostered the imagination of the Romantic School – a notion that was popularized in the nineteenth century by Ingres and troubadour painters. He was buried, as he had requested in his will, in Saint Florentin at Amboise; but his body disappeared during the religious wars of the second part of the sixteenth century.

STUDY FOR THE CASTLE OF ROMORANTIN
Chalk drawing; $7\frac{1}{16} \times 9\frac{5}{8}$ in
(18×24.5 cm)
Windsor, Royal Library
(Inv. no. 12292 *recto*).

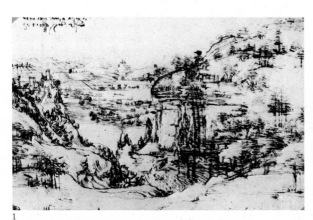

1

3

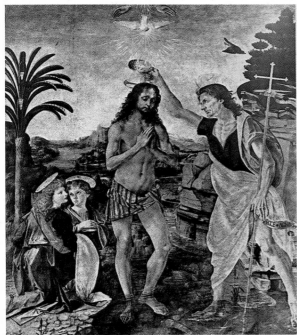

2

3,a

3,b

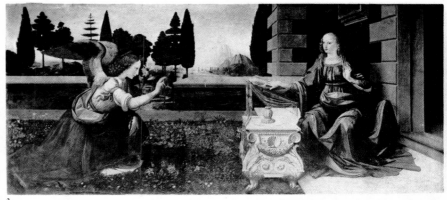

4

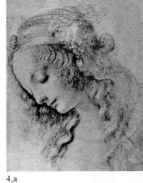

4,a

1. Landscape of the Valley of the Arno
Pen drawing on white paper; $7\frac{5}{8} \times 11\frac{1}{4}$ in (19.4×28.6 cm)
Dated August 5 1473
Florence, Uffizi Gallery, Drawings and Prints Collection

Leonardo, Verrocchio and workshop (?)
2. Baptism of Christ
Tempera and oil on wood panel; $61\frac{3}{4} \times 59\frac{1}{2}$ in (177×151 cm)
Florence, Uffizi Gallery

3. Annunciation
Oil on wood panel; $41 \times 85\frac{1}{2}$ in (104×217 cm)
Florence, Uffizi Gallery
Two preliminary drawings for the Annunciation:

a) Study for the arm of the archangel
Pen drawing on white paper, with touches of red chalk; $3\frac{1}{4} \times 3\frac{5}{8}$ in (8.2×9.3 cm)
Oxford, Christ Church College

b) Drapery study for the cloak of the Madonna
Watercolor drawing with black and heightened with white, on linen canvas; $10\frac{3}{8} \times 9\frac{1}{16}$ in (26.3×22.9 cm)
Paris, Louvre, Drawings Room

4. Annunciation
Tempera on wood panel; $5\frac{1}{2} \times 23\frac{1}{4}$ in (14×59 cm)
Paris, Louvre

a) Study for the Madonna of the Annunciation
Watercolor drawing with chalk and heightened with white, on yellowish paper; largely drawn with the right hand; probably retouched; $10\frac{7}{8} \times 7\frac{5}{8}$ in (27.5×19.5 cm)
Florence, Uffizi Gallery, Drawings and Prints Collection
Verified by Berenson; not cataloged by Popham

179

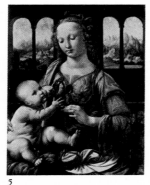

5

7

8,c

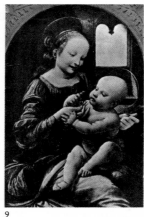

9

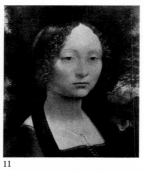

11

5,a

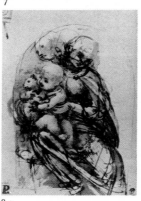

8,a

8,d

9,a

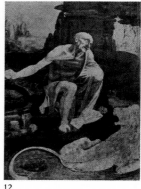

12

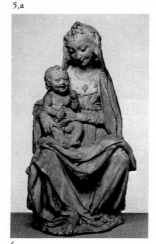

6

8,b

8,e

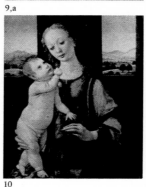

10

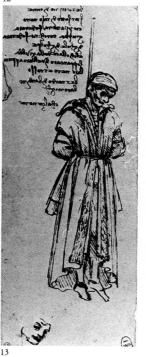

13

5. Madonna with the Carnation (Madonna with the Vase)
Oil on poplar panel;
$24\frac{3}{8} \times 18\frac{3}{4}$ in (62×47.5 cm)
(the left-hand side of the panel is cut off)
Munich, Alte Pinakothek

a) Study for the Madonna with the carnation (?)
Charcoal drawing gone over with brushpoint on pink paper; $8\frac{7}{8} \times 10\frac{1}{2}$ in (22.5×26.5 cm)
Paris, Louvre, Drawings Room (Cat. no. 18965)
Cataloged neither by Berenson nor Popham

Leonardo (?)
6. Madonna with Child
Terracotta; height 19 in (48.3 cm)
London, Victoria and Albert Museum

7. Study for the Madonna with the fruit stand
Silverpoint drawing gone over with pen, on white paper; $14\frac{1}{8} \times 10$ in (35.9×25.4 cm)
Paris, Louvre, Drawings Room (His de la Salle Collection, no. 101)

Some studies for the
8. Madonna with the Cat:

a) Study for the Madonna with the cat
Pen and watercolor drawing; $5\frac{3}{16} \times 3\frac{3}{4}$ in (13.2×9.5 cm)
Circa 1478
London, British Museum (no. 1856–6–21 *verso*)

b) Studies for the Madonna with the cat
Detail of a page
Pen drawing on white paper; $10\frac{3}{4} \times 7\frac{3}{4}$ in (27.4×19.8 cm)
London, British Museum (no. 1860–6–16–98 *recto*)
Formerly in the collections of Cerquozzi, Lawrence and Woodburn

c) Study for the Madonna with the cat
Pen and watercolor drawing on white paper; $4\frac{7}{8} \times 4\frac{1}{4}$ in (12.4×10.7 cm)
Florence, Uffizi Gallery Drawings and Prints Collection

d) Preliminary studies for the Madonna with the cat
Pen drawings; $8\frac{7}{8} \times 6\frac{5}{8}$ in (22.5×17 cm)
Bayonne, Léon Bonnat Museum (no. 152)

e) Study for the Madonna with the cat
Pen drawing on white paper; $5\frac{3}{16} \times 3\frac{3}{4}$ in (13.2×9.5 cm)
London, British Museum (no. 1856–6–21 *recto*)

9. Madonna with the Flower (Benois Madonna)
Oil on wood panel transferred to canvas;
$19\frac{1}{2} \times 12\frac{3}{8}$ in (49.5×31.5 cm)
Leningrad, Hermitage

a) Study for the Benois Madonna
Chalk and pen drawing; $7\frac{3}{4} \times 5\frac{7}{8}$ in (19.8×15 cm)
London, British Museum (no. 1860–6–16–100 *verso*)

Verrocchio's workshop
10. Madonna with the Pomegranate (Dreyfus Madonna)
Oil on canvas; $6\frac{1}{2} \times 5$ m (16.5×12.7 cm)
Washington, National Gallery of Art, Kress Collection

11. Portrait of a Woman (Ginevra De' Benci ?)
Oil on wood panel;
$16\frac{1}{2} \times 14\frac{1}{2}$ in (42×37 cm)
Washington, National Gallery of Art

12. St. Jerome in Penitence
Wood panel; $40\frac{5}{8} \times 29\frac{1}{2}$ in (103×75 cm)
Rome, Vatican Gallery

13. Picture of a Hanged Man: Bernardo di Bandini Baroncelli
Pen drawing on white paper; signature from left to right; $7\frac{1}{2} \times 2\frac{13}{16}$ in (19.1×7.2 cm)
1479
Bayonne, Léon Bonnat Museum

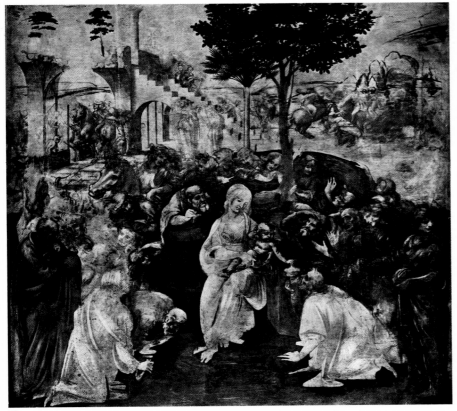

14

14,e

14,f

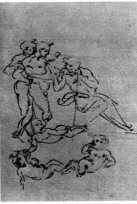

14,h

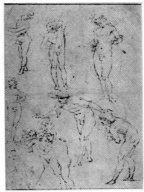

14,i

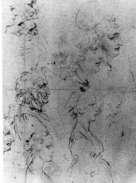

14,a

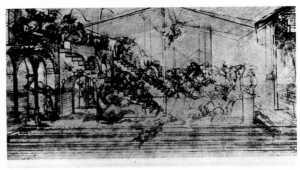

14,c

14,b

14. Adoration of the Magi
Oil and bistre on wood panel; 96 × 97 in (240 × 246 cm)
1481–1482
Florence, Uffizi Gallery

Preliminary drawings for the ADORATION OF THE MAGI:
a) Study of profiles
Pen drawing on white paper; signature from left to right; 16 × 11⅜ in (40.5 × 29 cm)
Windsor, Royal Library (no. 12276 *verso*)
Clark and Pedretti agree on the date as 1478–80, but do not refer to the *Adoration of the Magi*.

b) Study for the suckling Madonna
Pen drawing on white paper; signature from left to right; 16 × 11⅜ in) 40.5 × 29 cm)
Windsor, Royal Library (no. 12276 *recto*)

c) Study in perspective for the background
Pen, sepia and white lead drawing on white paper; signature from left to right; 6½ × 11⁷⁄₁₆ in (16.5 × 29 cm)
Florence, Uffizi Gallery, Drawings and Prints Collection

14,d

d) Study of rearing horse with outline figure of the rider
Red chalk drawing on pink-tinted paper; 6 × 5⅝ in (15.3 × 14.2 cm)
Windsor, Royal Library (no. 12336)
According to Clark and Pedretti, most probably for the *Battle of Anghiari*.

e) Study of the Madonna and Child and other figures
Pen drawing on white paper; 11¼ × 8½ in (28.5 × 21.5 cm)
Paris, Louvre, Drawings Room

14,g

f) Study of facing profiles of an old man and a youth, with sketches of machines
Pen drawing on white paper; *recto* of a page; 8 × 10½ in (20.2 × 26.6 cm) (the bottom right-hand corner of the page is torn)
Florence, Uffizi Gallery Drawings and Prints Collection

g) Study of the Nativity of Jesus
Detail of the upper part of the page
Silverpoint, pen and sepia drawing on liliaceous paper; signature from left to right; 8⅝ × 6 in (21.8 × 15.1 cm)
Bayonne, Léon Bonnat Museum
Acquired at the Breadalbane sale

h) Study for two young shepherds talking with St. Joseph and for three children
Prepared silverpoint drawing, outlined in pen, on purpurin paper; 6⅞ × 4⅜ in (17.4 × 11 cm)
Hamburg, Kunsthalle, Kupferstichkabinett (Inv. no. 21488)

14,l

i) Study for seven individual figures of shepherds and a group of another five
Pen drawing on white paper; signature from left to right; *recto* of a page; 10⅞ × 7⅜ in (27.7 × 18.7 cm)
Cologne, Wallraf-Richartz Museum

i) Four studies for Madonna adoring the Child
(in the bottom right-hand corner drawing of a section of a cylinder)
Pen and bistre drawing on pink paper; signature from left to right; 7⅝ × 5⅝ in (19.5 × 16.7 cm)
New York, Metropolitan Museum of Art, Rogers Fund, 1917 (no. 17.142.1)
Some connect with a never-executed Nativity, or in view of the artist's note on sheet 446, with the "Two Madonnas". Kept in the Drawings and Prints Collection of the Uffizi. Attributed by Popham to the first Milanese period.

181

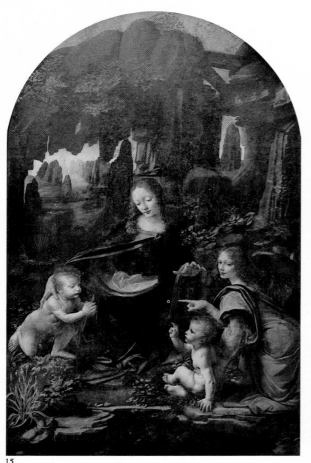

15

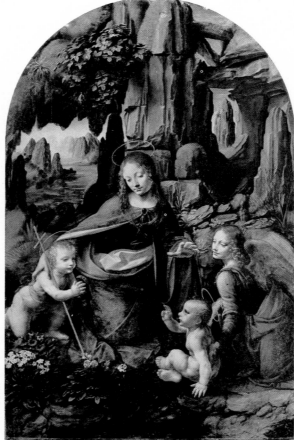

16

19

20

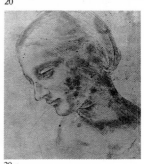

20,a

15,a

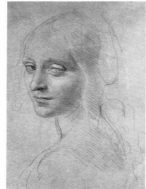

15,b

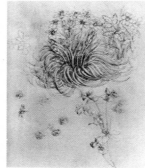

15,c

15,d

15,e

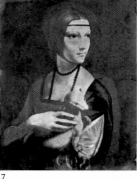

17

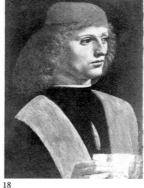

18

15. Virgin of the Rocks (Madonna with St. John, the Child Jesus and an Angel)
Oil on canvas; 77½ × 48½ in (198 × 123 cm)
Paris, Louvre

Preliminary drawings of the
VIRGIN OF THE
ROCKS:

a) Study of the rocks
Pen drawing on pink paper; 8⅝ × 6¼ in (22 × 15.8 cm)
Windsor, Royal Library (no. 12395)
Clark dates it around 1484

b) Study for the angel's head
Silverpoint drawing on yellowish paper; 7⅛ × 6¼ in (18.1 × 15.9 cm)
Turin, Royal Library (no. 15572)

c) Study of liliaceous plant with ranunculus and Euphorbia
Drawing; 7¾ × 6¼ in (19.8 × 16 cm)
Windsor, Royal Library (no. 12424)
Despite evident "scientific" connections with the clusters of vegetation in the *Virgin of the Rocks*, generally dated around the first decade of the sixteenth century.

d) Drapery study for the angel
Watercolor and charcoal drawing heightened with white, on bluish paper; 8⅜ × 6¼ in (21.3 × 15.9 cm)
Windsor, Royal Library (no. 12521)
According to Clark, refers to the preparation for the second version of the painting, in London.

e) Study for the arm and pointing finger of the angel
Charcoal and pen drawing; 6 × 8⅝ in (15.3 × 22 cm)
Windsor, Royal Library (no. 12520)

Ambrogio de Predis and Leonardo (?)
16. Virgin of the Rocks (Madonna with St. John, the Child Jesus and an Angel)
Oil on wood panel; 75 × 47¼ in (190 × 120 cm)
London, National Gallery

17. Portrait of a Lady with an Ermine ("Lady with a Stone-Marten" "with a ferret" "with a marten")
Oil on wood panel; 21¼ × 15½ in (54 × 39 cm)
Cracow, National Museum

Leonardo or school
18. Portrait of a Musician (Franchino Gaffurio?)
Oil on wood panel; 17 × 12¼ in (43 × 31 cm)
Milan, Ambrosian Gallery

Leonardo (?)
19. Head of a Girl (The Dishevelled Woman)
Wood panel; 10⅝ × 8¼ in (27 × 21 cm)
Parma, National Gallery

School of Leonardo (?)
20. Madonna Suckling the Child Jesus (Litta Madonna)
Tempera on wood panel transferred to canvas; 16½ × 13 in (42 × 33 cm)
Leningrad, Hermitage

a) Preliminary study for a Madonna for the "Litta Madonna" (?)
Silverpoint drawing on green prepared paper; 7⅛ × 6⅝ in (18.1 × 16.8 cm)
Paris, Louvre, Drawings Room (Inv. no. 2376)
According to Popham, from the first Florentine period.

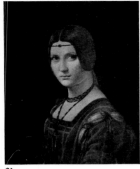

21

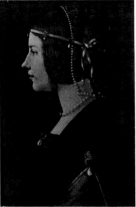

22

23,a

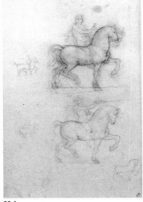

23,b

24

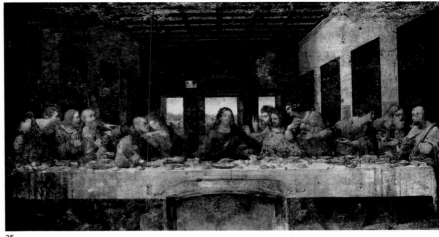

25

25,a

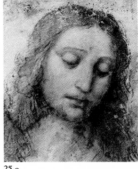

25,c

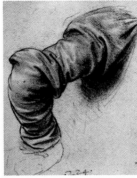

25,g

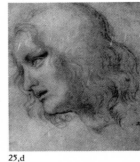

25,b

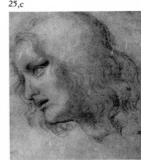

25,d

25,e

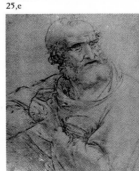

25,f

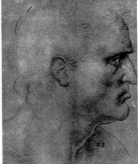

25,h

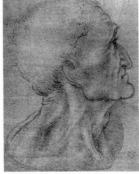

25,i

School of Leonardo
21. La Belle Ferronnière
Oil on oak panel; 24¾ × 17¼
in (62 × 44 cm)
Paris, Louvre

School of Leonardo
**22. Portrait of a Woman
with a Pearl Hairnet
(Beatrice d'Este?)**
Oil on wood panel; 20 × 13⅜
in (51 × 34 cm)
Milan, Ambrosian Gallery

Two studies for the
23. Sforza Monument:

**a) Preliminary drawing
for equestrian
monument**
Silverpoint drawing on
blue prepared paper;
5⅞ × 7¼ in (14.8 × 18.5 cm)
Windsor, Royal Library
(no. 12358 *recto*)

**b) Preliminary drawing
for equestrian
monument**
Charcoal drawing on grey-
yellowish paper; 11 × 7¼ in
(27.8 × 18.4 cm)
Circa 1508–1511
Windsor, Royal Library
(no. 12342)
Generally thought to be for
the Trivulzio Monument,
between the first two
decades of the sixteenth
century.

Leonardo (?)
24. Equestrian group
Bronze; height 9½ in (24 cm)
Budapest, Szépmüvészeti
Museum

25. The Last Supper
Tempera on wall; 15 × 28 ft
(460 × 880 cm)
1495–1497
Milan, Refectory of
Convent of Santa Maria
delle Grazie

Preliminary drawings for
THE LAST SUPPER
**a) Compositional study
with geometric figures
and calculations**
Pen drawing on yellowish
paper; 10¼ × 8¼ in (26 × 21
cm)
Windsor, Royal Library
(no. 12542 *recto*)

**b) Study of figures and
disc with balancing
cross-bar**
Pen and silverpoint
drawing on white paper;
signature from left to
right; 11 × 8 in (27.8 × 20.5
cm)
Paris, Louvre, Drawings
Room (no. 2258)
According to Popham, for
the *Adoration of the Magi.*

Head of Christ
Drawing retouched with
tempera; 15¾ × 12⅝ in
(40 × 32 cm)
Milan, Brera Gallery
Not regarded by all experts
as authoritative

d) Head of St. Philip
Chalk drawing on white
paper; 7½ × 5⅞ in (19 × 15
cm)
Windsor, Royal Library
(no. 12551)

**e) Head of James the
Great**
Detail of upper part of the
page
Red chalk and pen drawing
on white paper; 9¹⁵⁄₁₆ × 6¾ in
(25.2 × 17.2 cm)
Windsor, Royal Library
(no. 12552)

f) Study for St. Peter
Pen and silverpoint
drawing on blue prepared
paper; 5¹¹⁄₁₆ × 4⁷⁄₁₆ in
(14.5 × 11.3 cm)
Vienna, Albertina,
Drawings Collection

**g) Study for the right
arm of St. Peter**
Black chalk drawing,
heightened with white, on
white paper; 6½ × 6⅛ in
(16.5 × 15.5 cm)
Circa 1496
Windsor, Royal Library
(no. 12546)

**h) Youthful head of an
apostle (St.
Bartholomew?)**
Red chalk drawing on pink
paper; 7⅝ × 5¹³⁄₁₆ in
(19.3 × 14.8 cm)
Windsor, Royal Library
(no. 12548)
According to Berenson, for
St. Matthew

**i) Head of an apostle
(Judas?)**
Red chalk drawing on pink
paper; 7¹⁄₁₆ × 5⅞ in (18 × 15
cm)
Windsor, Royal Library
(no. 12547)

183

26

28,b

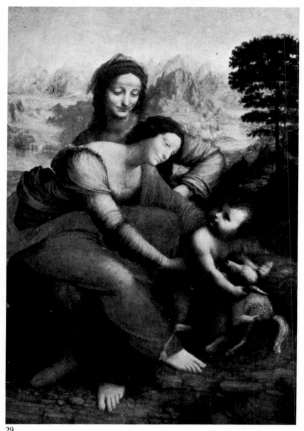

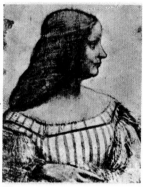

27

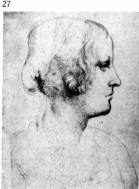

27,a

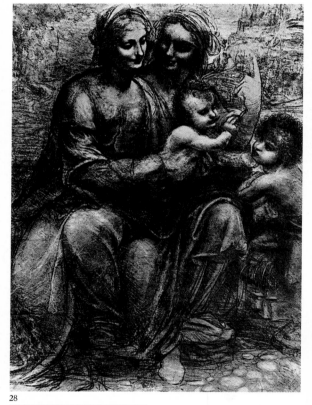

28

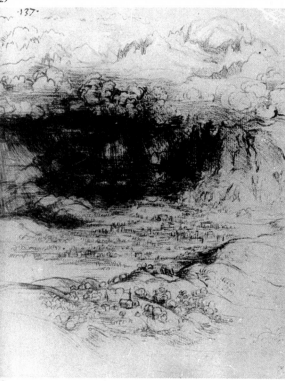

29

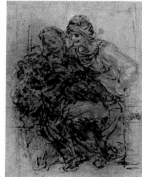

28,a

29,a

26. Interlacing leaves
Detail of the decoration on
the ceiling of the Sala delle
Asse in the Sforza Castle in
Milan
1496–1498 (?)

**27. Portrait of Isabella
d'Este Gonzaga**
Charcoal drawing with
touches of red chalk, on
white paper; $24\frac{3}{4} \times 18$ in
(63×46 cm)
Circa 1500
Paris, Louvre

**a) Preliminary drawing
of female head: for
Isabella d'Este
Gonzaga (?)**
Silverpoint drawing on
pink paper; $12\frac{5}{8} \times 7\frac{7}{8}$ in
(32×20 cm)
Windsor, Royal Library
(no. 12505)
Clark places it before the
portrait of Isabella d'Este
and dates it to the later
years of the first Milanese
period.

**28. Virgin and Child
with St. Anne and the
Infant St. John the
Baptist (The Holy
Family)**
Monochrome cartoon;
$54\frac{3}{4} \times 39\frac{3}{4}$ in (139×101 cm)
London, National Gallery

*Two preliminary drawings
for* VIRGIN AND CHILD
WITH ST. ANNE AND
THE INFANT ST. JOHN
THE BAPTIST:

**a) Sketch for the initial
composition of the
Virgin and Child**
Pen drawing on white
paper; $6\frac{3}{8} \times 5$ in
(16.2×12.6 cm)
Paris, Louvre

**b) Further sketch for the
initial composition of
the Virgin and Child**
Detail; the composition is
drawn by pen on a square
between a clock, a wheel
and other sketches.
Pen and chalk drawing on
white paper; $10\frac{1}{4} \times 7\frac{3}{4}$ in
(26×19.7 cm)
Circa 1498–1499
London, British Museum

**29. Virgin and Child
with St. Anne and the
Lamb**
Oil on wood panel; $66 \times 51\frac{1}{4}$
in (168×130 cm)
Paris, Louvre

*Preliminary drawings for
the* VIRGIN AND CHILD
WITH ST. ANNE AND
THE LAMB:

**a) Study for the
hurricane**
Red chalk drawing on
white paper; $8\frac{1}{8} \times 5\frac{7}{8}$ in
(20.8×15 cm)
Windsor, Royal Library
(no. 12409)
It is a scientific-naturalistic
study probably of an
alpine landscape. The
rendering of the mountains
is very similar to that on
the panel in the Louvre, as
Clark mentions, which
suggests a date around
1506.

184

29,b

29,c

29,d

29,e

29,f

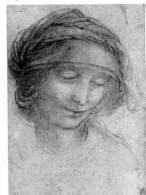

29,g

29,h

29,i

30,B

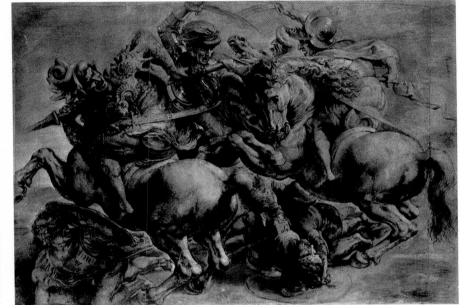

30,A

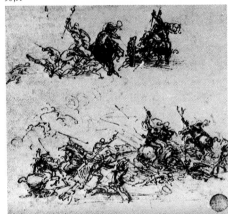

30,a

30,b

b) Lighting study of trees
Red chalk drawing; $7\frac{1}{2} \times 6$ in (19.1 × 15.3 cm)
Circa 1498–1502
Windsor, Royal Library (no. 12431 *recto*)
Clark relates it to the previous study because of the technique and stylistic rendering.

c) Drapery study for the arm of the Madonna
Red, black and blue brush drawing on red-tinted paper; $3\frac{3}{8} \times 6\frac{3}{4}$ in (8.6 × 17 cm)
Windsor, Royal Library (no. 12532)
According to Clark, the hand was by a pupil and was only completed by Leonardo

d) Drapery study for the knee of the Madonna
Charcoal drawing heightened with blue and white lead, on yellowish paper; $6\frac{1}{2} \times 5\frac{3}{4}$ in (16.4 × 14.5 cm)
Windsor, Royal Library (no. 12530)

e) Initial composition with the Lamb
Pen and chalk drawing on white paper; $4\frac{3}{4} \times 4$ in (12.1 × 10 cm)
Venice, Academy (no. 230)

f) Study for the head of the Infant St. John the Baptist (?)
Silverpoint and pen drawing with dusting marks; fragmented page on a separate sheet; $6\frac{3}{8} \times 5\frac{1}{2}$ in (17 × 14 cm)
Paris, Louvre, Drawings Room (no. 2347)
According to Berenson, for the Infant St. John the Baptist of the *Virgin of the Rocks*. Not cataloged by Popham.

g) Study for the head of St. Anne
Charcoal drawing on white paper; $7\frac{3}{8} \times 4\frac{1}{8}$ in (18.8 × 13 cm)
Windsor, Royal Library (no. 12533)

h) Drapery study for the legs of St. Anne
Charcoal drawing on light brown paper; $6\frac{5}{8} \times 5\frac{3}{4}$ in (16.7 × 14.7 cm)
Windsor, Royal Library (no. 12527)

i) Study for the head of St. Anne (?)
Black chalk drawing, with touches of pen and red chalk and heightened with white, on brownish paper; $9\frac{5}{8} \times 7\frac{3}{8}$ in (24.4 × 18.7 cm)
Windsor, Royal Library (no. 12534)

Amply retouched, perhaps by Melzi. According to Clark and Pedretti, for a lost *Madonna* after 1500.

30. The Battle of Anghiari

A) Copy by Pieter Paul Rubens
Paris, Louvre

B) Copy by an unknown
Florence, Uffizi Gallery

Preliminary drawings of the BATTLE OF ANGHIARI:

a) Study of two groups of fighting horsemen
Pen drawing on yellowish paper; $5\frac{11}{16} \times 6$ in (14.5 × 15.2 cm)
Circa 1503–1504
Venice, Academy (no. 215 A/r)

b) Study for a battle with cavalry and infantry
Pen drawing on yellowish paper; $6\frac{1}{2} \times 6$ in (16.5 × 15.3 cm)
Circa 1503–1504
Venice, Academy (215/r)

30,c

30,d

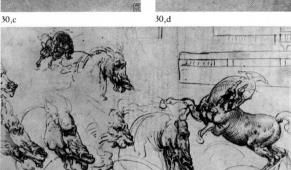

30,e

30,f

30,g

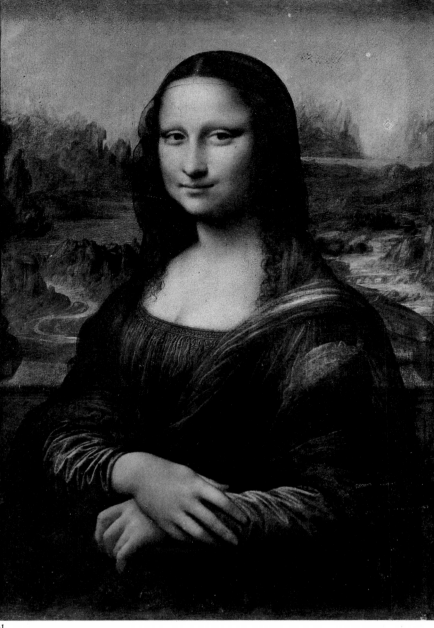

31

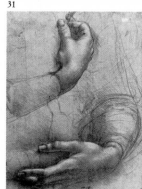

31,a

c) Heads of warriors
Silverpoint and charcoal drawing, with touches of red chalk, on white paper; $7\frac{9}{16} \times 7\frac{3}{8}$ in (19.2 × 18.8 cm)
Circa 1503–1504
Budapest, Szépmüvészeti Museum ("segn.E.1. f/A")

d) Head of a warrior
Red chalk drawing on pink paper; $8\frac{15}{16} \times 7\frac{5}{16}$ in (22.7 × 18.6 cm)
Circa 1503–1504
Budapest, Szépmüvészeti Museum (segn. E.1. 5V")

e) Study of horses
Pen and sepia drawing on white paper; signature from left to right; $7\frac{3}{4} \times 12\frac{1}{8}$ in (19.6 × 30.8 cm)
Circa 1503–1504
Windsor, Royal Library (no. 12326 recto)

f) Horsemen galloping and other figures
Red chalk drawing on white paper; $6\frac{5}{8} \times 9\frac{1}{2}$ in (16.8 × 24 cm)
Circa 1503–1504
Windsor, Royal Library (no. 12340)

g) Horsemen with standards
Charcoal drawing on white paper stained yellow; $6\frac{5}{16} \times 7\frac{3}{4}$ in (16 × 19.7 cm)
Circa 1503–1504
Windsor, Royal Library (no. 12339 recto)

31. La Gioconda (Mona Lisa)
Oil on wood panel; $30\frac{1}{4} \times 20\frac{7}{8}$ in (77 × 53 cm)
Paris, Louvre

Preliminary drawing for
LA GIOCONDA:

a) Study for the hands (?)
Silverpoint drawing, heightened with white, on pale pink paper; $8\frac{1}{2} \times 5\frac{7}{8}$ in (21.5 × 15 cm)
Windsor, Royal Library (no. 12558)
Muller-Walde, Bode, Clark all relate the drawing to the *Ginevra Benci*.

186

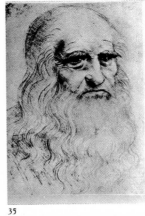

32

33

34,b

35

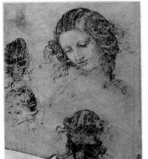

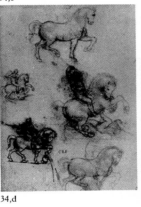

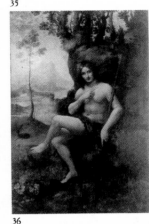

33,a

33,c

34,a

33,b

33,d

34,c

36

34,d

37

d) Study of Leda and the Swan
Pen and charcoal drawing;
$4\frac{15}{16} \times 4\frac{5}{16}$ in (12.5 × 11 cm).
Rotterdam, Boymans-van
Beuningen Museum

e) Study of Leda and the Swan
Pen and brown ink
drawing on paper; $6\frac{5}{16} \times 5\frac{1}{2}$
in (16 × 13.9 cm)
Chatsworth, Devonshire
Collection
Cataloged neither by
Berenson nor Popham.

33,e

School of Leonardo
32. "Spiridon" Leda
Wood panel; $52 \times 30\frac{3}{4}$ in
(132 × 78 cm)
Rome, State Gallery

School of Leonardo
33. "Borghese" Leda
Canvas; 44 × 34 in
(112 × 86 cm)
Rome, Borghese Gallery

*Preliminary drawings for
the* LEDA:

**a) Study for the head
and hair**
Pen drawing with a little
watercolor on white paper;
$7\frac{7}{8} \times 6\frac{3}{8}$ in (20 × 16.2 cm)
Windsor, Royal Library
(no. 12516)

b) Study for the head
Pen drawing with a little
watercolor on yellowish
paper; $7 \times 15\frac{13}{16}$ in
(17.7 × 14.7 cm)
Windsor, Royal Library
(no. 12518)

**c) Study with figure of
Leda**
Detail of a page; $14\frac{7}{8} \times 10\frac{3}{8}$
in (37.7 × 26.3 cm)
Pen drawing over chalk
preparation; $11\frac{5}{16} \times 16$ in
(28.7 × 40.5 cm)
Windsor, Royal Library
(no. 12337 *recto*)

*Preliminary drawings for
the*
**34. Trivulzio Equestrian
Monument**

a) Study
Pen drawing on white
paper; $11 \times 7\frac{13}{16}$ in
(28 × 19.8 cm)
Windsor, Royal Library
(no. 12355)

b) Study
Red chalk drawing,
partially gone over with
pen, on white paper;
$8\frac{9}{16} \times 6\frac{5}{8}$ in (21.7 × 16.9 cm)
Windsor, Royal Library
(no. 12356 *recto*)

c) Study
Chalk drawing on gray
paper; $7\frac{7}{8} \times 4\frac{7}{8}$ in
(20.1 × 12.4 cm)
Windsor, Royal Library
(no. 12354)

d) Study
Charcoal and pen drawing
on pale pink paper;
$8\frac{13}{16} \times 6\frac{5}{16}$ in (22.4 × 16 cm)
Windsor, Royal Library
(no. 12360)

35. Self-portrait
Red chalk drawing;
$13\frac{1}{8} \times 8\frac{3}{8}$ in (33.3 × 21.3 cm)
Turin, Royal Library
(15571)

School of Leonardo
36. Bacchus
Oil on canvas; $69\frac{3}{4} \times 45\frac{1}{4}$ in
(177 × 115 cm)
Paris, Louvre

37. St. John the Baptist
Wood panel; $27\frac{1}{4} \times 22\frac{3}{4}$ in
(69 × 57 cm)
Paris, Louvre

Contemporary records attest that Leonardo had attracted the attention of the pundits while still little more than a youth. In the verse *Cronaca* of Giovanni Santi, father of Raphael, painter and man of letters to the court of Urbino, we read: *"Due giovin par d'ingegno e par d'etade/Leonardo da Vinci e il Perugino Pier della Pieve..."* ("Two youths equal in age and genius/ Leonardo da Vinci and Perugino Pier della Pieve...").

This was before the departure for Milan when Leonardo and Perugino were still together in Verrocchio's workshop. Also part of this first Milanese period are the encomiums of the poets of the court of Duke Ludovico, Bellincioni, for instance, in 1493, and the inestimable testimony of his friend, the Franciscan friar and mathematician, Luca Pacioli, for whose treatise on geometry, *De Divina Proportione*, Leonardo drew the five "regular bodies." To this same source we also owe the first mention of the Leonardo manuscripts.

Further echoes of Leonardo's Milanese period are to be found in the famous *Novelle* (published in 1554–77) of Matteo Bandello, a young student of Pavia and Milan. References to Leonardo's second visit to Florence, and to the "rivalry" with Michelangelo, are contained in contemporary chronicles and manuals of Florentine art (Albertini, 1510, Antonio Billi); while the tradition of Leonardo's perfectionism and his penchant for "philosophy" to the detriment of "art" figures in the *Cortegiano* of Baldassar Castiglione (1528) and later in the *Anonimo Gaddiano* or *Magliabechiano* (around 1537–42) – all material which was to find its way into Vasari's *Lives* (1550–68). The first biography of Leonardo occurs in *De Viris Illustribus*, by Paolo Giovio of Como, published around 1524.

The northern answer to the *Lives* of the Tuscan Vasari, whose boundless admiration for the genius of Michelangelo and complex attitude towards Leonardo have already been noted, consists of the *Treatise on the Art of Painting* and the *Concept of the Temple of Painting*, by the painter, poet and theoretician Giovan Paolo Lomazzo, and published in Milan in 1584 and 1590 respectively. For Lomazzo, who became blind at thirty-three, not only is Leonardo – and to a lesser degree Mantegna and Gaudenzio Ferrari – one of the greatest exponents of northern painting, but his own academic and stylistic theories on the relationship between light, space, and movement, the "science of human feelings," were fundamentally affected by his reading of Leonardo's *Treatise on Painting* – the artist's notes collected together and edited by his pupil and heir Francesco Melzi.

A similar event took place at the beginning of the sixteenth century when, using Leonardo's manuscripts, which were then in the possession of his family shortly before being donated to the Ambrosian Library, the Milanese count Luigi Arconati compiled a *Treatise on the Movement and Measurement of Water* (edited and printed in Bologna in 1826). In fact during the seventeenth and eighteenth centuries, while the paintings of Leonardo were fast becoming only a memory, especially in most of Italy, though not in Milan where pupils of his school continued to execute innumerable studies and variations of his works, Leonardo's fame and the concept of the scientific genius and "universal" explorer were kept alive. This occurred through the circulation of his drawings and manuscripts, such as the engravings made by. Hollar and published at Antwerp in 1645–51 of heads and "caricatures" then in the possession of Lord Arundel and today held at Windsor. An especially influential publication was the first printed edition of the *Treatise on Painting* based on a manuscript derived (but in a shortened form) from that compiled by Melzi and given to Chantelou in Rome by Cassiano del Pozzo; presiding over this 1651 Paris edition were the brother of Chantelou, Frèart de Chambray, Raphael du Fresne and the great exponent in Rome and Paris of classical-baroque painting, Nicolas Poussin, author of the nude studies from which the book's engravings were taken.

The rediscovery of Leonardo continued to gather force in the early nineteenth century. While Napoleon could boast of the Louvre's unique collection of Leonardo's works (previously in the French royal collections) – and it is here that the romantic myth of the *Gioconda* was born, its present stature largely attributable to Corot – he was at the same time trying to lay his hands on the manuscripts in the Ambrosian Library in Milan; only the Codice Atlantico was to return to Paris.

The neoclassical painter from Lombardy, and secretary of the Brera Academy, Giuseppe Bossi, collected and copied Leonardo's drawings, and in 1810 published in Milan the result of his studies, *Four Books on the Last Supper by Leonardo da Vinci*. Six years previously, in Milan, C. Amoretti brought out the first modern biography, the *Historic Memoirs on the Life... of Leonardo da Vinci*, while the Roman edition, edited by Manzi, of the manuscript of the *Treatise on Painting*, the *Codex Urbinas* (1270 in the Vatican Library), was published in 1817. (It is from this last work that the present-day editions derive: Borzelli, Lanciano, 1924; McMahon-Heydenreich, facsimile and in English, Princeton, 1956; Chastel, collation of Leonardo's manuscripts and in French, Paris, 1960.)

The "Leonardo problem" was as far reaching in the eighteenth and nineteenth centuries as in the sixteenth. In *Italian Journey*, Goethe speaks of the very essence of Leonardo, the "ideal" human value of the man and the "rational" naturalism of the artist. It is from this point that the appreciation of Leonardo's art assumes three distinct elements: firstly, the literary, romantic, and later decadent glorification of the "mystery" and indefinibility of the man and his work, expressed in Baudelaire and Walter Pater, and at its most pseudo-historic, esoteric, and messianic extreme in

Dmitrij Merezkovskij's highly successful novel, *Leonardo da Vinci or the Resurrection of the Gods* (1901), part of the trilogy *Christ and Anti-Christ*; secondly, an inter-disciplinary study, of a markedly positivist stamp, on the ramifications of Leonardo's imagination and "science," allied to a philological examination of the manuscripts, which formed the basis for the many editions and scientific transcriptions (in 1881 those of the Institut de France, edited by Ravaisson-Mollien; in 1894 the Codice Atlantico, edited by Piumati for the Lincei Academy; in 1898 the Windsor Anatomy, edited by Piumati and Sabachnikoff; in 1923, the Arundel Manuscript, the beginning of the modern editions and re-editions of the Commissione Vinciana di Roma; more recent editions: Manuscript B, edited by Corbeau, de Toni, Authier, Grenoble, 1960; K. Clark – C. Pedretti, *The Drawings of Leonardo da Vinci . . . at Windsor Castle*, London 1968; in the course of being edited, the Codice Atlantico and the Madrid Manuscripts); thirdly, the rediscovery of works and the problem of authentication, and the search for a formal expression in language. The second and third elements culminated in the first great synthesis spanning the nineteenth and twentieth centuries: P. Müller Walde (Munich, 1889–90), G. Séailles (Paris, 1892), E. Müntz (Paris, 1899), W. von Seidlitz (Berlin, 1909), O. Sirén (New Haven, 1916), A. Venturi (Bologna, 1920), up to Suida (Munich, 1929).

The first element, together with an idealistic and formalistic rejection of the "extra-artistic" problems posed by Leonardo's work, gave rise to R. Longhi's "avant-garde" and highly controversial essay entitled "The Two Lisas" in the 1914 issue of *La Voce*: "Against this man who in a period of empirical culture gave us the blissful concept of the universal genius, the precursor of the modern Larousse, using art solely in the furtherance of science and never for the satisfaction of his own ego, against this man whose

most definite characteristic was a confusion of ends rather than means and who therefore found it difficult to comprehend the most disinterested end of all – art for its own sake – against this man there should be a great deal to say, but I intend to speak only of the Mona Lisa. And, indeed, all we discover in this painting is a sad decomposition of many styles, under the guise of a realistic preconception. The outstanding plastic qualities that required large areas, empty spaces, a treatment of unrelenting consistency, are reduced to almost nothing in the vain search for a feeling between the sentimental and the realistic in the gray-green of the painting. No one can blind us to the contagion beneath this yellowing mask, limp and soft as a pincushion, to the deception in the weight of this wan and paltry loaf."

The opposing standard in Italian art criticism is taken up by L. Venturi (*La Critica e l'Arte di Leonardo*, Bologna 1919), who, precisely because of the universal significance of the formal aspects and theoretical formulations of Leonardo, goes beyond criticism *per se* and concentrates on a conceptual understanding of the *sfumato* and, working to a wider brief, on the revolutionary value of Leonardo's art in the context of his own time. The same Venturi also examines the critical "fame" of Leonardo especially in the nineteenth century.

Leonardo continues to be a lodestar for every age. Specialists solely concerned with his work, such as E. Solmi and G. Calvi from Italy and P. Duhem from France, have published results of their studies. The need for bibliographies is apparent: the definitive compilation is E. Verga's *Bibliografia Vinciana* (Bologna, 1931), to be taken in conjunction with the periodic revisions of the *Raccolta Vinciana* of Milan. Further excellent publications are for example L. H. Heydenreich's revision in the *Zeitschrift für bildende Kunst*, 1935, and the catalog of the specialized Elmer Belt Library in Los

Angeles, edited by K. Steinitz.

In recent years the vast assortment of specialist commentaries and studies on Leonardo's work and thought has continued to spread, written by experts among whom we may mention A. Corbeau, N. de Toni, C. Pedretti, K. Clark, A. M. Brizio, A. Chastel, A. Marinoni, L. H. Heydrenreich, G. Castelfranco, I. Calvi, A. Uccelli, S. Esche, M. V. Brugnoli, E. Winternitz, C. Zammattio, L. Reti, J. Gantner.

Leonardo's philosophical thought, which had already drawn the interest of B. Croce in 1906 (*Saggio sullo Hegel*, Bari, 1913) and E. Cassirer (*Individuum und Kosmos in der Philosophie des Renaissance*, Leipzig, 1927) has been further studied by C. Luporini (*La Mente di Leonardo*, Florence, 1953) and K. Jaspers (*Lionard als Philosoph*, Berne, 1953).

Standard monographs: K. Clark, Cambridge, 1952 (II ed.); G. Castelfranco, Milan, 1952; L. H. Heydenreich, Basle, 1954; L. Goldscheider, London, 1959; C. Baroni, Milan, 1962 (II ed.); V. P. Zubov, Moscow-Leningrad, 1962; A. Ottino della Chiesa, Milan, 1967; A. Pedretti, London, 1973. Drawings: A. E. Popham, *Les dessins de Léonard de Vinci*, Brussels, 1947. Collections of Leonardo's writings: J. P. Richter, London-New York, 1939 (II ed.); A. M. Brizio, Turin, 1966 (reprint); A. Chastel, Paris, 1953; A. Marinoni, Milan, 1952. Collections of essays: *Leonardo da Vinci*, Novara, 1939 (New York, 1967); *Atti del Congresso di Studi Vinciani*, Florence, 1953; *Leonardo da Vinci. Saggi e Ricerche*, Rome, 1954; *Leonardo*, Milan, 1974. Finally, as quoted several times in the text, the essay of L. H. Heydenreich and E. Garin: "Leonardo da Vinci," in the *Encyclopedia of World Art*, IX (New York, 1968). The quoted passages from the Manuscripts are based on E. MacCurdy, ed., *The Notebooks of Leonardo da Vinci* (London, 1938).

Photographic Sources

Index